The VICTORIANS: British Painting 1837–1901

BY MALCOLM WARNER

with contributions by
Anne Helmreich
and Charles Brock

National Gallery of Art
Washington

Distributed by
Harry N. Abrams, Inc.
New York

The VICTORIANS

British Painting 1837–1901

The exhibition is made possible by a generous grant from United Technologies Corporation

The exhibition was organized by the
National Gallery of Art, Washington

EXHIBITION DATES
National Gallery of Art, Washington
February 16–May 11, 1997

The book was produced by the
Editors Office, National Gallery of Art
Frances P. Smyth, *Editor-in-Chief*
Susan Higman, *Editor*
Margaret Bauer, *Designer*
Typeset in Janson and Aureus Uncial
by Duke and Company, Devon,
Pennsylvania. Printed on Consolidated
Centura by Hull Printing Company,
Meriden, Connecticut.

Hardcover distributed by
Harry N. Abrams, Inc., New York.

NOTE TO THE READER
The sequence of paintings is chrono-
logical; works are grouped by artist
and ordered according to date. In gen-
eral, the titles used are those under
which the paintings were first exhibited.
Dimensions are given in inches, followed
by centimeters in parentheses; height
precedes width.

LIBRARY OF CONGRESS
CATALOGUING-IN-PUBLICATION
DATA

Warner, Malcolm, 1953–
The Victorians: British painting,
1837–1901/Malcolm Warner; with
contributions by Anne Helmreich
and Charles Brock.

p. cm.

Catalog of an exhibition held at the
National Gallery of Art, 16 Feb.–
11 May 1997. Includes bibliographical
references.

ISBN 0-89468-263-6 (paper)
ISBN 0-8109-6342-6 (cloth)

1. Painting, British—Exhibitions.
2. Painting, Victorian—Great
Britain—Exhibitions.

I. Helmreich, Anne. II. Brock, Charles,
1959–. III. Title.

ND467.W37 1997
759.2'074'753—dc20 96-27598

ILLUSTRATIONS
Front: detail of cat. 46, James Tissot,
The Ball on Shipboard, c. 1873/1874.
Tate Gallery, London. Presented by the
Trustees of the Chantrey Bequest 1937.

Back: detail of cat. 19, Ford Madox
Brown, *Work*, 1852, 1856–1863.
Manchester City Art Galleries.

Details: page 6, cat. 63; page 10, cat. 6;
page 16, cat. 15; pages 42-43, cat. 22;
pages 56-57, cat. 25; pages 216-217,
cat.38; pages 242-243, cat. 57.

CONTENTS

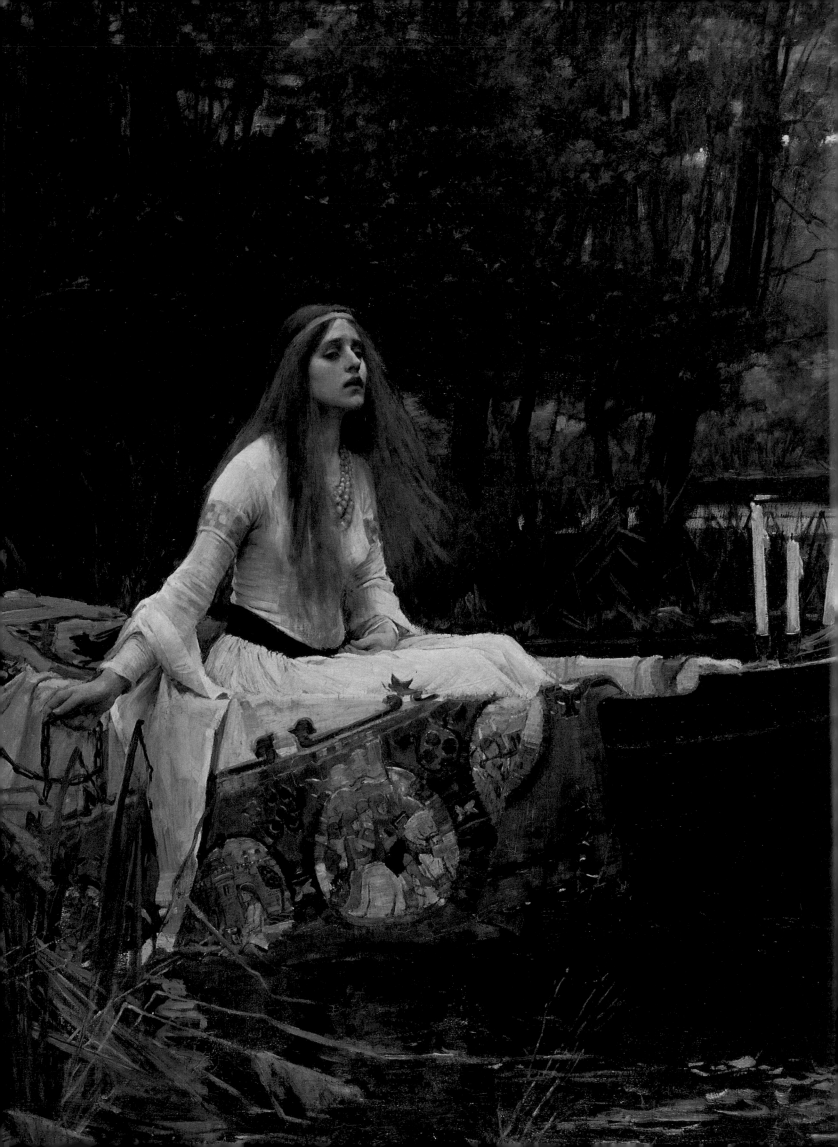

That the achievements of British painters in the nineteenth century are too little known in America may be attributed in part to the unabashedly literary character of the work of such artists as Landseer, Millais, Hunt, Brown, Egg, Frith, Fildes, and Burne-Jones. Their masterpieces repose virtually without exception in British public and private collections, inaccessible to many Americans. Perhaps most important, the dates of most of these paintings coincide almost exactly with the reign of Queen Victoria — which is still, for many Americans, a misunderstood era. It is our hope that *The Victorians: British Painting, 1837–1901*, the first major survey of Victorian art to be mounted in the United States, will address these problems and prejudices.

Victorianism, for many, still connotes prudery, hypocrisy, sentimentality, and especially in its architecture (particularly in its American offshoots), a tendency toward ornamental excess. Yet, the Victorian painters directly and intensely experienced the fruits of modernity — the unprecedented achievements of the industrial revolution as well as its profound social changes and moral and intellectual challenges. No country responded artistically to those changes and challenges, in visual and literary form, earlier or more compellingly than Britain. While the novels of Thackeray, Dickens, and George Eliot are well known in America, as are, to a lesser degree, the poems of Tennyson and Browning, Victorian paintings are less familiar. This exhibition will therefore be full of pleasing surprises and revelations for both scholars and visitors alike.

Malcolm Warner selected the paintings in collaboration with Nicolai Cikovsky, Jr., curator of American and British paintings at the National Gallery, and D. Dodge Thompson, chief of exhibitions at the National Gallery, and wrote the catalogue, to which Anne Helmreich and Charles Brock also contributed. We wish to thank Steven L. Brezzo, director of the San Diego Museum of Art, and Patrick McCaughey, director of the Yale Center for British Art, for allowing Malcolm time away from his regular duties to serve as guest curator for this exhibition.

The exhibition and catalogue were made possible by a generous grant from United Technologies Corporation. With *The Victorians*, this enlightened corporation has supported seven exhibitions at the National Gallery, most recently *Johannes Vermeer*. We are profoundly grateful to George David, president and chief executive officer, for his continuing support of the Gallery's exhibition program.

The exhibition would not have been possible without our lenders, public and private. We requested their most treasured objects, and received the most generous responses possible, for which no amount of thanks, however lavish, is fully adequate. We are particularly grateful to the Tate Gallery for its unstinting support from the outset, and for its generous loan of seventeen paintings. We wish its director, Nicholas Serota, and his superb staff the warmest of best wishes in the Tate's centenary year.

Earl A. Powell III
Director, National Gallery of Art

Lenders
to the
exhibition

Aberdeen Art Gallery
Birmingham Museums and Art Gallery
Bury Art Gallery and Museum
Her Majesty Queen Elizabeth II
Glasgow Museums: Art Gallery and Museum, Kelvingrove
Harris Museum and Art Gallery, Preston
Mr. and Mrs. Henry Keswick
Laing Art Gallery, Newcastle upon Tyne
Leeds City Art Gallery
The Makins Collection
Manchester City Art Galleries
The Metropolitan Museum of Art, New York
Geoffroy Richard Everett Millais Collection
Museo de Arte de Ponce, The Luis A. Ferré Foundation, Inc.
Museum of Fine Arts, Boston
National Galleries of Scotland
National Gallery of Art, Washington
National Museums and Galleries on Merseyside, Walker Art Gallery,
 Liverpool: Lady Lever Art Gallery, Port Sunlight
National Portrait Gallery, London
His Grace The Duke of Northumberland
Philadelphia Museum of Art
Plymouth City Museum and Art Gallery
Mrs. Bunny C. Price
Mr. Michael F. Price
Private collections
Royal Holloway College, University of London, Surrey
Russell-Cotes Art Gallery and Museum, Bournemouth
Santa Barbara Museum of Art
Spencer Museum of Art, The University of Kansas, Lawrence
Staatsgalerie Stuttgart
Tate Gallery, London
The Toledo Museum of Art
Wadsworth Atheneum, Hartford
Wakefield Museums and Arts
The Walters Art Gallery, Baltimore
Watts Gallery, Compton

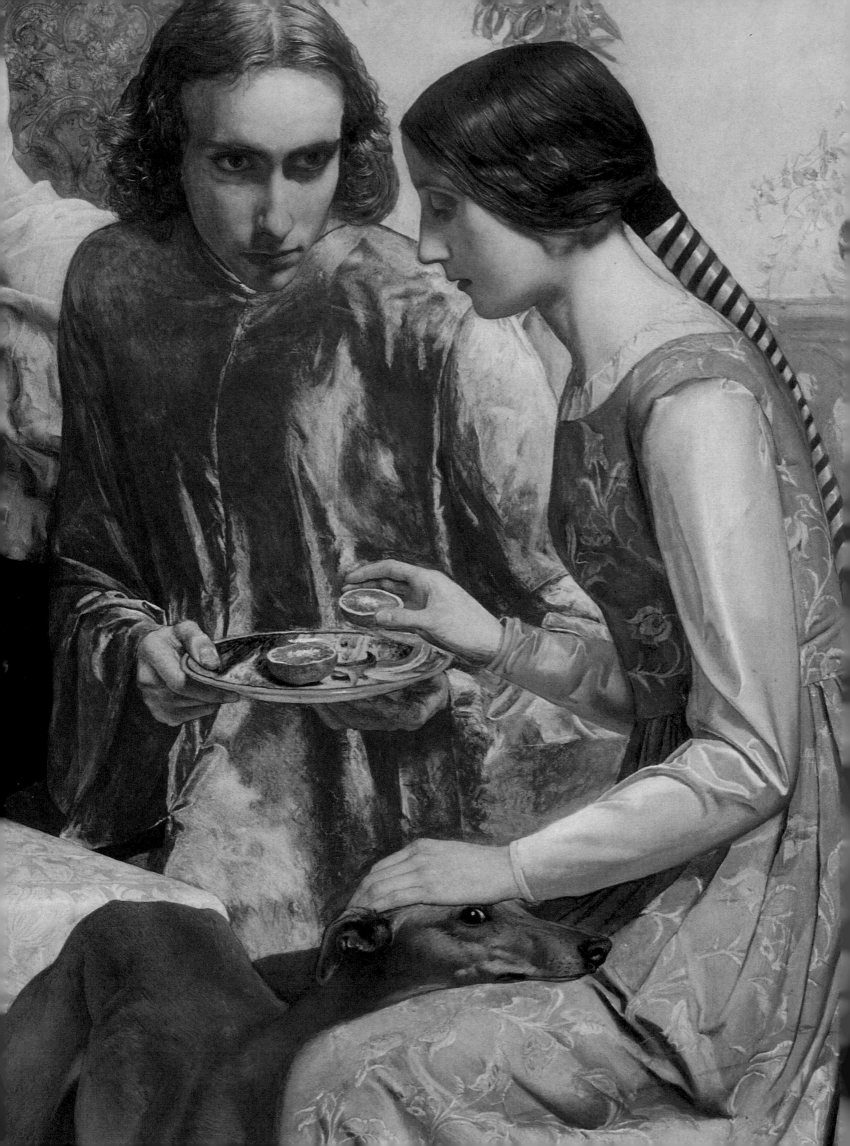

INTRODUCTION

The famous painters of Victorian Britain were more celebrated and richly rewarded for their work than probably any other artists in history. Yet in the forty years after Queen Victoria's reign ended, their reputation sank to depths they could hardly have imagined. The real slump set in with the national nightmare of World War I (1914–1918), which many British people ascribed to arrogance and hypocrisy on the part of their Victorian fathers and grandfathers. As early as 1915 they were using the word "Victorian" to mean self-righteous, stuffy, strait-laced, and generally silly. Soon the period provided the material of urbane satires, Lytton Strachey's *Eminent Victorians* (1918) and Max Beerbohm's *Rossetti and His Circle* (1922), and when its artistic achievements were weighed in the twentieth-century balance, they were found deeply wanting. The influential critics of the modernist movement in Britain, who believed that the business of painting was form and color, pronounced such Victorian concerns as detailed observation, storytelling, symbolism, and beauty to be irrelevant, if not ridiculous. They measured Victorian painting against the work of their idol, Paul Cézanne, and dismissed it as mere "illustration." Clive Bell described the art of the Pre-Raphaelites as "a sermon at a tea-party." "What painters have to do is not convey sentiments about morals and religion, but to create forms which have an emotional significance of their own," he wrote. "The Pre-Raphaelites . . . took little joy in seeing, and less in the problems of plastic expression; they had neither pride of the eye nor a lust of paint."[1] The tendency to associate the Victorians and their art with ser-

mons, tea parties, and general uptightness has persisted, and one aim of the present exhibition is to help people see such stereotypes of so-called Victorianism for what they are. For too many, "Victorian" conjures up the stiff, unsmiling figures in nineteenth-century photographs, not the rich culture that could produce the *Alice* books of Lewis Carroll, the plays of Oscar Wilde, or the paintings of Albert Moore.

Despite the lingering stigma, Victorian painting has enjoyed a revival. In Britain this began as early as the 1940s with an upswing in the reputation of the Pre-Raphaelites. The rush of patriotism and national pride that was part of the British experience in World War II inspired some critics and historians to play up the achievements of British artists generally. There was a nostalgia for more secure and peaceful times, perhaps also a feeling that the twentieth century would be no improvement on the nineteenth, and that sermons and tea parties might not be so bad after all. The Victorian enthusiasts of that time were mostly young, and many took as their guiding light William Gaunt's vivid and inspiring book *The Pre-Raphaelite Tragedy* (1942). In 1948 several British museums, including the Tate Gallery, held exhibitions to mark the centenary of the

formation of the Pre-Raphaelite Brotherhood. The same year saw the publication of another seminal book, the intelligent, well-illustrated *Pre-Raphaelite Painters* by Robin Ironside and John Gere, and many of the greatest Pre-Raphaelite pictures were brought together again for the Royal Academy's winter exhibition of 1951–1952, *The First Hundred Years of the Royal Academy, 1769–1868*. The Pre-Raphaelite revival gathered momentum in the 1960s, when their work struck a chord with the idealism and psychedelic interests of the flower power generation, and appeared to some to relate to pop art. Among the landmarks of its progress to date have been the successful commercial show of Pre-Raphaelite pictures and drawings at the newly opened Maas Gallery in 1961; the one-artist exhibitions curated by Mary Bennett of the Walker Art Gallery, Liverpool, which dealt in a serious art-historical manner with Ford Madox Brown (1964), John Everett Millais (1967), and William Holman Hunt (1969); the retrospectives of Dante Gabriel Rossetti (1973) and Edward Burne-Jones (1975); and the Tate Gallery's blockbuster exhibition of the Pre-Raphaelite movement (1984), which remains among the top box-office triumphs of the gallery's history.

The Victorian painters outside the Pre-Raphaelites' charmed circle were slower to regain their prestige after the interwar years. The dealers Thomas Agnew & Sons mounted an intrepid exhibition of *Victorian Painting, 1837–1887* in 1961, but otherwise there was little significant movement, either in the marketplace or in the literature of art history, until the later 1960s. In 1963 Frederic Leighton's *Flaming June* (cat. 66), today among the most famous images of the Victorian period, was on the London art market priced at a derisory £50. The introductory books on Victorian painting published by Graham Reynolds (1966), Raymond Lister (1966), and Clive Bell's son, Quentin Bell (1967), did much to prepare the groundwork for change. But the real fanfare of the Victorian revival that has been in progress in Britain since the 1960s was Jeremy Maas' lavishly illustrated *Victorian Painters* (1969). Aptly enough, the cover bore a large color reproduction of Leighton's *Flaming June*; Maas had bought the work for his gallery, tried in vain to persuade several British museums to take an interest, and finally sold it to Governor Luis A. Ferré for the Museo de Arte de Ponce, Puerto Rico. In 1975 Richard and Leonée Ormond published a scholarly monograph on Leighton, which

ten years earlier would have seemed the height of eccentricity; in 1978–1979 he was featured with his fellow Victorian classical painters George Frederic Watts and Albert Moore in the major exhibition *Victorian High Renaissance*; and in 1996 he was the subject of a full-scale retrospective at the Royal Academy. Leighton has fared better probably than most of his contemporaries; nevertheless, the steady rise in his reputation over the past thirty years is reasonably typical of Victorian painting as a whole.

Roughly the same pattern, that of a Pre-Raphaelite revival opening out to a more general Victorian revival, emerges from the history of exhibitions and publications on the subject outside Britain. The Pre-Raphaelites were the discovery of the exhibition *Masters of British Painting 1800–1950*, which opened at the Museum of Modern Art in New York and traveled to Saint Louis and San Francisco in 1956–1957. A large Pre-Raphaelite exhibition toured Australia in 1962, and there were others at New York and Indianapolis in 1964, Paris in 1972, Baden-Baden and Frankfurt in 1973–1974, and various venues in Japan in the 1980s. In the United States the problem for all the Victorians has been that the modernist view of nineteenth-century painting, with its focus on the

French avant-garde from Manet to Cézanne, has had an even stronger and more lasting hold over American taste than over European, a fact clearly reflected in the acquisition records of American museums. The literary biographer Lord David Cecil spoke on Burne-Jones in his A. W. Mellon Lectures at the National Gallery of Art in 1966 (published 1969), but the only Victorian paintings to enter the Gallery's collection have been special cases, the Whistlers and the late works of J. M. W. Turner. As in Britain, the 1960s and 1970s saw a number of landmark exhibitions, the best given authority by the scholarship of Professor Allen Staley of Columbia University: *Romantic Art in Britain. Paintings and Drawings 1760–1860* at Detroit and Philadelphia (1968), which included a strong group of Victorian works; the splendid *Forbes* Magazine Collection shown at the Metropolitan Museum of Art, New York, and Princeton (1975); and *Victorian High Renaissance*, which traveled from Manchester in Britain to Minneapolis and Brooklyn (1978–1979). Exhibitions devoted to a single Victorian artist other than a Pre-Raphaelite have been rare on both sides of the Atlantic, and the Edwin Landseer retrospective at the Philadelphia Museum of Art and the Tate

Gallery in 1981–1982 stands out as a noble exception. It was a heady symbolic moment for Victorian art in the United States when Leighton's *Flaming June* appeared on the cover of *Nineteenth-Century Art* by Robert Rosenblum and H. W. Janson (1984). The American taste for Victorian painting continues to grow, especially among students and the young. But it is still hampered by the difficulty of seeing examples in the flesh. Although a number of museums show one or two fairly significant works, and more substantial holdings are available at the Delaware Art Museum in Wilmington, the Fogg Art Museum at Harvard University, and the Yale Center for British Art, there is really no American public collection that does the Victorian period justice.

The books, exhibition catalogues, articles, and reviews generated by the Pre-Raphaelite and Victorian revivals have tended to dwell on the lives of the painters, the interest of their works as illustrations of the Victorian social scene, and the phenomenon of Victorian popular taste. For the most part, this has been highly entertaining. With all their romantic entanglements, the lives of the Pre-Raphaelites in particular are a gift to the biographer; the work of genre painters such as William

Powell Frith provide colorful glimpses into the manners and customs, the dress, occupations, and recreations of the time; and it is certainly interesting to consider the likes and dislikes in art of the huge middle- to lowbrow art public that the Victorian age brought into existence. On the other hand, there has been an unfortunate reluctance among writers on the subject to engage directly in the interpretation and criticism of Victorian paintings as works of art. It is as if they were worried about embarrassing themselves, holding on to solid biographical and sociological justifications for their interest, sometimes even adopting a tone of amused condescension. They have tended to assign to pictures that illustrate painters' lives, facts of social life, or aspects of popular taste an importance out of scale to their quality; some of the kitschiest Victorian paintings have been widely discussed, reproduced, and exhibited, while some of the best are neglected. Feminist scholars and historians of the wider visual culture have done much in recent years to move discussion to what Victorian paintings mean rather than what they illustrate; but they too have singled out artists and pictures on grounds other than artistic ones, many of them regarding the whole notion of quality in art with distaste.

The present exhibition has been selected more critically than historically. It is the first survey exhibition of Victorian painting ever held in the United States, and we felt that our main concern should be to show the best rather than the most representative examples. We certainly have not tried to recreate the exhibitions of Victorian painting held by the Victorians themselves, abundant as they were in what Nathaniel Hawthorne called "Pretty village-scenes of common life —pleasant domestic passages, with a touch of easy humor in them—little pathoses and fancynesses."[2] By Victorian standards the selection is distinctly highbrow, and some famous and popular artists have been omitted. We did not approach the task from any particular theoretical or thematic angle. Of course, all the paintings included reveal something about Victorian taste and the Victorian mentality, and they are discussed from these points of view in the essay and entries in this catalogue. Many are characteristic works by prominent artists of the time, and some arose out of riveting biographical situations. But these were not the primary reasons for their selection; the first goal was always high artistic quality, to represent Victorian painting by its greatest works. We looked for techni-

cal control and refinement, a richness and depth of meaning, ambiguity, a certain resistance to easy interpretation. To venture any more elaborate description of what makes for quality in Victorian or any other kind of painting would be foolhardy. If we have to any degree succeeded in our aim, the exhibition should speak for itself.

For his guidance and wise counsel in the selection of the exhibition, the writing of the catalogue, and the general navigation of the project, I am heartily grateful to my co-curator, Nicolai Cikovsky, Jr., curator of American and British paintings at the National Gallery of Art. We would both like to thank D. Dodge Thompson, chief of exhibitions, for launching the idea of a Victorian exhibition and bringing to the project his constant support and enthusiasm. Anne Helmreich, former research assistant to the associate dean of the Center for Advanced Study in the Visual Arts, has not only contributed a number of fine entries and the bibliography to this catalogue, but has also brought the benefit of her acuity and scholarship to the preparation of the exhibition generally. The catalogue entries on Whistler's paintings are by Charles Brock, exhibitions assistant, who also worked on the chronology, and helped move the project along in

ways too many and various to mention. Lynn Roberts gave invaluable assistance to the catalogue contributors through the detailed notes she supplied on frames. In addition, we would like to thank Ann Bigley Robertson, exhibition officer, Jennifer Fletcher Cipriano, and Jonathan Walz in the department of exhibitions, and Stephenie Schwartz, staff assistant in the department of American and British paintings, for the efficient and cheerful manner in which they have handled the administrative details of the project. Susan Arensberg, head of the department of exhibition programs, and Lynn Russell and Faya Causey, of the department of adult programs in the education division, supervised the educational components of the exhibition. In the editors office, Frances Smyth, editor-in-chief, Susan Higman, editor, and Margaret Bauer, designer, handled daunting deadlines with great professionalism and flair. Joseph Krakora, external affairs officer, Sandy Masur, corporate relations officer, and Diane D. Colaizzi, senior corporate relations associate, were instrumental in securing funding for the exhibition. Deborah Ziska, information officer, coordinated publicity. Ira Bartfield, Sara Sanders-Buell, and Barbara Bernard in the department of imaging and visual services handled photography requests for works in the exhibition. Nancy Hoffmann, assistant to the treasurer, was responsible for the insurance arrangements.

The actual assembling of the works for the exhibition was energetically arranged by Sally Freitag, chief registrar, and Lauren Mellon Cluverius, assistant registrar for exhibitions. The exhibition was gracefully and intelligibly designed and installed by senior curator and chairman of design Gaillard Ravenel, chief of design Mark Leithauser, lighting designer and head of exhibition production Gordon Anson, and head of silkscreen Barbara Keyes.

We are keenly grateful to the private owners of Victorian pictures who have welcomed us into their homes with such warmth and interest, notably Christopher Forbes, the Duke of Northumberland and Lady Victoria Cuthbert, Lord Sherfield, and Mr. and Mrs. Christopher Makins. We would also like to thank the directors and curators at the many museums that we have visited in the course of our researches for their time and hospitality. Julian Treuherz of the National Museums and Galleries on Merseyside and Robin Hamlyn of the Tate Gallery have been especially helpful, sharing with us their wealth of knowledge about Victorian paintings in their own collections and elsewhere. Among the other scholars who have given generously of their expertise and encouragement are Wendy Baron, Laurel Bradley, Judith Bronkhurst, Derrick Cartwright, Susan Casteras, Mary Cowling, Richard Dorment, Stephanie Grilli, Richard Jefferies, Jody Lamb, Jeremy Maas, Richard Ormond, Len Roberts, Vern Swanson, Michael Wentworth, and Stephen Wildman; and for their help and advice with pictures in private hands we owe special thanks to Simon Taylor of Sotheby's and to David Mason. On a more personal note, I would like to mention with deepest gratitude the Aldershot Public Library, where I ran across the books that first fired my enthusiasm for Victorian painting, and Sir Alan Bowness and Benedict Read, my teachers at the Courtauld Institute of Art, who showed me how rewarding the Victorian era could be as a field of study. Finally, for her good cheer, patience, and many kindnesses during the preparation of the exhibition, I offer my most heartfelt thanks of all to my wife, Sara Warner. M.W.

Notes
1. Bell 1927, 108, 109, 111.
2. Hawthorne 1941, 549.

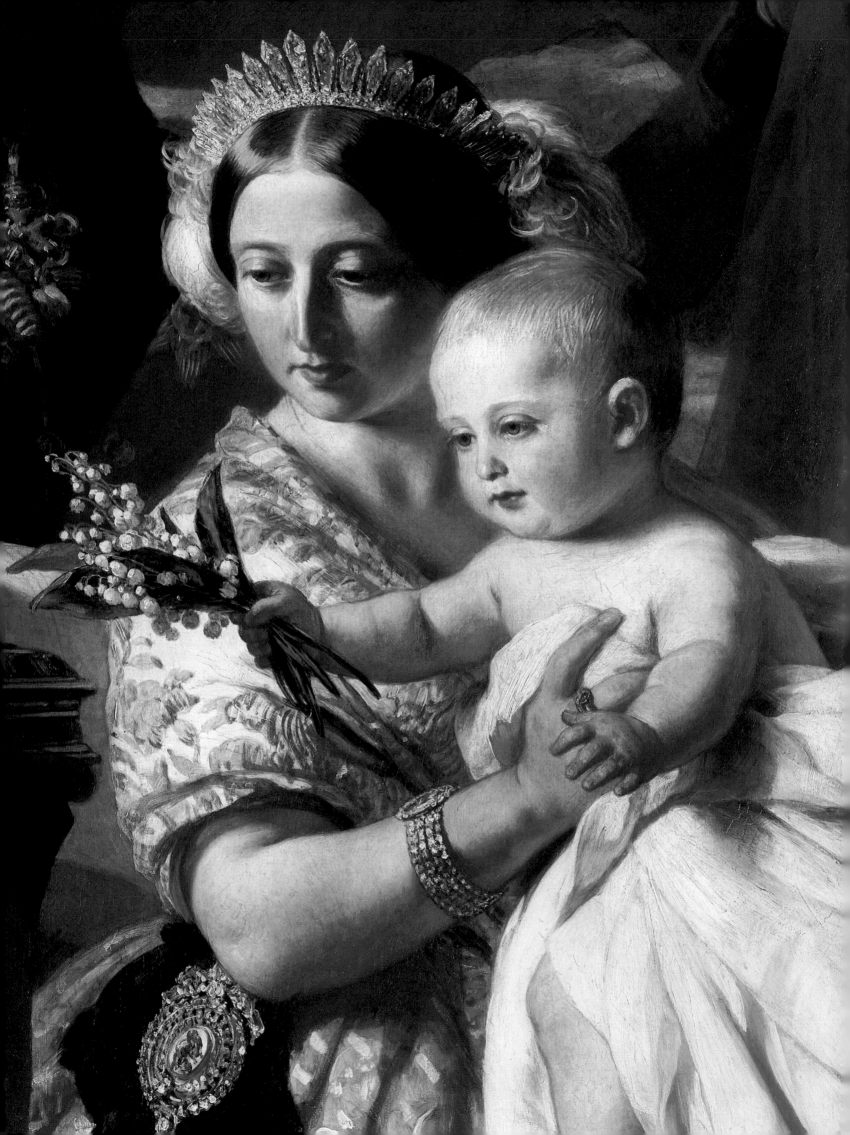

SIGNS OF
THE TIMES

Malcolm Warner

When Queen Victoria and her husband, Prince Albert, commissioned Franz Xaver Winterhalter to paint *The First of May, 1851* (cat. 15), they wanted a family portrait that would also be an allegory of national pride and achievement. The aged duke of Wellington—known affectionately as the Iron Duke, victor over Napoleon at the Battle of Waterloo—was the idol of the people, and for many the embodiment of British courage, forthrightness, and good sense. As godfather to Prince Arthur, he came to Buckingham Palace on the afternoon of 1 May 1851 with presents for the boy on his first birthday, and this is the event that occupies the queen, the child, and Wellington in the portrait. Prince Albert, however, turns slightly away, in the direction of a distant building with the sun's rays bursting from behind—not a royal palace, as one might expect, but the Crystal Palace, that huge structure of girders and glass erected in Hyde Park for the first world's fair, the Great Exhibition of the Works of Industry of All Nations. The exhibition, which the queen opened earlier that afternoon, had been largely Prince Albert's idea. He was president of the royal commission in charge of the project and read aloud the report of its proceedings at the inaugural ceremony. It was a day the queen considered "one of the greatest and most glorious days of our lives,"[1] a day full of symbolism. The period since Waterloo had been one of unbroken peace for Britain, and it was hoped that the exhibition would help maintain peace by promoting a spirit of friendly exchange among the nations. Peace had brought prosperity, and this too would continue as a benefit of the technological

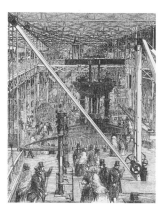

FIGURE I

"Machinery Court," from *The Crystal Palace: An Illustrated Cyclopedia of the Great Exhibition of 1851*

progress celebrated in the exhibition's extraordinary displays of machinery (fig. 1). If the Iron Duke was a living monument to the glory of the past, the Crystal Palace promised glories into the future.

Britain was the cradle of the industrial revolution and by the early Victorian period the most advanced and powerful country on earth. The British believed heartily in themselves and in progress at this time. They were leading the rest of the world into a new age of railways and factories, coal mines and iron works, engineering and shipbuilding, international business and trade, and their mood of optimistic materialism was triumphantly embodied in the Crystal Palace. Designed by Joseph Paxton as an unlikely hybrid of garden conservatory and cathedral, the structure was 1,848 feet long, 408 feet wide, and high enough to accommodate giant elm trees. It was fast and easy to build, practical, and had the look of engineering rather than architecture, which was agreed to be quite in the spirit of the occasion, indeed of the modern era. The palace housed one hundred thousand displays from thirteen thousand exhibitors. Not surprisingly, participants from Britain and its colonies dominated, occupying half the space; the largest of the foreign contingents were from France and Germany. By the time it closed the exhibition had attracted more than six million visitors, representing an average daily attendance of nearly 43,000. On view were raw materials and fine handmade goods, but the main attractions were the machines and inventions. Visitors were fascinated by the displays of state-of-the-art locomotives, carding and spinning machines, printing presses, and agricultural machinery; among the American exhibits, the most far-reaching in its importance, was a sewing machine. The queen herself marveled at the new electric telegraph and sent messages to her subjects in Manchester and Edinburgh. In the words of Prince Albert, the exhibition was "a true test and living picture of the point of development at which the whole of mankind has arrived . . . and a new starting-point from which all nations will be able to direct their future exertions."[2] The lesson it taught was peace and prosperity through technology. In his article "Signs of the Times" (1829), the social critic Thomas Carlyle had written: "Were we required to characterise this age of ours by any single epithet, we should be tempted to call it, not an Heroical, Devotional, Philosophical, or Moral Age, but, above all others, the Mechanical Age. It is the Age of Machinery, in every outward and inward sense of that word; the age which, with its whole undivided might, forwards, teaches and practises the great art of adapting means to ends."[3] In the Britain of the mid-century, this was more true than ever.

By bringing Britain's material achievements to the attention of the world, the exhibition, it was hoped, would advertise the wisdom of its ways in politics. The industrial revolution had diminished the wealth and power of the British aristocracy and gentry, based on the hereditary ownership of land and the profits of agriculture, and increased that of the urban "self-made men" of manufacturing and commerce. It was a source of national pride — especially when the British compared themselves to the French — that the process had been marked by moderate reforms rather than violent revolution. The First Reform Act (1832) had cleared away some of the worst anomalies of the old electoral system, improved the representation in Parliament of the industrial regions, and changed the property qualifications for voting to enfranchise the upper-middle classes. One result was the repeal of the Corn Laws (1846), which lowered the duties on imported wheat — a blow

to British agriculture, but a boon to the industrial interest in the form of cheaper bread. The agitation for repeal of the Corn Laws, organized largely in industrial Manchester, had done much to fix in the early Victorian, middle-class mind its articles of political faith. First among these was laissez-faire, the economic doctrine of individual enterprise and freedom from government interference, involving low taxation and a social policy based largely on the encouragement of charitable organizations. Laissez-faire and a belief in free trade were the main tenets of Victorian Liberalism. The Great Exhibition was a testament to their success, and as long as the mood of 1851 persisted, the Liberals were to dominate British political life.

The rise of Manchester and the other major industrial centers brought about a boom period in British art. The recently enfranchised, Liberal, upper-middle classes were not only wealthy enough to pay high prices for paintings, but also inclined to buy the work of modern British artists rather than the old masters. As Lady Eastlake explained:

The patronage which had been almost exclusively the privilege of the nobility and higher gentry, was now shared (to be subsequently almost engrossed) by a wealthy and intelligent class, chiefly enriched by commerce and trade; the note-book of the painter, while it exhibited lowlier names, showing henceforth higher prices. To this gradual transfer of patronage another advantage very important to the painter was owing; namely, that collections, entirely of modern and sometimes only of living artists, began to be formed. For one sign of the good sense of the *nouveau riche* consisted in a consciousness of his ignorance upon matters of connoisseurship. This led him to seek an article fresh from the painter's loom, in preference to any hazardous attempts at the discrimination of older fabrics.[4]

The commissioned portraiture that accounted for the bulk of aristocratic patronage no longer dominated; art became an open market. Artists would sell their work at the Royal Academy's summer exhibition, or through the dealers' galleries that multiplied in London from around 1850 onward. If they were fortunate, they would increase their return on a painting by selling the copyright to a publisher of engraved reproductions, a means by which art was circulated to, and supported by, a still broader band of the social spectrum. Patronage moved with the great historical forces of the age,

and took art along with it: Victorian painting vividly illustrates the play of ideas and attitudes, the tensions and debates, that exercised the modern middle-class mind.

The Victorian period was marked by a deep historical self-consciousness. The Victorians thought of the age in which they lived as an "Age" indeed, and looked to such latter-day prophets as Carlyle to define its character. Most would agree with him that, for better or worse, it was the age of machinery. This hardly boded well for the arts, and Carlyle himself thought that the proper concerns of the time were action and belief rather than imagination, that its culture should center on biography and history rather than poetry or art. Though seldom mentioned as such, the question underlying the Victorians' voluminous writings on art was, simply, did art have a place? How could it possibly live up to such a prodigious age as the present? It could always hang on as a plaything, taking the low road of prettiness, anecdote, and charm, but what of the high road, and of what would the high road consist? The decisions facing the serious-minded painter were bewildering and ever present. Nothing seemed to come naturally, as things had, presumably, for artists of simpler, slower-moving

times. "Painting is no longer the natural attaining of the sense of beauty and wonder that dwelt in all," wrote Frederic Leighton in his notebook. "The turmoil and complication of modern life make an artist's task incomparably more difficult and artificial. . . . We can no longer be the *unconscious* voice of our time. We are introspective, analytic. Doubts and self-consciousness beset and hamper us."[5] In his lecture "The English Renaissance of Art" (1882), Oscar Wilde spoke of "that strained self-consciousness of our age which . . . must be the source of all or nearly all our culture."[6]

There was sculpture in the Great Exhibition, but the only paintings admitted were "illustrations or examples of materials and processes."[7] If there had been paintings chosen as works of art, it is not difficult, knowing the eminent and popular painters of the day, to guess who the British contingent would have been; they would not, generally speaking, have presented a very bright prospect. Apart from the work of a few embattled young rebels, nothing in British painting showed even an inkling of the raw modernity Paxton had brought to architecture in the Crystal Palace. Some of the problems of painting in this brave new Britain

appear, although the artist himself would never have seen them as such, in Winterhalter's *The First of May, 1851*. The Great Exhibition was this picture's whole reason for being. It proclaims the triumph of the modern and the material; but its heart is clearly elsewhere, with the traditional and the ideal. It is couched as an homage to the old masters of the sixteenth and seventeenth centuries, a would-be Adoration of the Magi. As the queen explained later, disapprovingly, to Prince Arthur: "Dear Papa and Winterhalter wished it to represent an Event, like Rubens—& Paul Veronese did . . . *without any exact fact*."[8]

Since the middle of the eighteenth century, the goal of most ambitious painters in Britain had been to align themselves with the tradition of European art passed down from the High Renaissance in Italy through old masters such as Veronese and Rubens. The mainstay of this tradition, that of the so-called grand manner, was the notion of the ideal. The aim of the artist working in the grand manner was not to show people and things as they appeared in real life, or as they might plausibly have appeared, but in the noblest manner possible. The artist improved upon the facts, correcting the faults and oddities that make everyone

and everything in the world less than perfect. This was the aesthetic philosophy promoted by Joshua Reynolds, the eminent portraitist who had been the first president of the Royal Academy, and whose *Discourses on Art* (delivered 1769–1790) remained the canonical work of art theory in Britain. For him the ideal was "the great leading principle, by which works of genius are conducted," and the duty of artists "to conceive and represent their subjects in a poetical manner, not confined to mere matter of fact."[9] He held that they could follow no better model in this than the Renaissance master Raphael (fig. 2). Of Raphael's paintings of the apostles of Christ, he wrote: "he has drawn them with great nobleness; he has given them as much dignity as the human figure is capable of receiving; yet we are expressly told in scripture they had no such respectable appearance; and of St. Paul in particular, we are told by himself that his *bodily* presence was *mean*. . . . All this is not falsifying any fact; it is taking an allowed poetical licence."[10] From the time of Reynolds until well into the nineteenth century, "the divine Raphael" was revered in Britain as the most perfect painter of perfection. It was predictable, for instance, that a portraitist given the task of represent-

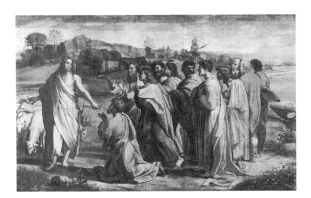

FIGURE 2

Raphael, *Christ's Charge to Peter*, 1515–1516, tapestry cartoon. Her Majesty Queen Elizabeth II, on loan to the Victoria and Albert Museum

ing Victoria as the ideal of a queen and a mother, as Winterhalter was, should make her look as much as possible like a Raphael Madonna.

By the time of the Crystal Palace, however, some bright, serious critics and painters had come to believe that Reynolds' version of the history and purpose of art was a dead hand. The critic John Ruskin asserted that the greatest of all British painters, J. M. W. Turner, had been hampered by the notion of the ideal in landscape painting, and risen to greatness only despite its influence. Ruskin's inspiring prose must have led many a young, dissatisfied painter to look to Turner for suggestions as to a way forward. But in the end, there seemed almost as little future in following him as in following Reynolds. One reason for this was an important shift of ideas by which the more extravagant products of the romantic movement, in art and literature, came to seem outdated. The highly influential writings of Carlyle, fiercely positive and responsive to the times, made the once fashionable persona of the Byronic hero, the solitary wanderer whose deeply troubled soul found resonance in the moods of nature and in acts of crime and violence, appear merely spoiled and immature. The writer Harriet Martineau described in

her autobiography how Carlyle, with his commitment to a socially responsible kind of heroism, "infused into the mind of the English nation a sincerity, earnestness, healthfulness and courage which can be appreciated only by those who are old enough to tell what was our morbid state when Byron was the representative of our temper."[11] The artist William Holman Hunt remembered being appalled at the taste among the older dons at Oxford for Byron's "bombastic and false heroism," and turning to the Victorian poets Alfred Tennyson and Robert Browning for "the manliness and heroism of simple goodness."[12] Despite Ruskin's brilliant descriptions of Turner's art in terms of truth to nature, his general reputation in the 1840s was for a wild, Byronic willfulness.

This was an age that had broken away from the past as no other in history, and was keenly conscious of its own singularity. It was a mechanical age, which called for a progressive art in tune with its practical, inquiring tendencies. The painting that would speak to the age would present the world neither as beautified and old masterly, nor as apprehended through strong, complicated, and personal feelings; like the age itself, it would deal honestly and heartily in facts. It would respect the

importance of material things in themselves. It would allow people and objects to strike the beholder as beautiful, or to inspire emotion, to exactly the degree that they would in real life. Nature needed no help from the artist, and in any case poetic license and subjectivity were out of keeping with the materialistic, scientific tenor of the modern mind. The subject matter of the new painting need not be literally mechanical, showing scenes of locomotives and factories, nor even drawn from modern life. Whether modern or historical, biblical or literary, it need only be of serious interest to living men and women. The revolution would lie in the handling, the description of things in a language that was nineteenth-century Britain's own. These are some of the ideas that lay behind the foundation, in 1848, of the Pre-Raphaelite Brotherhood.

The Pre-Raphaelites knew a little about art before Raphael, and admired Van Eyck's *Arnolfini Marriage Portrait* in the National Gallery, London. They believed artists must have been more humbly observant of nature before the High Renaissance, and in that sense were trying to return to an earlier time. But if their choice of name sounds regressive rather than progressive, that is misleading. In fact, their main idea was

to insult Reynolds and the grand manner; they should perhaps have called themselves "Anti-Raphaelites," which would have prevented at least some of the misunderstanding that met their first works. Reynolds urged the artist to avoid the particular: "His eye being enabled to distinguish the accidental deficiencies, excrescences, and deformities of things, from their general figures, he makes out an abstract idea of their forms more perfect than any one original."[13] The Pre-Raphaelites believed that the particular was everything, and that the people and things in a painting should approach not the ideal, but the most painstaking, warts-and-all kind of portraiture. "Pre-Raphaelitism has but one principle," stated their friend Ruskin, "that of absolute, uncompromising truth in all that it does, obtained by working everything, down to the most minute detail, from nature, and from nature only. . . . Or, where imagination is necessarily trusted to, by always endeavouring to conceive a fact as it really was likely to have happened, rather than as it most prettily *might* have happened."[14]

The members of the "PRB," especially Hunt and John Everett Millais, tried to approach painting with the rigor of the modern scientist: they disdained received notions, working directly and entirely from their own observations. "It is by this attachment to truth in its most severe form that the followers of the Arts have to show that they share in the peculiar character of the present age," wrote their Pre-Raphaelite brother, Frederic George Stephens, in the group's journal *The Germ*:

The sciences have become almost exact within the present century. Geology and chemistry are almost re-instituted. The first has been nearly created; the second expanded so widely that it now searches and measures the creation. And how has this been done but by bringing greater knowledge to bear upon a wider range of experiment; by being precise in the search after the truth? If this adherence to fact, to experiment and not theory,—to begin at the beginning and not fly to the end,—has added so much to the knowledge of man in science; why may it not greatly assist the moral purposes of the Arts? It cannot be well to degrade a lesson by falsehood. Truth in every particular ought to be the aim of the artist. Admit no untruth: let the priest's garments be clean.[15]

The Pre-Raphaelites presented no glimpse or "impression" of the world; their method was more to do with collecting data than with the everyday experience of the eye. It developed in the spirit of modern empiricism and, more than any other kind of contemporary British art, in the spirit of the Crystal Palace. Their pictures are great exhibitions in themselves: an accumulation of objects is carefully displayed, and the sheer quantity to see and consider demands a long visit. The light is display lighting, designed for crystal clarity, with little regard to effects of modeling, atmosphere, or changing weather; nothing is lost in shadows. The particulars of the scene all press themselves upon the viewer's attention at once, and it is usually closed in. Everything is offered for scrutiny; there are botanical and geological specimens to examine, seldom the relief of airy distance. With its all-over, bright, ringing detail, Pre-Raphaelite painting even shares some of the hardness and transparency, the rawness and dazzle, of Paxton's iron and glass.

The Pre-Raphaelites loved facts for themselves, but also as the means to a higher end. Stephens said that the scientific approach to painting was calculated to serve art's "moral purposes" and compared the artist to a priest. It was a central idea of the period that art should be the instrument of good. It could do good even at the level of tech-

nique, by showing the right moral qualities in the way it was made. The products of intense and grueling application on the part of the painters, Pre-Raphaelite pictures served this end by suggesting sheer hard work; they embodied the idea of industry. It is almost impossible to overestimate the reverence felt by the Victorians for work, the gospel of which was given to them from early in the period by Carlyle. In a typical swipe at romantics and intellectuals, he wrote: "Think it not thy business, this of knowing thyself; thou art an unknowable individual: know what thou canst work at; and work at it, like a Hercules! That will be thy better plan. . . . all true Work is Religion."[16] The moral and religious understanding of work grew naturally, in the minds of earnest painters, into a moral and religious understanding of brushwork: if it showed honest toil, it was good; if not, especially if it suggested some kind of sensual pleasure in paint as a material, it smacked of sin. Only against the background of the Carlylean religion of work can we begin to understand, for instance, the fervor of Hunt as he described the fluent, old masterly technique taught to him by his early teachers as "loose, irresponsible handling," or warned that the "wildness" of impressionist brushwork "stimulates a progressive lowering of the standard of personal responsibility, and must breed increased laxity of principle in social rectitude, until the example of defiant indolence imperils the whole nation."[17]

Art should also do good, painters like Hunt believed, through the ideas suggested by its subjects and symbols. Their paintings tell stories with morals, and present characters of interest and importance from the moral point of view. In the scene he painted from Keats' "The Eve of Saint Agnes," Hunt meant to show "the sacredness of honest responsible love and the weakness of proud intemperance,"[18] reading a lesson into the poem that would have surprised its author, to say the least. They found morals in everything; they revered nature not only for its glories and wonders as God's creation, but for the capacity of each object to suggest ideas. They used much flower symbolism: the botanical accuracy this required suited their aim of truth to nature, flowers could be included in almost any scene, and the popular language of flowers was readily understood by their audience. Even the man-made world, viewed in the spirit of humility and moral awareness, contained in latent symbolic form an elaborate commentary upon itself: Hunt depicts a woman's entire future in a dropped glove. There was no need to invent anything to make a point: the deepest thoughts were all to be found in actual objects in the world. The painter had no need of dreams and visions, just an eye for the symbol in the real, and, of course, a sure hand for its accurate transcription. His duty was to ensure that, among the facts he assembled as an account of his chosen subject, there were as many as possible with apt symbolic connotations. The Pre-Raphaelites' extreme attention to detail was as much to do with including more symbols as with including more facts, the two aims being practically inseparable, and their works demand hard interpretative work from the viewer.

Though entirely sincere in the optimism and self-confidence they announced to the world in the Great Exhibition, the early Victorians were by no means free of private doubt and anguish. The sheer speed at which society and ideas were changing, the transitional state of everything, induced a mental and spiritual unease. In "The Scholar-Gipsy" (1852–1853), the poet Matthew Arnold wrote of

. . . this strange disease of modern life,
With its sick hurry, its divided aims,
 Its heads o'ertax'd, its palsied
 hearts. . . .[19]

The discomfort was nowhere more intense than in the sphere of religion, where people quite rightly sensed an impending crisis. The certainties of Christian faith that most of them had grown up with were beginning to fade under the influence of scientific and materialistic habits of thought. Biblical scholars had begun to study the holy scriptures not as divine revelation but as historical documents that could be judged to be fact or, as was disturbingly often the case, something else. More important, the whole tendency of modern geology, particularly in the work of Charles Lyell, was to show the natural world not as the once-and-for-all work of a creator, but as the result of a slow, constant, and continuing process of change, operating under its own laws, over a long period of time. Tennyson caught the feelings of spiritual loss that such discoveries brought about, the yearning for faith in a world of doubt, in his poem *In Memoriam* (1850):

I falter where I firmly trod,
 And falling with my weight of cares
 Upon the great world's altar-stairs
That slope thro' darkness up to God,

I stretch lame hands of faith, and grope,
 And gather dust and chaff, and call

To what I feel is Lord of all,
And faintly trust the larger hope. [20]

Science affected people's imaginations as never before, changing their view of the world and themselves. The British coastline and its cliffs, regarded by earlier generations as the very bulwark of national stability and security, began to suggest a whole new set of associations, with troubling scientific knowledge, with fossils and erosion. As he read the new biblical criticism, the writer and clergyman Charles Kingsley felt as if he were "on a cliff which is crumbling beneath one, and falling piecemeal into the dark sea." [21] In *In Memoriam*, Tennyson imagined cliffs full of fossils crying out the bleak message of evolution: "I care for nothing, all shall go." [22] Under the famous white cliffs of Dover, where he wrote "Dover Beach" (1851), Matthew Arnold seemed to hear the ebbing of the sea of faith:

Its melancholy, long, withdrawing roar,
Retreating, to the breath
Of the night-wind, down the vast edges
 drear
And naked shingles of the world. [23]

In *Pegwell Bay: A Recollection of October 5th, 1858* (cat. 25), that most intelligent of all Pre-Raphaelite paintings, William Dyce shows himself sighting a comet over more fossil-rich cliffs, an image suggesting the immensities of both geological time and astronomical space. Pegwell Bay was where Saint Augustine landed to bring Christianity to Britain; the boy and woman looking out from Dyce's picture could almost be scanning the horizon for a new Saint Augustine to deliver the country, not from paganism this time but from doubt. The Pre-Raphaelite vision, which looked and found meaning everywhere, focused inexorably on the telling detail, even if what it told was disturbing. When Hunt and Ruskin visited the church of the Salute in Venice, Ruskin pointed out the shell fossils embedded in the very pillars of an altar. [24]

In this time of religious uncertainties, in which modern knowledge was undermining the authority of Bible and Church alike, people looked for certainties from their writers and artists. It was the age of the writer as prophet, the artist as preacher. The Pre-Raphaelites were interested in religious subjects from the outset, and Hunt was to lead a realist revolution in sacred art; arising, in part, from the British Protestant's traditional distaste for devotional images, it may be more apt to call it a reformation. In a state-

ment of Pre-Raphaelitism *avant la lettre*, the artist David Wilkie said that "a Martin Luther, in painting, is as much called for as in theology, to sweep away the abuses by which our divine pursuit is encumbered."[25] Wilkie's own attempt to take the lead in this had come to little, but he might well have recognized his Luther in Hunt. Hunt's response to Ruskin's fossils in Venice was optimistic: that even if the literal reading of Genesis had to go, there was still much for modern Christians to believe—and the paintings of his maturity pursue the same reassuring train of thought. Taking his Pre-Raphaelite principles to their natural conclusion, he made it his practice to paint scenes from the scriptures—as far as possible—on the spot in the Holy Land, observing the local people, manners, customs, and surroundings, taking into account the discoveries and theories of biblical archaeologists. In *The Finding of the Saviour in the Temple* (1854/1860; Birmingham Museums and Art Gallery), he painted the heads and costumes of the elders largely from models in Jerusalem. Believing Islamic architecture to be descended from that of the ancient Middle East, he based the setting on a reconstruction of the Alhambra in the Crystal Palace, which by this time had been rebuilt in south

London as a permanent place of recreation. Each picture stood as a testament to the truth of the given event and the characters involved, arrived at scientifically; if there were symbols pointing to higher truths, as there always were, they were confined to objects that would appear in the actual scene. It was no vision of beauty and perfection, no icon inviting people to kneel down, but an account of the story based on fact. It was something that a Doubting Thomas of an age could believe in, and from which it could take much-needed comfort.

The spirit of the Great Exhibition held through the 1850s. But in the 1860s and early 1870s it showed signs of waning, and in the last quarter of the nineteenth century the early Victorian attitude of self-assured powering ahead turned into something more like coasting along. It was apparent that the creed of Liberalism that seemed to promise the increase ad infinitum of national wealth, power, and well-being could not, in fact, be counted upon to deliver all things in all circumstances. The defeat of the Liberal Party under William Ewart Gladstone in the general election of 1874, ending twenty-eight years of Whig-Liberal domination in Parliament, marked a shift in the national consciousness. Although

Britain remained the most powerful country in the world, its preeminence in industry and commerce was no longer unchallenged. The later Victorians expanded the British Empire, and on 1 May 1876 proclaimed the queen "Empress of India," but some of their enthusiasm came from that need to show superiority that comes from fear of its loss. Their rivals, the younger industrial powers of Germany and the United States, posed increasing threats, even to the naval supremacy that was their guarantee of trading freedom and national security. Most troubling of all, strengthened alliances between the European states, along with the buildup of huge national arsenals, pointed more and more clearly to the prospect of war on a large scale, a Great War that would be fought with deadly efficiency with the products of modern science and industry. This was matched at home by a growing sense of antagonism in public life, in particular by the controversy and violence over home rule for Ireland. The birth rate declined, strife between the classes increased, the countryside became more depressed, and the cities more polluted. The mental affliction that Arnold called "this strange disease of modern life" began to appear terminal, and by the end of the century the

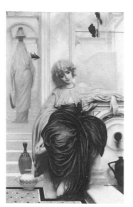

FIGURE 3

Frederic Leighton, *Leider ohne Worte*, 1860/1861, oil on canvas. Tate Gallery, London

optimistic Crystal Palace seemed to the young G. K. Chesterton and his contemporaries like "the temple of a forgotten creed."[26]

The early Victorians may have been shaky in their beliefs, full of questions, unsure where to turn for answers. But they held fast to the idea that, in the end, definite answers did exist, that there was an absolute truth to be revealed and known, even if it might take the overthrow of cherished traditions and conventions of thought. It was an age in which the doubter was as earnest a seeker after spiritual truth as the believer. From the 1860s onward, however, ideas developed and spread that made early Victorian doubt look almost like belief. After the publication of Darwin's *The Origin of Species* (1859), which built on Lyell's ideas and advanced the theories of evolution and natural selection, the debate between science and faith grew more intense and upsetting. Whereas Darwin himself believed that the scientific and religious views of the universe could be reconciled, many of his supporters did not. The scientist Thomas Henry Huxley, "Darwin's bulldog" as he called himself, maintained that the existence of God or anything else beyond the material was utterly unknowable, the doctrine for which he introduced the

term "agnosticism" in 1869. There was a tendency in later Victorian thought toward the philosophy of relativism, which denied the existence of absolutes, all so-called truth being relative to the mind and culture in which it appeared. Such were the ideas behind the highly seductive writings of Walter Pater, notably in his collection of essays *Studies in the History of the Renaissance* (1873). For Pater reality began and ended within the human consciousness; to comprehend experience we should think "not of objects in the solidity with which language invests them, but of impressions, unstable, flickering, inconsistent, which burn and are extinguished with our consciousness of them. . . . Every one of those impressions is the impression of the individual in his isolation, each mind keeping as a solitary prisoner its own dream of a world."[27] The person who believed that he could think his way out of his dream of a world, know things as they really were, discover the right way to live, was deceiving himself. The only life of any meaning was the inner, aesthetic life, the only faculty worth cultivating was that of taking pleasure in one's own sensations. The greatest wisdom lay in "the poetic passion, the desire of beauty, the love of art for its own sake."[28] To the fact-

loving, morally conscious, early Victorian way of thinking this was, of course, anathema—which is why Pater, though writing mostly on the art of the past, had such a radical effect on the arts of his own time. Under his sway, the principles of truth and goodness valued by the Crystal Palace generation appeared to younger minds as false gods, to be set aside.

One way in which the movement against the factual and moral idea of art showed itself was in the increasing fondness of artists for likening visual art to music, which tends by its nature to be fact-free and moral-free. As early as 1861 Leighton called a painting *Lieder ohne Worte* or "Songs without Words" (fig. 3), a title borrowed from Mendelssohn. It shows a girl at a fountain listening to running water and birdsong, and the artist explained to a friend that he was trying "both by colour and by flowing delicate forms, to translate to the eye of the spectator something of the pleasure which the child receives through her ears."[29] The water and the bird are making sounds, and the painter makes a kind of visual music through carefully chosen colors and forms; realism, storytelling, and moral suggestion are not part of the equation. From the later 1860s James McNeill Whistler also gave pictures

musical titles—symphonies, arrangements, nocturnes, and so on—with the predominant colors given in place of keys, as in *Symphony in White No. 1: The White Girl* (cat. 28). The idea was to warn his viewers from too great an interest in subject, to expect abstraction rather than observation. Pater stated the principle of musicality in its most quotable form when he wrote: "*All art constantly aspires towards the condition of music.* For while in all other kinds of art it is possible to distinguish the matter from the form, and the understanding can always make this distinction, yet it is the constant effort of art to obliterate it."[30] In his "Ten O'Clock" lecture (1885), Whistler argued that "Nature contains the elements, in colour and form, of all pictures, as the keyboard contains the notes of all music. But the artist is born to pick, and choose, and group with science, these elements, that the result may be beautiful—as the musician gathers his notes, and forms his chords, until he brings forth from chaos glorious harmony."[31]

For Whistler and his friends, the idea of the painter as observer of facts was ridiculous. In his Ten O'Clock lecture he quipped that "To say to the painter, that Nature is to be taken as she is, is to say to the player, that he may sit on the piano." The Pre-

Raphaelites' clarity of vision, their exhibitions of detail, their rawness were strictly for the tone deaf and lowbrow: "The sun blares, the wind blows from the east, the sky is bereft of cloud, and without, all is of iron. The windows of the Crystal palace are seen from all points of London. The holiday-maker rejoices in the glorious day, and the painter turns aside to shut his eyes." Nature may inspire the artist, but should never obsess him. "He looks at her flower, not with the enlarging lens, that he may gather facts for the botanist, but with the light of the one who sees in her choice selection of brilliant tones and delicate tints, suggestions of future harmonies." People had come to expect too little of art and too much, ignoring the music of form and color in their desire for realism and improving stories; they had acquired "the habit of looking . . . not *at* a picture, but *through* it, at some human fact, that shall, or shall not, from a social point of view, better their mental or moral state." True art was no preacher, but "reticent of habit, abjuring all obtrusiveness, purposing in no way to better others."[32] Wilde made the same point with aphoristic flair in the preface to *The Picture of Dorian Gray* (1891): "No artist has ethical sympathies. An ethical sympathy in an artist is an

unpardonable mannerism of style."[33]

To the "aesthetic movement," as this tendency in British art and taste came to be known, the only essential concern of art was beauty. The aesthetic artists and critics used this term more broadly and vaguely than Reynolds: it was not necessarily bound up with bodily perfection, nobility, and the classical tradition. They found it in Greek sculpture and Renaissance painting, especially in Giorgione and the other Venetians, but also in medieval art and Japanese woodblock prints, both of which Reynolds would have considered primitive. For them, beauty lay in exquisiteness, in objects that gave pleasure simply by being well formed, in works of art with an arrangement of lines, shapes, colors, brushwork, and so on, that had a life and a grace of its own, independent of whatever it might describe. A painting could be beautiful even if its subject were unpleasant; indeed, this could add a piquancy to the viewer's experience. "Beauty may be strange, quaint, terrible, may play with pain as with pleasure, handle a horror till she leaves it a delight," wrote Algernon Charles Swinburne.[34] By the same token, a pleasant subject could never by itself make a beautiful painting; nor could hard work, skill, deep thoughts, or feel-

ings. What must appear, before any of those considerations that tie art to the world outside—the representation of reality, the expression of meaning—is the artist's delight in his art. Writing of Whistler and Dante Gabriel Rossetti, Swinburne observed that they had in common "one supreme quality of spirit and of work, coloured and moulded in each by his individual and inborn force of nature; the love of beauty for the very beauty's sake, the faith and trust in it as a god indeed."[35]

According to Whistler, the problem for art and beauty in the modern world was the rise of the commercial and industrial middle class. When art was the province of the favored few, taste was governed by artists and all was well. But when the industrial revolution elevated the middle class, it also elevated bad taste: "there arose a new class, who discovered the cheap, and foresaw fortune in the facture of the sham. . . . And Birmingham and Manchester arose in their might—and Art was relegated to the curiosity shop."[36] To distance themselves from the prevailing spirit of philistinism in the world, he and other artists of the aesthetic movement assumed the position and demeanor of an upper class, a cultural aristocracy. As the poet and literary critic F. W. H. Myers observed of

Rossetti: "his sensitive and reserved individuality; his life, absorbed in Art, and aloof from . . . the circles of politics or fashion; his refinement, created as it were from within, and independent of conventional models, point him out as a member of that new aristocracy . . . which is coming into existence as a cosmopolitan gentility among the confused and fading class-distinctions of the past."[37] The persona of the aristocrat of art and beauty was aloof and impeccably reserved. In Disraeli's novel *Lothair* (1870), the painter Gaston Phoebus, who is based on Leighton, argues that the "virtue" needed in the pursuit of beauty lies "in the control of the passions, in the sentiment of repose, and the avoidance of all things of excess."[38] To put too much of one's private self in one's art would be bad manners tending toward exhibitionism. "An artist should create beautiful things," says the painter Basil Hallward in *The Picture of Dorian Gray*, "but should put nothing of his own life into them."[39]

The last thing this breed of artist sought was engagement with the real world; the social turbulence of the times was something from which to remove himself as far as possible. In a lecture to students of the Royal Academy (1883), Wilde advised them "to

realise completely your age in order completely to abstract yourself from it."[40] The artist must be, in Whistler's words, "a monument of isolation—hinting at sadness—having no part in the progress of his fellow men."[41] The cozy togetherness of middle-class Victorian family life held as little appeal to him, generally, as industry and commerce, politics and fashion. The studio, not the parlor, was his sanctuary. He took no great pains to disguise the fact that his pictures were created in the studio, even relished a certain artificiality, allowing models to look like models, costumes like costumes, props like props. Henry James described the work of another leading aesthetic painter, Edward Burne-Jones, as the product of "a complete *studio* existence, with doors and windows closed."[42] The suggestion of the studio served as a gesture against vulgar realism, but also as a sign to the world that the artist had his own, better world at home. He might afford people glimpses of that better world, out of a feeling of *noblesse oblige*, but would never wish to meet them on their own cultural ground. It was no coincidence that the annual exhibition created as a showcase for the aesthetic movement, that of the Grosvenor Gallery, was held in premises designed to suggest

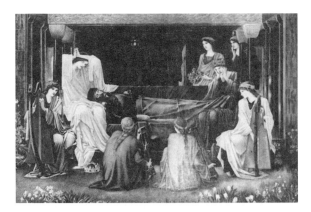

FIGURE 4

Edward Burne-Jones, *The Sleep of King Arthur in Avalon* (detail), c. 1881/1898, oil on canvas. Museo de Arte de Ponce, The Luis A. Ferré Foundation, Inc., Ponce, Puerto Rico

an aristocratic country house.

For those earlier Victorians who did seek engagement with society at large, the casting of models for figures in their pictures and the catching of expressions, the signs of both character and emotion, were of the utmost importance. Much of the appeal of the modern-life subjects of William Powell Frith, his "hat and trousers pictures" as he called them, lay in the panoramic view of society they represented, in the careful selection and description of "types" from different classes and races, following accepted ideas about physiognomy. The legible, plausible expression was vital to the telling of stories and the making of moral points. By contrast, the beautiful female face that was the chief icon of aestheticism was virtually without expression, at most "hinting at sadness" in Whistler's phrase. The models artists chose were not representative or typical, hardly human-looking in some cases; they were merely superior, an aristocracy of beauty. Their beauty was the mainstay of art; nothing could be allowed to disturb the perfect harmony of their features, and any marked expression, artists believed, would do just that. Never mind that their paintings would be lacking in narrative force, their figures in character, feeling, and intel-lect: with beauty at stake, such concerns seemed irrelevant. "Now this is evidently the game the Greeks played in Art, they avoided all expression, feeling that it was detrimental to beauty," observed Millais while working on his prototypical aesthetic picture *Autumn Leaves* (cat. 12). "I believe that perfect beauty and tender expression alone are compatible."[43] If the aesthetic face expresses anything at all, it is tenderness and gentle melancholy, a vague regret about things in general, a weariness. It suggests a state of dreamy abstraction, oblivious to the petty concerns and anxieties of the everyday world. Its blankness was a requirement of beauty, but it also served as a distancing device. Burne-Jones touched upon this in defending the minimal expressions on the faces of the three grieving queens in *The Sleep of King Arthur in Avalon* (fig. 4): "A little more expression and they would be neither queens nor mysteries nor symbols, but just . . . Augusta, Esmeralda, and Dolores, considerably overcome by a recent domestic bereavement."[44] As it is, their strange impassivity helps the viewer to respond to them on the proper high level of suggestiveness, not too literally, as if they were actual people one might know. As Pater wrote of Leonardo da Vinci's studies of female heads: "faint always with some inexplicable faintness, these people seem to be subject to exceptional conditions, to feel powers at work in the common air unfelt by others, to become, as it were, the receptacle of them, and pass them on to us in a chain of secret influences."[45]

The aristocratic persona and serious work hardly go together, and the painters of the aesthetic movement took almost as much delight in idleness as the early Victorians in industry. Never do their beautiful models actually do much; typically they stand or sit still, recline, even fall asleep. Seldom could their works be said to promote morality in the early Victorian sense; on the contrary, the combination of beauty and lassitude could be powerfully erotic, suggesting fleshly abandon. By the same token, artists played down any suggestion of labor in the way they painted, going for an impression of virtuosity rather than virtue, playing up the sensual side to picture-making. They allowed the materials of painting a life of their own, free of the demands of describing reality. They tended to suppress space, making their compositions work first as designs in themselves, on the decorative, abstract level, and only after that as representations. They used color and technique

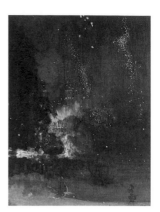

FIGURE 5

James McNeill Whistler, *Nocturne in Black and Gold: The Falling Rocket*, c. 1875, oil on panel. The Detroit Institute of Arts 1989

as all-over, keynote devices, to harmonize the figures and objects in their compositions rather than to individualize them. Brushwork was there to be beautiful, to be looked *at* not *through*. Millais, the lapsed Pre-Raphaelite, gave up painting single blades of grass in favor of a painterly bravura recalling Frans Hals and Velázquez; Burne-Jones would work the surface of a picture with decorative textures suggesting tapestry, or the punchwork on early Italian panels; Leighton painted flesh in a smooth, diffuse technique and draperies in contrastingly thick, creamy brushstrokes, like a sculptor combining marble and bronze; Whistler painted fireworks in a manner that was pyrotechnic in itself (fig. 5), and Ruskin accused him of "flinging a pot of paint in the public's face."[46]

Whistler believed that artists always had to edit the world in their art, and that nineteenth-century Britain presented no particular problems in that respect; he could paint warehouses as palaces in the night, factory chimneys as campanili, the industrial riverfront as a fairyland.[47] But for many later Victorians, finding beauty in the modern world seemed impossible. The problem went far beyond that of low taste and greed among the newly enfranchised middle class: it was the

machinelike soullessness of modern life in general. "Modern habits of investigation have sapped unquestioning faith, and have not supplied anything more consoling," observed George Frederic Watts. "Material prosperity has become our real god, but we are surprised to find that the worship of this visible deity does not make us happy."[48] Art had always been a holy war for beauty, a struggle against the philistines and Mammon; but now the fight seemed more intense than in earlier times, a matter of spiritual life or death. In the "idealist" brand of aestheticism, the purpose of art was to show beauty in the highest, in the world of myth, legend, and allegory, leaving the base, material world far below. William Morris' prologue to his poem *The Earthly Paradise* (1868–1870) invited the reader to "Forget six counties overhung with smoke, / Forget the snorting steam and piston stroke, / Forget the spreading of the hideous town."[49] If art had a "moral" purpose at all, and in this sense the idealists believed it did, it was the inbuilt one of removing the mind from a demeaning present. Watts described it as dealing "with everything that is most beautiful and consequently farthest from the sordid accumulation of modern social conditions"; it suggests

"the noblest and tenderest thoughts, inspiring and awakening, if only for a time, the highest sensibilities of our nature."[50]

What exactly those "noblest and tenderest thoughts" should be, Watts was reluctant to pin down. "All I claim," he said, "is to be a pioneer in the direction of artistic thought, the key to understanding my representations being that the interpretation should be the widest; that each should find there suggestions shaping his best thoughts; and that the member of every creed and every sect may find in it what he holds as best."[51] His was high art for a relativistic age, containing "suggestions" (one of his favorite words) rather than specific ideas. His abstractions are not absolutes; their meaning is in the eye of the beholder. As Chesterton remarked:

The attitude of that age of which the middle and best part of Watts' work is most typical, was an attitude of devouring and concentrated interest in things which were, by their own system, impossible or unknowable. . . . And its supreme and acute difference from most periods of scepticism . . . was this, that when the creeds crumbled and the gods seemed to break up and vanish, it did not fall back, as we do, on things yet more solid and definite. . . . It fell in

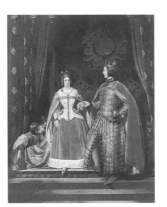

love with abstractions and became enamoured of great and desolate words.[52]

The point is that mighty, absolute truths are beautiful, even when it is no longer possible to believe in such things. The task of the idealist was to distill the beauty; he offered the pleasant sensation that some deep mystery of life was about to be revealed, but never the revelation itself. The basis of his whole art was vagueness.

The Victorians were haunted, ever increasingly, by nostalgia. In the optimistic time of the Crystal Palace, when progress was an article of national faith, it was easy to see the present as ascending toward an even better future; by the 1870s, it seemed to many to be more like exile from a better past. Some, including Whistler, disagreed with this whole downhill way of looking at history. "Why this lifting of the brow in deprecation of the present— this pathos in reference to the past?" he asked. "It is false, this teaching of decay."[53] But as the Britain of the industrial revolution appeared ever smokier, grimier, and more inhuman, most people longed for the handmade, for the rural, for almost any and every preindustrial era. This had a profound and obvious effect on all the arts: it was an age of revivals. The history of art

is full of revivals, but never has there been such self-consciousness and regret about the present, such a hunger for guidance from the past, such a casting around for different period styles and settings, as there was in Victorian Britain. Millais painted "souvenirs" of Gainsborough and Reynolds meant to bring back the supposed grace and refinement of British life just before industry took hold, part of an eighteenth-century revival that made itself felt in all the arts, as well as in fashion. John Singer Sargent's portraits flattered people that they were like aristocrats from the time of Velázquez and Van Dyck; Lawrence Alma-Tadema's archaeological genre scenes compared them to the ancient Romans. Leighton believed that the culture from which modernity could learn most was ancient Greece. But there is no doubt that the greatest historical yearning of the Victorians was for the Middle Ages.

The medieval appeared to the Victorian mind as a national alternative to the classical, a rich source of stories like the myths and legends of the Greeks and Romans, only set in Britain. In a time of bewildering change people enjoyed the thought, right or wrong, that the monarchy and other beloved institutions had descended from the Middle Ages in a continuous

tradition. The queen and Prince Albert played up to this when they had Edwin Landseer paint them as the fourteenth-century Queen Philippa and Edward III (fig. 6). Medieval history and legend, above all the adventures of King Arthur and the Knights of the Round Table, provided both escape and inspiration to an age in which, for all its successes, there seemed so few certainties to act upon, so little occasion for real heroism, such a lack of romance and glamour in life. Carlyle wrote of the appeal of Walter Scott's novels:

[from] an age fallen into spiritual languor, destitute of belief, yet terrified at scepticism; reduced to live a stinted half-life . . . The reader was carried back to rough strong times, wherein those maladies of ours had not yet arisen. Brawny fighters . . . went forth in the most determined manner, nothing doubting. The reader sighed . . . "O, that I too had lived in those times, had never known these logic-cobwebs, this doubt, this sickliness; and been and felt myself alive among men alive!"[54]

At the medieval ruins of Godstowe the young Burne-Jones dreamed of "pictures of the old days, the abbey, and long processions of the faithful, banners of the cross, copes and crosiers,

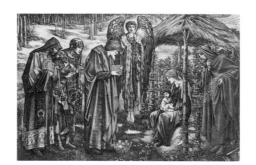

gay knights and ladies by the river bank, hawking-parties and all the pageantry of the golden age"; visiting the Crystal Palace he found only "gigantic wearisomeness . . . cheerless monotony, iron and glass, glass and iron," and foresaw future generations asking "Was this their great palace they talked so much about, poor fools!"[55]

In the earlier Victorian imagination, the history and legends of the Middle Ages were seen as morality teaching by examples. Dyce's idea in his Arthurian frescoes for the Queen's Robing Room in the New Palace of Westminster (Houses of Parliament) was to "consider the Companions of the Round Table as personifications of certain moral qualities, and select for representation such adventures of Arthur and his knights as best exemplified the courage, magnanimity, courtesy, temperance, fidelity, devoutness, and other qualities that make up the ancient idea of chivalric greatness."[56] In Tennyson's *Idylls of the King* (1859–1885), the legends symbolize moral conflict, the war of sense against soul. In the paintings of Rossetti, Burne-Jones, and others from around 1860, however, a different medieval and Arthurian world emerges, one beyond good and evil, a world of beauty, love, and mysticism. For them the

adulterous Queen Guinevere was no longer Tennyson's "wicked one, who broke / The vast design and purpose of the King,"[57] but a kind of sacred personage, whose great beauty and passion put mere morality to shame. The medieval world was a beautiful dream that no one pretended had any relation to the reality of life in that time, and paintings of the dream were self-consciously dreamlike. There is no attempt to recreate an historical scene accurately, "to conceive a fact as it really was likely to have happened" as a Pre-Raphaelite would. Instead, there is a distancing, achieved both through impassivity in the faces of the characters involved, and through a deliberate artificiality in such areas as lighting and the treatment of space. Much takes place in what Burne-Jones called "that mournful twilight that is the sky of dreams."[58] The painter tends to flatten and stylize, sometimes recalling medieval manuscript illuminations, removing his scene from any possible reality. We get the dream and at the same time a melancholy sense of its being *only* a dream.[59]

The Victorian nostalgia for the Middle Ages was, at root, a nostalgia for that most lamented casualty of the modern world, religious faith. Burne-Jones was typical in his love of the

Middle Ages as the age of faith, and of faith as a beautiful, medieval idea: "I could not do without mediaeval Christianity," he wrote. "The central idea of it and all it has gathered to itself made the Europe that I exist in."[60] Of course he was too much a man of the nineteenth century to hold medieval Christian beliefs, but on an aesthetic level he could immerse himself in them totally. Like the "last romantics" in the poem by W. B. Yeats, he "chose for theme / Traditional sanctity and loveliness."[61] While at work on his large watercolor of *The Star of Bethlehem* (fig. 7), he was asked whether he believed in the miraculous story of the Magi and the guiding star; he answered: "It is too beautiful not to be true."[62] How different his attitude to religion and religious art was from that of Hunt, for whom beauty was hardly a consideration, let alone a guarantee of truth, and whose paintings could be described as too true not to be sometimes a little ugly. How ironic that Hunt, the earnest, modern believer and seeker after truth, received no commissions from the church, while Burne-Jones, for whom religion was more a matter of nostalgia and aesthetics, was in constant demand as a designer of stained-glass windows. In the medievalist-aesthetic understanding, the

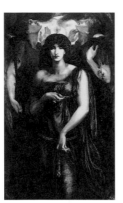

FIGURE 8

Dante Gabriel Rossetti, *Astarte
Syriaca*, 1875–1877, oil on canvas.
Manchester City Art Galleries

importance of religion was not its truth, but its beauty and its poetry. When Rossetti heard of Hunt's plan to treat sacred scenes with some regard to the time and place in which they actually took place, in accordance with "the additional knowledge and longings of the modern mind," he told Hunt that the use of "oriental properties" was bound "to destroy the poetic nature of a design."[63] On seeing the realistic New Testament illustrations of James Tissot, Burne-Jones remarked that in the Annunciation he wanted to see the Virgin's face and was "not to be put off with turban and burnous instead."[64] Religious imagery was not something to be accommodated to the modern scientific mentality, but the antidote to that mentality. "The more materialistic science becomes," Burne-Jones once told Oscar Wilde, "the more angels I shall paint."[65]

Many and various were the ways in which the Victorians sought relief for their spiritual homesickness and longings for something to believe in. The early Victorian, Carlylean urge to lose one's self in hard work, the creed of work for work's sake, was a form of displaced religious piety that was more or less openly laid down as such. The aesthetic movement looked to art in much the same way, not necessarily for any

religious meaning or purpose in the usual sense, just for its own sake, as a religion in itself—and again, talk on the subject took over the language of faith. Among artists, critics, and art lovers phrases such as "the religion of art" and "the worship of beauty" became almost commonplace. Swinburne described the painting of Albert Moore as "the faultless and secure expression of an exclusive worship of things formally beautiful."[66] Wilde called Pater's *Renaissance* "the holy writ of beauty."[67] Burne-Jones, who went to Oxford to become a clergyman, lapsed from his faith and took up art instead, painted *Laus Veneris* ("The Worship of Venus," cat. 41) as an aesthetic catechism; it shows medieval knights and ladies as beauty's cult members. In all her many forms, the impassive goddess of aestheticism appeared to her devotees aurified in mystery, as though the keeper of occult secrets (fig. 8). "Above the enthroning throat . . . Her face is made her shrine," wrote Rossetti in his poem "The Portrait."[68] Myers described Rossetti's paintings as "the sacred pictures of a new religion; forms and faces which bear the same relation to that mystical worship of Beauty . . . as the forms and faces of a Francia or a Leonardo bear to the mediaeval mysteries of the worship of Mary or of

Christ."[69] In painting the icons of what Myers called "this religion of beauty spiritualised into a beatific dream,"[70] artists drew upon traditional patterns of Christian devotional art. The general setting of Burne-Jones' *King Cophetua and the Beggar Maid* (fig. 9), an image of beauty's ascendancy over wealth and power, comes clearly from a fifteenth-century type of Madonna with saints, the *sacra conversazione*. It was common for such works to be framed, heavily and elaborately, in a way that enhanced their altarpiecelike appearance.

As a nation of engineers and empire builders, the most powerful on earth, the Victorians readily identified themselves with the ancient Romans. The comparison was obvious, and the American philosopher and poet Ralph Waldo Emerson was typical of British and foreign observers alike in describing London as "the epitome of our times, and the Rome of to-day."[71] Yet the ancient culture that most interested them, perhaps for the very reason that they were like the Romans, was Greece. The ancient Greece of their imagination was a time that was good for all time, when eternal beauty took shape in the world. It was a dream of fair women in beautiful, flowing draperies. Typically, Leighton believed

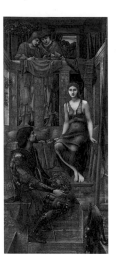

FIGURE 9

Edward Burne-Jones, *King Cophetua and the Beggar Maid*, c. 1875/1884, oil on canvas. Tate Gallery, London

the Greek draperies that were the leit-motif of his art to be free of those ties to time and place that made historical dress, even medieval, unsuitable for high art. "By degrees . . . my growing love of Form made me intolerant of the restraint and exigencies of costume," he wrote in a letter describing his early career, "and led me more and more, and finally, to a class of subjects, or, more accurately, to a set of conditions, in which supreme scope is left to pure artistic qualities, in which no form is imposed upon the artist by the tailor, but in which every form is made obedient to the conception of the design he has in hand. These conditions classic subjects afford, and as vehicles, therefore, of abstract form, which is a thing not of one time but of all time, these subjects can never be obsolete."[72] Greek drapery was not costume but pure form, to be described in the terms one might use of a piece of music; elsewhere he wrote of the "source of fascination in drapery" as being its "combination of expressed motion & rest . . . wayward flow & ripple like living water together with absolute repose."[73] With their commitment to such "pure artistic qualities," the painters who drew upon Greek art, myth, and life were central to the aesthetic movement, offering the harried modern mind an-

other refuge, perhaps less resonant than the Middle Ages spiritually, but beautiful in a primal, abstract sense. To a northern nation the appeal also had something to do with setting; they brought southern warmth and light to cold, foggy London, a touch of the Mediterranean to the Midlands; and as "progress" filled the air with smoke and soot, and gave large areas of the country the look of infernal regions, the old British yearning for the South ran deeper than ever.

"We are of a different race from the Greeks, to whom beauty was everything," protests John Thornton, the industrialist from "Darkshire" in Elizabeth Gaskell's novel *North and South* (1855). "Our glory and beauty arise out of our inward strength, which makes us victorious over material resistance, and over greater difficulties still."[74] To his early Victorian mind, north was north and south was south, and Britain had little use for Greece. But it was not long before critics of the materialistic, laissez-faire attitude that Thornton represented began to say that some Greekness of soul might be exactly what the country needed. In the view of Arnold, the British love of freedom, machinery, and productivity was leading to a brutal, every-man-for-himself kind of society, a state of anarchy that

could be resisted only by devotion to culture. "What an unsound habit of mind it must be which makes us talk of things like coal or iron as constituting the greatness of England," he wrote in the seminal work of social commentary *Culture and Anarchy* (1869), "and how salutary a friend is culture . . . fixing standards of perfection that are real!"[75] For him the properties of culture were order, sweetness, and light; and the model of its highest development was ancient Greece. The Greek possibilities in the British soul had been stifled by an excess of what he called "Hebraism," an Old Testament-driven will to action as opposed to thought, to work and getting ahead, earnestness, and self-control. There was no longer any grace or serenity to life. "The true grace and serenity is that of which Greece and Greek art suggest the admirable ideals of perfection," he wrote, "a serenity which comes from having made order among ideas and harmonised them."[76]

The Victorians looked to classical culture as they looked to medieval culture, for qualities of which they felt bereft in their own. This is why the work of the Victorian classical painters, the "Olympians" as they have been called, has a quite different flavor from neoclassical art of the eighteenth cen-

tury. For Reynolds in Britain, as for his contemporaries all over Europe, the classical world was one of grandeur, nobility, and virtue; the work of art that seemed best to capture its essence was the commanding, heroic figure of the famous Apollo Belvedere. To aesthetic taste, the sense of purposeful action about the Apollo compromised its beauty, while the writhing dynamism and emotion in a piece such as the Laocoön were anathema. Burne-Jones dreaded the sight of the latter among art school collections of plaster casts: "If Laocoön's there," he would say, "all's amiss."[77] The aesthetic movement chose classical touchstones showing the avoidance of emotion that Millais considered "the game the Greeks played in Art." They were works of the most patent grace and serenity, female and passive: the goddesses from the pediment of the Parthenon (then known as the "Fates"), and the Venus de Milo. Leighton, Moore, and Watts included easily recognized allusions to these in their paintings, paying homage to the Greeks and making clear their cultural allegiance. More generally, they took ideas from classical relief sculpture as a form, staging their figures across a relatively shallow space, playing down perspective in favor of lines and planes parallel to the picture

surface. If they addressed any definite subject in their work, such as one of the Greek myths, their emphasis was on personal, inward drama rather than the large event involving dynamic actions and gestures. Their version of the Greek world was insistently ordered and abstracted; in Arnold's terms, it was a haven of culture, a retreat from Hebraism and anarchy.

Unlike their counterparts of the previous century, who tended to value line and form above color, the Victorian classical painters were ardent colorists. They had no wish to carry over into their pictures the austerity of bare marble; on the contrary, they believed color to be the vital touch that could make Greece come alive in nineteenth-century Britain. They were given heart by recent archaeological discoveries, which suggested that originally some Greek sculpture itself had been brightly painted. Watts attended excavations by Charles Newton at the Mausoleum of Halicarnassus, and was thrilled to see colors, though rapidly fading, on fragments as they were unearthed.[78] Not that they wished literally to reconstruct Greek art; their work was more of a free adaptation suited to the modern sensibility. Burne-Jones said of the Greek sculptors: "They give you the godlike

beauty, strength, and majesty. They suggest that wisdom is godlike. They nowhere suggest the mystery of life. That is later."[79] Similarly, Pater believed that whereas sculpture was naturally definite and simple, and for that reason could be considered the essential art of ancient Greece, "painting, music and poetry, with their endless power of complexity, are the special arts of the romantic and modern ages. Into these, with the utmost attenuation of detail, may be translated every delicacy of thought and feeling, incidental to a consciousness brooding with delight over itself."[80] Through color and brushwork, the attributes of painting as opposed to sculpture, the painter could infuse Greek form with some of the mystery and suggestiveness that the modern mind craved. "It is really from the union of Hellenism, in its breadth . . . , its calm possession of beauty, with the passionate colour of the romantic spirit, that springs the art of the nineteenth century in England," said Wilde in "The English Renaissance of Art."[81] He meant "colour" both metaphorically and literally; classical beauty took on a new depth of feeling as marble became paint.

The later Victorians' vision of the British landscape was almost as saturated with nostalgia and longing as

FIGURE 10

John Everett Millais, *Chill October*, 1870, oil on canvas. Sir Andrew Lloyd Webber

their dreams of the Middle Ages and ancient Greece. Nowhere did industrialization show its dark side more ominously than in the spoiling of the countryside, made yet grimmer by agricultural depression and depopulation. "England may be found left . . . without a tree or a hedgerow—a mass of unsightly shells of uninhabited houses, a hideous network of unused railways," wrote Watts, "and, as we now lament the destructive work of the Puritans, we may in a future day lament too late . . . the beauty nature gave and materialism ruthlessly destroyed."[82] As fears of irrevocable loss deepened, as the preservation of the countryside became an emotional issue, the painting of landscape became more charged with mood, or "sentiment" as it was commonly called. The fact-by-fact, tightly symbolic approach taken by the Pre-Raphaelites gave way to a concern with broad conditions of light, atmosphere, and weather, nature's mood-creating "effects." In his *Imagination in Landscape Painting* (1887), the critic P. G. Hamerton argued that the best landscapist exercised his imagination "far more in the creation or selection of effects than in the portrayal of tangible and measurable things," doing so "because he perceives in them certain obscure analogies with

the moods of man."[83] There is a pervasive sentiment of melancholy about the later Victorian landscape, a dwelling on grayness and bleakness, a liking for dusk, autumn, and winter (fig. 10). The feeling of transience and loss, the knell-tolling, echoes the landscape imagery of Tennyson with its "meadows breathing of the past, / And woodlands holy to the dead."[84] The countryside seems almost to mourn for some happier time when man and nature lived in harmony. The nostalgia for old country ways seen in the work of John Constable, especially in his later paintings, becomes at once more intense and hopeless. The parish church that in Constable stood for the beneficent presence of God, in nature and in agriculture, becomes more of a memorial, the sad remnant of a secure, believing, preindustrial society that had passed away.

The painting of proletarian subjects, both rural and urban, took on a seriousness and grandeur far beyond traditional genre painting at this time. Like landscape, scenes of hard work, hard times, and poverty were charged heavily with sentiment, generally pessimistic in tone, and painted with an eye to broad, overall effects. The interest in such subjects emerged from a complicated weave of middle-class atti-

tudes that included both pity and a slightly envious admiration: the life of manual labor was tough, yet glorious in its physicality; it was free of mind-wearying complexity; its joys, sufferings, and tragedies were elemental. The fascination of country people in particular, farm workers, fishermen, and their families, was that they were supposedly in touch with nature; their daily communion with the land or sea gave them an old-world nobility and goodness. They were also thought of as pious, childlike in their souls, accepting of all the beautiful religious beliefs that modernity had rejected. The work they did, sowing and scything for instance, evoked deep symbolic and biblical associations. In *A Hopeless Dawn* (fig. 11), Frank Bramley shows a print of *Christ's Charge to Peter* by Raphael in the fisherman's cottage to make the point that fishermen were Christ's first followers. Hubert von Herkomer's *Hard Times* (cat. 51) recalls the traditional Christian subject of the Rest on the Flight into Egypt. The elevation of the rural lower class to high art was an international trend growing from the highly popular peasant scenes of the French painter Jean-François Millet. It gave rise to artistic "colonies," at Barbizon, Grez-sur-Loing, and Pont-Aven in France, then throughout

FIGURE 11

Frank Bramley, *A Hopeless Dawn*, 1881, oil on canvas. Tate Gallery, London

Europe, where painters could study country life at first hand (often a disillusioning experience) and still enjoy the sophisticated company of their peers. The leading British colony was at the Cornish fishing village of Newlyn; the studio in which Bramley painted *A Hopeless Dawn* was on a lane in the center of the village nicknamed the "Rue des beaux-arts."

The pursuit of sentiment and effects in the grander forms of landscape and genre painting that flourished from the 1870s onward fostered much experimentation in technique. Artists looked with renewed admiration to the painterly touch of the old masters, to Velázquez in particular; they looked to the great painters of the British tradition, to Gainsborough and Constable, with the thought that the free, direct, natural feeling about their brushwork expressed the national character. Most controversially, some young artists of the 1880s and 1890s developed bold techniques influenced by contemporary painting in France. Among the Newlyn school and other groups formed on the model of the French artists' colonies, the preference was for the "square" touch, in which strokes and dabs of color retain enough of their separateness and direction to give a slight all-over blockiness to the

image, a highly infectious technique invented by the French painter of peasants Jules Bastien-Lepage. Painting on the spot, often in the open air, working hard to capture every nuance in the gray light and atmosphere they so relished, the Newlyners brought to their canvases a feeling of honesty and truth that suited their chosen subject; the square touch played its part in this, suggesting that the picture was made with the rough directness that was part of country life. But the breadth of execution British painters learned from the French could bring force to their treatment of a wide variety of subjects, and serve an equally wide range of artistic ends. Although the faces of the unearthly beauties in John William Waterhouse's paintings from myth and legend are handled in a smooth and finished manner, the settings are painted in the style of Bastien-Lepage, becoming more and more exaggeratedly brushy toward the edges. Walter Sickert learned his version of French impressionist technique from Edgar Degas, and used its uncanny power of suggesting the play of light, its glints, gleams, reflections, and color-rich shadows, to paint the highly British subject of the London music hall (cat. 68). His aim was to be neither moral nor particularly realistic, he claimed,

but to catch the protean beauty that was particular to modern urban life. In his preface to the catalogue for the exhibition "London Impressionists" (1889), he wrote: "for those who live in the most wonderful and complex city in the world, the most fruitful course of study lies in a persistent effort to render the magic and the poetry which they daily see around them."[85]

To many older British painters, the spread of French technique appeared as an insidious disease afflicting the young. One objection was that it was un-British, not just in the literal sense, but in going against the national character. For Millais, part of the essence of Britishness was being an individual; the truly British painter, Gainsborough or Constable for instance, developed a technique that was British not only in its freedom and naturalness, but also in being wholly and unmistakably his own. The French-influenced painters, on the other hand, "persist in painting with a broken French accent, all of them much alike, and seemingly content to lose their identity in their imitation of French masters."[86] To Burne-Jones they represented simply the dire impoverishment of painting: "They don't make beauty, they don't make design, they don't make idea, they don't make anything else but atmo-

sphere and I don't think that's enough —I don't think it's very much."[87] Watts saw them as typical of the spirit of indolence growing among the British, "shirking their labour instead of showing sign of determination to overcome difficulties of approach to perfection."[88] The classical painter William Blake Richmond felt that they catered to the short attention span of the modern mind: "In this moment of our century, arising from a variety of causes, rapidly executed suggestions rather than complete and finished pictures are in fashion; people want what they can take in at a glance, without expenditure of time or trouble."[89] For Hunt their work was "materialistic and soulless."[90] Hunt's own painting was materialistic in a sense, but its attention to the material always led through symbolism to moral and spiritual meaning beyond; it had a soul. Here were young painters whose subjects seemed chosen for their sheer insignificance, whose only concern appeared to be the manipulation of paint. It was just as important for British painting to escape from this, as it had been for him and his fellow Pre-Raphaelites to escape from "slosh" (as they called it), the free, lazy old masterly style that dominated British painting when they were students in the 1840s. The anti-French camp

brought together some strange bedfellows; the issues on which Burne-Jones and Hunt agreed were few, and to find themselves on the same side of a question as Frith, another avid anti-French campaigner, must have been an odd thought for both of them. But perhaps its most remarkable feature was its zeal; this was a sign of nationalism obviously, but also of the high moral and spiritual value that art was still widely assumed to have, even among artists of very different stripes.

The most pessimistic of these older Victorians could never have suspected that a century later, at the end of the twentieth century, French impressionist painting would be the most beloved and celebrated art of the Western world. Now all nineteenth-century art tends to be measured against the French avant-garde, the impressionists and the postimpressionists, leading toward fauvism, cubism, and so on. People commonly speak of Turner, rather insultingly, as if his main importance were as a forerunner of impressionism, a voice crying in the artistic wilderness. In this light the Victorians can seem hopelessly stuck in a preimpressionist mentality, as they did to those British modernist critics of earlier this century who did so much to blight their reputation. Of course, it all

depends on which aspects of Victorian painting, and which artists, one takes as representative. Sometimes a Victorian can almost out-modern the moderns. When urged by a friend to add some touch of realism to one of his paintings, Burne-Jones replied with the resoundingly twentieth-century statement: "I don't want to pretend that this isn't a picture."[91] Like Whistler and all the painters of the aesthetic movement, he thought of a painting in protomodernist terms, as a musical arrangement of forms and colors on a surface, a thing to be looked *at*, not *through*. It is not as surprising as it might first seem that the young Pablo Picasso admired Burne-Jones; after seeing some of his paintings reproduced in art magazines, he hoped to come to Britain to study them at first hand. Victorian painters even discussed and experimented with the idea of abstraction. Leighton recommended classical subjects "as vehicles . . . of abstract form," and the briefest look at Watts' *The Sower of the Systems* (cat. 34) shows the leaning toward abstraction that was present in all aesthetic and idealist painting.

Looking at the Victorians within such a frame of reference, assessing their position in the history of European nineteenth-century art, has its

value. Certainly it makes for an interesting debate. But Victorian painting really comes alive when we understand its currents and cross-currents as part of the history of ideas, representing movements and tendencies within the Victorian frame of mind. The period was Britain's heyday of wealth and power, an age that knew it was an Age, and demanded of its painters that they respond in some way, inevitably with a high degree of self-consciousness, to the character of the times. From most points of view, including that of national morale, it falls into two phases divided by the watershed years of the 1870s. The art of the period follows two broad tendencies, engagement with the times and retreat from them, and these were dominant in the earlier and later phases respectively. Throughout Victorian painting we see great economic, social, and political forces in play, but perhaps more than any of these the struggles of religious faith in the modern world. It would be hard to overestimate the importance of religion to Victorian society, or indeed the tensions of its particular spiritual state, deeply religious, yet less and less able to believe. The early Victorians thought that art could serve religion by showing the workings of God in the real world: it could clarify moral issues;

it could affirm the actuality of events described in the Scriptures. Later in the period belief in God, or any other moral or spiritual absolute, came for many to seem impossible. The yearning for faith remained; it simply became a hopeless yearning. Art responded by becoming a religion of its own, its sacred object not the God who may or may not be there in the darkness above the great world's altar stairs, but a deity created in the beholder's own eye, beauty. Almost all the best of Victorian art could in some important sense be called religious, a sign of anxious, doubting times, constantly aspiring toward the condition of faith.

Notes

1. Gibbs-Smith 1950, 17.
2. Gibbs-Smith 1950, 9.
3. *Edinburgh Review* (1829), in Carlyle 1901, 21:465.
4. Eastlake 1870, 147.
5. Ormond and Ormond 1975, 83.
6. Wilde 1908–1922, 14:269–270.
7. R.H. Love, "A Memorial of the Great Exhibition, 1851," quoted in Robertson 1978, 119.
8. Letter of 20 April 1871, Royal Archives, Windsor, quoted in Millar 1992, 1:295.
9. Reynolds 1959, 45, 59.
10. Reynolds 1959, 60.
11. Martineau 1877, 1:387.
12. Hunt 1905, 1:326.
13. Reynolds 1959, 44.
14. *Lectures on Architecture and Painting, Delivered at Edinburgh in November, 1853,* in Ruskin 1903–1912, 12:157.
15. Stephens 1850, 59, 61.
16. *Past and Present* (1843), in Carlyle 1901, 12:190, 194.
17. Hunt 1905, 1:53, 2:461.
18. Hunt 1905, 1:85.
19. Arnold 1993, 99.
20. Section 55, in Tennyson 1953, 243.
21. Quoted in Thorp 1937, 125.
22. Section 56, in Tennyson 1953, 243.
23. Arnold 1993, 77.
24. Hunt 1905, 2:269.
25. Cunningham 1843, 3:442.
26. Chesterton 1904, 10.
27. Pater 1910, 235.
28. Pater 1910, 239.
29. Letter to Edward von Steinle, 30 April 1861, quoted in Barrington 1906, 2:63.
30. Pater 1910, 135.
31. Whistler 1890, 142–143.
32. Whistler 1890, 143, 143–144, 145, 138, 136.
33. Wilde 1908–1922, 12:x.
34. *Notes on Some Pictures of 1868* (with William Michael Rossetti), in Swinburne 1925–1927, 15:215–216.
35. Swinburne 1925–1927, 15:215.
36. Whistler 1890, 141–142.
37. Myers 1885, 331–332.
38. Disraeli, *Lothair,* 3 vols. (London, 1870), 3:136, quoted in Ormond and Ormond 1975, 66.
39. Wilde 1908–1922, 12:18.
40. Wilde 1908–1922, 14:313.
41. Whistler 1890, 155.
42. James 1920, 1:126.
43. Letter to Charles Collins, 1855/1856, Bowerswell Papers, Pierpont Morgan Library, New York, quoted in Warner 1984, 137.
44. Burne-Jones 1904, 2:141.
45. Pater 1910, 116.
46. "Letter 79: Life Guards of New Life" (July 1877), in Ruskin 1903–1912, 29:160.
47. See Whistler 1890, 144.
48. Watts 1912, 3:166.
49. Morris 1910–1915, 3:3.
50. Watts 1912, 3:2, 1:284.
51. Watts 1912, 3:36.
52. Chesterton 1904, 12–13.
53. Whistler 1890, 154.
54. "Sir Walter Scott," *London and Westminster Review* (1838), in Carlyle 1901, 23:433.
55. Burne-Jones 1904, 1:97, 101.
56. Letter to Charles Eastlake as secretary of the fine arts commission, 20 July 1848,

Royal Archives, Windsor, quoted in Girouard 1981, 181.

57. Tennyson 1953, 433.

58. Burne-Jones 1904, 2:7.

59. The "medievalism" of subject and style seen in the work of Rossetti and Burne-Jones, along with the fact that the young Rossetti was one of the founders of the Pre-Raphaelite Brotherhood, has led people to call them and their followers "Pre-Raphaelite"; admittedly this goes back to the artists' own lifetimes but it is none the less confusing for that, and the term is best reserved for the altogether different, factual kind of painting that dominated the 1850s.

60. Burne-Jones 1904, 2:160.

61. From "Coole and Ballylee, 1931," in Yeats 1989, 245.

62. Burne-Jones 1904, 2:209.

63. Hunt 1905, 1:149.

64. Burne-Jones 1981, 96.

65. Wilde 1908–1922, 14:259.

66. Swinburne 1925–1927, 15:198.

67. Wilde 1908–1922, 13:539.

68. Rossetti 1910, 321.

69. Myers 1885, 325.

70. Myers 1885, 330.

71. Emerson 1856, 168.

72. Letter to Joseph Comyns Carr, 1873, quoted in Carr 1908, 98.

73. Ormond and Ormond 1975, 131.

74. Elizabeth Gaskell, *North and South* (London, 1855), chap. 40.

75. Arnold 1932, 51.

76. Arnold 1932, 84.

77. Burne-Jones 1904, 2:158.

78. Watts 1912, 1:165–166.

79. Burne-Jones 1904, 2:263.

80. Pater 1910, 211.

81. Wilde 1908–1922, 14:244.

82. Watts 1912, 3:168.

83. Hamerton 1887, 67, 1.

84. *In Memoriam*, section 99, in Tennyson 1953, 256.

85. *A Collection of Paintings by London Impressionists* [exh. cat., Goupil Gallery] (London, 1889), repr. in Baron and Shone 1992, 59.

86. "Thoughts on Our Art of To-Day," *Magazine of Art* 11 (1888), repr. in Spielmann 1898, 16.

87. Burne-Jones 1981, 122.

88. Hunt 1905, 2:391.

89. Richmond 1896, 475.

90. Hunt 1905, 2:490.

91. Burne-Jones 1904, 2:261.

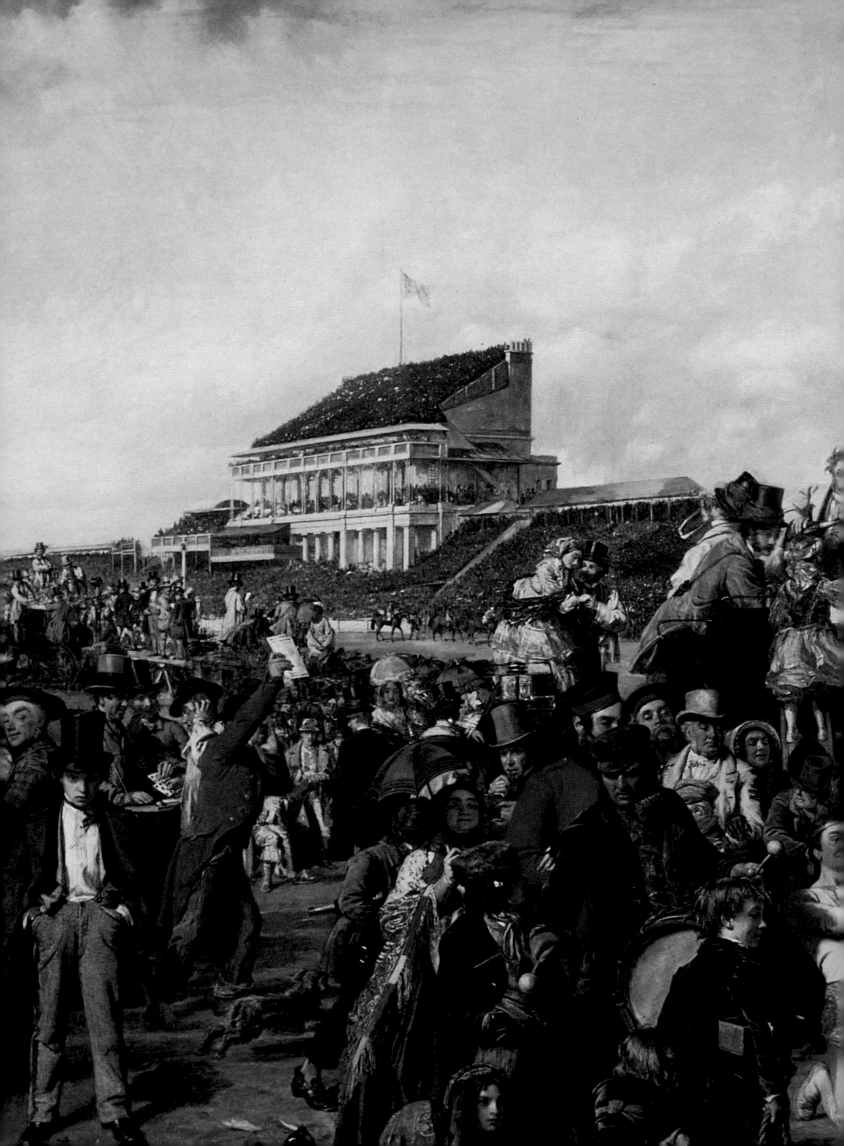

George Cruikshank, frontispiece to Charles Dickens, *Sketches by Boz*, Philadelphia, 1839 edition. National Gallery of Art Library

1837

20 JUNE

Death of King William IV; accession of Queen Victoria, aged eighteen. Born on 24 May 1819, Victoria was to rule over the United Kingdom and its possessions overseas for sixty-three years, by the 1890s claiming a quarter of the world's population as her subjects. Her political role was generally limited to acting upon advice from her ministers, but as an exemplar of the manners and morals of the era, and as a symbol of empire, her influence was considerable. By the end of her long reign her name was synonymous with nineteenth-century British life and culture.

The central event in the artistic calendar throughout Victoria's reign was the annual exhibition of the Royal Academy, the country's main professional body for artists, which opened to the public on the first Monday in May and closed at the end of July. The 1837 exhibition comprised 1,289 works including Landseer, *The Old Shepherd's Chief Mourner* (Victoria and Albert Museum) and Turner, *The Parting of Hero and Leander* (National Gallery, London); by the end of the

century, the number of works shown had increased to more than two thousand. From 1837 to 1868 the RA occupied the east wing of the National Gallery building in Trafalgar Square; since 1868 its premises have been in Burlington House, Piccadilly. The RA was administered by forty royal academicians, who elected a president from among themselves. The Victorian presidents were Martin Archer Shee (1830–1850), Charles Eastlake (1850–1865), Francis Grant (1866–1878), Frederic Leighton (1878–1896), John Everett Millais (1896), and Edward Poynter (1896–1918). In addition to selecting and hanging the annual exhibition, the academicians were responsible for running the Royal Academy schools, which offered a rigorous but narrow professional training for young artists.

Formation of The Clique, composed of the young artists Richard Dadd, Augustus Egg, William Powell Frith, H.N. O'Neil, and John Phillip. This was the first in a series of art movements that arose during the century in opposition to the conservatism of the Royal Academy.

The beginning of the career of Charles Dickens coincided with Victoria's ascent to the throne. *Sketches by 'Boz'* and *The Pickwick Papers*, first published in book form in 1837, made his name as the popular writer of the day. His novels, including *Oliver Twist* (1837–1838), *Nicholas Nickleby* (1838–1839), *David Copperfield* (1849–1850), *Bleak House* (1852–1853), *Hard Times* (1854), and *A Tale of Two Cities* (1859), were, in part, social critiques of the effects of the industrial revolution in Britain. Dickens presented the ethical dilemmas of Victorian life through a vast array of modern types. Many painters, including William Holman Hunt, William Powell Frith, Augustus Egg, and Luke Fildes, shared his interest in contemporary subject matter and moralizing narrative, and were directly inspired by his work.

1838

9 APRIL

Official public opening of the National Gallery in Trafalgar Square. The gallery was founded in 1824 with the government purchase of the Angerstein Collection. The first important additions of British painting were Robert

Vernon's gift of 157 pictures, including works by William Etty, David Wilkie, J.M.W. Turner, William Mulready, and Edwin Landseer, in December 1847, and the Turner Bequest of March 1856. The Turner Bequest, contested for five years following the artist's death in 1851, consisted of 100 paintings, 182 unfinished oils, and more than 19,000 drawings. The British collections were located in South Kensington from 1859 until the completion of a new wing of the National Gallery in 1876. In 1897 a majority of the works were transferred to the newly opened Tate Gallery.

1839

JANUARY

First issue of *The Art-Union*, later known as the *Art Journal* (1849–1912), which provided comprehensive coverage of art exhibitions and sales. Art periodicals were part of the proliferation of affordable magazines that occurred in the nineteenth century with advances in the technology of printing. These included news weeklies, such as the *Illustrated London News* (from 1842); comic magazines, such as *Punch* (from 1841); and literary journals, such as the

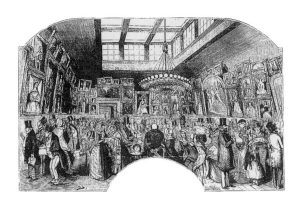

Saturday Review (1855–1938). The *Graphic*, a general-interest magazine featuring engravings by such social realist artists as Luke Fildes and Hubert von Herkomer, was founded in 1869. Among other important art periodicals were *The Magazine of Art* (1878–1904), *The Portfolio* (1870–1893), and *The Studio* (1893–).

MAY–JULY
Royal Academy: Turner, *The Fighting Temeraire* (National Gallery, London)

1840
..

10 FEBRUARY
Marriage of Queen Victoria to her first cousin, the German Prince Albert of Saxe-Coburg-Gotha. With a family of nine children, the royal couple were to project an image of domestic harmony for the nation. As Victoria's private secretary and adviser, Prince Albert argued effectively for a policy of nonpartisanship to strengthen the constitutional monarchy. He was active in a number of administrative bodies connected with art. He died from typhoid in 1861, two years after being proclaimed prince consort. Queen Victoria, devastated by the loss, lived the next ten years

in seclusion, losing much of the affection she had previously enjoyed from her subjects.

MAY–JULY
Royal Academy: Turner, *The Slave Ship* (cat. 2)

1841
..

Launch of the humorous magazine *Punch*. Combining literary sketches, political cartoons, and social and cultural lampoons, and containing the work of leading illustrators such as George Du Maurier, Richard Doyle, and John Leech, *Punch* became the major comic periodical of its day. Among its many targets were British artists and their contributions to the Royal Academy and Grosvenor Gallery exhibitions.

1842
..

MAY–JULY
Royal Academy: Landseer, *Eos* (cat. 3); Turner, *Peace — Burial at Sea* (Tate Gallery), *Snow Storm — Steam-Boat off a Harbour's Mouth* (Tate Gallery)

1843
..

Publication of *Past and Present* by Thomas Carlyle. A writer, historian, and social critic, Car-

lyle was one of the leading thinkers of his time. In *Past and Present*, as Ruskin would do later, Carlyle unfavorably compared modern Britain with the medieval past, matching the religious faith and coherent social order of the Middle Ages against the alienation, skepticism, and social chaos of a country abandoned to rampant materialism. In *Sartor Resartus* (1833–1834), Carlyle reformulated his own faith in response to the challenges of modern rationalism, asserting that through duty and reverence one could triumph over skepticism and discern what he termed a "natural supernaturalism" at work in the world.

MAY
First volume of *Modern Painters* by John Ruskin (5 vols., 1843–1860), a defense of J.M.W. Turner as the greatest living artist and the first painter in history to have given "an entire transcript of the whole system of nature." The cornerstone of Ruskin's beliefs was that the artist must copy nature directly and faithfully to achieve a true expression of the divine qualities in natural forms. In the 1850s he defended the Pre-Raphaelites for their meticulous attention to detail and fact.

Ruskin shared the medievalizing tendency of his era and extolled the virtues of Gothic architecture, as evidence of a profoundly spiritual society, in *The Seven Lamps of Architecture* (1849) and *The Stones of Venice* (1851–1853). Later in his life, he came to view British society as corrupted by self-interest, laissez-faire economics, and materialism, offering his views for its reform in a series of letters to the working classes entitled *Fors Clavigera* (1871–1884). The last twenty years of his life were blighted by mental illness, and he died in 1900.

1 JULY–2 SEPTEMBER
Exhibition at Westminster Hall of cartoons entered for the competition to select artists to paint frescoes in the New Palace of Westminster (Houses of Parliament), run by the Fine Arts Commission, headed by Prince Albert. The subjects were to be from English history, or the works of Spenser, Shakespeare, or Milton, which lent impetus to the painting of English historical and literary subjects. The prizewinners included the young G.F. Watts. Work on the frescoes went on into the 1860s. The most successful were Daniel Maclise's scenes from the Napoleonic

Wars (Royal Gallery), and William Dyce's series of Arthurian subjects (Queen's Robing Room).

1844

MAY–JULY
Royal Academy: Dyce, *Joash Shooting the Arrow of Deliverance* (Kunsthalle Hamburg); Landseer, *Coming Events Cast Their Shadow Before Them* (cat. 4); Turner, *Rain, Steam, and Speed — the Great Western Railway* (National Gallery, London)

Parliament declares art unions legal. These commissioned prints and paintings by well-known artists, then organized lotteries for their distribution. Attacked by their opponents as a form of gambling, the art unions helped to stimulate the burgeoning market for prints.

1845

OCTOBER
Loss of the potato crop in Ireland leads to the Irish Famine, resulting in the deaths of more than a million people and the emigration of an even greater number over the next four years. The failure of the government in London to address the famine effectively aggra-

vated relations between England and Ireland, leading to a surge in Irish nationalism.

1846

MAY–JULY
Royal Academy: Landseer, *Stag at Bay* (private collection); Turner, *The Angel Standing in the Sun* (Tate Gallery); Dyce, *Madonna and Child* (Royal Collection)

JUNE
Parliament repeals the Corn Laws, which regulated grain imports. The laws were supported by landed interests, whose agricultural concerns were protected from foreign competition, and opposed by members representing new manufacturing and commercial concerns, who viewed them as a drag on growth and progress. The repeal signaled the political ascendancy of industry and commerce, and began a period of Whig (later Liberal) Party control of Parliament that lasted, with only brief interruptions, until 1874.

1847

5 FEBRUARY
First Meeting of the Printsellers Association, established

to register and control the distribution of fine art prints. The association included publishers, dealers, artists, and engravers. By assigning values to prints and artists' proofs and making lists of prices and edition numbers available to its members, the association spurred speculation and encouraged the boom in the print industry. The sale of engravings after popular paintings was lucrative for both artists and dealers: the copyright to a painting was sometimes worth more than the canvas itself. While deplored by its critics as a sign of philistinism, the market for prints reflected the democratic tendencies of the age, bringing the work of Victorian artists into the homes of the British middle-class in unprecedented numbers.

1848

FEBRUARY
Publication of the *Communist Manifesto* by Karl Marx and Friedrich Engels (English translation 1850), who critiqued the effects of industrialization and urbanization in Britain. Engels had published *The Condition of the Working Class in England* in 1845 and Marx moved to London in

1849, shortly after the *Communist Manifesto* was issued. He published the first volume of *Das Kapital* there in 1867.

10 APRIL
As political revolutions occur across Europe in Austria, France, and Italy, the last Chartist demonstrations are held in England. Chartism was derived from the six-point charter drafted in 1838 by the London Working Men's Association. Its main aims were the representation of the working classes in Parliament through universal manhood suffrage, the institution of salaries for members of Parliament, and the abolition of the property requirement for election to the House of Commons. Though their petitions were rejected by Parliament in 1838, 1842, and 1848, all the Chartists' goals, with the exception of annual parliaments, were eventually realized.

Free exhibition, near Hyde Park Corner: F.M. Brown, *The First Translation of the Bible into English: Wycliffe Reading His Translation of the Bible to John of Gaunt* (Bradford City Art Gallery)

SEPTEMBER
Foundation of the Pre-Raphaelite Brotherhood by William Holman Hunt, John Everett Millais, and Dante Gabriel Rossetti while students at the Royal Academy schools; the other four members, Thomas Woolner, James Collinson, F. G. Stephens, and Rossetti's younger brother William Michael Rossetti, were comparatively minor figures. The PRB believed that the dogged allegiance of older British painters to the Renaissance (or "Raphaelite") tradition was misguided, and that it was time for a return to nature. They painted in sharp detail and bright colors, rejecting the hallowed principle of ideal beauty, by which the artist "improves" upon reality, taking instead a factual approach based on meticulous observation. Their pictures often contain elaborate schemes of symbolism, in which almost every object has a latent significance. In January–April 1850 they published *The Germ*, a magazine that served as a mouthpiece for their ideas and literary efforts; it folded after four issues. The PRB had disbanded by 1854, but the Pre-Raphaelite style dominated advanced British painting throughout the 1850s.

1849

MAY–JULY
Royal Academy: Hunt, *Rienzi* (private collection); Millais, *Isabella* (cat. 6)

Free exhibition, near Hyde Park Corner: Rossetti, *The Girlhood of Mary Virgin* (Tate Gallery)

1850

MARCH
The heated controversy over the Gorham Judgment revealed tensions between high church and low church Anglicans. Gorham was a vicar whose views were held by high churchmen (also known as Tractarians, or members of the Oxford Movement) to be heretical. The question was decided by the judicial committee of the privy council in Gorham's favor, after which several high churchmen seceded to the Church of Rome.

MAY–JULY
Royal Academy: Hunt, *A Converted British Family Sheltering a Christian Missionary from the Persecution of the Druids* (Ashmolean Museum, Oxford); Millais, *Christ in the Carpenter's Shop* (cat. 7), which

brought forth a storm of violent criticism against the Pre-Raphaelites.

National Institution, Regent Street: Rossetti, *Ecce Ancilla Domini!* (Tate Gallery)

19 NOVEMBER
Alfred Tennyson named poet laureate in succession to Wordsworth. Among his major works were *The Princess* (1847), *In Memoriam* (1850), and *Maud* (1855). The 1857 Moxon edition of his poems included wood engravings by William Holman Hunt, Dante Gabriel Rossetti, and John Everett Millais. Tennyson's fascination with Arthurian legend, evident in *Idylls of the King* (1859–1885), was shared by numerous Victorian artists, including Hunt, Rossetti, Edward Burne-Jones, and William Morris, as well as the writers Matthew Arnold and Algernon Swinburne.

1851

1 MAY
The Great Exhibition of the Works of Industry of All Nations opened by Queen Victoria. The first of the nineteenth-century world's fairs, celebrating the accomplish-

ments of manufacture and industry, the exhibition was housed in the Crystal Palace, designed by Joseph Paxton. The exhibition reflected Britain's sense of national supremacy in the modern, industrial age.

MAY–JULY
Royal Academy: F. M. Brown, *Geoffrey Chaucer Reading the "Legend of Custance" to Edward III and His Court* (Art Gallery of New South Wales, Sydney); Landseer, *The Monarch of the Glen* (John Dewar and Sons). When the critics again attacked works by the Pre-Raphaelites at the RA, including Millais' *Mariana* (cat. 8), Ruskin came to their defense in letters to *The Times* (13 and 30 May).

19 DECEMBER
Death of Turner; burial in Saint Paul's Cathedral.

1852

MAY–JULY
Royal Academy: Hunt, *The Hireling Shepherd* (Manchester City Art Galleries); Millais, *A Huguenot* (cat. 10), *Ophelia* (cat. 9)

1853

MAY–JULY

Royal Academy: Dyce, *Jacob and Rachel* (Kunsthalle Hamburg); Hunt, *Our English Coasts, 1852* (Tate Gallery); Millais, *The Order of Release, 1746* (Tate Gallery)

1854

MARCH

Declaration of war against Russia, leading to the Crimean War, Britain's largest foreign conflict between the Battle of Waterloo (1815) and World War I (1914–1918). The war ended, inconclusively, in February 1856.

MAY–JULY

Royal Academy: Frith, *Life at the Sea-Side (Ramsgate Sands)* (Royal Collection); Hunt, *The Awakening Conscience* (cat. 16), *The Light of the World* (Keble College, Oxford)

1855

MAY–JULY

Royal Academy: John William Inchbold, *A Study, in March* (Ashmolean Museum, Oxford); Leighton, *Cimabue's Celebrated Madonna is Carried in Procession Through the Streets of Florence* (Royal Collection); Millais, *The Rescue* (National Gallery of Victoria, Melbourne). This year's exhibition was the subject of the first of Ruskin's critical *Academy Notes*, which he published annually until 1859.

15 MAY

Opening of the Exposition Universelle in Paris. The British Fine Arts section was well received, and the Pre-Raphaelites' work won praise from the French romantic painter Eugène Delacroix, as well as from Charles Baudelaire and Théophile Gautier. Gautier commented that "An English picture is as modern as a volume of Balzac; it reveals civilization in its latest form and minutest details."

1856

MAY–JULY

Royal Academy: Hughes, *April Love* (Tate Gallery); Hunt, *The Scapegoat* (cat. 17); Millais, *Autumn Leaves* (cat. 12), *The Blind Girl* (cat. 11); Wallis, *The Death of Chatterton* (cat. 20)

6 JUNE

Parliament approves funds for a National Portrait Gallery, with Prime Minister Viscount Palmerston arguing that a collection of likenesses of the nation's greatest men would serve as "an incentive to mental exertion, to noble actions." In the same year G.F. Watts began work on his "Hall of Fame," a series of portraits featuring eminent Victorians, forty-two of which later entered the National Portrait Gallery's collections. The portrait collection had no permanent home until the completion of its premises next to the National Gallery, which opened to the public on 4 April 1896.

1857

5 MAY

Manchester Art Treasures Exhibition opened to the public by Prince Albert. The show was a vast survey of the decorative and fine arts, totaling sixteen thousand objects, with two thousand paintings by old and modern masters from the Dutch, Flemish, French, German, Spanish, and British schools. Among these were twenty-one Raphaels, twenty-eight Titians, thirty Rembrandts, thirty-four Rubenses, and fourteen canvases by or attributed to Velázquez, as well as works by Turner, Constable, Landseer, and the Pre-Raphaelites. Drawn entirely from British collections, the exhibition attracted 1,300,000 visitors.

MAY–JULY

Royal Academy: Brett, *The Glacier of Rosenlaui* (Tate Gallery); Dyce, *Titian Preparing to Make His First Essay in Colouring* (Aberdeen Art Gallery); Millais, *A Dream of the Past (Sir Isumbras at the Ford)* (Lady Lever Art Gallery, Port Sunlight)

10 MAY

Outbreak of the Indian Mutiny. With atrocities committed on both sides, the mutiny marked the end of the East India Company and the establishment of crown rule in India. Peace proclaimed on 8 July 1858.

20 JUNE

Opening of the South Kensington Museum. After the Great Exhibition of 1851, a committee was chosen to purchase objects from the show to form the basis of a new museum of manufactured goods, and Prince Albert suggested a site for the museum at South Kensington. Paintings were added in 1856 when the gift by John Sheepshanks of his collection of modern British pictures was accepted by Parliament

with money also granted for a building. With additional galleries constructed from 1857 to 1861 for the Vernon Collection and Turner Bequest (on temporary loan from the National Gallery), the South Kensington Museum became the most important venue for viewing contemporary British art. In 1899 Victoria laid the foundation stone for a new building and the museum was renamed the Victoria and Albert.

SUMMER

Dante Gabriel Rossetti begins work on murals, based on the Arthurian legends, for the new Union Debating Hall in Oxford. Rossetti was joined on the project by William Morris, Edward Burne-Jones, Spencer Stanhope, Val Prinsep, John Hungerford Pollen, and Arthur Hughes. Because the artists were ignorant of fresco techniques, their brilliantly colored designs began to deteriorate shortly after completion.

20 OCTOBER

Opening of an exhibition of contemporary British painting, showcasing the work of the Pre-Raphaelites, at the National Academy of Design, New York. The exhibition, organized with the assistance of William Michael Rossetti, traveled to Philadelphia and Boston, and included 168 oils and 188 watercolors.

1858

MAY–JULY

Royal Academy: Brett, *The Stonebreaker* (Walker Art Gallery, Liverpool); Egg, *Past and Present* (cat. 24); Frith, *Derby Day* (cat. 22); Wallis, *The Stonebreaker* (Birmingham Museums and Art Gallery)

1859

JANUARY

British Institution exhibition: Egley, *Omnibus Life in London* (cat. 26)

APRIL

A letter signed by a group of thirty-nine women artists is sent to the forty royal academicians urging the opening of the Academy to females. Laura Hereford, using the signature L. Hereford, was admitted later that year, opening the door for other applicants. While the Royal Academy reluctantly and gradually increased the number of women in its classes, the Slade School of Art at University College began admitting women shortly after its foundation in 1871 and actively encouraged their enrollment. By the 1880s and 1890s opportunities for women artists had increased with the proliferation of art schools generally. Study from the nude model, an essential part of academic art training, remained a controversial issue until the end of the century; the Slade finally dropped its prohibition in 1898, followed by the Royal Academy in 1903.

MAY–JULY

Royal Academy: Brett, *Val d'Aosta* (private collection); Hughes, *The Long Engagement* (Birmingham Museums and Art Gallery); Millais, *The Vale of Rest* (cat. 13)

NOVEMBER

Publication of *On the Origin of Species by Means of Natural Selection, or the Preservation of Favoured Races in the Struggle for Life* by Charles Darwin. In this revolutionary work Darwin proposed that forms of life are not static but evolve in response to their environment, with those species best fitted to their surroundings surviving. Darwin defended and refined his views in works such as *The Descent of Man, and Selection in Relation to Sex* (1871) and *The Expression of the Emotions in Man and Animals* (1872), which, among other theories, advanced the idea that man had descended from primates. Ridiculed and caricatured by the Victorian press, Darwin's theories addressed central issues of human identity that struck at the heart of the religious, social, and political orthodoxies of his day.

1860

17 APRIL

Private viewing of Hunt's *The Finding of the Saviour in the Temple* (Birmingham Museums and Art Gallery) at the German Gallery, a landmark in the rise of the one-picture exhibition.

MAY–JULY

Royal Academy: Dyce, *Pegwell Bay* (cat. 25); Millais, *The Black Brunswicker* (Lady Lever Art Gallery, Port Sunlight); Whistler, *At the Piano* (Taft Museum, Cincinnati)

LATE 1860

Thomas Agnew and Sons open a London office, under the direction of William Agnew, at 5 Waterloo Place (they move to New Bond Street in 1875). Beginning in the 1840s, dealers had become increasingly prom-

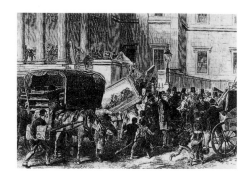

"Taking in the Pictures at the Royal Academy," *Illustrated London News*, 21 April 1866

inent in the art world with Agnew's, based in Manchester and Liverpool, particularly successful in creating a taste for modern British art among the Lancashire industrialists. By the 1860s and 1870s, with Agnew's joining other prominent London firms led by Ernest Gambart, Louis Victor Flatow, and the Colnaghis, dealers had largely supplanted the network of private patronage upon which artists had before largely depended.

1861

APRIL

William Morris and his associates found the design firm of Morris, Marshall, Faulkner, & Co. (after 1874 Morris and Co.). The company's intent was to elevate public taste by designing furniture, wallpapers, textiles, glassware, tapestries, and carpets of the highest quality for use in domestic interiors. Morris was a major Victorian poet, publishing *The Defence of Guenevere* (1858), *The Earthly Paradise* (1868–1870), and *Poems by the Way* (1891). He was also at the forefront of the English socialist movement, lecturing widely for the cause, editing the *Commonweal*, and writing numerous works

of social and political commentary, including his vision of a pastoral anarchist utopia, *News from Nowhere* (1890).

MAY–JULY

Royal Academy: Dyce, *George Herbert at Bemerton* (Guildhall Art Gallery); Leighton, *Lieder ohne Worte* (Tate Gallery)

1862

Beginning of the Lancashire Cotton Famine, resulting from the Union blockade of the South during the American Civil War. Textile mills closed in the north of England, forcing half a million people to seek economic assistance.

1 MAY

Opening of the International Exhibition, South Kensington: F.M. Brown, *The Last of England* (Birmingham Museums and Art Gallery); Martineau, *The Last Day in the Old Home* (Tate Gallery)

1 JUNE–2 AUGUST

Whistler's *The White Girl* (cat. 28), rejected by the Royal Academy, exhibited at Morgan's Gallery, Berners Street; also at the Salon des Refusés, Paris, 1863

1863

MAY–JULY

Royal Academy: Millais, *The Eve of Saint Agnes* (Royal Collection); Whistler, *The Last of Old Westminster* (Museum of Fine Arts, Boston)

10 JULY

Report of the Royal Academy Commission, appointed in response to criticisms that the institution had become too narrow, conservative, and clubbish; the report concluded that this was indeed the case.

1864

MAY–JULY

Royal Academy: Landseer, *Man Proposes, God Disposes* (cat. 5); Leighton, *Dante in Exile* (private collection), *Golden Hours* (Tapeley 1978 Chattels Trust); Lewis, *The Hosh (Courtyard) of the House of the Coptic Patriarch, Cairo* (private collection); Millais, *Leisure Hours* (Detroit Institute of Arts); Watts, *Choosing* (cat. 31); Whistler, *Wapping* (cat. 27)

1865

MARCH–JUNE

Exhibition of one hundred works by Ford Madox Brown,

featuring *Work* (cat. 19), 191 Piccadilly. Attendance was thin, and *Work* failed to attract a buyer.

MAY–JULY

Royal Academy: Whistler, *Symphony in White, No. 2: The Little White Girl* (Tate Gallery); Leighton, *Helen of Troy* (private collection); Moore, *The Marble Seat* (location unknown)

1866

The first series of *Poems and Ballads* by Algernon Charles Swinburne is published, with a dedication to Burne-Jones, then withdrawn. In this series of dramatic monologues, Swinburne caused a scandal by parodying and subverting established Victorian notions of Christian piety and romantic love. In opposition to the moral understanding of art promoted by Ruskin and others, Swinburne espoused the doctrine that came to be known as "art for art's sake," derived from the French writers and poets Théophile Gautier and Charles Baudelaire. His work was the seminal influence on later aesthetes such as Walter Pater and Oscar Wilde.

MAY–JULY

Royal Academy: Leighton, *The Syracusan Bride* (private collection)

1867

MAY–JULY

Royal Academy: Whistler, *Symphony in White, No. 3* (Barber Institute, Birmingham)

JULY 1867 – SEPTEMBER 1868

Publication of *Culture and Anarchy* by Matthew Arnold as a series of articles in the *Cornhill Magazine*; published in a single volume in January 1869. Arnold argued persuasively for culture as a means of developing one's "best self" despite the anarchic materialism prevailing in British society.

AUGUST

Passage of the Second Reform Act by Parliament. The First Reform Act of 1832 had extended the franchise, with qualifications, to male property owners. The 1867 Act, carried through by a short-lived Conservative government under Benjamin Disraeli, swelled the electorate by adding large numbers of urban laborers. In 1884 the third and final Reform Act extended the franchise to the agricultural working class. The effect of the three Reform Acts was to move Britain away from an aristocratic and toward a more democratic electoral system.

1868

MAY–JULY

Royal Academy: Millais, *Souvenir of Velasquez* (Royal Academy of Arts)

1869

MAY–JULY

Royal Academy, first exhibition in its new premises, Burlington House, Piccadilly: Lewis, *An Intercepted Correspondence, Cairo* (private collection)

1870

MAY–JULY

Royal Academy: Millais, *The Boyhood of Raleigh* (Tate Gallery)

19 JULY

Franco-Prussian War declared. The war, the defeat of the French, and the rise and fall of the Paris Commune led many artists to flee Paris for London, including Claude Monet, Camille Pissarro, and James Tissot.

1871

MAY–JULY

Royal Academy: Millais, *Chill October* (Sir Andrew Lloyd Webber)

1872

MAY–JULY

Royal Academy: Millais, *Hearts are Trumps* (Tate Gallery); Tissot, *Les Adieux* (Bristol Art Gallery); Whistler, *Arrangement in Grey and Black: Portrait of the Painter's Mother* (Musée d'Orsay, Paris)

1873

Publication of *Studies in the History of the Renaissance* by Walter Pater. In this influential work, Pater introduced the phrase "art for art's sake," which became synonymous with the aesthetic and decadent movements in Britain. Setting aside the moral and utilitarian purposes of art, Pater concluded that the act of perceiving beauty, the aesthetic experience in and of itself, was paramount. Pater's work was an inspiration to Oscar Wilde, among others.

1 OCTOBER

Death of Landseer; burial in Saint Paul's Cathedral.

1874

FEBRUARY

Election of a Conservative government with Benjamin Disraeli as prime minister. Disraeli remained in power until 1880, bringing an era of Whig-Liberal domination of Parliament to a decisive close. A study in contrasts, he and his great Liberal opponent William Ewart Gladstone between them shaped the character of Victorian politics.

MAY–JULY

Royal Academy: Fildes, *Applicants for Admission to a Casual Ward* (cat. 45); Millais, *The North-West Passage* (Tate Gallery); Elizabeth Thompson (later Lady Butler), *The Roll Call* (Royal Collection); Tissot, *The Ball on Shipboard* (cat. 46), *London Visitors* (cat. 47)

1875

MAY–JULY

Royal Academy: Tissot, *Hush!* (Manchester City Art Galleries); Herkomer, *The Last Muster: Sunday at the Royal Hospital, Chelsea* (Lady Lever Art Gallery, Port Sunlight)

"The Grosvenor Gallery, New Bond Street—The Entrance," *Graphic*, 19 May 1877

"Whistler Versus Ruskin: An Appeal to the Law," *Punch*, 7 December 1878

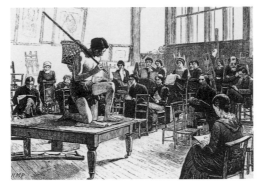

1880
..

MAY–JULY
Grosvenor Gallery: Burne-Jones, *The Golden Stairs* (Tate Gallery); Lawson, *The August Moon* (Tate Gallery); Millais, *Mrs Jopling* (private collection); Watts, *Psyche* (Tate Gallery)

1881
..

23 APRIL
Opening of Gilbert and Sullivan's satire of the aesthetic movement, *Patience, or Bunthorne's Bride*, produced by Richard D'Oyly Carte. The operetta mocked such aesthetes as Whistler and Oscar Wilde, as well as the "Greenery-Yallery-Grosvenor-Gallery." It became a success in America and along with Wilde's lectures there made the aesthetic movement widely known.

MAY–JULY
Royal Academy: Leader, *February Fill Dyke* (cat. 53); Clausen, *A Spring Morning, Haverstock Hill* (cat. 54); Alma-Tadema, *Sappho and Alcaeus* (cat. 67)

Grosvenor Gallery: Watts, *Endymion* (private collection); Whistler, *Harmony in Grey and Green: Miss Cicely Alexander* (Tate Gallery)

DECEMBER 1881 – MARCH 1882
Grosvenor Gallery, winter exhibition: 205 works by Watts, the first major retrospective of a living British artist.

1882
..

9 JANUARY
Oscar Wilde delivers his lecture "The English Renaissance of Art" for the first time at the Chickering Hall, New York City.

9 APRIL
Death of Rossetti.

DECEMBER 1882 – MARCH 1883
Grosvenor Gallery, winter exhibition: paintings by Alma-Tadema and the late Cecil Lawson, including *A Hymn to Spring* (cat. 43)

1883
..

WINTER
Royal Academy: memorial exhibition of Rossetti, who had withheld his works from public display since 1850.

1884
..

MAY–JULY
Royal Academy: Orchardson, *Mariage de Convenance* (cat. 56); Moore, *Reading Aloud* (cat. 57)

Grosvenor Gallery: Burne-Jones, *King Cophetua and the Beggar Maid* (Tate Gallery)

1885
..

20 FEBRUARY
At Princes Hall in London Whistler delivers his "Ten O'-Clock Lecture," a succinct expression of the theory of "art for art's sake." Following in the wake of Oscar Wilde's lectures in America and Britain, Whistler appeared before his audience with "much misgiving . . . in the character of the Preacher." In a series of inspired witticisms he proclaimed the supremacy of art over nature and over society, ridiculing Ruskin's morality, Morris' socialism, and Wilde's attempts to popularize notions of taste and refinement.

MAY–JULY
Royal Academy: Forbes, *A Fish Sale on a Cornish Beach* (cat. 60); Herkomer, *Hard Times* (cat. 51)

JUNE
Election of Conservative government under Lord Salisbury, the beginning of twenty years of more or less uninterrupted Conservative rule.

16 JULY
On the recommendation of Gladstone, Millais created a baronet, the first British artist honored at a level above knighthood.

1886
..

JANUARY–MARCH
Grosvenor Gallery, winter exhibition: Millais retrospective

8 APRIL
Introduction of an Irish Home Rule Bill in Parliament by Gladstone. Despite the efforts of the Irish Home Rule Party's chairman Charles Stewart Parnell and the support of Gladstone, the measure was defeated in the House of Commons.

22 APRIL
Formal institution of the New English Art Club. The club's purpose was to offer exhibition opportunities for artists influenced by the French school of *plein-air* painters, to whom the Royal Academy exhibition was

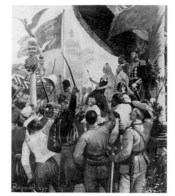

generally closed. Often trained in Paris, and admirers of Jules Bastien-Lepage, these artists included many of the painters identified with the Newlyn school (named after the Cornish fishing village where they gathered to work), such as Stanhope Forbes and Frank Bramley.

MAY–JULY
Royal Academy: Lavery, *The Tennis Match* (cat. 59); Sargent, *The Misses Vickers* (Sheffield City Art Galleries)

Grosvenor Gallery: Watts, *Hope* (cat. 33)

30 JUNE
Royal Holloway College opened by Queen Victoria, with gallery displaying the large collection of modern British paintings formed by the college's founder, Thomas Holloway, who made his fortune in patent medicines; the collection includes Landseer, *Man Proposes, God Disposes* (cat. 5) and Fildes, *Applicants for Admission to a Casual Ward* (cat. 45)

1887

MAY–JULY
Royal Academy: Moore, *Midsummer* (cat. 58); Sargent, *Carnation, Lily, Lily, Rose* (cat. 61)

Grosvenor Gallery: Burne-Jones, *The Baleful Head* (Staatsgalerie Stuttgart)

21 JUNE
National celebration of the fiftieth anniversary of Victoria's reign, the Golden Jubilee. The pomp and circumstance reflected Queen Victoria's popularity as well as her importance as a symbol of the British Empire.

1888

MAY–JULY
Royal Academy: Alma-Tadema, *The Roses of Heliogabalus* (private collection); Leighton, *Captive Andromache* (Manchester City Art Galleries); Waterhouse, *The Lady of Shalott* (cat. 63); Bramley, *A Hopeless Dawn* (Tate Gallery)

First exhibition of the New Gallery, Regent Street, a breakaway institution founded by former directors of the Grosvenor Gallery, Charles Hallé and J. Comyns Carr. Burne-Jones, who showed *The Doom Fulfilled* (cat. 42), was to be its main attraction until his death in 1898.

1889

DECEMBER
London Impressionists Exhibition at the Goupil Gallery: Steer, *Knucklebones, Walberswick* (Ipswich Art Gallery); Sickert, *Little Dot Hetherington at the Bedford* (private collection). The exhibition was organized by Walter Sickert in response to a division that had arisen within the New English Art Club in 1888 between the rural naturalists and members more closely aligned with the radical experiments of Whistler and French impressionism.

1890

New Gallery: Millais, *Dew Drenched Furze* (cat. 14)

20 JUNE
The Picture of Dorian Gray by Oscar Wilde published. Wilde was notorious as the most flamboyant personality of the aesthetic movement, asserting the superiority of art to nature, and fashion to morality. With his wit and personality, and through his plays, including *Lady Windermere's Fan* (1892) and *The Importance of Being Earnest* (1895), Wilde created a stage upon which he made public the Victorian conflict between aestheticism and a socially conscious art. Wilde's homosexual relationship with Lord Alfred Douglas led to a series of trials on morality charges, ending with Wilde's conviction and imprisonment in 1895. He died in 1900.

1891

MAY–JULY
Royal Academy: Leighton, *Perseus and Andromeda* (Walker Art Gallery, Liverpool), *The Return of Persephone* (cat. 65); Fildes, *The Doctor* (Tate Gallery)

1892

MAY–JULY
Royal Academy: Leighton, *The Garden of the Hesperides* (Lady Lever Art Gallery, Port Sunlight)

New Gallery, winter exhibition: Burne-Jones retrospective

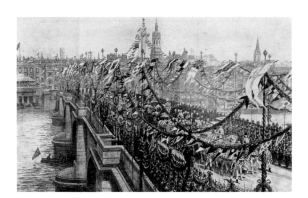

"The Royal Procession: The Queen's Carriage Crossing London Bridge," *Illustrated London News*, 26 June 1897

1893
...

MAY–JULY
Royal Academy: Sargent, *Lady Agnew of Lochnaw* (cat. 62)

1895
...

MAY–JULY
Royal Academy: Alma-Tadema, *Spring* (J. Paul Getty Museum, Malibu); Leighton, *Flaming June* (cat. 66)

New English Art Club, winter exhibition: Sickert, *The Gallery of the Old Bedford* (cat. 68)

1896
...

25 JANUARY
Death of Leighton; burial in Saint Paul's Cathedral.

MAY–JULY
Royal Academy: Clausen, *Bird Scaring* (cat. 55)

13 AUGUST
Death of Millais; burial in Saint Paul's Cathedral.

1897
...

MAY–JULY
Royal Academy: Waterhouse, *Hylas and the Nymphs* (Manchester City Art Galleries)

22 JUNE
National celebration of the sixtieth anniversary of Victoria's reign, the Diamond Jubilee.

21 JULY
Tate Gallery opened by the Prince of Wales. The core of the collection is a group of modern British (i.e., Victorian) paintings given to the nation by Sir Henry Tate, the millionaire and inventor of the sugarcube; these include Millais, *Ophelia* (cat. 9) and *The Vale of Rest* (cat. 13), and Waterhouse, *The Lady of Shalott* (cat. 63). The gallery's range was broadened to include British art in general, as well as modern foreign art, on the recommendation of the Curzon Committee report of 1915.

1898
...

16 JUNE
Death of Burne-Jones.

1900
...

20 JANUARY
Death of Ruskin.

1901
...

22 JANUARY
Death of Queen Victoria.

1

··

Joseph Mallord William Turner

*Keelmen Heaving in Coals
by Night*

1834/1835, oil on canvas,
36⅜ x 48⅜ (92.3 x 122.8).
First exhibited: Royal Academy
1835 (no. 24). *References*: Butlin
and Joll 1984, 1:205–206,
210–211 (no. 360); Hayes
1992, 278–280

*National Gallery of Art,
Washington, Widener Collection,
1942.9.86*

Though completed two or
three years before Queen Victoria ascended the throne, this
painting reflects ideas about
modern Britain that were central to the Victorian age. The
view is of the Tyne in northeast
England, where workers are
shoveling coal from keels (coal
barges) into colliers for transportation by sea, probably to
London. On the right is South
Shields, the main port serving
the Northumberland coal fields,
which stands on the south bank
of the Tyne at its mouth, about
ten miles downriver from Newcastle upon Tyne. Turner had
painted the same view in watercolor in 1823,[1] and it appears

in his series of topographical
engravings *The Rivers of England*. He seems to have based
the oil on this earlier work; it
follows the composition fairly
closely, except that the viewpoint is further back, and the
expanse of water broadened to
create a grander space.

The work was commissioned by Henry McConnel,
partner in a Manchester cotton
mill. Though still in his early
thirties, McConnel was assembling a serious collection of
modern British art. He bought
the view of Venice that Turner
exhibited at the Royal Academy
in 1834, now also in the collection of the National Gallery of
Art (fig. 1), and afterwards asked
the artist to paint him a companion piece. In a letter about
the *Keelmen*, he wrote that it
was done "at my especial suggestion,"[2] which may mean that
he even dictated the subject,
presumably on the basis of the
earlier watercolor or engraving.
Whether McConnel's or Turner's idea, the aim was clearly
to contrast one scene with the
other: north against south,
moonlight against sunlight, and
so on. It is typical of the levels
of prestige attaching to different subjects at the time that the
Venice cost McConnel £350 and
the *Keelmen* only £300, which

was still a larger sum than Turner had originally requested.

The area around Newcastle
upon Tyne had long been famous
for its coal mines; the expression "carrying coals to Newcastle" had been in common usage
since the seventeenth century.
By the time of Turner's painting, however, coal had assumed
an importance far beyond its
familiar use for domestic heating: it was now the fuel of the
industrial revolution. The presence of coal was soon to make
Tyneside a major center for the
iron industry, for the manufacture of armaments, and for the
building of locomotives and
ships. In relation to the view of
Venice, the *Keelmen* represents
not just Britain, but the new
world that was coming into
existence there; it is a scene
that would have carried special
significance for a young industrialist and man of the age such
as Henry McConnel.

As in his pendant paintings
of the building and decline of
Carthage, or of ancient and
modern Rome, Turner uses the
comparison to suggest ideas
about the rise and fall of empires. For him, as for Byron in
the celebrated reverie in *Childe
Harold's Pilgrimage*, Venice is
the very image of the fallen
state, the capital of indolence,

melancholy pleasures, and
splendor in decay. By contrast,
Tyneside represents the rising
world of labor, commerce, and
progress, where work carries
on by day and night. Venice
seems ready to melt away in
its own light and atmosphere,
while Tyneside asserts itself as
a sooty, smoke-belching blot
on nature. Venice languishes
and looks heavenly; Tyneside
produces wealth and looks
like hell. As a city of the past,
Venice serves not only as
a foil to the actuality of nineteenth-century Britain, but also
as a warning. On the right of
Turner's view stands the Dogana,
or custom house, a symbol
of Venice's former trading position, its tower topped by a
statue of Fortune. This was a
dominant maritime power too,
and as its successor, Britain
should know that its fortunes
are likewise temporary. If he
had subtitled the *Keelmen* and
Venice together, Turner might
well have thought of Byron's
Childe Harold, calling upon
the nation to beware: "Albion!
. . . in the fall / Of Venice think
of thine, despite thy watery
wall." M.W.

Notes

1. Repr. Hayes 1992, 278.

2. Butlin and Joll 1984, 1:205.

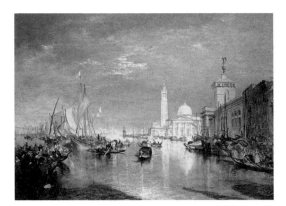

FIGURE I

Joseph Mallord William Turner, *Venice: The Dogana and San Giorgio Maggiore*, 1834, oil on canvas. National Gallery of Art, Washington. Widener Collection

2

·····

Joseph Mallord William Turner

Slavers Throwing Overboard the Dead and Dying—Typhon Coming On (The Slave Ship)

c. 1839/1840, oil on canvas, 35 ¾ x 48 (90.8 x 121.9). *First exhibited*: Royal Academy 1840 (no. 203). *References*: Butlin and Joll 1984, 1:236–237 (no. 385)

Museum of Fine Arts, Boston. Henry Lillie Pierce Fund 99.22

Tossed by a storm on the high seas, a slave ship has jettisoned some of its human cargo, the slaves still in their shackles; nightmarish scavenging fish, sea monsters, and gulls have closed in for a feast. Turner probably took the idea for this highly charged subject from one of his favorite sources, James Thomson's poem *The Seasons* (1726–1730). In his description of a typhoon, Thomson imagines a slave ship in trouble and "the direful shark" awaiting both slaves and tyrants. Turner also seems to have read the horrifying, though by no means unique, story of a particular slave ship, the *Zong*. With an epidemic spreading among the slaves and a storm brewing,

the ship's captain ordered the sick slaves thrown overboard, as insurance covered those drowned at sea but not lost to disease. This incident and the captain's court-martial, which took place in 1783, were recounted in a book on the slave trade published in its second edition in 1839, about the time Turner began his painting. The same year saw the appearance of the biography of William Wilberforce, the great antislavery campaigner in Parliament, and both may have inclined Turner toward the slavery issue.

The movement against the slave trade, which was carried on largely by British ships plying routes between Africa and the Americas, took hold in Britain toward the end of the eighteenth century. After a series of failed attempts, Wilberforce finally managed to get an abolition bill through Parliament in 1807, and by 1820 all the other major European countries involved in the trade, as well as the United States, had followed suit. Wilberforce went on to agitate for the abolition of slavery itself, and an act emancipating all slaves within the British Empire was passed in 1833, shortly before his death. By the time of Turner's painting, therefore, the

kind of atrocity he depicted was a thing of the past. The topical and political significance of the work, if any, was as a reminder of the shameful part Britain had played in fostering slavery where it still existed. The spirit of Wilberforce lived on in Britain, and while the painting was shown at the Royal Academy in 1840, the Anti-Slavery League held a conference in London that was opened by Prince Albert.

When the work was first exhibited, the title was accompanied in the catalogue by some of Turner's own poetry:

Aloft all hands, strike the topmasts
 and belay;
Yon angry setting sun and fierce-
 edged clouds
Declare the Typhon's coming.
Before it sweeps your decks,
 throw overboard
The dead and dying—ne'er heed
 their chains
Hope, Hope, fallacious Hope!
Where is thy market now?

This was an extract from the *Fallacies of Hope*, a rambling work composed by Turner over many years without ever reaching a definitive form, portions of which he attached to a number of his paintings. Its themes, like those of much of Turner's

work as an artist, are the futility of mankind's endeavors, the transience of human life, the decline and fall of empires, the irresistible power of nature and time. Looking at the *Slavers* in relation to the poetry, especially the description of the setting sun as "angry" and the clouds as "fierce-edged," the painting takes on a distinctly apocalyptic resonance, as though the sun were a wrathful God and the clouds his avenging angels, bringing an indiscriminate justice down upon oppressors and oppressed alike. Turner certainly associated the sun with the power and vengeance of God, an idea he expressed in its canonical, visionary form in *The Angel Standing in the Sun* (1845/1846; Tate Gallery). But perhaps the most telling line of the poetry is the last, "Where is thy market now?" On the surface the question is simply addressed to Hope, asking who is going to "buy" such an idea when its fallacy is so clearly revealed. On another level it suggests the idea of the slave market, asking the traders what good their enterprise will do them when they and their cargo are lost at sea. In this way, Turner guided people toward reading his painting as a reflection on the inhumanity and

destruction that come with un-bridled commerce, a salutary message of deep relevance to the age.

At the Academy exhibition the painting met with general ridicule. The young John Ruskin, however, already the most passionate and intelligent of the artist's admirers, proclaimed it "the noblest sea that Turner has ever painted, and, if so, the noblest certainly ever painted by man." In a passage in the first volume of *Modern Painters* (1843), building to a climactic invocation of Macbeth's famous image of the whole sea reddening with murderous blood, he made the *Slavers* the subject of arguably his finest description of any work of art:

Purple and blue, the lurid shadows of the hollow breakers are cast upon the mist of night, which gathers cold and low, advancing like the shadow of death upon the guilty ship as it labours amidst the lightning of the sea, its thin masts written upon the sky in lines of blood, girded with condemnation in that fearful hue which signs the sky with horror, and mixes its flaming flood with the sunlight, and, cast far along the desolate heave of the sepulchral waves, incarnadines the multitudinous sea.[1]

At the end of 1843, the year in which that passage was published, Ruskin's father bought the painting for him as a New Year's gift. By 1872 it had come to seem too painful for him to live with, and he sold it in the United States. It entered the collection of the Museum of Fine Arts, Boston, in 1899.
M.W.

Notes

1. Ruskin 1903–1912, 3:571–573.

3
...

Edwin Landseer

Eos, a Favorite Greyhound, the Property of H. R. H. Prince Albert

1841, oil on canvas, 44 x 56 (111.8 x 142.2). *First exhibited*: Royal Academy 1842 (no. 266). *References*: Ormond 1981, 152–155 (no. 106); Millar 1992, 153–154 (no. 424)

Lent by Her Majesty Queen Elizabeth II

The early years of Queen Victoria's reign were the heyday of Landseer's career as a court painter, during which—despite his tardiness in completing commissions—he managed to bring a fresh, modern feeling to the iconography of British royalty. His contribution was to offer charming glimpses behind the facade of pomp, showing the private and domestic world of the royal family, their off-duty moments, their children, and especially their pets. For all the luxury and glamour of their lives, his paintings suggested, they felt the same home pleasures and affections as ordinary people.

Eos is the grandest of Landseer's portraits of the royal pets, and arguably the artistic highpoint of all his work for the queen. Named for the Greek goddess of the dawn, the dog was an Italian greyhound bitch that had belonged to Prince Albert since boyhood. The grace, speed, and hunting prowess of greyhounds had recommended them to young men of the European nobility for centuries, and they appear fairly often in aristocratic portraiture, their refined, sensitive looks and high breeding supposedly reflecting those very qualities in their owners. Eos had come with Prince Albert from Germany when he married Queen Victoria in 1840 and remained his favorite among the many dogs the couple owned; she appears at his feet in Landseer's most successful royal group portrait, *Windsor Castle in Modern Times* (fig. 2). Her death on 31 July 1844 affected the prince deeply. "I could see by his look that there was bad news," wrote the queen in her journal:

She had been his constant & faithful companion for 10 & ½ years and she was only six months old, when he first had her. She was connected with the happiest years of his life, & I cannot somehow imagine him without her. She was such a beautiful & sweet creature & used to play so much with the Children, & be so full of tricks As for poor dear Albert, he feels it too terribly, & I grieve so for him. It is quite like losing a friend.[1]

Eos was buried in the gardens of Windsor Castle and commemorated there by a bronze statue based on Landseer's portrait.

The work, painted in December 1841, was commissioned by the queen for 150 guineas; she gave it to Prince Albert as a Christmas present. In her journal she noted that it came as a complete surprise to him, and that he was delighted. It was hung in his dressing room at Buckingham Palace. The opera hat and gloves on

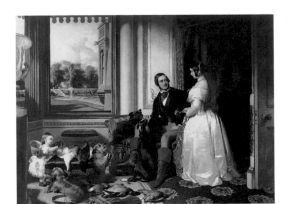

FIGURE 2

Edwin Landseer, *Windsor Castle in Modern Times: Queen Victoria, Prince Albert and Victoria, Princess Royal*, 1841–1845, oil on canvas. The Royal Collection, © Her Majesty Queen Elizabeth II

the deerskin footstool and the cane on the table were the prince's own; they were smuggled out to Landseer's studio to be painted, and on one occasion the hat and gloves had to be rushed back to the palace before he missed them. In the portrait they suggest the nearby presence of the prince, and establish that the dog's attentive look is for her master. She appears as the very image of natural energy brought under discipline, an impression given force by the overall tightness and control about the composition, its lines dominated by horizontals, its subject profiled against a flat background like a classical relief. The blacks and whites of the hat and gloves play as a variation on the black coat and white markings of the dog, set off brilliantly against the red tablecloth. The work is a showpiece for Landseer's abilities as a designer, colorist, and not least as a painter of textures, with the sheen on the dog's coat his pièce de resistance.

An engraving after *Eos* by Thomas Landseer, the painter's brother, was published in 1843. M.W.

Notes
1. Ormond 1981, 152–153.

4

...

Edwin Landseer

Coming Events Cast Their Shadow Before Them (The Challenge)

c. 1843/1844, oil on canvas, 38 x 83 (96.5 x 210.8). *First exhibited*: Royal Academy 1844 (no. 272). *References*: Ormond 1981, 171–172 (no. 122)

His Grace The Duke of Northumberland

Landseer had included deer in hunting scenes since early in his career, but it was only in the 1840s that he began painting visions of them in their own world. He imagined heroic stags, devoted hinds, and wild, animal versions of the dramas normally played out by human figures in paintings of history, myth, and legend. Against the bleak, almost primeval setting of the Scottish Highlands, the lives and deaths of the deer took on even more of an elemental feeling than those of their human counterparts, representing in pure form the violence and danger that were central to the romantic view of nature. In *Coming Events*, the protagonist bellows out across

a moonlit loch, in defiance of a rival swimming across from the opposite shore. The situation is the artist's invention; stags may fight during the rutting season, but they would never swim across a lake to reach an opponent. The scene is contrived to show the tension between the stags as filling a great space, their impending death struggle as typical of the whole, wide, inhospitable world they inhabit. The dead trees scattered about the foreground underline the desolation; they echo the hard, angular forms in the mountains and subtly suggest the remains of bones and antlers from past encounters.

The rugged grandeur of the Highlands had inspired Landseer since his first visit to Scotland in 1824. His memories of hunting and shooting there, along with sketches he had made during his visits, provided material for some of his most successful paintings. He was a frequent guest at The Doune, the retreat of his patrons the duke and duchess of Bedford in the Cairngorm Mountains, and at their deerstalking camp in nearby Glen Feshie. On a visit to The Doune in 1837 he attempted to articulate his feelings about stags, his great admiration for

them mixed with a guilty fascination at seeing them hunted and killed. In a letter to Lord Ellesmere, another patron, he wrote:

There is something in the toil and trouble, the wild weather and savage scenery that makes butchers of us all. Who does not glory in the death of a fine stag? on the spot—when in truth he ought to be ashamed of the assassination Still, with all my respect for the animal's inoffensive character— my love of him *as a subject for the pencil* gets the better of such tenderness—a creature always picturesque and *never* ungraceful is too great a property to sacrifice to common feelings of humanity.[1]

During another Scottish visit, around 1842, Landseer painted frescoes in Ardvereike Lodge on Loch Laggan, which was leased by the duchess of Bedford's daughter Lady Abercorn; the frescoes included a forerunner of the bellowing stag in *Coming Events*, and it has been suggested that the landscape in the painting may be based on Loch Laggan.

Like countless other lovers of Scotland and its scenery, Landseer was deeply affected by the romantic vision of the place created by the poet and

novelist Walter Scott, whom he met and painted at his home, Abbotsford, during his 1824 tour. The critic of the *Athenaeum* picked up on this when *Coming Events* was first exhibited at the Royal Academy in 1844:

Never has the deep and terrible stillness of Winter and of Night (if we may hazard the expression) been better painted. It is the death of Nature that we see, the entire torpor whereof enhances and poetizes by contrast the violent expectations of the animal. We were reminded, while looking at this work . . . of that thrilling passage in Scott's romance, where Marmion waits in the moonlight the spectre challenger! There is awe as well as beauty and poetry in this picture.[2]

Scott's *Marmion: A Tale of Flodden Field* (1808) is a dramatic story of love, betrayal, and combat in sixteenth-century England and Scotland. It was not from Scott that Landseer took his title, however, but from another popular Scottish poet, Thomas Campbell. In Campbell's "Lochiel's Warning" (1802), the hero learns of his fate in the impending battle of Culloden from an old wizard, who intones: "Tis the sunset

of life gives me mystical lore / And coming events cast their shadows before." Whether the bellowing stag be a Marmion or a Lochiel, Landseer and his audience thought of such paintings in human terms; they were deliberately anthropomorphic.

Coming Events was commissioned by the 4th duke of Northumberland, a naval officer and supporter of scientific, literary, and artistic ventures, who was one of Landseer's most important early patrons. When shown at the Academy in 1844, the painting would certainly have been seen by the young William Holman Hunt, then a student, and his memory of it probably played some part in the genesis of *The Scapegoat* (cat. 17). Hunt may also have been familiar with the engraving after it by John Burnet, which was published in 1846. M.W.

Notes
1. Ormond 1981, 17.
2. *Athenaeum*, 11 May 1844, 433.

5
...

Edwin Landseer

Man Proposes, God Disposes

1863/1864, oil on canvas, 36 x 96 (91.4 x 243.8). *First exhibited*: Royal Academy 1864 (no. 163). *References*: Ormond 1981, 206–208 (no. 151); Chapel 1982, 101–104 (no. 34)

Royal Holloway, University of London

The title of this harrowing and pessimistic work is from the fifteenth-century devotional text *The Imitation of Christ* by Thomas à Kempis: "Nam homo proponit, sed Deus disponit" (For Man proposes, but God disposes). The human proposition of an Arctic voyage has ended in the divine disposition of shipwreck, and scavenging polar bears pick over the remains. The telescope and fragments of leather case at lower left indicate that the action occurs in modern times. Within the broad idea of mankind's powerlessness against the will of God, the artist underscores the vanity of modern science and the quest for knowledge. The God who presides over such disasters is clearly a

God of vengeance and judgment. Or perhaps it would be closer to Landseer's vision to say no God at all: the mood is that of a Godless world in which humanity falls prey to a rapacious nature. He plays up the resemblance of the ice forms to teeth, suggesting the idea of the landscape's tearing the ship apart like a wild animal at a kill, a task of destruction being finished off, down to the last details, by the polar bears. The broken ship's mast resembles a half-destroyed cross. By implication nature appears as the enemy of religion as well as human endeavor, recalling Tennyson's famous image of mankind trusting in God, and love as the final law of creation, "Tho' Nature, red in tooth and claw / With ravine, shriek'd against his creed."[1]

The inspiration for the subject was the disastrous Arctic expedition of Sir John Franklin. In May 1845, Franklin, a distinguished naval officer, set out with two specially equipped ships, 138 men, and provisions for three years, searching for a sea route across northern Canada allowing navigation between the Atlantic and the Pacific. The elusive "northwest passage" had preoccupied English explorers since Eliza-

bethan times, and by Franklin's day there was a standing reward, instituted by an act of Parliament, for its discovery. Three years passed with no word from or about Franklin, at which point a series of relief expeditions was launched. The continuing search became a much discussed news story. Some remains including a telescope were found in 1854 by Dr. John Rae, a factor in the Hudson Bay Company, and conclusive proof of Franklin's fate, in the form of skeletons and other relics, was found by an expedition of 1858–1859 financed by Lady Franklin and led by Sir Leopold McClintock. Both Franklin's ships had been wrecked on King William Island, and he and all his men had perished, apparently after resorting to cannibalism. Polar bear tracks were found near the remains, and some of the skeletons had clearly been destroyed by large animals. In the course of the search for Franklin the existence of the northwest passage was finally confirmed, although no further British voyages of discovery were undertaken.[2]

Though presented as a general reflection on the human condition, *Man Proposes, God Disposes* appears such an indulgence in horror that it is hard to resist speculating on the artist's state of mind when he painted the work. Landseer had suffered from nervous ailments from an early age. His moodiness and excitability were exaggerated by heavy drinking, and by the mid-1860s he had to be confined for periods under the care of a neurologist. His most demanding project at this time was the sculpting of the famous bronze lions at the base of Nelson's Column in Trafalgar Square. He received the commission in 1858, amid much controversy since he was a painter and not a sculptor. Like other major projects, the lions cost him an enormous amount of time and anxiety. It was only in 1863 that he completed his final design, a clay model on a reduced scale, by which stage he was the target of complaints from both Parliament and the press over the protracted delays. It must have been at this time that he dreamed of himself lying dead or unconscious, the prey of a ferociously roaring lion, and recorded the image in a sketch inscribed "My last Night's Nightmare."[3] It seems possible that, at some level, he thought of himself as the Sir John Franklin of art, doomed to be overwhelmed in his grandest endeavor.

Certainly his imagination tormented him with the vision of terrible violence against himself.

Landseer would have been able to study polar bears at the London Zoo, where there was a pair of adults, and he borrowed a polar bear skull from the paleontologist Hugh Falconer.[4] He had never seen the Arctic, and presumably based his impression of the polar wastes upon paintings and prints by other artists. The strange effects of translucency and colored reflection in the ice are rendered convincingly nonetheless, and brushed in with a breadth and ruggedness suited to the subject as a whole. The unusual proportions of the canvas, the width almost three times the height, help convey the idea of a landscape not only unnavigable but infinite in expanse.

Man Proposes, God Disposes was the most talked-about picture at the Royal Academy exhibition of 1864, and was published as an engraving three years later. It was bought from Landseer by Edward John Coleman, a wealthy stockbroker, for 2,300 guineas including the copyright. Coleman was on close terms with the artist, entertained him frequently at his home, Stoke Park, near

Slough, and provided a studio for his use during visits. M.W.

Notes

1. *In Memoriam*, section 56.
2. The first successful navigation was made by the Norwegian explorer Roald Amundsen in 1903–1906.
3. Repr. Ormond 1981, 20.
4. Chapel 1982, 102.

6

John Everett Millais

Isabella

1848–1849, oil on canvas, 40½ x 56¼ (102.9 x 142.9). *First exhibited*: Royal Academy 1849 (no. 311). *References*: Bennett 1967, 25–26 (no. 18); Parris 1984, 68–70 (no. 18); Bennett 1988, 118–126

Millais was only nineteen when he painted *Isabella*. It is a remarkable technical achievement, a display of the great natural gifts he had shown since childhood, and in some ways a manifesto of the ideas behind the

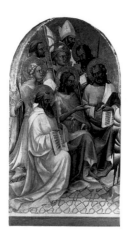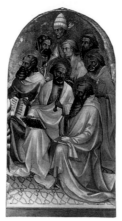

FIGURE 3

Lorenzo Monaco, *Coronation of the Virgin*, 1415/1420, wings, tempera on panel. The National Gallery, London

formation of the Pre-Raphaelite Brotherhood.

The painting illustrates the story of doomed love recounted in Keats' poem "Isabella; or, The Pot of Basil":

Fair Isabel, poor simple Isabel!
Lorenzo, a young palmer in
 Love's eye!
They could not in the self-same
 mansion dwell
Without some stir of heart, some
 malady;
They could not sit at meals but
 feel how well
It soothed each to be the other by.

Isabella has fallen in love with Lorenzo, an employee in her brothers' business. Having hoped she would make a profitable marriage, the brothers are enraged. They murder Lorenzo, bury him in a forest, and tell Isabella that he has been sent away on business. Lorenzo's ghost appears to her to reveal his true fate; she exhumes the body and cuts off the head, which she keeps in a garden pot covered with basil. The brothers finally discover and steal the pot, then flee. Isabella dies, broken-hearted.

The scene contains a number of symbolic objects that relate to the story. At a meal with the brothers and other employees or family members, the lovers share a blood orange. The majolica plate before them shows a beheading scene, probably of David and Goliath or Judith and Holofernes; the plate in front of the brother kicking the dog shows a scene of something being torn by a bird of prey, perhaps Prometheus and the eagle. The falcon tearing at a feather alludes to Keats' description of the brothers as "the hawks of ship-mast forests." On the balcony in the background are two passion flowers and some ominous garden pots. The carved scene on the bench end may show an adoration of the shepherds, or perhaps some pilgrims, a reference to Keats' descriptions of Lorenzo as "a young palmer in Love's eye."

Isabella was the first exhibition picture Millais produced after the formation of the Pre-Raphaelite Brotherhood. His allegiance to the group is proclaimed in the "PRB" monogram after the signature and date, and again under the image on the bench end. The picture's miniaturistic technique, perspectival distortion, angular poses, use of symbols, and preponderance of gold betoken a response to early Italian (i.e., pre-Raphael) painting. Millais

may have been thinking in particular of the wings to Lorenzo Monaco's *Coronation of the Virgin* triptych (fig. 3), which in 1848 were a recent acquisition of London's National Gallery.

The work was carried out according to the brotherhood's principle of painting every figure and object as far as possible from an actual model, directly, and with meticulous attention to detail. The figures are all portraits from life, adapted to suit the narrative sometimes, but never conventional ideas of beauty. The model for Isabella was the artist's sister-in-law Mary Hodgkinson; her elaborate hairstyle is based on an illustration in a book on historical costume, its original source the figure of Beatrice d'Este in the Pala Sforzesca (Brera, Milan). Lorenzo was William Michael Rossetti, Dante Gabriel's brother, with his dark hair lightened; and the brother kicking the dog was Jack Harris, a contemporary of Millais' at the Royal Academy schools. It was perhaps an inside joke that Dante Gabriel Rossetti and Frederic George Stephens, the artist's Pre-Raphaelite brothers, are the only people drinking, Rossetti emptying his glass in the background, while

Stephens examines a full glass to the left. The head next to Stephens' was that of Walter Deverell, a painter friend of the group, and the man paring an apple was William Hugh Fenn, an early patron of Millais. The man wiping his mouth was Millais' father, and the servant was probably Charles Compton, another Academy student. By using friends and relatives rather than professional models, the Pre-Raphaelites believed they could bring a greater naturalness to their compositions.

When first exhibited at the Royal Academy in 1849, *Isabella* was, for the most part, warmly received. The critics admired Millais' youthful virtuosity, and, with some reservations, the ingenuity with which he had evoked early Italian painting. "Nothing offends but one Gothic limb in the centre," wrote the *Literary Gazette*. "The absence of perspective and aerial distance is of a piece with the original school which is imitated, and the very formality of the impasting and distribution of the forms, carries us back to the period of aspiring but imperfect art."[1] The *Art Journal* concurred: "There is no more shade than is demanded for the drawing, the relief being effected by

FIGURE 4

Correggio, *Madonna of the Basket*, early 1520s, oil on panel. The National Gallery, London

the opposition of colour. The figures are crowded, but this is a characteristic of the period to which the work points The picture is, perhaps, on the whole, the most remarkable of the whole collection; it cannot fail to establish the fame of the young painter."[2] It was only when Millais applied Pre-Raphaelite ideas and techniques to a sacred subject, in *Christ in the Carpenter's Shop* (cat. 7), that the critics turned against him.

Isabella was bought jointly by three minor art dealers, one of whom was also a tailor, for £150 and a new suit of clothes; they soon afterwards sold it to the collector Benjamin Godfrey Windus, a retired coachbuilder of Tottenham, north of London. Windus' spectacular collection of more than fifty Turners had been an inspiration to the young John Ruskin, and he was to amass equally remarkable holdings in works of the Pre-Raphaelites, including Millais' *Isabella, Mariana, Ophelia, A Huguenot*, and *The Vale of Rest* (cats. 6, 8–10, 13), and William Holman Hunt's *The Scapegoat* (cat. 17). M.W.

Notes

1. *Literary Gazette*, 9 June 1849, 433.
2. *Art Journal* 9 (June 1849), 171.

7

John Everett Millais

Christ in the Carpenter's Shop

1849–1850, oil on canvas, 34 x 55 (86.4 x 139.7). *First exhibited*: Royal Academy 1850 (no. 518). *References*: Bennett 1967, 28–29 (no. 26); Parris 1984, 77–79 (no. 26)

Tate Gallery, London. Presented with assistance from the National Art Collections Fund and various subscribers 1921

As the artist's first major venture into sacred subject matter, *Christ in the Carpenter's Shop* followed the lead Rossetti had taken with *The Girlhood of Mary Virgin* (1848–1849; Tate Gallery). The scene is from Christ's boyhood in Nazareth; he is shown in the workshop of his father, Joseph, and many of the objects depicted symbolize coming events in his life and death. Christ and the Virgin Mary occupy the central foreground, with Joseph and John the Baptist to the right, and the Virgin's mother Anne and a workshop assistant to the left. The wood and nails in Joseph's workshop are traditional prefigurations of the Crucifixion,

and Millais expands on this idea by showing the young Christ as having cut his hand on a nail, spilling a drop of blood on his foot. The sticks protruding from the unfinished wicker basket at left allude to the flagellation of Christ before his death, and the ladder in the background suggests the deposition of his body from the cross afterwards. John is shown bringing a bowl of water, which identifies him as the Baptist, to bathe the wound. The baptismal theme is continued in the white dove perched on the ladder, which anticipates the descent of the Holy Spirit at Christ's baptism. The triangle above Christ's head suggests the Holy Trinity, or the "Two Trinities" of Father, Son, and Holy Spirit, and Christ, the Virgin Mary, and Joseph. The sheep in the background, at left, represent the Christian flock, and the birds drinking at a bowl of water on the right represent human souls enjoying spiritual refreshment. The exotic red flower near the door is a symbol of Christ's blood.

The subject is not uncommon in art, although the scene is usually limited to Joseph, the Christ child, and Mary, who is shown spinning or sewing. Millais would have known Cor-

reggio's *Madonna of the Basket* (fig. 4) at the National Gallery in London, for instance, and this may have been among his sources, although he would have regarded his own picture as a corrective rather than an homage to this highly idealized, "Raphaelite" treatment of the subject. He may also have known the British artist J.R. Herbert's *Our Saviour, Subject to His Parents at Nazareth* (Guildhall Art Gallery), which appeared at the Royal Academy exhibition in 1847. According to William Holman Hunt, Millais' immediate inspiration was a sermon he heard in Oxford during the summer of 1849.[1] When *Christ in the Carpenter's Shop* was shown at the Royal Academy in 1850, it was given no title in the catalogue, only a biblical quotation: "And one shall say unto him, What are those wounds in thine hands? Then he shall answer, Those with which I was wounded in the house of my friends" (Zech. 13:6). The use of this passage in reference to the Passion of Christ is odd, as the wounded man appears, in the context, to be a false prophet. The same verse was interpreted in terms of the Passion by the eminent Oxford Movement theologian Edward Pusey, however, and it

may well have been him or a follower whom Millais heard preaching.[2]

William Michael Rossetti recorded some of the details of Millais' progress on *Christ in the Carpenter's Shop* in the *P.R.B. Journal*. He had sketched out the composition by 1 November 1849, by 29 December he had begun painting the setting from an actual carpenter's shop, and the work was finished by early April 1850.[3] The carpenter's shop was said by Hunt to have been on Oxford Street.[4] Following Pre-Raphaelite principles, Millais avoided professional models, instead giving his figures a strong sense of individuality by making them more or less unedited portraits of particular people. The model for the Virgin Mary was his sister-in-law Mary Hodgkinson, who also appears in *Isabella* (cat. 6). Noël Humphreys, son of an artist friend, sat for Christ; his cousin Edwin Everett posed for John the Baptist; and H. St. Ledger was the workshop assistant. An anonymous carpenter sat for Joseph's body, with Millais' father the likely model for the head. The model for Anne is unknown, although she too appears in *Isabella*. The sheep were painted at the last minute from two heads bought at a local butcher shop.[5]

The painting was bought from Millais by the dealer Henry Farrer on the day before its submission for the Royal Academy exhibition of 1850. It was accepted for the exhibition, but attacked with an unprecedented ferocity by the newspaper and magazine reviewers. The realistic treatment of the Holy Family—showing Joseph with dirty fingernails, for instance—offended some deeply entrenched expectations about religious art. The Protestant majority in Britain was full of fears about the growth of Roman Catholicism at this time; although no one actually accused the artist of "papist" sympathies, the strangely ascetic and sacramental feeling about his painting played into their idea of Roman Catholicism as a morbid culture, and this probably lay behind the remarks made by almost all the critics on the supposed pains and diseases among the figures. The *Art Journal* called it "a remarkable example of the asceticism of painting; for there was a time when Art was employed in mortification of the flesh; and of that period is this work, for few ordinary observers there are who can look on it without a shudder

the impersonation of Joseph seems to have been realised from a subject after having served a course of study in a dissecting-room."[6] The harshest attack came from Charles Dickens, writing in his own magazine *Household Words*:

You will have the goodness to discharge from your minds all Post-Raphael ideas . . . and to prepare yourselves, as befits such a subject—Pre-Raphaelly considered—for the lowest depths of what is mean, odious, repulsive, and revolting. . . . In the foreground of that carpenter's shop is a hideous, wry-necked, blubbering, red-haired boy, in a bed-gown; who appears to have received a poke in the hand, from the stick of another boy with whom he has been playing in an adjacent gutter, and to be holding it up for the contemplation of a kneeling woman, so horrible in her ugliness, that (supposing it were possible for any human creature to exist for a moment with that dislocated throat) she would stand out from the rest of the company as a Monster, in the vilest cabaret in France, or in the lowest gin-shop in England.[7]

The painting became such a talking point that Queen Victoria had it removed from the Royal Academy exhibition and brought to her for a special viewing.[8] "I hope it will not have any bad effects on her mind," wrote Millais in a letter to his friend Hunt.[9] M.W.

Notes

1. Hunt 1905, 1:194–195.
2. For further discussion of this painting in relation to the Oxford Movement and Victorian religious life, see Grieve 1969, 294–295; Morris 1970, 343–345; and Errington 1984.
3. Fredeman 1975, 21, 38, 69.
4. Hunt 1905, 1:202–205.
5. Millais 1899, 1:78.
6. *Art Journal*, June 1850, 175.
7. *Household Words*, 15 June 1850, 265–266.
8. Fredeman 1975, 71.
9. Huntington Library, San Marino.

8

..

John Everett Millais

Mariana

1850–1851, oil on panel,
23 ½ x 19 ½ (59.7 x 49.5). *First
exhibited*: Royal Academy 1851
(no. 561). *References*: Bennett
1967, 31 (no. 30); Parris 1984,
89–90 (no. 35)

The Makins Collection

The subject of this painting is
from Tennyson's poem "Mari-
ana," which is based, in turn,
on a character in Shakespeare's
Measure for Measure. Mariana
has been rejected by her fiancé,
Angelo, and for five years has
lived a lonely life in a moated
grange. She still loves Angelo
and longs to be reunited with
him. In the play this eventually
comes about, although neither
the poem nor the painting gives
any clue that a happy ending is
in store.

When he showed the work
at the Royal Academy exhibition
of 1851, Millais had printed
in the catalogue the mournful
refrain that, with variations,
closes each of the seven stanzas
of Tennyson's poem:

She only said, "My life is dreary,

He cometh not," she said;
She said, "I am aweary, aweary,
I would that I were dead!"

Millais' Mariana stretches her
back in weariness, presumably
after a long period of work at
the embroidery before her. She
seems to be looking intently at
the stained glass window of
the Annunciation, the scene in
which the angel brings news to
the Virgin Mary that she is to
bear the Christ child. In the
background is a miniature altar
decorated with a devotional
triptych, a candlestick, and sil-
ver casters. Millais was an avid
admirer of Tennyson, and the
imagery of the windows and
altar suggests that he was read-
ing not only "Mariana" but
also its pendant, "Mariana in
the South," in which the poet
describes Mariana desperately
moaning and praying to the
Virgin Mary. Millais hints that
his Mariana might be a devotee
of the Virgin—a true Marian,
in other words—and, by dress-
ing her in blue and showing
her engaged in needlework,
actually likens her to the Vir-
gin. Needlework is a common
occupation of the Virgin as she
appears in painting, and it plays
an unusually important part in
the scenes from her life painted
by Dante Gabriel Rossetti in

The Girlhood of Mary Virgin
(1848–1849; Tate Gallery) and
Ecce Ancilla Domini! (1849–1850;
Tate Gallery); the embroidery
she is doing as a dutiful girl in
the first of these is shown com-
plete in the second, symboli-
cally, as Gabriel tells her of her
sacred role. For Millais' Mari-
ana there is no such fulfillment,
neither angel nor Angelo ("He
cometh not"), and she must live
in yearning and frustration.

The stained glass design in
the side window, a heraldic
device featuring a snowdrop,
alludes to yet another poem by
Tennyson, "Saint Agnes Eve,"
in which a nun stands yearning
at a window like Mariana. She
looks out over a winter land-
scape and longs for union with
Christ through death, praying:
"Make Thou my spirit pure
and clear / As are the frosty
skies, / Or this first snowdrop
of the year / That in my bosom
lies." In floral symbolism the
snowdrop represents "consola-
tion," and it is also the birthday
flower for Saint Agnes Eve,
20 January, when maidens sup-
posedly have visions of their
lovers. The motto in the upper
part of the device reads "In
coelo quies" ("In Heaven there
is rest"), a reference to Mari-
ana's wishing she were dead.
The mouse in the lower right

corner is presumably Tenny-
son's mouse that "Behind the
mouldering wainscot shriek'd,
/ Or from the crevice peer'd
about." According to the art-
ist's son, he painted this from
a mouse he killed himself in
the studio. [1]

Millais may have started
Mariana in the spring of 1850,
but began work in earnest in
mid-September. He was stay-
ing in Oxford at the time, with
his friends and patrons Thomas
and Martha Combe. Thomas
Combe was printer to the uni-
versity and superintendent
of the Clarendon Press. They
were devout Christians and
staunch supporters of the An-
glican High Church, and the
particular religious trappings
and overtones that Millais
brought to his painting may
well reflect their interests. He
is said to have painted the view
through the window from their
garden. [2] He copied the stained
glass window of the Annun-
ciation from windows at Mer-
ton College Chapel, gaining
close access to them, high
above the altar, by means of the
scaffolding that John Hunger-
ford Pollen was using to paint
the chapel ceiling. [3] He followed
the designs and colors of the
originals faithfully, but changed
the overall shapes.

He left Oxford for London on 11 November. No doubt he was given heart in his choice of subject by Tennyson's appointment as poet laureate on the 19th of that month. On 30 December he wrote to Martha Combe that he was "deep in the mystery of purchasing velvets and silk draperies for my pictures."[4] He probably painted the figure in his London studio, from an unidentified model, in the early weeks of 1851. By 10 February he could report to Martha Combe that "The Mariana is nearly completed and as I expected the gentleman to whom I promised the *first* refusal, has purchased it."[5] The buyer was the dealer Henry Farrer, who had bought *Christ in the Carpenter's Shop* (cat. 7).

Mariana was the subject of a typically brilliant and idiosyncratic reading by John Ruskin in *The Three Colours of Pre-Raphaelitism* (1878):

Since Van Eyck and Dürer there has nothing been seen so well done in laying of clear oil-colour within definite line . . . and on the whole the perfectest of his works, and the representative picture of that generation—was no Annunciate Maria bowing herself; but only a Newsless Mariana stretching herself;

which is indeed the best symbol of the mud-moated Nineteenth century; in *its* Grange, Stable—Stye, or whatever name of dwelling may best befit the things it calls Houses and Cities . . . craving for any manner of News from any world—and getting none trustworthy even of its own.[6] M.W.

Notes

1. Millais 1899, 1:109.
2. Millais 1899, 1:109.
3. Pollen 1912, 268.
4. Millais 1899, 1:94.
5. Millais 1899, 1:99.
6. Ruskin 1903–1912, 34:165–166.

9

...

John Everett Millais
Ophelia

1851–1852, oil on canvas, 30 x 44 (76.2 x 111.8). *First exhibited*: Royal Academy 1852 (no. 556). *References*: Bennett 1967, 32–33 (no. 34); Parris 1984, 96–98 (no. 40)

Tate Gallery, London. Presented by Sir Henry Tate 1894

In Shakespeare's *Hamlet*, the innocent Ophelia is driven mad when Hamlet, her lover, murders her father Polonius. She collects garlands of flowers and weeds, goes to a stream by a willow, and drowns. Her death scene is not part of the action of the play, but is described by Hamlet's mother, the queen:

There is a willow grows aslant a
 brook,
That shows his hoar leaves in the
 glassy stream;
There with fantastic garlands did
 she come,
Of crow-flowers, nettles, daisies
 and long purples,
That liberal shepherds give a
 grosser name,
But our cold maids do dead
 men's fingers call them.
There, on the pendent boughs
 her crowned weeds
Clambering to hang, an envious
 sliver broke;
When down her weedy trophies
 and herself
Fell in the weeping brook. Her
 clothes spread wide,
And, mermaid-like, awhile they
 bore her up;
Which time she changed snatches
 of old tunes,
As one incapable of her own
 distress,
Or like a creature native and
 indued
Unto that element; but long it
 could not be
Till that her garments, heavy
 with their drink,
Pulled the poor wretch from her
 melodious lay
To muddy death.

The plays of Shakespeare were a standard source of subjects for Victorian artists. Paintings of the pathetic derangement and death of Ophelia were a regular part of the Royal Academy's annual exhibition, and in the same year as Millais showed his version of the subject there was another by the young Arthur Hughes (Manchester City Art Galleries). What sets the Millais apart from the rest, and indeed accounts for its position as one of the best known and beloved of all Victorian paintings, is the almost miraculous acuity of observation in the vegetation, the natural grave in which Ophelia appears laid out like a corpse though still distractedly singing her songs; the pathos of her maiden's death is set off by the green abundance of life around her.

The setting of *Ophelia* is a botanical compendium. Its numerous plants and flowers are differentiated with a typically Pre-Raphaelite attention to detail, and many of them, equally typically, are charged with symbolic significance; the floral symbolism used by

FIGURE 5

William Holman Hunt, *The Hireling Shepherd*, 1851–1852, oil on canvas. Manchester City Art Galleries

Shakespeare was still more or less common currency, and the Victorians' own manuals of the language of flowers were in wide circulation. The willow, the nettle growing among its branches, and the daisies near Ophelia's right hand, emblems of forsaken love, pain, and innocence, respectively, are all taken from the queen's speech. The purple loosestrife at upper right is probably intended for the "long purples" that the queen names among the flowers in Ophelia's garlands, although Shakespeare actually meant early purple orchids. The pansies Millais shows floating on the dress may come from the scene shortly before Ophelia's death, in which she mentions pansies among the flowers she has gathered in the fields; the pansy can signify both "thought" and "love in vain." In the same scene Ophelia speaks of violets that "withered all when my father died," an image that draws on the association of violets with faithfulness, although they can also symbolize chastity and the death of the young. Millais probably had one or more of these meanings in mind when he gave his Ophelia a chain of violets around her neck. The roses near her cheek and at the edge of her dress, and the field

rose on the bank, may allude to her brother Laertes' calling her "rose of May."

The rest of the plants and flowers are of Millais' choosing rather than Shakespeare's. The poppy next to the daisies is a familiar symbol of death; and the faded meadowsweet on the bank can signify "uselessness," although the fact that the artist had trouble remembering the name of this plant casts doubt on the idea that he had any symbolic connotation in mind.[1] The pheasant's eye near the pansies, and the fritillary floating between the dress and the water's edge, are both associated with sorrow, and the forget-me-nots at the mid-right and lower left edges of the composition carry their meaning in their name. According to a story told by Tennyson to his fellow poet William Allingham, Millais had painted in some daffodils bought at the Covent Garden flower market, but Tennyson pointed out that as spring flowers these were inconsistent with the summer blooms elsewhere in the work, and so he removed them.[2] Tennyson said that Millais merely "wanted a bit of yellow," but daffodils can mean "delusive hope," which would certainly have been apt for the subject.

Even without the daffodils, the flowers in *Ophelia* are highly unlikely to be in bloom simultaneously, which is hardly surprising since the artist spent at least four months painting them.

The robin at upper left may refer to one of the songs Ophelia sings: "For bonny sweet Robin is all my joy." To the left of the forget-me-nots is a configuration of light and shade that vaguely resembles a skull. This common *memento mori* may refer both to Ophelia's death and to the famous graveyard scene that follows. The idea of hinting at a skull through apparently random shapes may have something to do with Hunt's *The Hireling Shepherd* (fig. 5)—which he was painting in a nearby field at the same time as Millais was at work on *Ophelia*—where the shepherd is showing the shepherdess the skull-like markings on a death's-head moth.

The background of *Ophelia* was painted in the summer and autumn of 1851, from a spot on the Hogsmill River, near Ewell in Surrey. Millais had been to Ewell often to visit some family friends, the Lemprières. By 2 July he and Hunt were staying in lodgings together on Surbiton Hill, both hard at work on their pictures. "We get up . . .

at six in the morning and are at work by eight, returning home at seven in the evening . . . ," he wrote to his friend Mrs. Thomas Combe:

I sit tailor fashion under an umbrella throwing a shadow scarcely larger than one halfpenny for eleven hours, with a child's mug within reach to satisfy my thirst from the running stream beside me. I am threatened with a notice to appear before a magistrate for trespassing in the field and destroying the hay, likewise by the admission of a bull in the same field after the said hay be cut, also in danger of being blown by the wind into the water and becoming intimate with the feelings of Ophelia when that lady sank to muddy death, together with . . . total disappearance through the voracity of the flies. There are two swans who not a little add to my misery by persisting in watching me from the exact spot I wish to paint, occasionally destroying every water weed within their reach. My sudden perilous evolutions on the extreme bank to persuade them to evacuate their position, has the effect of entirely deranging my temper, my picture, brushes and palette, [and] on the other hand causes those birds to look most benignly upon me with an expression that seems to advocate greater patience. Certainly the

painting of a picture under such circumstances would be a greater punishment to the murderer than hanging.[3]

Hunt recalled that both he and Millais used white porcelain tablets that could be wiped completely clean as palettes, to avoid accidental adulteration of their colors, afterwards changing to lighter ones made of papier-mâché.[4] They painted the blossoms in their pictures, and possibly other parts as well, onto a wet white ground. By 3 September they had moved to new lodgings at Worcester Park Farm, where they were more comfortable and closer to the places they were painting, and Millais had more or less completed the background to *Ophelia* by the end of October. A late addition was a swimming rat, which he eventually erased on the advice of the painter C. R. Leslie.[5] While at Worcester Park Farm, he also painted the background to *A Huguenot* (cat. 10).

Shortly after returning to London on 6 December, Millais sold his unfinished painting for 300 guineas to Henry Farrer, the dealer who already owned *Christ in the Carpenter's Shop* (cat. 7) and *Mariana* (cat. 8). He added the figure of

Ophelia between December and early April of 1852, when he submitted the work for the Royal Academy exhibition. He painted the figure in his studio from Elizabeth Siddall, who entered the Pre-Raphaelite circle as a model and had already sat for figures in two of Hunt's paintings; she was to become Rossetti's favorite model and eventually his wife, as well as a poet and artist in her own right. According to the biography of Millais by his son, she posed in a bath full of water kept warm by lamps underneath; one day the lamps went out and she caught a severe cold, at which her father threatened the artist with legal action until he agreed to pay her doctor's bills.[6] M.W.

Notes

1. See Millais 1899, 1:123.
2. Allingham 1907, 379.
3. Private collection, quoted in Millais 1899, 1:119–120.
4. Hunt 1905, 1:264.
5. Millais 1899, 1:129–131; Hunt 1905, 1:304–305.
6. Millais 1899, 1:144.

IO

..

John Everett Millais

A Huguenot, on Saint Bartholomew's Day, Refusing to Shield Himself from Danger by Wearing the Roman Catholic Badge

1851–1852, oil on canvas, 36½ x 24¼ (92.7 x 61.6). *First exhibited*: Royal Academy 1852 (no. 478). *References*: Bennett 1967, 33–34 (no. 35); Parris 1984, 98–99 (no. 41)

The Makins Collection

This scene of star-crossed love and religious heroism is set at the beginning of the notorious Massacre of Saint Bartholomew's Day. Over a period of several days from 24 August 1572, French Roman Catholics led by the duc de Guise slaughtered thousands of Huguenots (Protestants) in Paris. Millais shows a Catholic girl trying to persuade her Huguenot lover to save himself by binding around his arm the white cloth that is to be the Catholics' means of identification. He resists, preferring to die rather than deny his faith. The source for the story was the opera *Les Huguenots* by Meyerbeer, which had been performed to acclaim

at Covent Garden every season since 1848. In a scene in a Huguenot churchyard, the Catholic heroine Valentine tries in vain to tie the white cloth on the arm of her lover Raoul de Nangis, a Huguenot nobleman. He refuses her entreaties, she embraces Protestantism, and they marry. In the opera's climactic final scene they both die in the massacre, unknowingly killed by Valentine's own father.

Millais paints the lovers' moment of truth in a style that insists on its own truthfulness. Flouting the rules of composition, he takes mere background material, things such as a wall, plants, and flowers, and observes them from life with degrees of focus and fidelity that demand the viewer's scrutiny. The idea is both to invest the image with a feeling of unedited fact, and to force every part to come alive with the possibility of symbolic meaning. Since the species of plants and flowers are carefully identified, they can be read according to the Victorian language of flowers: the ivy clinging to the wall for "dependence," the Canterbury bell in the lower left for "constancy," the nettles and nasturtiums in the lower right for "pain" and "patriot-

ism." The half-destroyed flower at the Huguenot's foot foreshadows the violence of the massacre. The old wall suggests both the idea of the lovers as penned in, with no escape from the horrors to come, and at the same time the fateful religious barrier between them.[1]

The work was begun during the time Millais shared lodgings with his friend William Holman Hunt at Worcester Park Farm, near Ewell. After completing the background to *Ophelia* (cat. 9), Hunt recalled, he thought of painting a subject based on the line "Two lovers whispering by an orchard wall" from Tennyson's poem "Circumstance," and duly began work on the wall. Hunt told him that he found such self-contained love scenes lightweight and uninteresting, and urged him to switch to a subject of moral significance, "with the *dramatis personae* actuated by generous thought of a larger world." As an example of what he meant, Hunt sketched a composition with lovers from opposite sides in the Wars of the Roses. Millais proposed a similar subject from the English Civil War, but Hunt said he thought that the theme of the Cavaliers and Roundheads had been "rather worked to death," at which

Millais thought of the scene from Meyerbeer's opera.[2] The discussion seems to have taken place on 16 October, when Millais wrote in his diary: "Sat up till past twelve and discovered first-rate story for my present picture."[3] The diary contains many detailed references to his work on the background to *A Huguenot*, done mostly inside a makeshift hut at his chosen piece of wall, between that date and 5 December.[4]

Following his usual practice, Millais painted the figures from models in his London studio. The model for the head of the Huguenot was the fifteen- or sixteen-year-old Arthur Lemprière, whose family was close to the artist's and also originated from Jersey in the Channel Islands; they now lived at Ewell. "I have rubbed twice out the head I have been commencing from young Lemprière," Millais wrote to Hunt on 26 January 1852.[5] The male figure was painted at least partly from a professional model named Child, and the model for the Catholic girl was the young Irish beauty Anne Ryan, also a professional; she was dark-haired but Millais painted her as blond. The girl's face was one of the last parts of the picture to be painted, toward the

end of March.[6] Shortly before it was finished Millais sold the work for £250 to the dealer David Thomas White, who almost immediately sold it to B.G. Windus.[7]

A Huguenot was Millais' first popular success. The anti-Catholic implications of the subject may well have struck a chord at a time of general fear among Protestants at the spread of Catholic influence in Britain, the so-called papal aggression. The picture was the talking point of the Royal Academy exhibition of 1852, attracted largely favorable reviews, almost all dwelling on the emotional subtleties of the couple's expressions, and in 1856 was published as an engraving. The artist followed up with a series of subjects involving couples caught in harrowing historical circumstances, including *The Order of Release, 1746* (1852–1853; Tate Gallery) and *The Black Brunswicker* (1859–1860; Lady Lever Art Gallery, Port Sunlight). M.W.

Notes

1. For a detailed account of the imagery of *A Huguenot* and its considerable influence, see Casteras 1985, 71–98.
2. Hunt 1905, 1:282–283, 285, 289–290.
3. Millais 1899, 1:125.
4. See Millais 1899, 1:125–134, 141–144.
5. Huntington Library, San Marino.
6. Millais 1899, 1:160, 162.
7. Millais 1899, 1:163–164.

11

John Everett Millais
The Blind Girl

1854/1856, oil on canvas, 32 ½ x 24 ½ (82.6 x 62.2). *First exhibited*: Royal Academy 1856 (no. 586). *References*: Bennett 1967, 39–40 (no. 51); Parris 1984, 134–136 (no. 69)

Birmingham Museums and Art Gallery

With this subject, the Pre-Raphaelite clarity and detail with which Millais painted his setting works as a celebration of the sense of sight, pointing up the pathos of the girl's blindness. He pays careful attention to things that are a joy to see, from close objects such as the harebells, forget-me-nots, and butterfly, to the sunlit landscape and double rainbow in the distance, and everything is sharply in focus at once. As

the artist's son and biographer John Guille Millais pointed out, the rainbow is "a sign of Divine promise specially significant to the blind."[1] It is a manifestation of light and, as the symbol of God's covenant with mankind, carries the promise of a new and better vision in the afterlife. The concertina, the wet grass and flowers, and the girl's fingering of the grass at her side, suggest that, despite her blindness, her senses of hearing, smell, and touch are still alive. As William Holman Hunt remarked in a letter to Millais, "It is an incident such as makes people think and love more."[2]

As a subject that addressed a social ill of the day, that of vagrancy among children and the disabled, *The Blind Girl* followed from a series of drawings Millais made in 1853–1854; one of these shows a blind beggar, also wearing a "PITY THE BLIND" sign around his neck, being escorted across a busy street (Yale Center for British Art). He was encouraged to treat such subjects by his close friend John Leech, many of whose drawings in *Punch* commented upon society's injustices, and who played an important part in the magazine's campaign of ridiculing hack-

neyed historical subjects and calling upon artists to deal with the present. Hunt had taken a lead in the painting of modern life with *The Awakening Conscience* (cat. 16), which was exhibited at the Royal Academy in 1854, and *The Blind Girl* was in some respects Millais' response to that work. It is a far milder statement than Hunt's, less insistently of the moment as there is no fashionable dress or interior decoration, less insistently moral as there is no villain of the piece; the situation is presented as pathetic rather than iniquitous. The differences reflect the personalities of the artists, but also the fact that *The Awakening Conscience* was a commissioned work for which Hunt was guaranteed payment, whereas Millais' painting was speculative, produced for sale on the open market.

The background is a view of Winchelsea in Sussex, painted on the spot in the summer and autumn of 1854; he arrived there about 24 August with Michael Halliday and reported in a letter of 18 October that he was working on the rainbow and would soon be finished. He did not begin the figures until the following year, after moving to Perth in Scotland with his new wife, the former Effie

Ruskin. He began painting the blind girl from Effie, but later changed to a younger model, Matilda Proudfoot. The model for the blind girl's companion was Isabella Nicol. Matilda and Isabella, both local girls, also appear on the right side of Millais' *Autumn Leaves* (cat. 12). Some of the flowers and grasses, and possibly a section of the middle distance, seem to have been painted in Perth too.

Millais displayed the painting in an informal showing at his London studio before the Royal Academy exhibition of 1856, and it was bought from him by the dealer Gambart for 400 guineas. Originally the double rainbow was painted incorrectly, with the colors arranged in the same order in each arc. After the work was shown at the Academy a writer signing himself "Chromas" contributed a note to the *Art Journal* pointing out that the weaker rainbow should be in reverse.[3] Millais duly made the correction. M.W.

Notes
1. Millais 1899, 1:240.
2. Millais 1899, 1:236.
3. *Art Journal* 2 (August 1856), 236.

12

John Everett Millais
Autumn Leaves

1855–1856, oil on canvas, 41 x 29 (104.1 x 73.7). *First exhibited*: Royal Academy 1856 (no. 448). *References*: Bennett 1967, 40–42 (no. 53); Parris 1984, 139–141 (no. 74)

Manchester City Art Galleries

Painted largely in the fall of 1855, *Autumn Leaves* shows a scene in the garden of Annat Lodge, Perth, where Millais and his wife Effie had settled after their honeymoon earlier that year. The models for the girls around the bonfire were, from left to right, Effie's sisters Alice and Sophie Gray, Matilda Proudfoot, and Isabella Nicol. Matilda and Isabella, whom Effie found in a search through Perth for suitable models, also appear together in *The Blind Girl* (cat. 11).

According to Effie's account, Millais set out to paint "a picture full of beauty and without subject,"[1] in which the storytelling that had played such an important part in works to date would be replaced by a concern with mood, and the

suggestion of universal and religious ideas through symbolism. The season of autumn, the dead leaves, the smoke, and the sunset are images of transience, reminders that all things must pass. It is a landscape redolent of decay and death, suggesting that for all their youth and beauty, the girls, too, are subject to the same natural processes. With their strangely detached and solemn expressions, the girls look as if they might even be conscious of this themselves; their manner is more funereal than playful. The sunset behind them casts light around their heads like haloes. Indeed, the group gently recalls a company of saints in an altarpiece; the two girls at left look out as though offering intercession. Each holds an object like a saint with an attribute; the apple of the youngest girl serves as an emblem not only of autumn but also of original sin and the fallen state of mankind.

Writing of *Autumn Leaves* in a review, F.G. Stephens was moved to invoke some apocalyptic verses from the Bible: "For wickedness burneth as the fire . . ." (Is. 9:18–19), and "the night cometh in which no man can work" (John 9:4).[2] Millais responded enthusiastically, writing to him:

I have read your review of my works in the Crayon with great pleasure, not because you praise them so much but because you entirely understand what I have intended. I was nearly putting in the Catalogue an extract from the Psalms, of the very same character as you have quoted in your criticism, but was prevented so doing from a fear that it would be considered an affectation and obscure. I have always felt insulted when people have regarded the picture as a simple little domestic episode, chosen for effect, and colour, as I intended the picture to awaken by its solemnity the deepest religious reflection. I chose the subject of burning leaves as most calculated to produce this feeling, and the picture was thought of, and begun with that object *solely* in view. These kind of pictures are really more difficult to paint than any other, as they are not to be achieved by faithful attention to Nature, such effects are so transient and occur so rarely, that the rendering becomes a matter of feeling and recollection.[3]

Millais derived the idea of autumn as suggestive of "the deepest religious reflection" from a tradition in English poetry, and in particular from Tennyson, whose melancholy and nostalgia found natural expression in autumnal imagery. In the song "Tears, idle tears" from *The Princess*, he wrote:

Tears, idle tears, I know not
what they mean,
Tears from the depth of some
divine despair
Rise in the heart, and gather to
the eyes,
In looking on the happy Autumn-
fields,
And thinking of the days that are
no more.

In the autumn of 1854 Millais visited Tennyson at Farringford, where the poet's wife noted in her journal that he had been "beguiled into sweeping up leaves and burning them."[4] According to Hallam Tennyson, this was the inspiration for *Autumn Leaves*,[5] and the experience of autumnal activities in the presence of the poet himself may indeed have left a lasting impression. While working on his painting Millais would certainly have been thinking about Tennyson, as he was designing illustrations for the forthcoming Moxon edition of his selected poems. *Autumn Leaves* is deeply Tennysonian in the view of autumn it presents, in its strange conjunction of youthful beauty and decay, and above all in its use of religious imagery to suggest religious doubt, the poet's "divine despair," a yearning for faith rather than faith itself. It is a religious icon for its time, the most complex of Millais' modern life pictures, and arguably his greatest work.[6] M.W.

Notes

1. Parris 1984, 141.
2. *Crayon* 3 (November 1856), 324.
3. Parris 1984, 127, 139.
4. Hoge 1981, 40.
5. Tennyson 1897, 1:380.
6. See also Warner 1984, 126–142.

(NOT IN EXHIBITION)

13

...

John Everett Millais
The Vale of Rest

1858, oil on canvas, 40 ½ x 68 (102.9 x 172.7). *First exhibited*: Royal Academy 1859 (no. 15). *References*: Bennett 1967, 43–44 (no. 57); Parris 1984, 175–176 (no. 100)

Tate Gallery, London. Presented by Sir Henry Tate 1894

The Vale of Rest was the last of the great mood pictures, ominous in tone though lacking

FIGURE 6

John Everett Millais, *Spring*, 1856–1859,
oil on canvas. The Board of Trustees
of the National Museums and Galleries
on Merseyside, Lady Lever Art Gallery,
Port Sunlight

any definite narrative content, that were Millais' most important contribution to British painting in the later 1850s. Its predecessors included *Autumn Leaves* (cat. 12) and *Spring* (fig. 6), which shows a group of girls in a blossoming apple orchard, a symbolic scythe cutting into the composition at right. *The Vale of Rest* was painted as a pendant to *Spring*, and they were shown together at the Royal Academy exhibition of 1859. The theme of mortality strongly suggested in the earlier mood pictures is inescapable here. One nun is digging a grave, and the other carries a rosary that has a skull as well as its cross. It is sunset in the autumn, and above a cross-topped belfry appears a coffin-shaped cloud, a harbinger of death according to Scottish superstition. The bell presumably sounds the angelus or vespers. Millais had treated a convent subject in his drawing *Saint Agnes Eve* (1854; private collection), an illustration to Tennyson's poem of the same title, in which a nun longs for death as her way to union with Christ, "the Heavenly Bridegroom." The yellow funerary wreaths in the lower right corner, which resemble wedding rings, suggest the same resonant

idea. The ivy at left is a common symbol of everlasting life.

The picture was conceived and painted in Scotland, where Millais spent his honeymoon and much of his first five or six years of married life. His wife Effie wrote the following description of its origins and progress:

It had long been Millais' intention to paint a picture with nuns in it, the idea first occurring to him on our wedding tour in 1855. On descending the hill by Loch Awe, from Inverary, he was extremely struck with its beauty, and the coachman told us that on one of the islands there were the ruins of a monastery. We imagined to ourselves the beauty of the picturesque features of the Roman Catholic religion, and transported ourselves, in idea, back to the times before the Reformation had torn down, with bigoted zeal, all that was beautiful from antiquity, or sacred from the piety or remorse of the founders of old ecclesiastical buildings in this country. The abbots boated and fished in the loch, the vesper bell pealed forth the "Ave Maria" at sundown, and the organ notes of the Virgin's hymn were carried by the water and transformed into a sweeter melody, caught up on the hillside and dying away in the blue air. We pictured,

too, white-robed nuns in boats, singing on the water in the quiet summer evenings, and chanting holy songs, inspired by the loveliness of the world around them. . . .

Millais said he was determined to paint nuns some day, and one night this autumn [1858], being greatly impressed with the beauty of the sunset (it was the end of October), he rushed for a large canvas, and began at once upon it, taking for background the wall of our garden at Bowerswell [Effie's family home in Perth], with the tall oak and poplar trees behind it. The sunsets were lovely for two or three nights, and he dashed the work in, softening it afterwards in the house, making it, I thought, even less purple and gold than when he saw it in the sky. The effect lasted so short a time that he had to paint like lightning.

It was about the end of October, and he got on very rapidly with the trees and worked every afternoon, patiently and faithfully, at the poplar and oak trees of the background until November, when the leaves had nearly all fallen. He was seated very conveniently for his work just outside our front door, and, indeed, the principal part of the picture, excepting where the tombstones come, is taken from the terrace and shrubs at Bowerswell. . . . The graveyard portion was painted some months

later [from Kinnoull old churchyard, also in Perth], in the very cold weather, and the wind often threatened to knock the frame over. The sexton kept him company, made a grave for him, and then, for comfort's sake, kept a good fire in the dead-house. There Millais smoked his pipe, ate his lunch, and warmed himself.[1]

The title *The Vale of Rest* and the line "Where the weary find repose," which was given as a subtitle in the catalogue of the 1859 exhibition, are taken from the English version of Mendelssohn's part-song "Ruhetal."[2] As he told Effie in a letter of 7 April 1859, Millais happened to hear his brother William singing this, "and said it just went with the picture, whereupon he mentioned the name & words equally suitable."[3]

The reviews of the work were mixed. Probably the most appreciative came from *The Times*, which compared the landscape to a Giorgione.[4] The problem for many of the critics and exhibition visitors was that the setting seemed too macabre and the nuns too plain. Ruskin took them to task for this in his *Academy Notes*:

You would have liked them better to be fair faces, such as would grace

a drawing-room; and the grave to be dug in prettier ground—under a rose-bush or willow, and in turf set with violets—nothing like a bone visible as one threw the mould out. So, it would have been a sweet piece of convent sentiment. I am afraid it is a good deal more like convent sentiment as it is. Death—confessed for king before his time—asserts, as far as I have seen, some authority over such places.[5]

Among the other admirers of *The Vale of Rest* and Millais' other pictures at the exhibition were Whistler and his friend the French painter Henri Fantin-Latour.[6] The painting was bought a couple of weeks after the exhibition opened by the dealer D. T. White, on behalf of the well-known Pre-Raphaelite collector B. G. Windus, for £700. After it closed, Millais asked his brother to bring the work back to Perth for him to retouch the face of the nun on the right; presumably in response to the criticisms, he wished to make it "a little prettier," and planned to have a Mrs. Paton, presumably his original model, sit to him for the purpose.[7] He is said to have changed the same face again in 1862, this time using a different model, Miss Lane.[8] In later life Millais

would speak of *The Vale of Rest* as his favorite among his own pictures, "that by which, he said, he set most store."[9] M.W.

Notes

1. Millais 1899, 1:328–330.
2. *Sechs Lieder,* Opus 59, No. 5.
3. Millais 1899, limited edition with facsimiles, 1:336 and opp. 337.
4. *The Times,* 30 April 1859, 10.
5. Ruskin 1903–1912, 14:213.
6. See Pennell and Pennell 1908, 1:76–77.
7. Millais 1899, 1:349.
8. Millais 1899, 1:333.
9. Spielmann 1898, 74.

14

John Everett Millais

Dew Drenched Furze

1889–1890, oil on canvas, 67 x 48 (170.2 x 121.9). *First exhibited*: New Gallery 1890 (no. 119). *References*: Millais 1899, 2:210–214

Geoffroy Richard Everett Millais Collection

Between 1870 and 1892, Millais produced a series of large landscapes along the river Tay, above Perth in Scotland. *Dew*

Drenched Furze, one of the most poetic of these pictures, was painted in woods on the estate of Murthly, where Millais and his wife rented a house, Birnam Hall, from 1882 to 1891. During their stay there in the autumn of 1889, Millais vowed not to do any painting, but changed his mind one day in November when he saw the woodland undergrowth laced with dew. "It was a fairyland that met his eye, whichever way he looked, and under its spell the soul of the painter was moved to immediate action," wrote his son. Millais set to work in a clearing in the woods: "grappling with a scene such as had probably never been painted before, and might possibly prove to be unpaintable."[1]

The title of the painting is derived from Alfred Tennyson's poem *In Memoriam*:

Calm and deep peace on this high wold,
And on these dews that drench the furze,
And all the silvery gossamers
That twinkle into green and gold.

The poem is an elegy dedicated to the memory of Arthur Hallam, a close friend of Tennyson's who had been betrothed to his sister Emily.

Hallam died in Vienna in 1833, and Tennyson was grief-stricken. After composing individual poems to Hallam's memory for several years, he wove them into a single lengthy work, which he published anonymously as *In Memoriam* in 1850. The poem is a complex reflection on Tennyson's deep sorrow and the implications of Hallam's death for his understanding of the relationship of mankind, God, and nature. Millais' depiction of a mist-filled wood is a telling image for Tennyson's ideas and feelings: nature is sparkling, beautiful, and yet veiled by the damp air. Tennyson himself used the metaphor of a veil to describe his agonized attempt to understand nature's laws:

O life as futile, then, as frail!
O for thy voice to soothe and bless!
What hope of answer, or redress?
Behind the veil, behind the veil.

In the passage referred to in Millais' title, Tennyson describes an autumnal wood and its calm atmosphere; the silences of the early morning offer him solace: "Calm and deep peace in this wide air, / These leaves that redden to the fall; / And in my heart, if calm at all, / If any calm, a calm despair."

A difficult subject to render in paint, *Dew Drenched Furze* reveals technical mastery and the potential for poetry in a basically naturalistic art. Millais' shift from the literal to a more poetic representation of nature won him the praise of critics; a writer in the *Art Journal* noted that *Dew Drenched Furze* revealed "higher aspirations and more pathos than the master has often of late years exhibited in pure landscape."[2] Millais' main concern was not the description of a topographically recognizable scene, but the suggestion of a mood associated with a particular time of day: the hazy stillness of morning and, by implication, the gradual acceptance of the unalterable cycles of nature, life and death. Millais captures both the "silvery gossamers" and the dreamy mood of the poem. Unlike his earlier Pre-Raphaelite works, in which objects appear with sharpness and clarity, here landscape forms are softened in accordance with a unifying, suffusing atmosphere and light.

In the immediate foreground, under a bramble with leaves whitened by dew, is a nesting hen pheasant. Unstartled, the bird reinforces the calm mood described by Tenny-son. At one time a cock pheasant stood on the right, but it was removed in cleaning prior to the exhibition of the work in 1967. Painting this pheasant proved difficult; according to the artist's son, he went as far as to have a caged bird brought to his studio so that he could render it as lifelike as possible, then asked his son to paint it, and finally painted over that rendition "making it quite a different creature."[3] Gorse bathed in dew occupies the middle ground of the painting; dark shadows under the bushes contrast with the murky sunlight refracted through the droplets of dew. As the woodland scene retreats into the distance, the trees become increasingly indistinct as they are immersed in the opaque, yellow mist of sunrise. The artist's close study of nature is still evident, but in this instance it is used to support and enhance a mood, to present nature as a kind of sacred mystery. The painting was purchased by Everett Gray, Millais' brother-in-law, for the unusually low sum of £500. A.H.

Notes

1. Millais 1899, 2:213.
2. *Art Journal*, July 1890, 218.
3. Millais 1899, 2:213–214.

15

..

Franz Xaver Winterhalter
The First of May, 1851

1851, oil on canvas, 42 x 51 (106.7 x 129.5). Not exhibited in the artist's lifetime.
References: Millar 1992, 294–295 (no. 827)

*Lent by Her Majesty
Queen Elizabeth II*

The First of May, 1851 is the most symbolically elaborate of Winterhalter's many portraits of Queen Victoria and her family. It commemorates a visit to Buckingham Palace by the duke of Wellington, hero of the Battle of Waterloo, who came with gifts for the infant Prince Arthur, his godson. It was both Prince Arthur's birthday and his own, and the boy presented him with a nosegay. It was also the momentous opening day of the Great Exhibition of the Works of Industry of All Nations, and the exhibition building, the Crystal Palace in Hyde Park, is seen in the distance on the left. The queen is shown holding Prince Arthur, and wearing the dress in which she officially opened the exhibition, with the ribbon of the Order of the Garter. Wellington is shown in field marshal's uniform, as is the queen's husband, Prince Albert, who stands at the back. Prince Albert was involved in the planning of the exhibition from the outset, and appears in the portrait to be turning toward the Crystal Palace with satisfaction and pride. The text in his hands is probably the report of the royal commission in charge of the project, which he, as its president, had read at the opening ceremonies.

In her journal the queen suggests that the initial idea of commemorating the occasion was her own, but that the *mise-en-scène* of the portrait was dictated by Prince Albert. On 21 May 1851, after visiting Winterhalter's painting room at the palace to see a sketch for the work, she noted: "It was originally my wish, but Winterhalter did not seem to know how to carry it out, so dear Albert with his wonderful knowledge & taste, gave W the idea, which is now to be carried out."[1] By 29 May the artist was "engrossed" in the work, and by 18 June, after five sittings, he had completed the queen's face. The painting was officially purchased by the lord chamberlain on 30 September

and soon afterwards hung in the corridor at Windsor Castle, where it has largely remained.[2] A reproductive engraving by Samuel Cousins was published in 1852.

Winterhalter shows Wellington offering the boy a casket, although his actual gifts, as recorded in the queen's journal, were a gold cup and some toys. In the course of time this was forgotten, however, and a story became current in the royal household that the casket in the portrait was one that the duke had given Prince Arthur to open on his twenty-first birthday. With his twenty-first approaching, Prince Arthur wrote to ask his mother about this, to which she replied:

It is *utterly* without any foundation Now, the simple fact is that when the Picture was painted Dear Papa and Winterhalter wished it to represent an Event, like Rubens —& Paul Veronese did, *periods* of History,—*without any exact fact.* And as you were born on the Duke's birthday, & on *your* 1st birthday, the Gt Exhibition was opened & after the Duke came to see you, & you gave him flowers & he [gave] you, a Cup & a model of my throne —Papa suggested *something* more *picturesque* than the *cup* shd be put into the Duke's hands wh wd

equally *tell* the story & so pretty a box *now* on my table wch dear Papa gave me, was taken & painted in! These are the facts of the case. I *wish* it had been otherwise. But it only shows how wrong in fact it is not to paint things as they really are.[3]

It is difficult to guess from the queen's account what Rubenses and Veroneses Prince Albert and Winterhalter might have had in mind. From the portrait itself, however, it seems reasonable to infer that they wished to evoke an Adoration of the Magi, with the royal family as the Holy Family and Wellington as one of the Wise Men, and that they used the casket as better suited than a cup to this purpose.

The painting is in a Louis XIV Revival frame with a low-relief decoration of scrolling *rinceaux*, a style favored by Winterhalter for its association with royal and aristocratic portraiture of the seventeenth and eighteenth centuries. M.W.

Notes

1. Millar 1992, 295.
2. Millar 1992, 295.
3. Royal Archives, Windsor, quoted in Millar 1992, 295.

Keelmen Heaving in Coals by Night
Joseph Mallord William Turner

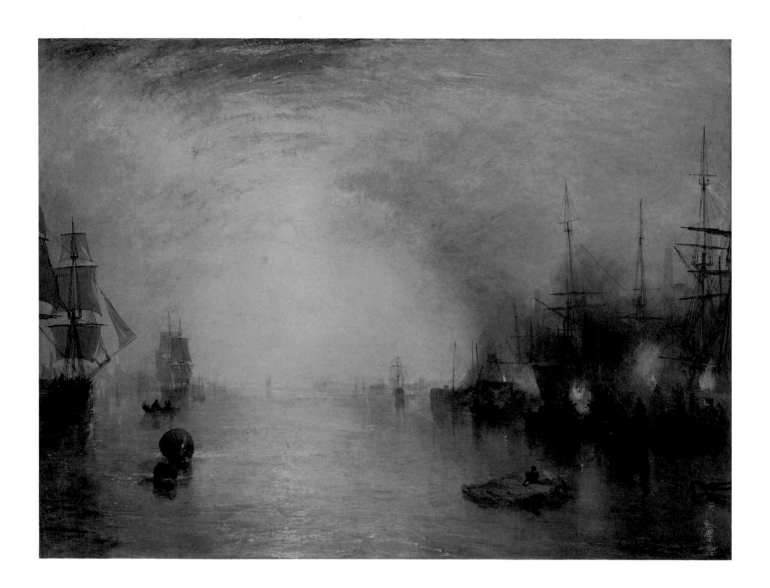

Slavers Throwing Overboard the Dead and Dying — Typhon Coming On
(The Slave Ship)
Joseph Mallord William Turner

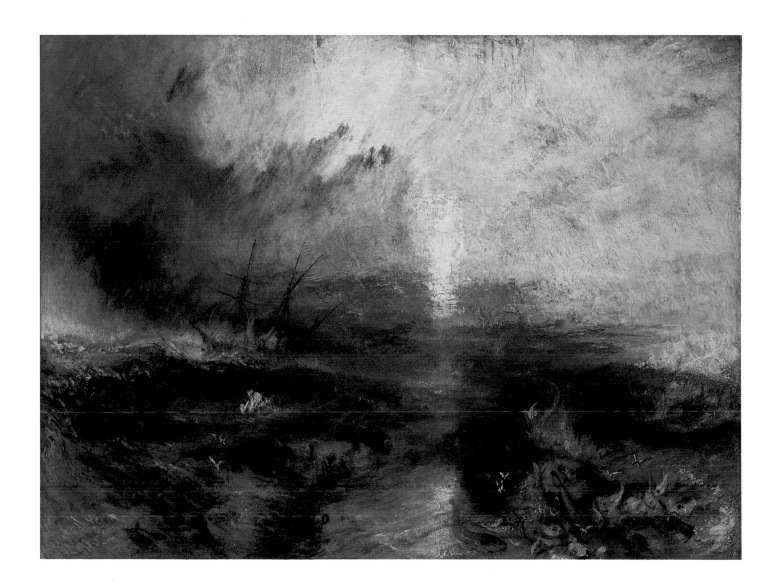

Eos, a Favorite Greyhound, the Property of H.R.H. Prince Albert
Edwin Landseer

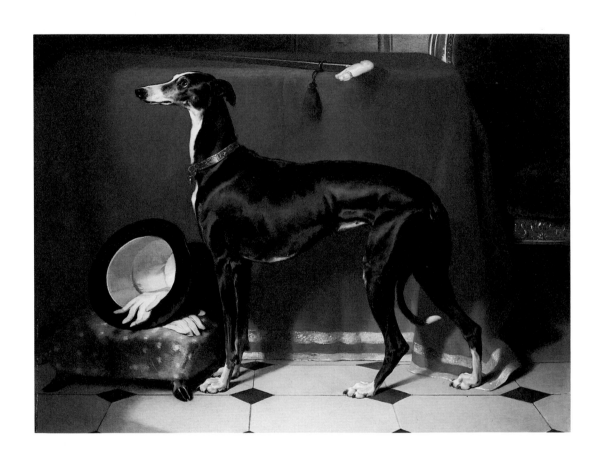

Coming Events Cast Their Shadow Before Them (The Challenge)
Edwin Landseer

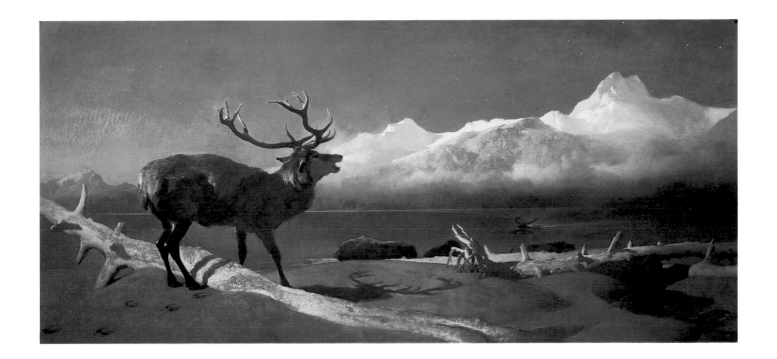

Man Proposes, God Disposes
Edwin Landseer

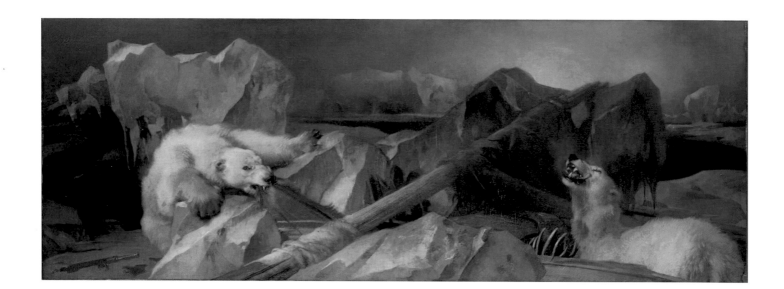

Isabella
John Everett Millais

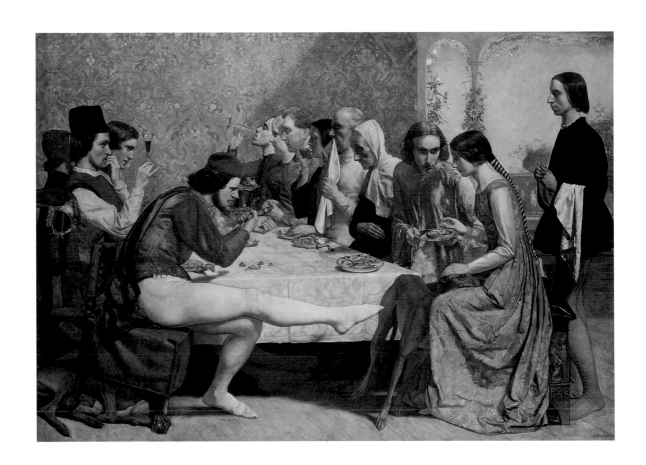

Christ in the Carpenter's Shop
John Everett Millais

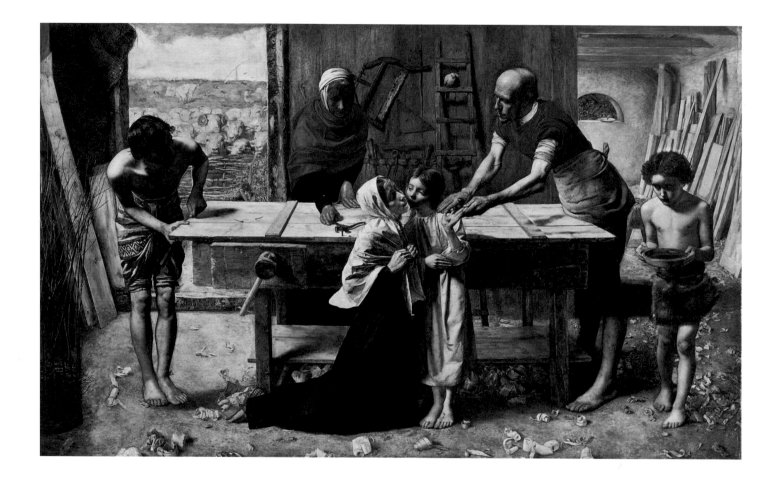

Mariana
John Everett Millais

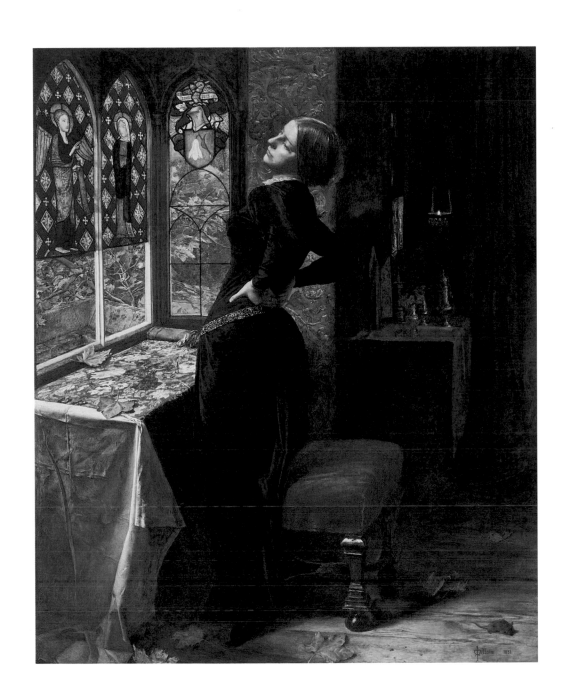

Ophelia
John Everett Millais

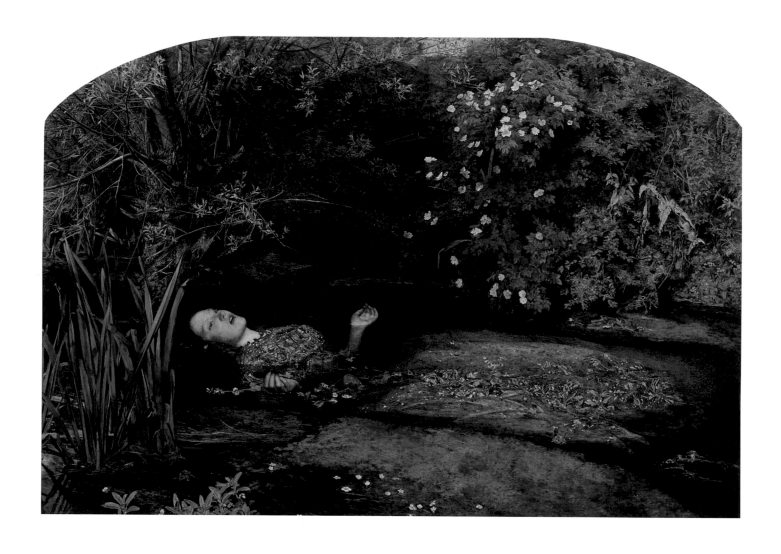

A Huguenot, on Saint Bartholomew's Day,
Refusing to Shield Himself from Danger by Wearing the Roman Catholic Badge
John Everett Millais

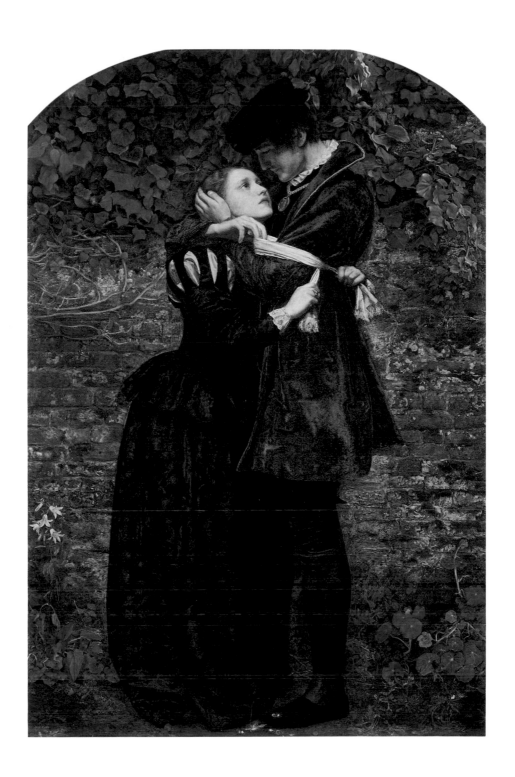

The Blind Girl
John Everett Millais

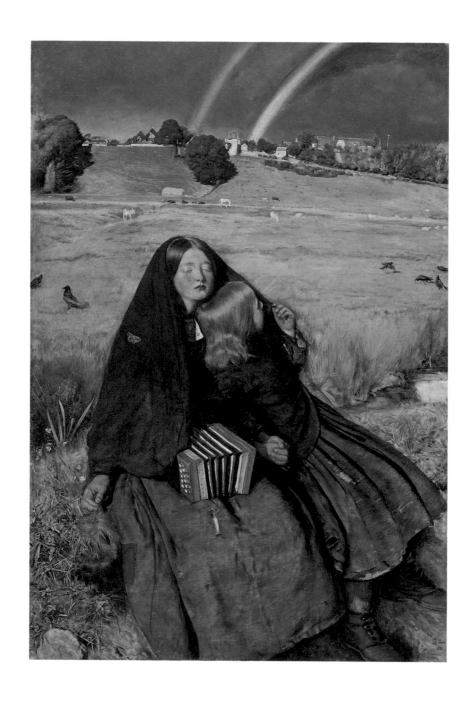

Autumn Leaves
John Everett Millais

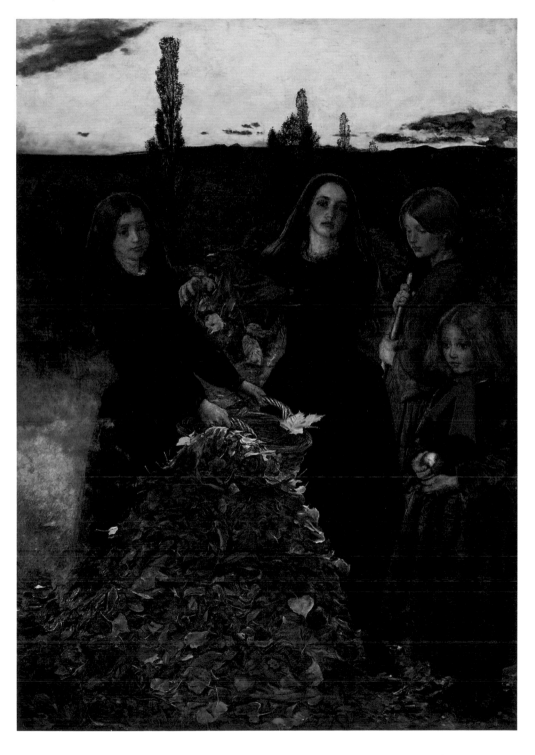

(NOT IN EXHIBITION)

The Vale of Rest
John Everett Millais

Dew Drenched Furze
John Everett Millais

The First of May, 1851
Franz Xaver Winterhalter

16

..

William Holman Hunt

The Awakening Conscience

1853–1854, retouched 1856,
oil on canvas, 30 x 22
(76.2 x 55.9). *First exhibited*:
Royal Academy 1854 (no. 377).
References: Bennett 1969,
35–37 (no. 27); Parris 1984,
120–121 (no. 58)

*Tate Gallery, London. Presented
by Sir Colin and Lady Anderson
through the Friends of the Tate
Gallery 1976*

The Awakening Conscience was
the prototype of the many seri-
ous, often moralizing scenes
from modern life painted by
the Pre-Raphaelites and their
followers from the mid-1850s
onward. The idea of tackling
such subjects grew naturally
out of the principle of being
in all things as truthful as pos-
sible; for artists concerned
with fact and observation, what
more proper study could there
be than the common sights
and dramas of their own time?
Hunt admired the "modern
moral subjects" in which Wil-
liam Hogarth had condemned
and ridiculed the failings of
British society in the previous

century, and was conscious that
painting in his own day had
fallen far behind the novel in
dealing with contemporary is-
sues. His painting is Hogarth-
ian in its use of intricate sym-
bolic detail to expand upon the
basic narrative, and indebted
to Charles Dickens and other
Victorian writers in its frank,
sympathetic treatment of the
theme of the modern Magda-
len or "fallen woman."

The principal character is
the mistress of a wealthy and
fashionable young man of the
upper-middle class or aristoc-
racy, kept comfortably by him
in a place of her own. A book
on the table has been identified
as a volume on handwriting;
her lover is apparently making
efforts to educate her, which
would suggest humble origins
on her part, and perhaps also
a relationship of some warmth
and duration. In all likelihood,
we are meant to think of her as
a pretty girl who has fallen
prey to poverty and to one man's
blandishments—like Little
Em'ly in Dickens' *David Copper-
field* (1849–1850) or the hero-
ine of Elizabeth Gaskell's *Ruth*
(1853)—and been lured into
dependency on him. Certainly
Hunt wished us to regard his
sin as much greater than hers.

Always thorough in the pur-

suit of authenticity, Hunt based
the setting on a room in a villa
in Saint John's Wood, the Lon-
don suburb commonly associ-
ated with this kind of *ménage*.
The model for the woman was
his beautiful, barely literate
girlfriend Annie Miller. The
identity of the model for the
man is uncertain, although he
bears a fairly close resemblance
to Hunt's friend and fellow
artist Thomas Seddon. Rising
to her feet and leaning slightly
against the arm of the chair, the
woman may have been sitting
on the man's lap; she is enter-
taining him in a state of undress,
and her hair hangs loose down
her back, all signs of extreme
licentiousness. To underscore
the fact that the couple is not
married, Hunt gives her a ring
on each finger of her left hand
except the one where she would
wear a wedding band. Her
lover sings her a song, which
we see from the sheet music on
the piano to be a setting of
Thomas Moore's poem "Oft,
in the stilly night":

Oft, in the stilly night,
 Ere Slumber's chain has bound
 me,
Fond Memory brings the light
 Of other days around me. . . .

The words have stirred the

woman's conscience by re-
minding her of the innocence
of her youth. She looks out of
the window into the sunlit
garden, which we see reflected
in the mirror behind her, and
"the light of other days" breaks
in. She sees the light, in both
the literal and the spiritual
senses: the unsullied world of
nature brings memories of for-
mer purity and the desire for
redemption.

The setting is full of sym-
bolic details. Beneath the table
a cat toys with a bird, a meta-
phor for the couple that leaves
no doubt as to Hunt's feelings
about each of them. On the
floor at left is another sheet
of music, a setting by Hunt's
friend Edward Lear of Tenny-
son's poem "Tears, Idle Tears."
As the painting appeared origi-
nally, the tears of the poem
were apt in the most literal
way, as the woman was shown
crying. (Her face was repainted
by Hunt in 1856, when the first
owner of the work, Thomas
Fairbairn, found this part too
painful to live with.) The
dropped kid glove foreshadows
that the man will cast her off
"like an old glove" when she
has served her purpose; kid
gloves could not be cleaned,
just as the virtue of the fallen
woman could never be restored.

FIGURE 7

Jan van Eyck, *Arnolfini Marriage Portrait*, 1434, oil on panel. The National Gallery, London

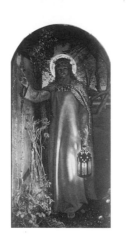

FIGURE 8

William Holman Hunt, *The Light of the World*, 1851–1853, oil on canvas, over panel. Keble College, Oxford

The yarn at right suggests the raveled and tangled state of her soul.

The clock on the piano indicates that it is shortly before noon, representing the idea that the woman is poised to enter a new phase in her life. The ornamental figures represent Chastity binding Cupid. The print behind the clock is after a painting by Frank Stone—one of the Pre-Raphaelites' bitterest critics—entitled *Cross Purposes*, a reference to the wholly different states of mind of the man and woman. The decoration on the wall behind the woman's head shows a boy asleep, a horn at his side, near the Eucharistic symbols of wheat and a vine; the birds that the boy is supposed to be scaring away are pecking at the ears of wheat and grapes. The scene represents the need for spiritual vigilance and, perhaps, the pastoral inadequacies of the Church of England.

One of the Pre-Raphaelites' touchstones as they developed their style of symbolic realism, and the greatest pre-Raphael painting available to them in London, was Jan van Eyck's *Arnolfini Marriage Portrait* (fig. 7). Hunt may have designed *The Awakening Conscience* deliberately to recall this work, as

something along the lines of a modern-life pendant. Perhaps the most obvious connection is the mirror, which in both cases serves the double function of adding a further space to the scene, and representing on a symbolic level the idea of truthfulness: both pictures hold the mirror up to nature. The dog that suggests fidelity in the Van Eyck becomes the vicious cat in the Hunt, and the shoes in the Van Eyck, removed as a sign of the sacredness of the place, become the casually dropped, soiled glove. The woman in the Van Eyck gives the man her hand; in the Hunt, she clutches one hand with the other as if to prevent her lover from taking it, creating a parody of the joining of hands in a wedding ceremony. The Van Eyck suggests the solemnity of marriage, the Hunt a mockery.

Hunt conceived *The Awakening Conscience* in relation to *The Light of the World* (fig. 8), which was also shown for the first time at the Royal Academy exhibition of 1854. This is an allegorical work showing Christ with the lantern of spiritual enlightenment, knocking at the weed-choked door of the human soul. With *The Light of the World* already under way, Hunt formed the idea of paint-

ing "a material interpretation" of the same idea. "My desire," he later wrote, "was to show how the still small voice speaks to a human soul in the turmoil of life."[1] His first sketch of the composition appears to date from January 1853. He was discouraged from beginning an actual painting by Edward Lear, however, who felt that the subject might be misunderstood. No doubt he also weighed the difficulties of finding a buyer for such a challenging work. In any case he did nothing until the summer of that year, when another artist friend, Augustus Egg, managed to persuade the collector Thomas Fairbairn to take on the commission. Hunt began work, and the painting was completed in January of 1854, just before he left on his first trip to the Holy Land. The original title was *A Still Small Voice*, which he changed to *The Awakening Conscience* at the suggestion of his friend and patron Thomas Combe, the owner of *The Light of the World*, who felt that the story was otherwise too difficult to interpret.

The frame was made to Hunt's own design (fig. 9). With its combination of Gothic lettering on the base and ornament along the other three sides, it

recalls the fifteenth-century Netherlandish frames that the artist would have seen when he visited Belgium with Rossetti in 1849. The inscription is a quotation from the Bible (Prov. 25:20, abbreviated): "As he that taketh away a garment in cold weather, so is he that singeth songs to an heavy heart." It was this passage, Hunt recalled, that inspired the idea of making the man, through his singing, the unconscious cause of his mistress' shame and repentance. The ornamentation around the rest of the frame features marigolds, ringing bells, and at the top a star, emblems respectively of sorrow, warning, and spiritual guidance. When the painting was first exhibited at the Royal Academy, the catalogue provided further biblical texts, from Isaiah and the apocryphal Ecclesiasticus.

Despite Hunt's efforts to make his high moral intentions clear, his picture was received largely with bewilderment, misunderstanding, and disapproval. Much to his delight, however, it was brilliantly defended by John Ruskin in a long letter to *The Times*:

There is not a single object in all that room, common, modern,

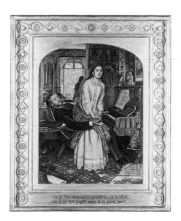

vulgar . . . but it becomes tragical, if rightly read. That furniture, so carefully painted even to the last vein of the rosewood—is there nothing to be learnt from the terrible lustre of it, from its fatal newness; nothing there that has the old thoughts of home upon it, or that is ever to become a part of home. . . . the very hem of the poor girl's dress, which the painter has laboured so closely thread by thread, has story in it, if we think how soon its pure whiteness may be soiled with dust and rain, her outcast feet failing in the street. . . . while pictures will be met by the thousand which literally tempt to evil . . . which are devoted to the meanest trivialities of incident or emotion . . . to the delicate fancies of inactive religion, there will not be found one powerful as this to meet full in the front the moral evil of the age in which it is painted, to waken into mercy the cruel thoughtlessness of youth, and subdue the severities of judgment into the sanctity of compassion.[2] M.W.

Notes

1. Hunt 1905, 1:347.
2. *The Times*, 25 May 1854, in Ruskin 1903–1912, 12: 334–335.

17

...

William Holman Hunt

The Scapegoat

1854–1855, oil on canvas, 33¾ x 54½ (85.7 x 138.4). *First exhibited*: Royal Academy 1856 (no. 398). *References*: Bennett 1969, 42–44 (no. 33); Parris 1984, 153 154 (under no. 84); Bennett 1988, 70–77

The Board of Trustees of the National Museums and Galleries on Merseyside, Lady Lever Art Gallery, Port Sunlight

The scapegoat was a sacrificial animal cast out into the desert by the Israelites to atone for their sins. According to the book of Leviticus, this was one of the offerings dictated by God to Moses, to be carried out by his brother Aaron, the high priest: "And Aaron shall lay both his hands upon the head of the live goat, and confess over him all the iniquities of the children of Israel, and all their transgressions in all their sins, putting them upon the head of the goat, and shall send him away by the hand of a fit man into the wilderness. And the goat shall bear upon him all their iniquities unto a land not inhabited" (16:21–22). Aaron's sacrifices were the origin of the annual Jewish rituals of the Day of Atonement. The scapegoat has commonly been interpreted in Christian theology as a precursor or "type" of Christ, who also dies for people's sins. By the Victorian period the reading of the scriptures from a typological point of view, in which characters and incidents of the Old Testament are both fact and symbol, existing historically but also as intimations of the New Testament, was a highly developed and familiar approach to biblical commentary.[1]

When the picture was first exhibited at the Royal Academy in 1856, Hunt explained the subject in the catalogue, including the following remarks on the fillet on the scapegoat's head:

A fillet of scarlet was bound about its horns, in the belief that, if the propitiation were accepted, the scarlet would become white (in accordance with the promise in Isaiah: "Though your sins be as scarlet, they shall be as white as snow: though they be red like crimson, they shall be as wool"). In order to ascertain the change of colour, in case the scapegoat could not be traced, a portion of the scarlet wool was preserved on a stone, and carefully watched by priests in the Temple.

His sources for this were the Talmud, and probably John Lightfoot's *The Temple Service as it Stood in the Dayes of Our Saviour* (1649).[2] The typological interpretation of the fillet was as a prefiguration of Christ's crown of thorns. The inclusion of the moon in the upper left was also probably intended to recall the Passion of Christ; medieval Crucifixion scenes often include the sun and moon to either side of the cross. It may also be relevant that Saint Augustine used the moon as an image of the Old Testament, illuminated by the typological sunlight shed upon it by the New.

Hunt painted most of the background to *The Scapegoat*, under conditions of discomfort and danger, on the salt-encrusted shores of the Dead Sea. He came to the Holy Land to paint biblical subjects with a greater authenticity than ever attempted in art before, pursuing to its natural conclusion the Pre-Raphaelite principle of painting all subjects as much as possible from reality, directly and truthfully. Finding himself unable to secure local models for the first composition he

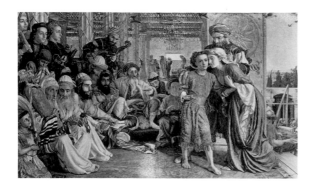

FIGURE 10

William Holman Hunt, *The Finding of the Saviour in the Temple*, 1854–1860, oil on canvas. Birmingham Museums and Art Gallery

began after arriving in Jerusalem, *The Finding of the Saviour in the Temple* (fig. 10), he took up the subject of the scapegoat partly as a means of avoiding the problem. He later recalled that the subject came to him as "one suited to Landseer,"[3] and his own conception may owe something to the older painter's *Coming Events Cast Their Shadow Before Them* (cat. 4).

He may have chosen his location after reading Félicien de Saulcy's *Narrative of a Journey Round the Dead Sea and in the Bible Lands in 1850 and 1851* (English translation, 1853), in which Oosdoom at the southern end of the Dead Sea is identified as the site of Sodom, the infamous city of vice destroyed by God in his wrath.[4] The Day of Atonement was on 2 October in 1854, and Hunt sought out his spot near Oosdoom later that month, probably beginning the canvas that was to become a smaller variant of the same composition (Manchester City Art Galleries). He returned to begin the present, large canvas, bringing a rare white goat with him to serve as his model, on 13 November; he painted most of his background on location between 17 and 26 November, carefully correcting the colors in the mountains

each day at sunset.[5] He managed only to sketch in the position of the goat before having to go back to Jerusalem, and it was there that he painted the rest of his picture. The original goat died on the return journey, but he managed eventually to find a substitute, which he posed in a tray of Dead Sea mud and salt; it was important to show a white goat to underline its freedom, as a type of Christ, from sin. He painted the goat, the sky, and parts of the foreground during the first half of 1855, and had finished the work by early June.

Hunt devoted more care and attention to frames than any of his friends within the Pre-Raphaelite circle, and designed the frame for *The Scapegoat* while still working on the painting itself. It is a simple cushion frame with emblems in shallow relief and inscriptions, its plainness in keeping with the desolate scene depicted in the painting, as well as to the high seriousness of Hunt's meaning. The seven stars at the top represent the seven gifts of the Holy Ghost, and the seven-branched candelabrum at the bottom symbolizes the faith of the Old Testament. They are accompanied respectively by quotations from Isaiah (53:4):

"Surely he hath borne our Griefs, and carried our Sorrows: yet we did esteem him stricken, smitten of God, and afflicted," and from Leviticus (16:22): "And the Goat shall bear upon him all their Iniquities unto a land not inhabited." The left rail bears a design of a dove and olive branch, alluding to the story of Noah's Ark and God's covenant with mankind; the rainbow that Hunt painted in the smaller variant of his picture served the same symbolic purpose. The trefoil within which they are contained represents the Holy Trinity. On the right rail is a heartsease, signifying the redemptive power of the New Dispensation.

Like many other major Pre-Raphaelite paintings, *The Scapegoat* was bought by the collector B.G. Windus. When it was shown at the Royal Academy exhibition of 1856, the reviewers were generally puzzled and disturbed, some finding the whole idea of a goat as a sacred symbol offensive. It was only with the successful exhibition of *The Finding of the Saviour in the Temple* four years later that Hunt was launched upon his career as Britain's leading painter of religious subjects. M.W.

Notes

1. For a fuller discussion of *The Scapegoat* in this connection, see Landow 1979, 103–113.
2. Parris 1984, 153.
3. Hunt 1905, 1:447.
4. Parris 1984, 153.
5. For an account of Hunt's tribulations at the Dead Sea, see Bronkhurst 1984, 111–125.

18

..

William Holman Hunt
The Lady of Shalott

1886–1905, oil on canvas, 74 x 57 ½ (188 x 146.1). *First exhibited*: Arthur Tooth and Sons Gallery 1905. *References*: Parris 1984, 249–250 (under no. 168); exh. cat. Providence 1985, 121 (no. 23)

Wadsworth Atheneum, Hartford, Connecticut. The Ella Gallup Sumner and Mary Catlin Sumner Collection Fund

The Lady of Shalott is based on Tennyson's poem of the same title. Though resembling an Arthurian legend, the story was largely of the poet's own invention. The Lady of Shalott weaves into a magic web images of people passing her castle on

FIGURE 11

William Holman Hunt, "The Lady of Shalott," illustration to the Moxon Tennyson, published 1857. Museum of Fine Arts, Boston. John H. and Ernestine A. Payne Fund

the road to Camelot, where King Arthur has his court. She is under a curse, and may only look at them in a mirror. She meets her fate when one day she sees Sir Lancelot riding by in all his splendor, and turns from her mirror to look at him directly:

Out flew the web and floated wide;
The mirror crack'd from side to
 side;
"The curse is come upon me," cried
 The Lady of Shalott.

She goes down to the river, boards a boat, and floats downstream, singing her swansong. By the time she reaches Camelot, she has died. "She has a lovely face," remarks Sir Lancelot, unaware that he has caused her death. "God in her mercy lend her grace, / The Lady of Shalott."

Hunt made a drawing of the Lady of Shalott with the curse coming upon her as early as 1850 (National Gallery of Victoria, Melbourne). This may have been intended as a sketch for a painting; in the same year his friend and fellow Pre-Raphaelite John Everett Millais began his *Mariana* (cat. 8), and they may have planned to show Tennyson subjects together at the next Royal Academy exhi-

bition. In the event Hunt made no painting at that stage, but a few years later he seized the opportunity of treating the scene in one of his contributions to the illustrated edition of Tennyson's poems published by Edward Moxon (fig. 11); this was much to the disappointment of Rossetti, who coveted the subject for himself. In the illustration Hunt followed the same basic staging as in the drawing of 1850, with the lady standing in her loom tangled in threads and Sir Lancelot reflected in the mirror behind her, but made an originally spare, angular design richer and more curvilinear.

When Tennyson saw the illustration, he felt that Hunt had treated his poem with too great a license, upbraiding him for placing the Lady of Shalott inside her loom when the poem describes her leaving it, and for showing her hair wildly tossing above her when the poem makes no mention of this. Hunt replied that he wished "to convey the idea of the threatened fatality by reversing the ordinary peace of the room and of the lady herself; [so] that while she recognised that the moment of the catastrophe had come, the spectator might also under-

stand it," reminding the poet of the challenges of representing in a single image an idea developed over a number of pages of poetry. [1] Hunt was pleased with his illustration, and returned to it some thirty years later as the basis for the present painting.

The Lady of Shalott was a fairly popular subject among Victorian painters (see cat. 63), but the complicated symbolism with which Hunt elaborated upon the theme was unique. For him it was an allegory of the dire consequences of turning away from duty, of yielding to worldly temptations. The Lady of Shalott is a kind of artist, and in addition to its general message for mankind, Hunt may have intended the painting as a statement of his aesthetic morality: in order to fulfill his or her holy mission, the artist must stay pure and apart from the world; too great a fascination with mere material realities leads to soulless and vacuous art. For Hunt, the most distressing contemporary example of this was, without doubt, the impressionist movement.

In his painting the "stormy east-wind" of the poem blows through the lady's chamber making a great plume of her hair, and frightening away the

doves of peace that have settled by her as she worked. Her weaving unravels, irrevocably ruined like her life, and she is tangled in its threads like an insect caught in a spider's web. What remains of the weaving shows not the casual passersby of the poem, but an allegory of King Arthur and his court. In the patch of sunlight immediately to the right we see the pure Sir Galahad offering the king the Holy Grail on his shield, and to the left the impure Sir Lancelot kissing his fingers; it is Lancelot who, through his adulterous affair with Queen Guinevere, brings about Arthur's downfall. Toward the back of the weaving are the figures of Charity on the left, and Justice and Truth on the right. The convex mirror in which the "real" Lancelot appears, brandishing his sword, is a distant recollection of the mirror in the famous *Arnolfini Marriage Portrait* of Van Eyck, a painting on which Hunt also drew in *The Awakening Conscience* (cat. 16). The Lady's pattens near the lower right corner probably come from the same source; as in the Van Eyck, the idea of showing them removed is to suggest that this is, in a sense, sacred ground.

The decoration of the lady's

chamber is not only a remarkable, fantastical essay in *art nouveau*, but also a dense symbolic accompaniment to the main action of the painting. The silver lamp to the right is ornamented with owls near the top and sphinxes at the bottom to suggest the light of wisdom triumphing over mystery and fear; now that she has succumbed to temptation, the light has been extinguished, blown out by the wind. The relief in the oval panel to the right of the mirror represents the mythic hero Hercules picking the golden apples in the garden of the Hesperides, one of his twelve labors; to reach them he has to slay the serpent Ladon, who guards them, and he picks them as the Hesperides, or "daughters of evening," sleep beneath the tree. Hunt gives Hercules a halo to mark him as a pagan counterpart or "type" of Christ, his victory over the serpent being a parallel to Christ's victory over sin. The panel on the other side of the mirror shows the Virgin Mary praying over the Christ child. Hercules in his valor and the Virgin in her humility are both exemplars of duty; they act as thematic foils to the Lady of Shalott, who personifies its dereliction. To show the

global and cosmic significance of the event, Hunt designed the posts of her loom to represent the elements of water, earth, and air, and the reliefs on the upper parts of the wall to represent the heavenly "music of the spheres." The carvings in the floor around the posts show the eternal struggle for life, evolving from primitive sea creatures devouring each other to the left, to fighting mammals and men in the center, to the tools of peace and war on the right.[2]

Typically, Hunt worked on *The Lady of Shalott* over a number of years, between 1886 and 1905. By the later 1890s his eyesight had seriously deteriorated, and for the rest of his career he relied on assistants. The Lady of Shalott's right foot, the upper part of the lamp, the skein of pink floss-silk hanging on the loom, the irises in the lower right corner, and possibly other details were executed under his direction by Edward Hughes. After suffering some damage in the 1940s, the work was retouched by Stanley Pollitt, who had also assisted Hunt in his last years.

The painting is in a grandiose frame designed by the artist on the pattern of an Italian Renaissance altarpiece, with

recessed columns at the sides twined to half their height with foliage. The frieze above is decorated with a fuming casket inscribed SPES ("Hope"). The allusion is to a classical parallel to the Lady of Shalott's story, the myth of Pandora's box. In order to punish the human race for the theft of fire by Prometheus, Jupiter ordained that when Pandora opened her box, all the evils of the world should fly out, leaving only Hope inside. M.W.

Notes

1. Hunt 1905, 2:124–125.
2. For further discussion of the genesis and symbolism of *The Lady of Shalott*, see exh. cat. Providence 1985, especially Timothy R. Rodgers, "The Development of William Holman Hunt's *Lady of Shalott*," 50–60, and Miriam Neuringer, "The Burden of Meaning: Hunt's *Lady of Shalott*," 61–70.

19

Ford Madox Brown
Work

1852, 1856–1863, oil on canvas, 54 x 77¾ (137.2 x 197.5). *First exhibited*: 191 Piccadilly 1865. *References*: Parris 1984, 163–165, no. 88

Manchester City Art Galleries

In *Work*, Brown took up one of the central principles of Pre-Raphaelitism, to paint improving and reforming subjects taken from scenes of daily life. Like his eighteenth-century predecessor William Hogarth, Brown took types from contemporary life and wove them into a narrative that spoke to the condition of British society. Much of our knowledge of this painting comes directly from Brown himself, who wrote a lengthy pamphlet to accompany its exhibition in 1865.[1] He began the painting after witnessing laborers engaged in "excavations, connected with the supply of water" in Hampstead, where he had moved in June 1852. He decided that "the British excavator, or *navvy*, as he designates himself, . . . was at least as worthy of the

powers of an English painter as the fisherman of the Adriatic, the peasant of the Campagna, or the Neapolitan lassarone. Gradually this idea developed itself into that of Work as it now exists, with the British excavator for a central group, as the outward and visible type of *Work*." Brown rejected the prevailing notion that the artist must draw subjects from history or picturesque locales, and his theme engaged directly with ongoing debates about the state of British society. The painting is both a representation of contemporary life, based on the close, faithful study of nature in natural light, and a modern allegory, encoded with moral values.

After beginning the painting in 1852 Brown set it aside, returning to it only sporadically until November 1856, when he received a commission to complete it from T. E. Plint, a Leeds evangelist, speculator, and picture collector. Plint offered Brown 400 guineas and requested that the artist make a number of changes to render the painting more in keeping with his politics. On 24 November 1856, he wrote Brown asking "cannot you introduce *both Carlyle & Kingsley*, and change one of the *fashionable*

young ladies, into a *quiet, earnest, holy* looking one, with a book or two & *tracts*, I want *this* put in, for I am interested in *this* work *myself*, & know others who are."[2] Thomas Carlyle, the preeminent social critic, proclaimed his belief in the gospel of work as the saving grace of the age. Under his influence the moral value of labor became a key tenet of the Victorians—particularly the entrepreneurial middle classes who were emerging as significant art patrons—and Brown's canvas is a direct embodiment of this. Carlyle appears to the right, in a soft felt hat associated with intellectuals and artists, and looks squarely at the viewer. To his left, gazing upon the excavators, book in hand, is F. D. Maurice, a leading Christian Socialist who helped found the Working Men's College where Brown taught. Maurice replaced the Rev. Charles Kingsley, another leading voice of Christian Socialism. According to Brown, who explained the entire painting by reference to the work ethic, Carlyle and Maurice may appear idle, but are in fact "brainworkers . . . and are the cause of well-ordained work and happiness in others." These figures contrast with the man on the opposite side of the

canvas: a chickweed seller, described by Brown as a "ragged wretch who had never been *taught* to *work*. . . . But for a certain effeminate gentleness of disposition and a love of nature," he added, "he might have been a burglar!" Between these two polar opposites are the excavators; the central figure of this group—the standing worker clenching a rose, symbol of beauty, between his teeth—was described by Brown as a hero, in keeping with Carlyle's veneration of the worker as an inherently noble figure. Carlyle considered the laborer and the intellectual as the types most worthy of honor in British society.

The nobility of the laborer was reinforced, rather than undermined, by Brown's depiction of another worker drinking beer, which was considered healthier than gin. Brown included several references to the ill effects of gin, which the Victorians regarded as a cause of idleness, disease, and death. Brown conjectured that his "hump-backed, dwarfish" pot boy, depicted in the midst of the excavators with the *Times* under his arm, was as a child "probably starved, stunted with gin, and suffered to get run over." This character earned

Brown's praise, however, because he advanced himself through hard work and adopted the entrepreneurial spirit of the age: "energy has brought him through to be a prosperous beer-man, and 'very much respected,' and in his way he also is a sort of hero; that black eye was got probably doing the police of his master's establishment." The bedraggled children standing in front of the excavators, according to Brown, "are motherless, [as] the baby's black ribbons and their extreme dilapidation indicate, making them all the more worthy of consideration; a mother, however destitute, would scarcely leave the eldest one in such a plight. As to the father, I have no doubt he drinks, and will be sentenced in the police court for neglecting them."

While Brown had sympathy for the pot-boy and the children, as well as the ragged flower seller, he heaped scorn on the more well-to-do and their associates. Behind the flower seller are several women that Brown placed in "a very different class . . . the *rich*, who have no need to work." Their wealth is symbolized by the pastry-cook's boy, carrying a green box on his head. His luxury product, according to

Brown, represents "superfluity" and demonstrates that the rich have "no need to work—not at least for bread—*the 'bread of life'* being neither here nor there."

The biblical verses inscribed on the frame take up the theme that the only honorable means by which to enjoy the benefits of the earth was through hard work: in the upper left, just above the pastry boy, is the verse "Neither did we eat any man's bread for nought; but wrought with labour and travail night and day" (2 Thess. 3:8); in the upper center, "I must work while it is day for night cometh when no man can work" (John 9:4); in the lower center, "In the sweat of thy face shalt thou eat bread" (Gen. 3:19); and in the upper right, "See'st thou a man diligent in his business? He shall stand before kings" (Prov. 22:29). The other well-to-do figures in the paintings include the woman with the blue-green parasol just behind the flower seller, for whom the model was Brown's wife Emma. Brown claimed that her sole purpose in life was "to dress and look beautiful for our benefit." The second well-dressed woman has a cause—passing out the pamphlet *A Hodman's Haven, or Drink for Thirsty Souls*, another reference to

temperance. In the background is a wealthy gentleman, painted from Brown's friend the painter R.B. Martineau, and his daughter, both on horseback. Although this couple is seemingly oblivious to the implications of the scene, Brown argued that if they could only hear what Carlyle and Maurice are discussing they could be persuaded of the social obligations of wealth.

The division of the figures in the painting into three groups, the idle poor, the working class, and the idle rich, was in keeping with emerging social doctrines. Henry Mayhew, who dissected the various functions performed by the English working classes in his *London Labour and the London Poor* of 1851, divided society into those who will work, those who cannot work, those who will not work, and those who need not work. Carlyle partitioned society into workers, master workers, and master unworkers; Maurice used the terms working classes, trading classes, and the aristocracy. According to these social commentators, the rich were like the idle poor because they did nothing to contribute to society's productivity.

Other details reinforce Brown's theme of the moral value of work and identify the

setting as a modern suburb. Posters, including one for the Working Men's College, are pasted on the brick wall lining the street. Modern advertisements can also be seen on the sandwich-boards in the distance, which promote the candidacy of "Bobus, our old friend, 'the sausage-maker of Houndsditch,' from *Past and Present*," for the county of Middlesex. To the right of Maurice a policeman pushes an orange seller, described in Mayhew's study as one of the lowliest of the street sellers, for "resting her basket on a post." On the opposite side of the road, under the shade of the tree, are several impoverished vagrants, including distressed haymakers seeking work and a nursing mother. These anecdotal scenes give the sensation of the chaos of the expanding modern city.[3]

The work is painted in thin, narrow strokes of paint, layered over a white ground which gives the painting a brilliance in keeping with the bright sunlight that illuminates the foreground. Brown's technique is seen at its most methodical and meticulous in such passages as the wood shaving that curls around the neck of the dog standing by the wheelbarrow.

Such attention to detail, as well as Plint's requested additions, slowed the completion of the picture, which Plint had hoped might be shown in the Royal Academy exhibition of 1858. In 1859, Brown received 300 guineas from James Leathart of Newcastle for a smaller replica (Birmingham Museums and Art Gallery). In 1860, he obtained a further £400 from Plint for the requested changes and another unspecified picture. The first canvas was not completed when Plint died in 1861, however, and the dealer Gambart, acting as the representative of Plint's executors, negotiated to pay the artist an additional £500 for the painting, including the copyright and the right to exhibit it. Gambart eventually reneged on his agreement and Brown arranged to include *Work* in his one-man exhibition held at 191 Piccadilly, London, from 10 March to 10 June 1865. Notices of the painting were generally favorable, but the exhibition cost the artist more than £300. The painting was included in Christie's auction of Plint's estate in 1865 and was bought for 510 guineas; it eventually entered the collections of the Manchester City Art Galleries in 1885. A.H.

Notes

1. Repr. in Treuherz 1993, 41–49.
2. Ford Madox Brown Papers, quoted in Parris 1984, 165.
3. For further information about *Work* and its various meanings, see Barringer 1994; Bennett 1984, 143–152; Boime 1981, 116–125; Curtis 1992, 623–636; Johnson 1980, 142–151.

20

..

Henry Wallis

The Death of Chatterton

c. 1855/1856, oil on canvas, 23 ¾ x 36 (60.3 x 91.4). *First exhibited*: Royal Academy 1856 (no. 352). *References*: Parris 1984, 142–144 (no. 75)

Tate Gallery, London. Bequeathed by Charles Gent Clement 1899

Thomas Chatterton (1752–1770) was apprenticed to a Bristol attorney from 1767 to 1769, but aspired to be a poet. In 1769, he sent Horace Walpole a sheaf of poems that he claimed were by a fifteenth-century monk, Thomas Rowley, but which were actually his own work. Walpole expressed doubt of their authenticity and returned the poems without showing any interest in publishing them. In 1770 Chatterton moved to London to try his hand at writing lampoons and other material for magazines. He earned little money from this, and in June moved to a garret at 39 Brooke Street, Holborn, where he took his own life on 24 August by swallowing arsenic.

Chatterton's text, written on parchment, was only one of a number of fraudulent manuscripts forged at the height of the romantic period, when a desire to engage with the past spurred an interest in early English literature. The suicide of the mistreated and misunderstood artist was also a leitmotif of the romantic period, and by the time of Wallis' painting Chatterton was something of a cult figure.[1] Between 1790 and 1796, Samuel Coleridge wrote a *Monody on the Death of Chatterton*; William Wordsworth mentioned him in *Resolution and Independence*, 1802; John Keats dedicated *Endymion* to him; Robert Browning wrote an essay about him in 1842; and Dante Gabriel Rossetti evoked his memory in his poem *Tiber, Nile and Thames*.

Wallis undertook *The Death of Chatterton* around the time of his closest contact with the members of the Pre-Raphaelite Brotherhood, and their appreciation for Chatterton, as well as the harsh treatment they occasionally received from the press, may have inspired him to take up the subject. The work was long believed to have been painted in the room in which Chatterton died, but it has been recently established that the exact location of his residence was not determined until 1857, the year after this painting was finished. Although Wallis did not have the benefit of this information, he fortuitously included a view of the tower of Holy Sepulchre, Holborn, and Saint Paul's Cathedral, landmarks consistent with Chatterton's address. As Robin Hamlyn has noted, this coincidence may stem from Wallis' desire, in keeping with accounts of Chatterton's death then circulating, to show dawn breaking, which meant a view looking east over the roofs of the city.[2] The artist's friend, the writer George Meredith, posed for Chatterton. The head and auburn hair are those of Meredith, although Wallis omitted his beard, probably to emphasize Chatterton's youth. He worked out the dramatic pose of the body, almost like a pietà, in a series of sketches now in the Tate Gallery.

Chatterton is shown lying on his coverlet, one shoe cast off, his left hand grasping at his open shirt, the other slumped to the floor. His hands, chest, and face show a deathly pallor set off by his deep red hair. In the center of the floor, highlighted by the early morning sun, is the empty vial of poison. Scattered near the poet's head are torn fragments of his writings; the frontispiece to the *Middlesex Journal*, to which Chatterton contributed, is visible.

Like his Pre-Raphaelite contemporaries, Wallis adopted the latent symbolism and meticulous painting techniques associated with such pre-Raphael works as Van Eyck's *Arnolfini Marriage Portrait* in the collections of the National Gallery in London. *Chatterton* is thinly painted on a white ground that endows the work with an enamellike brilliance akin to that of the Van Eyck. As in the Van Eyck, Wallis included a number of symbolic details: the exhausted candle, a trail of smoke wafting toward the open window, represents a life snuffed out; dropped rose petals suggest the transitory nature of life; Chatterton's breeches and satin-lined coat illustrate his pride, which

critics pointed to as the source of his downfall when the work was first exhibited.

On the frame are inscribed two lines from Christopher Marlowe's play *Dr. Faustus*, which allude to genius never permitted to blossom: "Cut is the branch that might have grown full straight, and burned is Apollo's laurel bough." This text was also printed in the accompanying exhibition catalogue.

Chatterton was well-received by critics, and according to the *Saturday Review* Wallis soon "found himself famous."[3] Ruskin praised it as "faultless and wonderful: a most noble example of the great school" and instructed viewers to study it slowly: "examine it well inch by inch, it is one of the pictures which intend, and accomplish, the entire placing before your eyes of an actual fact—and that a solemn one. Give it much time."[4]

Chatterton was purchased for either 100 gns. or £200 by Augustus Egg, who sold the copyright for £150, with rights for engraving, to Robert Turner, a publisher in Newcastle upon Tyne. Wallis also painted two smaller versions (c. 1855–1856, Yale Center for British Art; c. 1855–1856,

Birmingham Museums and Art Gallery).

Wallis returned to the tragic theme of society's indifference toward the individual in his *Stonebreaker* of 1857, a depiction of a laborer exhausted and on the brink of death, if not already dead. This work, like *The Death of Chatterton*, garnered Wallis much attention and critical acclaim. A.H.

Notes

1. For more on Wallis' painting in the context of romanticism, see Pointon 1981, 77–114.
2. Robin Hamlyn, "Henry Wallis, Chatterton," in Parris 1994, 143.
3. *Saturday Review*, 17 May 1856, 58.
4. Ruskin (1904) 1903–1912, 14:60.

2 1

Richard Dadd

The Fairy Feller's Master-Stroke

c. 1855–1864, oil on canvas, 21 ¼ x 15 ¼ (54 x 38.7). Not exhibited in artist's lifetime. *References*: Allderidge 1974, 125–129 (no. 190)

Tate Gallery, London. Presented by Siegfried Sassoon in memory of his friend and fellow officer Julian Dadd, a great-nephew of the artist, and of his two brothers who gave their lives in the First World War 1963

The historical, literary, and metaphorical associations of fairy subjects stimulated Victorian interest in this theme, which was brought to prominence through the work of Richard Dadd and other painters such as Sir Joseph Noel Paton and J.M.W. Turner. As a young man, Dadd had exhibited fairy subjects at the Royal Academy; after he was committed to Bethlem Hospital for insanity in 1843, he produced two major paintings of fairy subjects: *Oberon and Titania* and *The Fairy Feller's Master-Stroke*, painted in the

minute brushstrokes and flattened perspective that he adopted in the 1850s. In a poem about *The Fairy Feller*, entitled "Elimination of a Picture & its Subject—Called the Feller's Master Stroke" (1865), Dadd suggested that it was painted for George Henry Haydon, who became the new steward of the hospital around 1853. Haydon had seen Dadd's *Contradiction, Oberon and Titania* (1854–1858; private collection), painted for Dr. William Charles Hood, the superintendent of the hospital, and asked for a similar picture. Dadd chose "a fairy band" as his subject, and his poem identified the depicted characters, often humorously equating them with types from contemporary society.

In Dadd's painting, the fairies have gathered to witness whether the "fairy feller," shown in the lower third of the painting, can split an acorn in one stroke of his axe. Facing the feller is the patriarch, who gives the command when the axe may fall. Lining the brim of his hat are diminutive Spanish dancers (to the right) and Queen Mab with Cupid and Psyche as pages (to the left). Above the tip of the hat stand Oberon and Titania, the fairy

king and queen from Shakespeare's *A Midsummer's Night Dream*. Along the edge of a fallen tree trunk stand the soldier, sailor, tinker, tailor, ploughboy, apothecary, and thief, from the popular children's rhyme. A touch of red highlights the thief, who is picking the ploughboy's pocket. Otherwise, the painting does not embody any obvious narrative.

Moving clockwise, below the pickpocket are two minstrels, one of whom plays the lute. Standing to the right of the feller is an ostler from an inn (with his hands on his knees), a dwarf monk, another ploughman (recognizable by his smock), and a wagoner. Opposite is a dwarf couple; the man holds a conjuring stone in his left hand and gestures to the feller with his right. Another couple—a dairy maid and a tanner—stand behind the dwarfs. The two women posing just behind the acorn introduce an erotic note to the painting with their tiny ankles, thickened calves, and snug bodices. To their right, under the brim of the patriarch's hat, is a dandy attempting to seduce a nymph, and a politician, smoking a pipe in his pink robe. Of this figure, Dadd wrote "For argument or his

opinion ripe . . . He's pondering matters now as if his vote, / Ought to be given ere 't'is smote. / The nut—I mean."

Dadd's painting is like a window onto the fairy world, presented as a complex society living in the forest undergrowth. It resembles the vitrines in which natural history specimens were displayed in the nineteenth century, and the detailed depiction of plant life is consistent with this mode of representation. The high horizon line and shallow pictorial space fill the canvas with fantastic figures and vegetation, giving the work a quality described as "trancelike intensity."[1] In the immediate foreground, stalks of grass provide a fragile screen between our world and that of the fairies. The swirled tendrils of grass interwoven throughout the composition enliven the surface of the work and reinforce the distorted quality of the scene. In his poem, Dadd called attention to the chaotic impression of the painting:

Turn to the Patriarch & behold
Long pendants from his crown
 are rolled,
In winding figures circle round
The grass and such upon the
 mound,

They represent vagary wild
And mental aberration styled.
Now unto nature clinging close
Now wildly out away they toss,
Like cyclone uncontrll'd
Sweeping around with chance-
 born fold
Unto the picture brings a grace
Which else was wanting to its face.

In the conclusion of his poem, Dadd acknowledged, with a note of satisfaction, that the painting refused to resolve itself, revealing neither a recognizable story nor an easily discernable pattern:

But whether it be or be not so
You can afford to let this go
For nought as nothing it explains
And nothing from nothing
 nothing gains. A.H.

Notes
1. Allderidge 1974, 125.

22

William Powell Frith
Derby Day

1856–1858, oil on canvas, 40 x 88 (101.6 x 223.5). *First exhibited*: Royal Academy 1858 (no. 218). *References*: Cowling 1989, 232–366

Tate Gallery, London. Bequeathed by Jacob Bell 1859

Derby Day is the second of three large-scale paintings of modern life that were the high points of Frith's career. The painting depicts the crowd gathered for the horse races held each May at Epsom Downs. Derby Day, an unofficial national holiday—even Parliament shut down—was a great social event. Special trains ran between London and Epsom, and the roads leading to the Downs were always crowded with traffic. The idea of a horse race as a means to depict varied social types or characters came to Frith in 1854 when he attended a race in Hampton. Two years later he visited Epsom Downs, not to see the race but to study the "life and character" gathered for the event.[1] He was drawn in by the

FIGURE 12

"Visit of Her Majesty, Prince
Albert, and the Queen of Portugal
to the Royal Academy," *Illustrated
London News,* 22 May 1858

"kaleidoscopic aspect of the crowd" and decided "to attempt to reproduce it" in a painting.[2] The result was a work that engaged directly with the theme of modern life in a burgeoning metropolis, and spoke eloquently for the notion that serious art need not engage solely with noble historical or literary subjects.

Frith began painting *Derby Day* in earnest once he had obtained a commission for the work from his patron, Jacob Bell, a fellow art student at Sass' Academy, who had inherited a prosperous pharmaceutical business. In addition to the £1500 that Bell paid for the painting, Frith earned £1500 from the dealer Ernest Gambart for the rights to reproduce it as an engraving, which Gambart promoted by arranging a worldwide tour for the painting.

Gambart assisted Frith in other ways, as did Bell. In keeping with Frith's desire to "reproduce" the scene he had witnessed in 1854, Gambart and Frith engaged a photographer, Robert Howlett, to take photographs of Epsom Downs; Frith's depiction of the grandstand is quite close to Howlett's photograph. In January of 1857, Frith arranged for an acrobat and his son from the

Drury Lane pantomime to pose in his studio, but they proved unequal to the rigors of modeling. Frith then purchased their clothing to use with professional models, some of whom were hired by Bell. Frith also hired a jockey, "who rode a wooden horse in my studio He surprised me by his endurance of a painful attitude—that of raising himself in his stirrups and leaning forward. . . . This he would do for an hour at a stretch."[3] Realizing his inadequacy in depicting horses, he asked J. F. Herring (1795–1865), a well-known sporting painter, to send him sketches of racing horses.

When the Royal Academy opened on 3 May 1858, a crowd quickly formed about *Derby Day* and a policeman was hired to ensure that visitors did not get too close to the work. Bell, concerned about the crowds, lodged a complaint requesting that a rail be placed before the painting (fig. 12). The Academy complied; it was the first time a rail had been installed there since 1822.

As Bell himself noted, viewers pressed up close to the painting because "the nature of the picture requires a close inspection to *read, mark, learn, & inwardly digest* it." As Mary

Cowling has revealed, this act of reading was coupled with the act of recognition, as Frith crowded his painting with a collection of distinct types or characters well known to the Victorian audience.

Three scenes occupy most of the foreground. On the far left, a group has gathered around a thimble-rigger's table. To the right of the table is a victim of this con game, who is identifiable as a "city gent." City gents—extravagantly dressed, pretentious young men employed in city firms— were a new phenomenon in urban culture and the subject of much parody and caricature. Across from him stands a criminal, readily recognizable as such to Victorian audiences by his resemblance to the famous murderer John Thurtell, whose physiognomy was much studied by both scientists and artists. He holds a bank note in his hand, suggesting he is trying to entice bystanders into a shady scheme. To the left is a "country bumpkin" in a ploughboy's smock, who is being pulled away from the temptations of the table by a young country woman. Just behind the bumpkin, a recent victim of the gambling table complains to a police officer,

who lifts his cap and runs his fingers through his hair to explain that he cannot interfere. The figure in the red fez behind the policeman is a portrait of Frith's friend Richard Dadd. To the right of the table, behind the Scottish swindler in the plaid jacket, is another country bumpkin who has not been so lucky as his brethren: a cardsharper grins as the rural laborer in a white smock looks at his hand in dumbfounded disbelief. Ironically, these events transpire in front of the Reform Club's tent.

In the center of the painting, a cross-section of Victorians, ranging from the very poor to the very rich, are assembled. A cook on her day off walks arm and arm with her beau, an army sergeant. To their right is a thief in a scuffed brown top hat. He turns his head to his right while his left hand picks the pockets of a German tourist, wearing a buff top hat and smoking a cigarette. Seated on the grass before the performing acrobats is a group of gypsies in tattered clothes. In the carriage opposite are several finely dressed aristocratic women and gentlemen with the requisite aquiline profiles. The class difference between these two groups is marked by

the young acrobat who stops his performance to look over in hunger at the picnic the man-servant is laying out for his party. His mother, nursing a baby, passes a hat to the carriage and a young boy drops in some money. To the right of this aristocratic carriage is another, transporting a finely dressed woman. She is not an aristocrat but a kept woman, the mistress of the young gentleman who leans raffishly against the carriage. Her reluctance to allow the gypsy woman to tell her future reveals that she is not respectable, as does her companion's inattentive behavior. The looseness and casualness of the couple is symbolized by the bottle they have left on the ground, which a small urchin is attempting to steal.

Contemporary reviewers delighted in the varied social types portrayed, but a few voiced concern that the subject was not sufficiently elevated for serious art. In the end, public acclaim and brisk sales of the engraving validated Frith's choice of subject. A.H.

Notes

1. Frith 1887, 1:271.
2. Frith 1887, 1:272.
3. Frith 1887, 1:283.

23

..

Arthur Hughes

Home from Sea

1856/1862, oil on panel, 20 x 25 ⅝ (50.8 x 65.1). *First exhibited*: Pre-Raphaelite exhibition, 4 Russell Place, London, 1857 (no. 35). *References*: Parris 1984, 197 (no. 120)

The Visitors of the Ashmolean Museum, Oxford

A sailor boy has come home from the sea and lies weeping on the grave of his mother, who has died—presumably quite young—during his absence. The newly returfed grave is yet to be marked by a headstone. The boy's elder sister, dressed in mourning, kneels at his side. The abundance and beauty of the vegetation in the setting, painted with a Pre-Raphaelite devotion to detail, serves as a foil to the pathos of the situation, an idea Hughes derived from paintings by Millais, such as *The Blind Girl* (cat. 11). The most prominent plant in the foreground is a dandelion, a common Christian symbol of grief that appears often in paintings of the Crucifixion. Even the vignette

of sheep in the background relates metaphorically to the story of the boy and his mother; as they are separated by death, so the ewe and lamb are separated by a gravestone.

Scenes of bereavement and mourning, and indeed scenes of children in graveyards, were virtually a commonplace of Victorian art and literature. But Hughes' particular source of inspiration may have been the Pre-Raphaelite journal, *The Germ*, which had first fired his enthusiasm for the works and ideas of the Brotherhood in 1850. The inaugural issue contained a poem by Thomas Woolner entitled "Of My Lady. In Death," with an illustration by William Holman Hunt showing the narrator lying grief-stricken on his beloved lady's grave. Like the painting, Woolner's poem contains precise botanical observations, including a dandelion clock, and plays the theme of death against the vitality of nature:

Small birds twitter and peck
 the weeds
 That wave above her head,
 Shading her lowly bed:
Their brisk wings burst light
 globes of seeds,
 Scattering the downy pride
 Of dandelions, wide....

Hughes painted the setting of his picture in the graveyard of Old Chingford Church, north of London, in the summer of 1856; the model for the boy was probably his nephew Edward Robert Hughes, the future artist. Having been rejected by the Royal Academy, the work was first shown at the Pre-Raphaelite exhibition at Russell Place in 1857, under the title *A Mother's Grave*, then later the same year in William Michael Rossetti's exhibition of British art in New York. There is some evidence—in particular a drawing of the composition datable to 1857 (Ashmolean Museum, Oxford) —to suggest that at this point the boy was the only figure, the sister having been added later. The model for the sister was the artist's wife, Tryphena Foord. Certainly Hughes worked further on the picture after its initial showing, and exhibited it in its revised form at the Royal Academy in 1863. M.W.

(NOT IN EXHIBITION)

24

Augustus Leopold Egg

Past and Present (nos. 1, 2, and 3)

c. 1857/1858, oil on canvas, each: 25 x 30 (63.5 x 76.2). *First exhibited*: Royal Academy 1858 (no. 372). *References*: Treble 1978, 32–33 (no. 10); Edelstein 1983, 202–210; Faberman 1983, 244–272

Tate Gallery, London. Presented by Sir Alec and Lady Martin in memory of their daughter Nora 1918

The three paintings that form Egg's *Past and Present* are typical Victorian "problem pictures"—images that present didactic, moral narratives on social issues. This genre can be traced to at least the eighteenth-century, and especially to William Hogarth's print cycles and his "modern moral subjects." Like Hogarth, Egg shows a direct link between debauchery and social decline and makes use of serial imagery to convey his story. Whereas Hogarth's narratives proceed in a linear fashion, Egg chose a more complex way of arranging his paintings. When they were

shown in the Royal Academy of 1858, the scene of the drawing room was placed in the center, with the riverside scene to the left and the bedroom scene to the right. The left and right scenes are consequences of what is shown in the center panel, an arrangement that Egg may have derived from medieval triptychs.

In the drawing room scene, a woman lies prostrate on the floor. Behind her, seated at the table, is her husband, who has just returned home. His recently discarded satchel, wet umbrella, and topcoat (visible at lower left) lie on the floor by the open door, as revealed in the mirror opposite; his top hat and gloves have been tossed on the table. Under his foot is a crumpled pink envelope; he has just read a love letter intended for his wife. Her outstretched, clasped hands and distraught supplication suggest that she has been pleading for forgiveness; but her husband's stony expression and tight fist imply that his decision has been made. The dissolution of their marriage is foretold by the imminent collapse of the house of cards built by their daughters, one of whom looks up in astonishment at her mother's evident distress.

The house of cards is only one of the many symbols Egg included in this scene. Another is the apple, alluding to the biblical story of Adam and Eve. The link between the mother and Eve is reinforced by the pictures on the rear wall: her portrait, to the left of the fireplace, hangs beneath a representation of Adam and Eve driven from Paradise. The mother, Egg forecasts, will be banned from her home. Legislation passed as recently as 1857 enabled a husband to divorce his wife for adultery. He, too, faces an uncertain future, as implied by the shipwreck scene hanging over his portrait.[1] Egg points to a novel by Balzac, on which the fragile house of cards is built, as the source of the family's disintegration. As T.J. Edelstein has pointed out, English reviewers perceived French novels, such as those by Balzac, to be preoccupied with the theme of adultery, and therefore a threat to British morality.[2]

The compositional structure of the painting reiterates Egg's theme of the disintegration of the family. At the center of the painting is a bright, empty spot created by the reflection of the open door in the mirror. This gives added

metaphorical charge to the scene by intimating the forces from outside the family that cause it harm, and the gap in the center of the family that will be caused by the loss of the mother. According to Victorian social thought, the mother was the "angel in the house": the moral guardian of the family who gently ministered to her family's needs, putting their welfare above her own. The implied actions of the mother in Egg's painting suggest that she was far from the Victorian ideal of womanhood.

The other two paintings of the cycle are similarly structured around a central, open space. Both scenes reveal the tragic consequences of the mother's actions and are explained in the gloss Egg attached to the painting when it was first exhibited at the Royal Academy: "August the 4th. Have just heard that B—— has been dead more than a fortnight, so his poor children have now lost both parents. I hear she was seen on Friday last near the Strand, evidently without a place to lay her head, What a fall hers has been!" In the bedroom scene, we see the elder daughter looking out the window as she comforts her sister. The view to the rooftops

below reveals that they are no longer living in a well-appointed home but in a cheap garret. The elder daughter is dressed in mourning and the younger in white, the color of innocence.

In the third painting, the mother looks out from under the riverside arches of Adelphi Terrace at the same moon seen by her daughter. In her arms she holds a child, presumably the result of her illicit union. Cast in gloom, she sits beside the rotting hull of a boat; near her is an empty basket, suggestive of her poverty and the emptiness of her life. By depicting the mother at riverside, Egg not only effectively illustrates that she is now homeless, but also suggests that she may be contemplating suicide; in the Victorian period reports abounded of morally compromised women ending their lives by drowning. In addition to newspaper accounts, there were poems on the theme, such as Thomas Hood's *Bridge of Sighs* (1844), and paintings such as G. F. Watts' *Found Drowned* and *Under a Dry Arch* (1849–1850). A poster advertising cheap fares to Paris again links the mother's adultery with the supposed degeneracy of the French novel. Advertisements for three plays—*Victims, A*

Cure for Love, and *Return the Bride*—point to Victorian society's anxiety regarding fidelity and marriage.

Egg's triptych was painted just a few years after William Holman Hunt's *The Awakening Conscience* (cat. 16), which also uses symbols to recount a woman's seduction and moral awakening. Egg was aware of this precedent and had encouraged Hunt to complete the work. Such paintings illustrate the tensions in Victorian culture between morality and sexuality, and the degree to which Victorian artists engaged directly with these issues. Like the novels of the period, they helped to structure debates about Victorian society and articulate ideal roles for men and women. Some critics argued that fine art should console people rather than remind them of the ills of society and that Egg's theme was therefore inappropriate for painting. But the reception of *Past and Present* was mostly favorable, and the *Art Journal* grudgingly admitted that Egg's paintings "attract a large share of public attention."[3]

The painting was not sold during the artist's lifetime and was purchased by Agnew's, the London art dealer, for 330 guineas at Christie and Man-

son's auction of Egg's painting collection in July 1863. A.H.

Notes

1. The shipwreck is a print after Clarkson Stanfield's painting *The Abandoned* (1856; unlocated).

2. Edelstein 1983, 207–208.

3. *Art Journal*, 1858, 167.

25

...

William Dyce

Pegwell Bay: A Recollection of October 5th, 1858

1858/1860, oil on canvas, 25 x 35 (63.5 x 88.9). *First exhibited*: Royal Academy 1860 (no. 141). *References*: Pointon 1979, 169–174, 193; Parris 1984, 182–183 (no. 106)

Tate Gallery, London. Purchased 1894

Pegwell Bay is in southeast England, to the south of the resort town of Ramsgate in the county of Kent; in the Victorian period it was famous for its oysters and shrimp. Dyce visited the area in October 1857, when he painted a watercolor of the beach and cliffs (Aberdeen Art Gallery), and was presumably there again a

year later, on the day of which this larger oil painting is a "recollection." The watercolor shows more or less the same view, also at sunset, and Dyce may well have used it in preparing the oil.

The work is a combination of landscape and family portrait. Across the foreground, from right to left, are Dyce's wife Jane, her sisters Grace and Isabella, and one of his sons; the figure with artist's equipment in the middle distance on the right, though too far away to be recognizable, must surely be a self-portrait. It was presumably because of this family significance that the painting was bought from him, for £400, by his father-in-law James Brand. It seems fairly clear, however, that Dyce had something more in mind than portraiture, or the record of a pleasant family outing to the seaside. There is an air of solemnity about the figures in *Pegwell Bay* that seems at odds with what they are doing, namely, collecting seashells on the beach. Where one might expect some signs of fun, interaction, and togetherness, as in the traditional British "conversation piece," the figures appear impassive and isolated, each in his or her own world.

Their scale establishes them as fairly distant from the viewer, yet they are seen in crisp focus; indeed, the great clarity with which we see objects throughout the scene, curiously since it is dusk, makes for a slight feeling of hallucination. The mood of unease is enhanced by the way Dyce's wife and son look off to the left at something the viewer cannot see. Stranger still is what they fail to observe, for in the sky above them, noticed only by the artist, is a comet.

Dyce was a keen amateur scientist, and the paintings of his later career show a taste for meticulously documenting nature, for the intensely factual approach to picture-making pioneered by Millais and William Holman Hunt in the early 1850s; it was probably because of his scientific turn of mind that he was one of the few painters of the older generation who admired and supported the Pre-Raphaelites from the outset. He was particularly interested in geology, and must have been drawn to Pegwell Bay because its cliffs were rich in fossils; he paints the whole scene with a geological eye, the painstakingly detailed strata in the cliffs, and the rocks and pebbles on the beach giving a

sense of the process of erosion. Meanwhile, the inclusion of the comet bears witness to his awareness of topical developments in astronomy. It is Donati's comet, first observed by G.B. Donati on 2 June 1858, which appeared at its brightest on the date Dyce carefully specified in his title. A comet is traditionally a bad omen, usually foretelling the death or overthrow of a king. But its meaning in Dyce's painting, like that of the cliffs and rocks, has more to do with the importance that the physical sciences had assumed for the Victorians' outlook on life. Modern geology and astronomy were opening up terrible vastnesses of time and space that seemed to reduce humanity to an insignificant speck, calling into question the idea of mankind's special relationship with God, the Genesis account of the creation, and other traditional Christian beliefs. The notion that in the great scheme of things life might not really mean so much after all, that against the background of geological time and astronomical space it might be like an afternoon's seashell-gathering, was among the most deeply felt anxieties of the otherwise optimistic early Victorian mind.[1]

What gave special point to the observation of these troubling phenomena at Pegwell Bay was that it had long been a site of religious significance. It was at nearby Richborough that Saint Augustine was believed to have landed from Rome, in the year 597, on his mission to spread the Christian gospel in Britain. As a devout churchman, Dyce would have been keenly aware of this association with the early history of British Christianity, especially since he had earlier in his career painted a mural showing Saint Augustine baptizing King Ethelbert of Kent (1846; House of Lords Chamber, Palace of Westminster); the conversion of Ethelbert was one of the key moments in Saint Augustine's mission, after which he became the first archbishop of Canterbury. M.W.

Notes

1. For further discussion of the implications of *Pegwell Bay*, "a painting about time, explored through an image of a particular moment," see Pointon 1978, 99–103.

26

William Maw Egley

Omnibus Life in London

1858–1859, oil on canvas: 17 5/8 x 16 1/2 (44.8 x 41.9). *First exhibited*: British Institution 1859 (no. 318). *References*: exh. cat. Munich 1993 (no. 34)

Tate Gallery, London. Bequeathed by Miss J. L. R. Blaker 1947

Omnibuses, horse-drawn carriages that picked up and deposited passengers along an established route, were introduced to London on 4 July 1829 and quickly became a fixture of the urban scene. Perhaps inspired by the success of his friend William Powell Frith, Egley used the omnibus as a means by which to portray a variety of individuals. In his 1852 novel *Basil*, Wilkie Collins described the London omnibus as "a perambulatory exhibition room of the eccentricities of human nature. I know of no other sphere in which persons of all classes and all temperaments are so oddly collected together, and so immediately contrasted and confronted with one another."[1]

In the left foreground sits

an elderly woman wrapped in a red shawl with paisley trim. With her is a Christmas cactus in a clay pot, a straw basket, an umbrella, and a bandbox knotted up in a shawl, a bouquet of flowers on top. She brings a note of rural life to an otherwise urban scene. Beside her, next to the advertisement for a clothier, sits a man in a black top hat and coat, whose torn gloves suggest that he has fallen on hard times. He has drifted asleep and leans heavily on her shoulder. By contrast, the well-dressed gentleman to his left sits forward, attentive to the family seated opposite, which includes what Egley described as "a fashionable dressed little girl of twelve, wearing a straw hat with feathers and ribbons, the hair in long, dark ringlets; a grey jacket, and light, striped silk dress, with a short skirt displaying her long, white trousers trimmed with needle-work, and black kid boots with brilliant patent leather toes and high heels."[2] Egley painted this figure from life, after Miss Susannah (Blanche) Rix, and her mother from his own wife. A small, fussy boy in a blue coat and white trousers sits in his mother's lap with a toy trumpet and drum. Behind the mother,

only partially visible, is a man wearing a hat with a round crown; to his right is a young girl wearing a veil, whom Egley also painted from life. Seated opposite the veiled woman and holding a walking stick to his mouth is what viewers at the time would have recognized as a city gent—a type known for affecting excessive fashions and gestures. Next to him is a woman dressed in mourning clothes and another in a beige shawl with blue trim. At the rear the conductor has opened the door to admit more passengers, although the omnibus is already crowded. Through the open door can be glimpsed a London street; it was the view from the chemists' shop at the corner of Hereford Road (where Egley lived) looking toward Westbourne Grove.

The scene is animated by the expressions and gestures of the passengers. The country woman looks with sympathy at the mother across the way, oblivious to the discomfort she is causing the man to her left. The mother avoids her direct gaze and lowers her eyes in a gesture of gentility. The two women are a study in contrasts: the rural woman's plump face is reddened by the sun and she wears an old-fashioned hat; the

mother's face is pale and unlined and her hat, studded with imitation daisies, is a milliner's masterwork. While well-bred women were taught not to stare, men were permitted more freedom, as indicated by the man in the greenish top hat who gazes at the young girl. Like her mother, she does not return his gaze, but looks demurely at the floor. Similarly, the city gent stares fixedly at the veiled woman opposite, who looks down, her attention fixed on buttoning her glove. No one looks to the incoming passengers and the conductor peers in to see where he can squeeze in two more. The result, the *Illustrated London News* declared, was "a droll interior, the stern and trying incidents of which will be recognised by thousands of weary wayfarers through the streets of London."[3]

The painting reveals careful attention to detail and the tight, highly finished brushwork facilitated the recording of minute facts. For the street scene, Egley executed sketches on the spot and used them as studies for the final painting, which was executed in the studio. In preparation for the painting, he visited an omnibus yard at Paddington and then

constructed, as he described it, "a rude structure of boxes, planks, etc. . . . in my back garden," in which to pose his sitters and paint "as long as weather permitted."[4] The result of such meticulousness, the *Art Journal* claimed, was a "painfully true" study of London life.[5]

The painting was listed at the British Institution for £80, which works out to about £2 a day for the 44 days Egley spent on it. It was finally purchased for £52.10.0 by a William Jennings who found "the female figure seated next to the widow such an extraordinary likeness to a lady in whom I am interested that . . . [I am] most desirous to possess it."[6] A.H.

Notes

1. Wilkie Collins, *Basil* (repr. New York, 1980), 27.
2. Egley Catalogue 1:144.
3. *Illustrated London News*, 26 February 1869, 210.
4. Egley Catalogue 1:145.
5. *Art Journal*, 1 March 1859, 82.
6. Letter from W. Jennings Esq. to William Maw Egley, 23 March 1859, in Egley Catalogue 1.

27

James McNeill Whistler

Wapping

1860/1864, oil on canvas,
28 x 40 (71.1 x 101.6). *First
exhibited*: Royal Academy 1864
(no. 585). *References*: Young et
al. 1980, 14–15 (no. 35); Dor-
ment and MacDonald 1994,
103–104 (no. 33)

*National Gallery of Art,
Washington, John Hay Whitney
Collection, 1982.76.8*

When Whistler moved to Lon-
don from Paris in May 1859,
he rented rooms in a working-
class neighborhood along the
Thames and began painting
a series of images of contem-
porary life. The view here is
taken from the Angel Inn, near
Cherry Gardens in Rother-
hithe, looking across the river
toward Wapping on the north
shore. Whistler created two
other works from this vantage
point, the "Thames Set" etch-
ing *Rotherhithe* and the oil
painting *The Thames in Ice*
(Freer Gallery of Art). Neither
was as self-consciously ambi-
tious a project as *Wapping*, of
which Whistler wrote to the
French artist Henri Fantin-

Latour: "I should like to have
you with me in front of a
picture on which I set all my
hopes and which should be-
come a masterpiece."[1]

Whistler went on in his
letter to describe his painting
in detail and included a sketch
of the work in progress (fig. 13).
His original intention was to
tell a story of an encounter at
the inn between a young
woman, most likely a prosti-
tute, an old man, and a sailor
through nuances of gesture
and expression. Whistler was
especially pleased with the
expression of the woman and
imagined her mocking the
sailor with the line "'That's all
very well my friend, but I've
seen others!'" The sexual nature
of their exchange was to be fur-
ther underscored by Whistler's
rendering of the woman's hair
falling around her shoulders
and his daring exposure of her
bust with the chemise "almost
completely visible."

Whistler's early enthusiasm
eventually turned to frustration
and discouragement. In a letter
of 15 December 1863, Dante
Gabriel Rossetti noted that the
English sailor was "hardly yet
commenced."[2] Whistler had
by then also replaced the figure
of the old man with "a sort
of Spanish sailor" using the

French artist Alphonse Legros
as a model. As late as 3 Febru-
ary 1864 Whistler wrote to
Fantin-Latour bemoaning his
inability to finish his paintings:
". . . such painful and uncertain
work! I am so slow! . . . I pro-
duce very little because I scrape
off so much."[3] Even after its
exhibition at the Royal Acad-
emy *Wapping* was criticized for
the irresolution of the three
foreground figures.

During his work on *Wapping*,
from 1860 to 1864, Whistler
was negotiating a bewildering
array of artistic trends as he
shuttled back and forth between
London and Paris. Shortly be-
fore moving to London, he
had been introduced to Gus-
tave Courbet by Fantin-Latour
in Paris, and had formed the
Société des Trois there with
Fantin-Latour and Legros.
Whistler promoted their realist
principles in London, to which
Legros himself emigrated in
1863. In 1862 Whistler met
Rossetti, and in the following
year moved into his Chelsea
neighborhood. Through him
Whistler soon came to know
other members of the Pre-
Raphaelite circle.

The effect of these crossings
and contacts found material
expression in *Wapping*, both in
the clear intricate network of

lines and riggings in the back-
ground, "like an etching" as
Whistler put it, and in the signs
of scraping and repainting evi-
dent in the blurred puddles of
pigment that constitute the
foreground figures. It is, in
fact, the foreground where the
most telling changes to the
picture occurred. The three
figures began as an exercise in
realism with Whistler, in the
manner of Courbet, adventur-
ously seeking out a subject
from modern life previously
considered indecent and in-
artistic: a salacious encounter
between a woman and two
men. In its final form the nar-
rative is dissolved. The figures
do not encounter each other
but rather appear lost in their
own thoughts, with the harsher
more banal realities of the
earlier version displaced by an
aura of suspended reverie.
With the passive, nascent aes-
theticism in the foreground,
the aggressive, richly detailed
background of river commerce
emerges in stark contrast.

In 1867, Whistler finally
renounced *Wapping* as tarnished
by what he termed the "dis-
gusting" influence of Courbet.[4]
The painting is in many ways
divided against itself, with a
confusing mixture of realist and
aesthetic tendencies evident,

including not only Courbet's earthy realism, but early Pre-Raphaelitism's emphasis on detail and socially relevant subject matter, as well as the aestheticism of the second, Rossettian phase of the Pre-Raphaelite movement. Nevertheless, *Wapping* demonstrates the young Whistler's acute sensitivity to the most advanced artistic ideas in both Britain and France, and his ability to synthesize those influences into a wholly original statement. C.B.

Notes

1. Letter to Henri Fantin-Latour, undated, before July 1861, in the Library of Congress, manuscript division, Pennell Collection.
2. Letter to J. Leathart, 15 December 1863, quoted in Young et al. 1980, no. 35, 14.
3. Letter to Henri Fantin-Latour, 3 February 1864, quoted in Thorp 1994, 23.
4. Letter to Henri Fantin-Latour, August 1867, quoted in Spencer 1989, 82.

28

..

James McNeill Whistler

Symphony in White, No. 1: The White Girl

1862, oil on canvas, 84 ½ x 42 ½ (214.6 x 108). *First exhibited*: Morgan's Gallery, 14 Berners Street, London, 1862 (no. 42) as *The Woman in White*. *References*: Young et al. 1980, 17–20 (no. 38); Dorment and Mac-Donald 1994, 76–78 (no. 14)

National Gallery of Art, Washington, Harris Whittemore Collection, 1943.6.2

Whistler's model for *Wapping* (cat. 27), the Irishwoman Joanna Hiffernan, also appears in his three symphonies in white of the 1860s. In *The White Girl*, the aesthetic languor of *Wapping* becomes more pervasive with the expressionless, passive figure of Hiffernan, shown in a startling new role as the subject of a full-length grand manner portrait.

The history of *The White Girl* reveals the intricate pattern of artistic relationships that Whistler cultivated in his travels between Britain and France in the early 1860s. Hiffernan began posing for the

painting in Paris in December 1861. In February 1862 Whistler described the work in progress to the British artist George Du Maurier as a figure "standing against a window which filters the light through a transparent white muslin curtain—but the figure receives strong light from the right and therefore the picture barring the red hair is one gorgeous mass of brilliant white."[1] By April 1862 the painting had arrived in London. Hiffernan noted the response as Whistler prepared to submit the work to the Royal Academy's annual exhibition: "Some stupid painters don't understand it at all while Millais for instance thinks it splendid, more like Titian and those of Old Seville than anything he has seen—but Jim says for all of that, perhaps the old duffers may refuse it all together."[2] They did, and Whistler, always delighting in an opportunity to belittle the Royal Academy and rebut the English art establishment, sought to exhibit it elsewhere.

Advertised all over London as "Whistler's extraordinary Picture the Woman in White," the painting was first shown at Morgan's Gallery on Berners Street. Whistler described its effect as "an excitement in the

artistic world which the Academy did not prevent or foresee," and exulted in "waging an open war with the Academy."[3] When the critics of the *Athenaeum* took the picture as a description of the main character in the popular mystery-thriller by Wilkie Collins, *The Woman in White*, Whistler submitted the first of his many letters to the press noting "My painting simply represents a girl dressed in white standing in front of a white curtain."[4]

After exhibiting *The White Girl* once more in London in March 1863, Whistler shipped it back to Paris where, after being rejected by the Salon, it was shown at the famous Salon des Refusés, becoming a *succès de scandale* along with Edouard Manet's *Déjeuner sur l'herbe*. Emile Zola described the public response: "folk nudged each other and went almost into hysterics; there was always a grinning group in front of it."[5] While generally admiring *The White Girl*, the French critics could not refrain from offering interpretations of what might be happening in the picture. One commentator, Jules Castagnary, speculated that it depicted a bride the morning after her wedding night at "the troubling moment" when

she "questions herself and is astonished at no longer recognizing in herself the virginity of the night before."[6] On 15 May 1863 Fantin-Latour wrote to Whistler telling him that Manet, Baudelaire, and Legros all admired the work, and reporting that "you are famous."[7] Fantin-Latour noted, however, that the realist Courbet, though he liked the painting, was annoyed because Hiffernan looked like "an apparition, with a spiritual content."

While the girl's vacant stare evokes associations with table rapping and other forms of spiritualism popular at the time, the move away from realism that Courbet sensed in the painting is more accurately equated with Whistler's growing interest in aestheticism. *The White Girl* contains elements of realism, but is dependent upon the artist's aesthetic sense —the ability to find, isolate, and elevate beauty amid mundane reality. In contrast to Courbet's blatantly erotic rendition of Hiffernan in *Le sommeil* (fig. 14), Whistler achieves a balance between the realist and aesthetic agendas. As a realist he has painted his mistress posing in his studio in a manner usually reserved for historical figures or aristocracy.

As a burgeoning aesthete he has carefully chosen his subject and arranged her so that she becomes an anonymous, timeless expression of ethereal beauty.

By 1867 Whistler had openly condemned Courbet and realism and denigrated *The White Girl* along with *Wapping* as "canvases produced by a nobody."[8] Nevertheless, he was clearly pleased with the aesthetic aspects of the painting and began to refer to it retroactively around this time, in the ultimate aesthetic compliment, as a work of pictorial music, *Symphony in White, No. 1*. The painting can, in fact, be read as a harbinger of the triumph of aestheticism over realism in Whistler's work with the ethereal White Girl floating victoriously above the harsh carnal realities of the eviscerated bear skin below her.

In Victorian Britain Whistler's rendering of Hiffernan, as has often been noted, would have been associated with Pre-Raphaelite depictions of women, including the moralizing types found in works such as William Holman Hunt's *The Awakening Conscience* (cat. 16), as well as the unearthly femmes fatales of Rossetti and others. *The White Girl*, however, cannot be fully equated with either

type. Whereas Hunt's picture is clearly a morality play about the redemption of a fallen woman, Whistler's work is neither moral or immoral, but rather amoral; meanwhile his emphasis on the real just as clearly differentiates his painting from the poetic, dreamlike, and essentially literary images of Rossetti.

Underlying the differences between Whistler, Courbet, and the Pre-Raphaelites—as well as the misunderstanding that greeted the picture among the general public, the critics, and the Royal Academy—was the question of narrative. It was simply expected, both in Britain and France, that a picture this large should be explained by a story, whether it be the biography of the sitter, a literary allusion, or other narrative framework. In that context, Whistler's refusal to explain his picture was revolutionary and baffling.

In *Wapping*, a clash of influences, particularly realism and aestheticism, was evident in its division into the realms of working world and dream world. *The White Girl* describes the same dilemma but in much stronger pictorial terms, conflating these forces in a single monumental female figure. In

narrowing his subject matter and muting realism and narration even further, Whistler had discovered an equation that would allow him more effectively to express his aesthetic proclivities. He continued to transform the grand manner portrait format throughout his career, thinning the heavy impastoes of the dress and bear's head of *The White Girl* into evanescent sheets of oil paint in a later series of symphonies in black. c.b.

Notes

1. Du Maurier 1951, 105.
2. Mahey 1967, 249.
3. Letter to George Lucas, 10 April 1862, quoted in Young et al. 1980, 19.
4. *Athenaeum*, 5 July 1862, 23, reprinted in Thorp 1994, 12.
5. Zola 1967, 5:533–534.
6. Castagnary 1892, 1:179.
7. Henri Fantin-Latour to Whistler, 15 May 1863, quoted in Dorment and MacDonald 1994, 76.
8. Letter to Fantin-Latour, August 1867, quoted in Spencer 1989, 82.

FIGURE 15

James McNeill Whistler,
*Arrangement in Grey and Black:
Portrait of the Painter's Mother*,
1871, oil on canvas. Musée
d'Orsay, Paris

29

...

James McNeill Whistler

*Arrangement in Grey
and Black, No. 2: Portrait
of Thomas Carlyle*

1872–1873, oil on canvas,
67 3/8 x 56 1/2 (171.1 x 143.5).
First exhibited: Flemish Gallery,
48 Pall Mall, London, 1874
(no. 6). *References*: Young et al.
1980, 82–84 (no. 137);
Dorment and MacDonald
1994, 143–145 (no. 61)

*Glasgow Museums: Art Gallery
and Museum, Kelvingrove*

By the early 1870s, Whistler
was creating some of his most
original works, including the
nocturnes series, and the great
trio of portraits of his mother,
Cicely Alexander, and Thomas
Carlyle.

Carlyle (1795–1881), born
in Scotland in 1795 and edu-
cated at Edinburgh University,
was an eminent Victorian his-
torian and social critic. Begin-
ning with his formulation of a
"Natural Supernaturalism" in
Sartor Resartus (1833–1834) he
attempted to salvage the idea
of a divinely sanctioned social
order in the face of the more
skeptical, democratic, and

materialistic trends of modern
British life. Carlyle often used
historical precedent to indict
what he perceived to be the
social and spiritual chaos of
the times in works such as *The
French Revolution* (1837), *On
Heroes, Hero-Worship, and the
Heroic in History* (1841), and
Past and Present (1843). In 1834
he and his wife, Jane Welsh
Carlyle, moved to Chelsea
where their home became a
meeting place for the leading
thinkers of the Victorian era.

Whistler lived near Carlyle
and they met through a mutual
friend in 1872, when Carlyle
visited Whistler's studio and
home at 2 Lindsey Row in
Chelsea. The artist's *Arrange-
ment in Grey and Black: Portrait
of the Painter's Mother* (fig. 15)
was hanging, and Whistler
later recalled his neighbor's
reaction: "Carlyle saw it and
seemed to feel in it a certain
fitness of things. . . . He liked
the simplicity of it, the old lady
sitting with her hands in her
lap. . . . he came one morning
soon, and he sat down, and I
had the canvas ready, and my
brushes and palette, and Car-
lyle said, 'And now, mon, fire
away!'"[1]

Others recorded the inter-
action between the two men
during the sittings. The painter

Hugh Cameron described
"Carlyle sitting motionless, like
a Heathen God or Oriental
sage, and Whistler hopping
about like a sparrow."[2] On 29
July 1873 the poet William
Allingham noted in his diary
that Whistler "had begun by
asking two or three sittings but
managed to get a great many.
. . . If Carlyle makes signs of
changing his position, Whis-
tler screams out in an agonized
tone, 'For God's sake, don't
move!'"[3] Carlyle eventually
protested observing that Whis-
tler wanted "to get the coat
painted to ideal perfection, the
face went for little."[4]

Carlyle was seventy-eight-
years old when he met Whis-
tler and was nearing the end of
his life. It was a time of per-
sonal, professional, and physi-
cal hardship. Following the
death of his wife in 1866, he
had written in his diary that,
"since my sad loss I feel lone-
some in the earth. Oh, how
lonesome! and solitary among
my fellow creatures."[5] Carlyle
had also by this date aban-
doned his hopes of reforming
British society. In his journal
at the time of his sittings he
wrote: "More and more dreary,
barren, base, and ugly seem to
me all the aspects of this poor
diminishing quack world."[6]

Finally, Carlyle was burdened
by the infirmities of old age
with "the poor soul still vividly
enough alive, but struggling in
vain under the imprisonment
of the dying or half-dead body."[7]

In Carlyle Whistler had
found a sympathetic subject
whose waning mental and
physical energies corresponded
to the atmospheric conditions
he portrayed in his nocturnes.
Whistler spoke of the beauty
of dusk's fading light in his
"Ten O'Clock" lecture of 1885:
"The sun blares . . . and the
painter turns aside to shut
his eyes . . . the evening mist
clothes the riverside with
poetry, as with a veil . . . and
Nature . . . sings."[8] Similarly
the fading figure of Carlyle,
past the prime of life, cut off
from human companionship,
and without belief in the mor-
alizing effects of his writings,
had great appeal for the artist.
At the time of his portrait the
disillusioned moral philoso-
pher, "solitary among my fel-
low creatures," shared the con-
dition of the amoral artist, "a
monument of isolation-hinting
at sadness" as Whistler put it in
the "Ten O'Clock."[9] The result
is a painting of exquisite beauty
and dignity.

While repeating the elements
found in Whistler's portrait of

his mother, *Carlyle* improves its composition. Like the earlier portrait, Carlyle is profiled against the dado of Whistler's studio with framed works of art hanging on the wall. But Whistler corrects the odd sensation that the figure of his mother in the first *Arrangement in Grey and Black*, although seated, is somehow edging horizontally across the canvas or referring to something off to the left. He does this by squaring up his canvas, negating the backward tilt of the chair by hanging Carlyle's coat over it, adding a strong vertical with the upper of the two picture frames, and eliminating any cropping of objects at the edges. The cumulative effect of these changes is a more stable and self-contained image.

The thinly painted, uniform surface and incisive characterization of *Arrangement in Grey and Black, No. 2* present a striking contrast with the uneven technique and enigmatic qualities of *The White Girl* (cat. 28). In both paintings elements of realism and aestheticism are present, but in the *Carlyle* their respective roles have been clarified. As the sequence of its title declares, the painting is first an abstraction, second a portrait. Nature serves art,

with Whistler carefully choosing and arranging with great precision all the elements in his picture, finally arriving at a classical stasis of form. C.B.

Notes

1. Pennell and Pennell 1921, 174.
2. Quoted in Dorment and MacDonald 1994, 144.
3. Quoted in Dorment and MacDonald 1994, 144.
4. Pennell and Pennell 1921, 104.
5. Quoted in Dorment and MacDonald 1994, 144.
6. Quoted in Dorment and MacDonald 1994, 144.
7. Quoted in Dorment and MacDonald 1994, 144.
8. Whistler 1890, 144.
9. Whistler 1890, 155.

30

..

James McNeill Whistler
Nocturne: Grey and Silver

1873–1875, oil on canvas, 12 1/4 x 20 1/4 (31.1 x 51.4). *First exhibited*: possibly London, Grosvenor Gallery 1878 (56). *References*: Young et al. 1980, 91–92 (no. 156); Dorment and MacDonald 1994, 127 (no. 50)

The John G. Johnson Collection: Philadelphia Museum of Art

In *Wapping* (cat. 27) Whistler painted the Thames full of activity in the light of day; in *Nocturne: Grey and Silver*, he shows the river at rest by night. By this time, Whistler believed, as he later articulated in the "Ten O'Clock" lecture, that rather than gratify the public's "desire to see, for the sake of seeing," the artist must search for "the condition of things that shall bring about the perfection of harmony worthy a picture."[1] On evening expeditions along the Thames, rowed by his Chelsea boatmen, the Greaves brothers, Whistler surveyed the river for views suitable for his paintings. In *Nocturne: Grey and Silver* he depicted a large clock tower next

to Morgan's Crucible works on the Battersea shore, opposite Chelsea where he lived. The structure, known as Morgan's Folly, appears in one other work from this period (*Nocturne*, 1873, The White House, Washington, D.C.). The only illumination in the picture, other than the night sky, are the lamps of the tower and, to its right along the shoreline, a ray of light whose source cannot be determined.

Whistler had often been frustrated in his earlier attempts to paint outdoors. With the nocturnes he also had to contend with the movement of the boat and the lack of light. Whistler addressed these problems by using a technique recommended by the French painter Lecoq de Boisbaudran: while on the river he would turn his back on the scene he wished to depict and then proceed to describe the picture in detail to his companions. Once he was satisfied with his knowledge of the vista Whistler returned to the studio and executed his painting in an oil medium that was so thinned with turpentine and linseed oil that he called it his "sauce." The work would then be left in his garden to dry. Whistler's techniques were similar to that

of a watercolorist, and perfectly adapted to the fluid nature of the effects he was attempting to render.

Whistler painted numerous forerunners of the nocturnes from the mid to late 1860s, but executed his first true works of the series in the early 1870s. The title, which he first used at an exhibition in November 1872, was suggested by his patron Frederick Leyland, on the model of the famous piano pieces by Chopin. Whistler liked the term because it indicated "an artistic interest alone, divesting the picture of any outside anecdotal interest which might have been otherwise attached to it."[2]

The nocturnes are the most succinct expression of the theories Whistler was to expound in his "Ten O'Clock" lecture, delivered 20 February 1885 at Princes Hall in London. In his talk Whistler systematically disassociated himself from all notions concerning the social and national purposes of art then prevalent in Britain, including Oscar Wilde's brand of popular aestheticism. Instead he stressed the isolation of the artist in his communion with beauty, an isolation he had cultivated in his own career by distancing himself further and further from the realist and literary tendencies that dominated British art. Whistler's night paintings, quiescent meditations on the limits of vision, barely clinging to reality and consciousness, moving toward darkness and total abstraction, were the logical result of that process of isolation. In an oft-quoted passage about the nocturnes Whistler spoke about the type of solitary experience that inspired them:

the poor buildings lose themselves in the dim sky . . . and the warehouses are palaces in the night—and the whole city hangs in the heavens. . . . then the wayfarer hastens home—the working man and the cultured one—the wise man and one of pleasure—cease to understand, as they have ceased to see—and Nature, who for once, has sung in tune, sings her exquisite song to the artist alone.[3] C.B.

Notes
1. Whistler 1890, 144.
2. Merrill 1992, 144.
3. Whistler 1890, 144.

The Awakening Conscience
William Holman Hunt

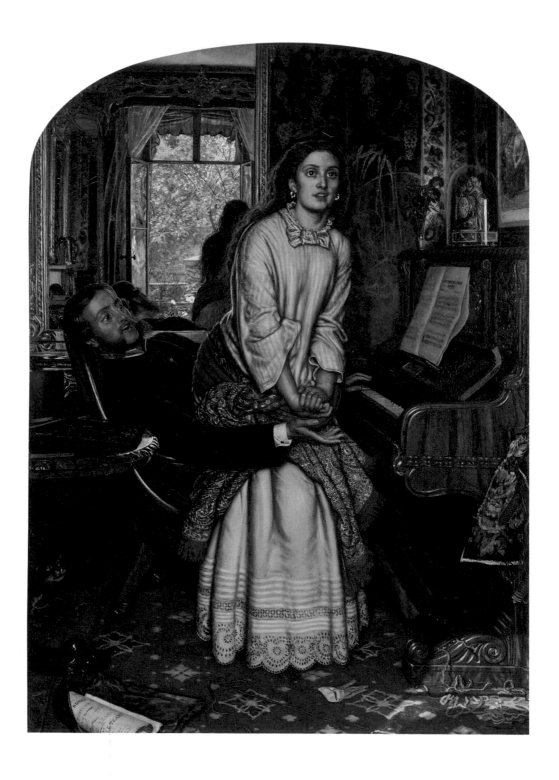

The Scapegoat
William Holman Hunt

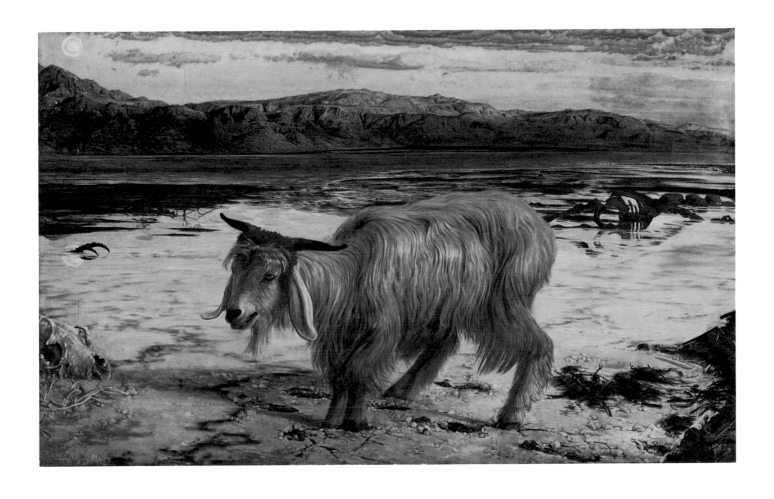

The Lady of Shalott
William Holman Hunt

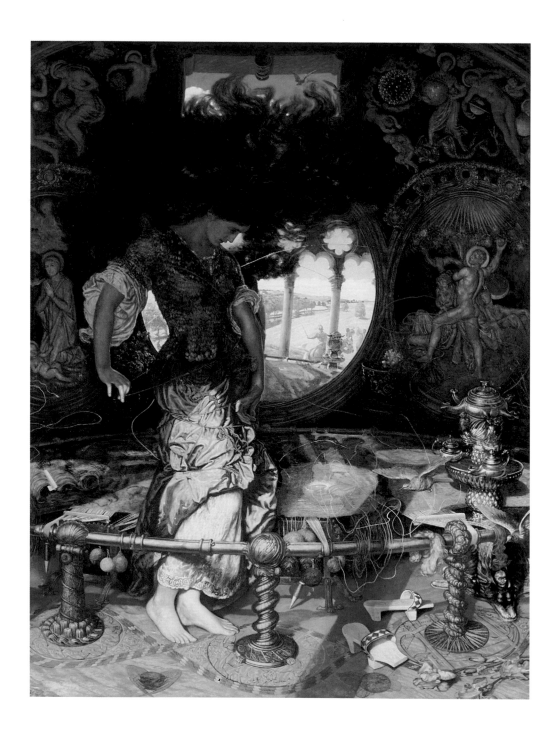

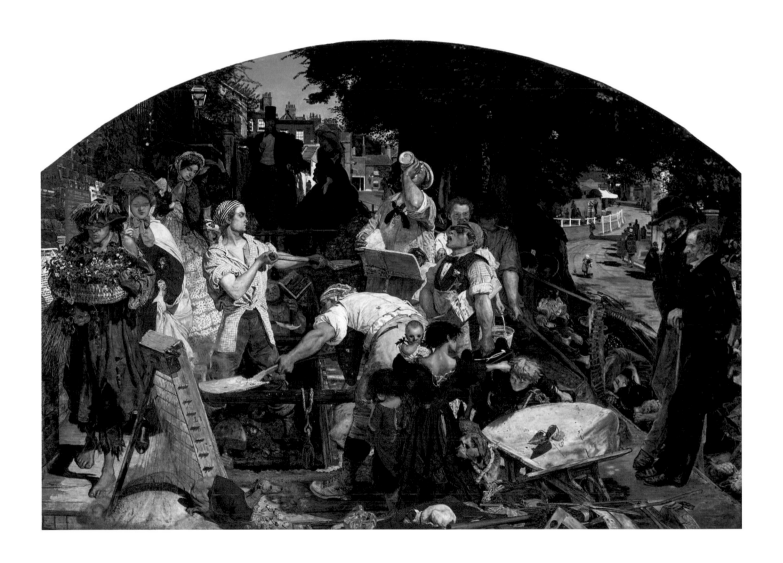

The Death of Chatterton
Henry Wallis

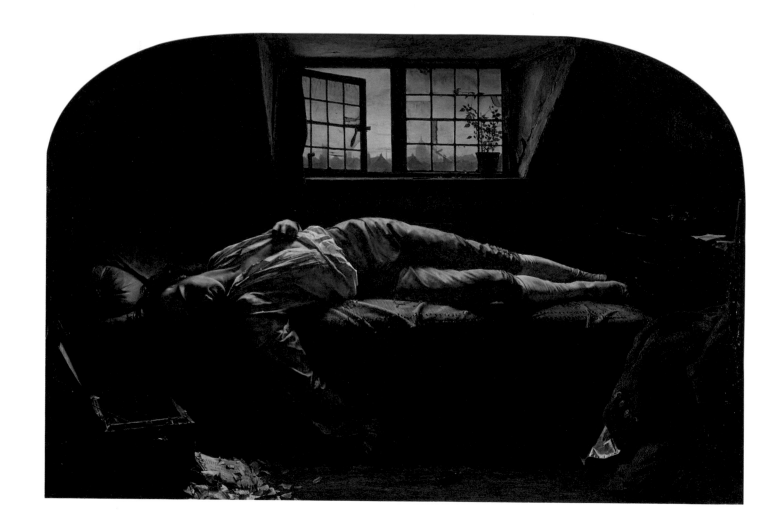

The Fairy Feller's Master-Stroke
Richard Dadd

Derby Day
William Powell Frith

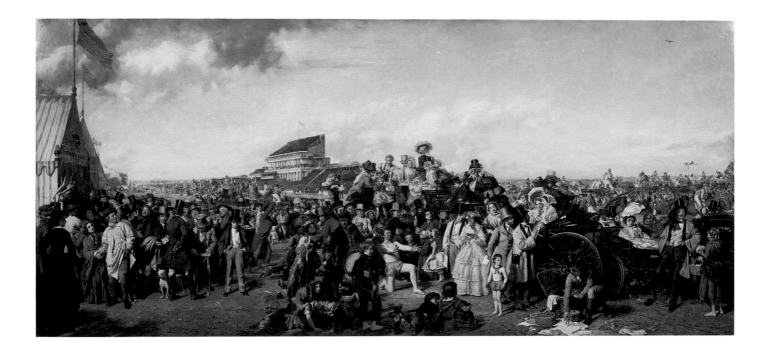

Home from Sea
Arthur Hughes

(NOT IN EXHIBITION)

Past and Present (no. 1)
Augustus Leopold Egg

Past and Present (no. 2)
Augustus Leopold Egg

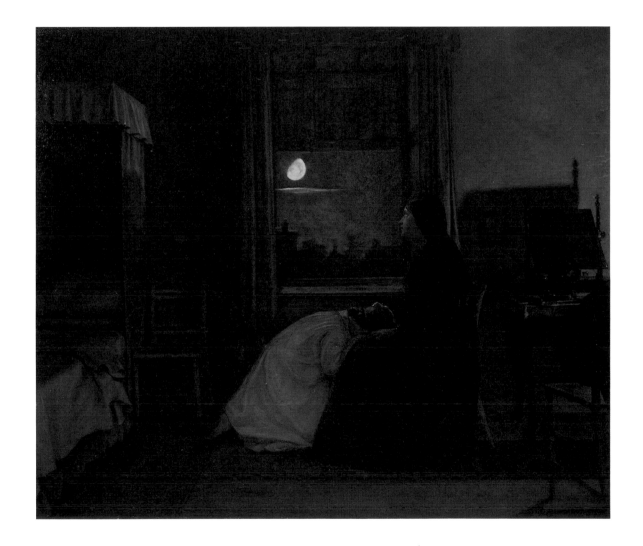

Past and Present (no. 3)
Augustus Leopold Egg

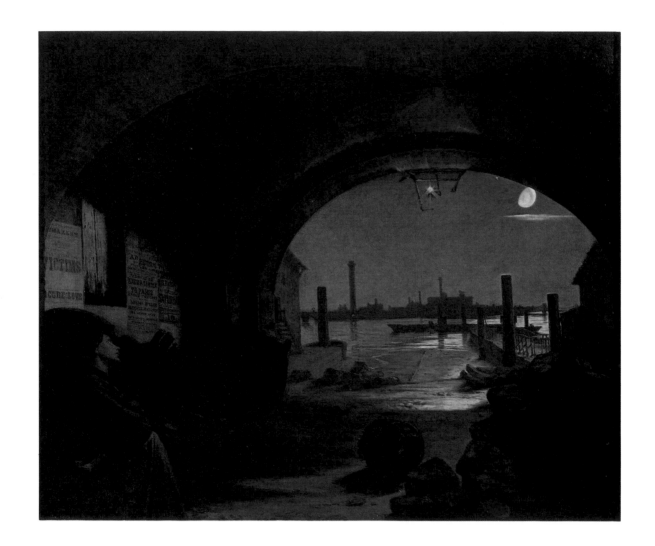

Pegwell Bay: A Recollection of October 5th, 1858
William Dyce

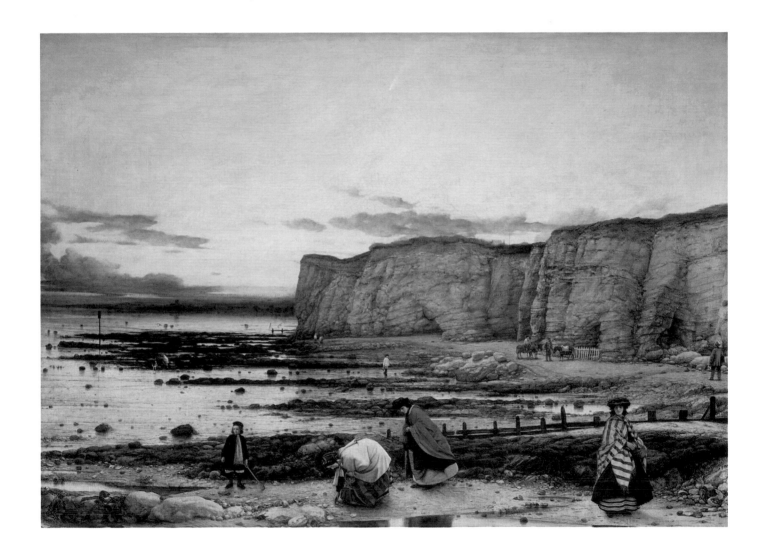

Omnibus Life in London
William Maw Egley

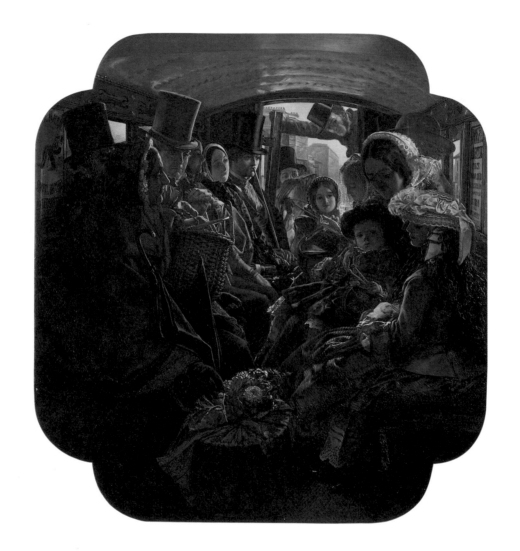

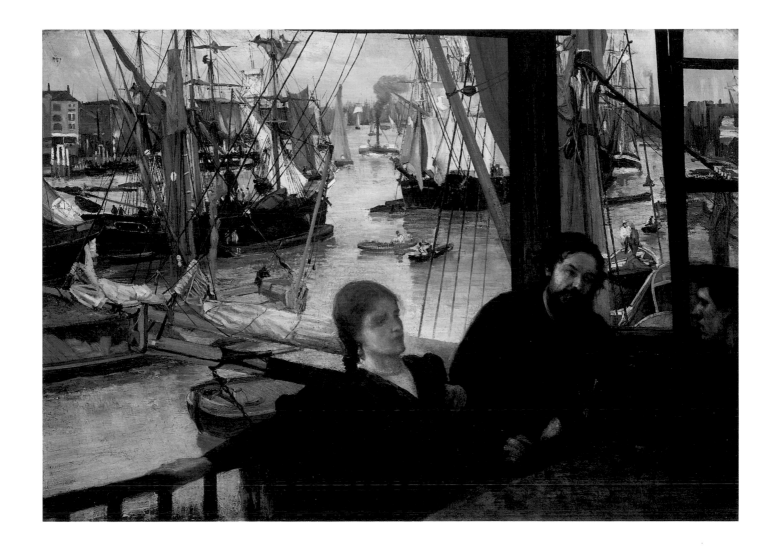

Symphony in White, No. 1: The White Girl
James McNeill Whistler

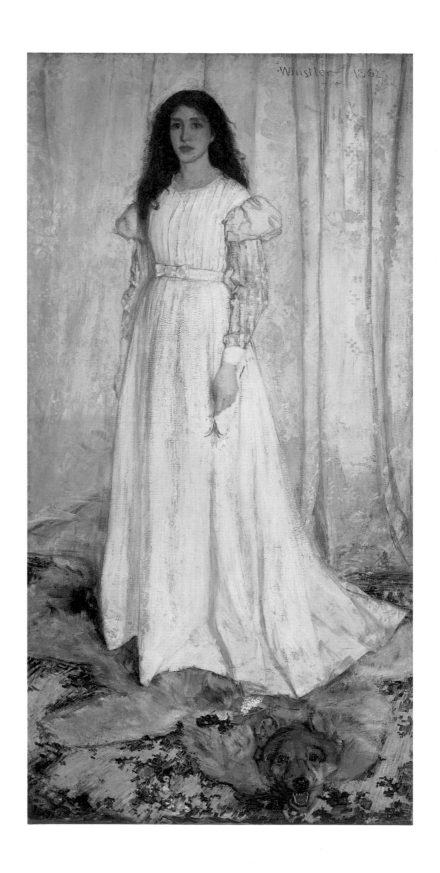

Symphony in White, No. 1: The White Girl

Arrangement in Grey and Black, No. 2: Portrait of Thomas Carlyle
James McNeill Whistler

Arrangement in Grey and Black, No. 2: Portrait of Thomas Carlyle
James McNeill Whistler

Nocturne: Grey and Silver
James McNeill Whistler

31

George Frederic Watts

Choosing

c. 1863/1864, oil on straw-
board, mounted on gatorfoam,
19 x 14 (48.3 x 35.6). *First
exhibited*: Royal Academy 1864
(no. 395). *References*: Loshak
1963, 483

National Portrait Gallery, London

In *Choosing*, a young woman
reaches up to smell a red
camellia blossom, presumably
before deciding which one to
pick. Her effort is in vain, as
the flowers have no fragrance.
This touch of enigma suggests
that the work is more than
decorative in intention, although
the artist's deeper purpose
remains elusive. Perhaps the
most likely interpretation
would be that the pleasures of
the senses are an empty delu-
sion; this would place the work
in the tradition of the *vanitas*, a
largely Dutch type of painting
in which objects are used to
illustrate the idea that all things
of this world are vanities,
or "omnia vanitas est," from
Ecclesiastes (1:2)—the moral
being that it is better to live a
spiritual life than a sensual one.

Watts may have chosen camel-
lias to this end in reference to
La Dame aux camélias, the play
by Alexandre Dumas the Young-
er, which reached the London
stage in the form of Verdi's opera
La Traviata in 1856. The story
is one of fleshly sin and redemp-
tion through love: the heroine
is a fashionable, high-living
courtesan who dramatically
sacrifices her own happiness
for that of the man she loves
before dying of consumption.

The model for *Choosing* was
the artist's young wife, Ellen
Terry, who was already an
actress and destined to become
one of the great figures of
British theater. Watts met her
in the spring of 1862, and they
were married on 20 February
1864; he was forty-seven at
the time, and she only sixteen.
Choosing may well have been
painted about this time, and
would have been submitted for
that year's Royal Academy ex-
hibition in early April. Watts
and Terry felt affection and
respect for one another, which
they maintained into later life,
but their marriage was doomed
to failure; they were legally
separated in January 1865, and
by 1868 Terry was living with
the architect E. W. Godwin.
They were finally granted a
divorce in 1877. Watts' evidence

in the divorce proceedings
throws light on the personal
significance *Choosing* probably
carried for him at the time it
was painted; he seems to have
thought of Terry as his own
modern Eve, liable to yield to
sinful temptations. By marry-
ing her, he stated, he "hoped to
influence, guide and cultivate a
very artistic and peculiar nature
and to remove an impulsive
young girl from the dangers
and temptations of the stage."[1]
After the divorce she married
the actor Charles Wardell. She
had her heyday in the theater
between 1878 and 1896, when
she played the leading female
roles in all the productions of
Sir Henry Irving.

As a small painting of a beau-
tiful female head, nonnarrative,
decoratively interwoven with
flowers, and occupying a shal-
low space, *Choosing* was un-
doubtedly Watts' response to
the works of similar character
that Dante Gabriel Rossetti
had been painting since the
landmark *Bocca Baciata* of 1859
(private collection). Watts cer-
tainly knew Rossetti, who was
a regular visitor to Little Hol-
land House. Both men were
important figures in the devel-
opment of the British symbolist
movement, and their careers
in the 1860s and 1870s present

a number of interesting points
of comparison.

The painting is in a type
of frame used so commonly by
Watts that it has come to be
known by his name. A "Watts"
frame consists of a wide, butt-
jointed flat, gilded directly
upon the wood, with moldings
of husks or other small deco-
ration around the inside, and
bead-and-bobbin alternating
with cross-cut acanthus around
the outside. M.W.

Notes
1. Loshak 1963, 483.

32

George Frederic Watts

Paolo and Francesca

c. 1872/1884, oil on canvas,
60 x 51 (152.4 x 129.5). *First
exhibited*: Grosvenor Gallery
1879 (no. 73). *References*: exh.
cat. Manchester 1978, 86–87
(no. 28)

Trustees of the Watts Gallery

In Canto V of his *Inferno*, the
poet Dante describes the sec-
ond circle of hell, where the
souls of carnal sinners, includ-
ing many famous lovers, are

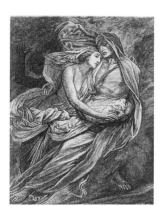

forever whirled around by stormy winds. He speaks with Paolo Malatesta and Francesca da Rimini, who committed adultery and were murdered by Francesca's husband, who was also Paolo's brother. He reflects on how many sweet thoughts and longings led them to everlasting misery, and asks them how they knew of their love for one another. Francesca tells him of their first kiss while reading a book about the Arthurian hero Lancelot and his passion for King Arthur's queen, Guinevere. Dante feels such a wave of pity that he faints.

Watts had been interested in the subject of Paolo and Francesca since early in his career. Perhaps drawing for inspiration upon the illustrations to Dante published by John Flaxman (1793), he painted a small fresco of the lovers' first embrace while in Italy in 1843–1847 (Victoria and Albert Museum). There he also made drawings of the couple whirling through hell, which he used as the basis for an oil of the subject—similar in composition and size to the present work but showing Francesca nude— soon after his return to London (private collection). Shown at the British Institution exhibition of 1848, this was to be the

first of four versions that are variations on the same design. The second was painted around 1865 (private collection); the third is dated 1870 (Manchester City Art Galleries); and the present work, the fourth and last, was painted largely between 1872 and 1875.

Originally this showed Francesca's right arm and the right side of her body as bare, and her long hair blowing in the wind; the design also included the figure of a demon, placed behind the main figures on the opposite diagonal (fig. 16). Watts later extended Francesca's draperies to cover her more fully, and simplified the composition by overpainting the demon; only a demonic foot remains visible, near the lower edge of the canvas, right of center. The changes probably date from the general reworking of the picture that he carried out between 1882 and 1884. Tracing the development of his idea of the subject through the four versions and the alterations in the fourth, one sees Francesca change from an open-eyed nude to a draped figure with eyes nearly closed. Both figures appear more clearly like corpses in the final version, and the draperies, which recall Greek

sculpture, more clearly like winding sheets. Typically, Watts moved from a time-specific, narrative approach, showing how the lovers might have appeared during their meeting with Dante, to a more general, allegorical image of their eternal fate.

In the catalogue to the exhibition of Watts' works held at the Metropolitan Museum of Art, New York, in 1884–1885, his friend Emilie Barrington wrote:

The artist has endeavoured to record in the countenances of these lovers their hopeless, tender love abiding through endless suffering; the passion of love imprinted forever on their souls, to be traced now only through the vaporous atmosphere of a spirit-world. Memory in these pale spirits, retaining a full consciousness of past joy, only adds acuter suffering to present pain.

With its fusion of past into present, love into horror, passion into pain, beauty into death, the lovers' fate possessed the high complexity and suggestiveness to which Watts aspired in his art. He developed his highly painterly technique, modeled on that of the Venetian painter Titian, as a vehicle for the indefinite: deliberately

vague in both style and content, his paintings seem to call endlessly for further, deeper interpretation. "In *Paolo and Francesca* passion is seen externalised at the moment of weary ecstasy when desire has become a memory, and memory has extinguished the world," wrote the poet and critic Arthur Symons, his response a model of the free association of ideas and images that Watts hoped to inspire:

These bodies are like the hollow shell left by flames which have burnt themselves out, and they float in the fiery air, weightless and listless, as dry leaves are carried along a wave of wind. All life has gone out of them except the energy of that one memory, which lives in the pallor of their flesh, and in the red hollows of the woman's halfclosed eyes, and in the ashen hollows of the man's cheeks. . . . Now, they do not love, nor repent, nor hope, only remember; they have lived, they are no longer living, and they cannot die.[1]

The Victorian painter most closely associated with subjects from Dante was Rossetti, who indeed painted a watercolor *Paolo and Francesca* in 1855 (Tate Gallery). Much younger than Watts, he arrived at Dante

independently and for altogether more personal reasons, but the Venetian-inspired technique and open, poetic approach to the subject he adopted in a work such as *Beata Beatrix* (cat. 35) bear witness to a considerable fellowship of interests. M.W.

Notes

1. Symons 1906, 114–115.

33

George Frederic Watts

Hope

1885–1886, oil on canvas, 59 x 43 (150 x 109). *First exhibited*: Grosvenor Gallery 1886 (no. 61). *References*: exh. cat. Manchester 1978, 90 (under no. 31); Treble 1978, 88 (under no. 63)

Private collection

The best known of all Watts' compositions, *Hope* typifies the artist's free and original approach to the traditions of allegory. Female figures representing the abstract idea of Hope have appeared in Christian art since the Middle Ages, normally with the other "theological virtues" of Faith and Charity, and in secular art since the Renaissance. Among their distinguishing features are an upward, longing gaze, and symbolic objects including crowns, anchors, headdresses in the form of ships, and flowers. Clearly Watts tried to conceive the given subject afresh, dispensing with the conventional imagery, and even appropriated to his Hope some of the attributes of quite different allegorical figures and personages: globes and blindfolds are usually associated with the fickle goddess Fortune, and lyres with the god Apollo or the art of Poetry. He carefully posed his figure, which plays gently off Michelangelo's sculpture of *Night* in the Medici Chapel, so that her straining action expresses his idea of Hope just as much as his chosen symbolic objects. As ever he wished subtly and suggestively to address a large spiritual issue; he tried to picture Hope in a way that resonated with his own times, and the result appears at some level a pronouncement on the soul of Britain in the nineteenth century.

Whereas the traditional imagery of Hope is positive, that of a virtue that will be rewarded, Watts dwells on the closeness of Hope to Despair. His blindfolded figure listens intently to the sound of the single string on her lyre that remains unbroken; this symbolizes Hope's persistence, but also the frailty of that which sustains it. To reduce the meaning of the painting to a simple verbal formula would run counter to Watts' philosophy of art, but certainly one of its main "suggestions" (a term he used in this way himself) would run broadly as follows: the quiet sound of the lyre's single string is all that is left of the full music of old-fashioned religious faith; those who still listen are blindfolded in the sense that, even if real reasons for Hope exist, they cannot see them; Hope remains a virtue, but in the age of scientific materialism a weak and ambiguous one. "All the trouble and disquiet of modern times is in that picture," wrote Julia Cartwright in an early study of Watts' art, "all the doubt and questioning of these latter days, when 'men lie down in darkness and sorrow, and know not whether their night has a morrow,' or, at best, cling despairingly to the old truths, and 'faintly trust the larger hope.'"[1] The second of Cartwright's quotations is from the classic expression of Victorian Hope-as-Despair, Tennyson's *In Memoriam.*

On the other hand, critics have also interpreted the painting as an image of Hope in all times and places, not nineteenth-century Hope in particular, but Hope as an eternal trait in the human character. G.K. Chesterton discussed it as such in his book on Watts. In the course of a brilliant defense of Watts' use of allegory, he imagined the response that this "dim canvas with a bowed and stricken and secretive figure cowering over a broken lyre in the twilight" would stir in the mind of an exhibition-goer coming across it unprepared.

His first thought, of course, would be that the picture was called *Despair*; his second (when he discovered his error in the catalogue), that it has been entered under the wrong number; his third, that the painter was mad. But if we imagine that he overcame these preliminary feelings and that as he stared at that queer twilight picture a dim and powerful sense of meaning began to grow upon him — what would he see? He would see something for which there is neither speech nor language, which has been too vast for any eye to see and too secret for any religion to

into Venus' magical realm, the Venusberg, and abandons himself to a life of carnal delight with her and her attendant nymphs and sirens.

The tapestries on either side of the window show the birth of Venus to the left, and to the right the goddess riding in a triumphal carriage drawn by doves, with Cupid before her firing an arrow; as Julian Treuherz has pointed out, the artist based the coach scene on an illumination in a favorite fifteenth-century manuscript of the *Roman de la Rose* (British Library).[1] Burne-Jones once described tapestries as "beautifully half way between painting and ornament,"[2] and the presence of the tapestries in *Laus Veneris* underlines the ornamental quality of the composition, inviting the viewer to enjoy it as the richly decorated surface that it is, intricately worked and embellished throughout.

Burne-Jones painted his first version of *Laus Veneris*, in the form of a watercolor, as early as 1861 (private collection). He was on close terms with the poet Algernon Charles Swinburne at this time, and the idea of the subject appears to have come out of discussions between them. They could have read the Tannhäuser legend in a number of forms, and as admirers of Wagner they must have heard of the controversy surrounding the performances of his *Tannhäuser* at the Paris Opera that year. In 1862, after Burne-Jones had made his watercolor, Swinburne wrote a poem of the same title, one of the notorious first series of *Poems and Ballads*, which he published with a dedication to his artist friend in 1866. He prefaced the poem with a passage on the legend from the *Livre des grandes merveilles d'amour* by Antoine Gaget (1530); the fragments of the song "Laus Veneris" legible in the ladies' music book in Burne-Jones' painting ("Doce amie, Hors de lis . . . etc.") may be taken, or pastiched, from this or a similar source. The poem itself is a monologue in which Tannhäuser confesses his lust, and describes the strange blend of pleasure and pain, passion and death longing, that is the lot of Venus' devotees. Swinburne's imagery is more perverse and fleshly than anything in Burne-Jones, but the mood of weary, hothouse sensuality that pervades his description of the Venusberg is probably close to what the artist intended in his painting:

Her gateways smoke with fume
 of flowers and fires,
With loves burnt out and
 unassuaged desires;
 Between her lips the steam of
 them is sweet,
The languor in her ears of many
 lyres.

Her beds are full of perfume and
 sad sound,
Her doors are made with music,
 and barred round
 With sighing and with laughter
 and with tears,
With tears whereby strong souls
 of men are bound.

As with *Le Chant d'Amour* (cat. 38), Burne-Jones' early watercolor version of *Laus Veneris* was bought by his great patron William Graham, who then commissioned the large oil. M.W.

Notes
1. Parris, *Papers*, 1984, 167.
2. Burne-Jones 1981, 105.

42

Edward Burne-Jones
The Doom Fulfilled

1888, oil on canvas, 61 x 55 ¼ (154.9 x 140.3). *First exhibited*: New Gallery 1888 (no. 55). *References*: Löcher 1973, 105–106 (no. 9); Christian 1975, 60–62 (no. 171)

Staatsgalerie Stuttgart

The Doom Fulfilled is from a series of paintings showing scenes from the myths of the Greek hero Perseus. The series was commissioned from Burne-Jones in 1875 by the young Arthur James Balfour, to decorate the music room of his London house, 4 Carlton Gardens, off Pall Mall. Balfour was the nephew of the Conservative statesman Lord Salisbury; he was also to have a distinguished career in politics, and in 1902 succeeded his uncle as prime minister.

No doubt Burne-Jones discussed his choice and treatment of subjects from the myths with his old friend and collaborator William Morris, who had recounted them, among others, in his long poem *The Earthly Paradise* (1868–1870); some

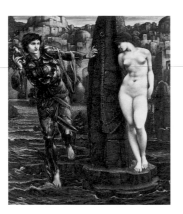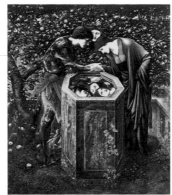

FIGURE 20

Edward Burne-Jones, *The Rock of Doom*, 1885–1888, oil on canvas. Staatsgalerie Stuttgart

FIGURE 21

Edward Burne-Jones, *The Baleful Head*, 1886–1887, oil on canvas. Staatsgalerie Stuttgart

early sketches for the scheme of the room suggest that Morris was to have been involved as a designer too, but the idea came to nothing. In the end the project underwent a number of revisions and stretched out to last for most of the rest of Burne-Jones' life. He produced full-scale cartoons in gouache on paper for ten different subjects from the myths, between 1876 and 1885, but realized only four of them as finished oils; the cartoons are at Southampton City Art Gallery, and the four finished oils, along with further, duplicate gouaches and unfinished oils, are at the Staatsgalerie Stuttgart.[1]

The designs for the series deal with the most familiar of the Perseus myths: the hero's quest for and beheading of the snake-haired Gorgon, Medusa, whose gaze turns her victims into stone, and his rescue of the princess Andromeda from a sea monster. Burne-Jones brought all three of his designs dealing with the Andromeda story to completion as finished oils, between 1885 and 1888, and they form a narrative triptych. The beautiful, innocent Andromeda is the daughter of Cepheus, King of Joppa in Ethiopia. In order to appease the gods

for some insults made by her mother, Queen Cassiopeia, she is to be offered as a sacrifice, and has been chained to a rock off the coast to be devoured by a monster sent by Poseidon, god of the sea. Perseus comes upon this scene while flying along the coast with the aid of his winged sandals, and falls in love with Andromeda on the spot; this is the episode shown in *The Rock of Doom* (fig. 20). He releases her from her chains and leaves her as a lure for Poseidon's monster, with which *The Doom Fulfilled* shows him doing battle. He manages to kill the monster, and in accordance with a promise secured from Andromeda's parents beforehand, takes her as his bride. In *The Baleful Head* (fig. 21) he shows her the head of Medusa safely reflected in a well.

The Greek myths held a powerful appeal for the Victorians. They offered an escape into a world of action and heroism, things for which there hardly seemed a place amid the humdrum realities of modern life, and in some cases could be read as satisfyingly clear-cut dramas of morality. The myth of Perseus and Andromeda lent itself readily to such an interpretation. The clergyman and

writer Charles Kingsley, for instance, considered Perseus a figure of "divine moral beauty," whose deeds were completely in line with the ideals of chivalry, the medieval-Christian moral code whereby the strong protected the weak.[2] He was a classical parallel to Saint George, the patron saint of England, who also risks life and limb to rescue a princess from a monster. Perhaps the basically medieval look that Burne-Jones gives Perseus' fantastic armor is meant to help open the myth to this kind of reading. It encourages us to see Perseus as the prototype of a knight errant or warrior saint, his fight with the monster representing the elemental Christian opposition of good and evil. For Burne-Jones good was inseparable from beauty, evil from ugliness, and at some level—perhaps even primarily—he would also have thought of Perseus as the artist rescuing beauty from the ugliness of the modern age. This idea certainly seems to inform Frederic Leighton's treatment of the subject (fig. 22), in which the monster is shown belching fire and smoke like a factory chimney.

In keeping with the decorative purpose of his painting, Burne-Jones underplays the

suggestion of depth and atmosphere in the scene, allowing the image to work more as a design or emblem than as an illusion. The space the figures and monster occupy is deliberately compressed, in places quite ambiguous. The convolutions of the monster's body recall the interlaced patterns adorning initial letters in medieval manuscripts. The rocks in the setting bear less resemblance to nature than to the highly stylized geology found in the work of the Italian fifteenth-century painter and printmaker Mantegna, one of Burne-Jones' favorite artists. Andromeda's pose is more or less a back version of the one in which we see her from the front in *The Rock of Doom*, a loose interpretation of the famous Greek sculpture of the Venus de Milo. Burne-Jones may have had in mind the account of the myth in Ovid's *Metamorphoses*, which likens Andromeda to a marble statue. By turning the head into profile and hiding one arm behind the torso, he presents the figure more as relief than mass, which again makes for a decorative rather than illusionistic effect. Characteristically, he also makes much play with paint surfaces: the nude is

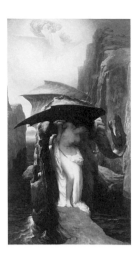

treated with a smoothness imitating marble, while Perseus' armor and the body of the monster have a rough, crusty texture. M.W.

Notes

1. The artist's changing ideas for his Perseus compositions are discussed in detail in Löcher 1973.
2. Houghton 1957, 316.

43

...

Cecil Gordon Lawson

A Hymn to Spring

1871–1872, oil on canvas, 60 x 40 (152.4 x 101.6). *First exhibited*: Grosvenor Winter Exhibition, 1882–1883 (no. 138). *References*: Gosse 1883, 18–20; Casteras and Denny 1996, 194 (no. 30)

Santa Barbara Museum of Art, Gift of Mr. and Mrs. Paul Ridley-Tree

A Hymn to Spring was Lawson's most ambitious painting to date. According to his biographer, Edmund Gosse, the work was based on Lawson's study of the Berkshire landscape near Hungerford. "The first of his great scenic landscapes," as Gosse described it, *A Hymn to Spring* established a compositional structure that Lawson followed in a number of later works.[1] In the foreground is a detailed portrayal of nature in the manner of the Pre-Raphaelites, albeit without the linear clarity of their distinctive brushwork. Like a stage proscenium, this frames a distant middleground and background. The elevated foreground, a distinctive motif in Lawson's work, produces an unsettling sensation as the close depiction of nature suddenly gives way to a more broadly painted background. The curving furrows of the hillside field, lined with puddles that reflect the sky, provide a bridge from the gnarled tree roots, leaves, narcissi, and flowering medlar tree of the foreground to the more vaguely realized river winding through the meadows, birches, and firs of the background. The white dove hovering above the river echoes the tremulous white blossoms of the tree and adds a note of delicacy to the painting that is reinforced by the violets and other flowers clustered around the roots. Although the painting depicts a vast vista of woods, the scene is rendered intimate by the detailed study of vegetation and the leafy apple tree branch, silhouetted against the cloud-streaked sky, that enclose the landscape. The general effect is of a countryside saturated with greenery and life.

Lawson studied nature closely, often executing landscape sketches on the spot, but his exhibited works were generally painted in the studio. He explained to Gosse that painting out-of-doors distracted him. According to the critic for *The Times*, Lawson's practice was to "steep himself in the spirit of landscape," and then "to select, eliminate, arrange, or, in a word, to compose"; this method of painting was out of step with *plein-air* naturalism, "which prefers exact observation to the power of generalization."[2] Lawson's painting was perhaps closer in method to that of John Crome or John Constable, who invested the natural beauty of England's countryside with a grandeur more typically associated with imagined or classical landscapes. Lawson sought to combine naturalism with expressiveness. Referring to his *Vale of Meifod, North Wales*, painted a year after *A Hymn to Spring*, he explained to Gosse that although the elements of the composition were taken from an actual village, he endeavored "to epitomise the characteristics of the locality rather than to paint any particular spot. The aim has been the realisation of a feeling."[3]

Gosse claimed that much of the symbolic or expressive charge of the painting derived from the medlar tree, a "slender and graceful object [that] attracts the eye at once by its feminine and virginal beauty, and seems to be the young laughing genius of spring herself."[4] The theme of the joy of spring is echoed throughout the painting: "All the rich foliage, every winding stream and pregnant cloud, seems to chant its homage to the image of spring, to the pure and rosy medlar-tree that quivers under its burden of living garlands." Speaking more generally of Lawson's work, Joseph Comyns Carr, of the Grosvenor Gallery, where Lawson frequently exhibited, claimed that "he brought to every scene the eager faith of a poet, and he knew how to bring the facts it contained into subjection to a poet's vision . . . without unduly disturbing the actual appearance of things."[5]

The impression of achieving the actual appearance of things

depended, in part, upon Lawson's adoption of painting techniques from Constable and other naturalistic painters. In the middleground and background, he used a relatively broad brushstroke with touches of highlight that endow the scene with a sense of freshness comparable to that found in Constable's work of the 1820s. Most of the work, with the exception of the sky, was probably painted over a dark ground in the manner of the old masters. A critic once objected to Lawson's paintings because they "seemed as if they had come out of the National Gallery."[6] Nevertheless, there are elements of his painting that could never be confused with an old master, such as the bright touches of yellow, green, blue, and white, and the compositional device of the cropped tree branch, which is an unmistakable homage to Japanese woodblock prints.

When Lawson submitted this painting to the Royal Academy exhibition of 1873 it was rejected, as were several of his landscapes from this period. The Academy's inability to recognize the potential of Lawson's work and that of other innovative artists encouraged Sir Coutts Lindsay to open the Grosvenor Gallery. The Grosvenor proved a conducive venue for Lawson's paintings, and within a few years he was regarded as one of England's finest landscape painters. Upon his death in 1882, the Grosvenor Gallery held a retrospective exhibition of his work, and *A Hymn to Spring* was exhibited publicly for the first time. This exhibition revealed that Lawson had developed an equivalent in landscape painting to the spirituality and beauty characteristic of aesthetic figure subjects. Neither wholly Pre-Raphaelite, realist, or impressionist, Lawson promised a new form of landscape painting suited to the individualism of the late nineteenth century. A.H.

Notes
1. Gosse 1883, 18.
2. *The Times*, 11 December 1882, 7.
3. Gosse 1883, 20.
4. Gosse 1883, 18–19.
5. Gosse 1883, 37.
6. Gosse 1883, 6.

44

......................................

Edward Lear

The Pyramids Road, Gizah

1873, oil on canvas, 20 x 40 (50.8 x 101.6). Not exhibited in the artist's lifetime. *References:* Noakes 1985, 154 (no. 61)

Michael F. Price

Edward Lear traveled extensively throughout his life, particularly in the Mediterranean region and the Middle East. During his travels, he developed a distinctive mode of recording the local landscape that he described as "Poetical Topography."[1] Like other orientalists, Lear's interest in the Middle East was aroused well before he traveled there: in 1848, while in Rome, he wrote to a friend that "the contemplation of Egypt must fill the mind, the artistic mind I mean, with great food for the rumination of long years."[2] Lear visited Egypt a number of times, beginning in 1849; his last trip was in 1872, when this painting was undertaken.

As Britain extended its economic and imperial network in the eighteenth and nineteenth centuries, travel to the Middle East became easier with the development of the railroad and the steamship. Egypt, a popular destination, held enormous historical appeal, and as it was on the main overland route from Britain to India, it was relatively accessible. Many artists traveled there, some seeking authentic backgrounds for biblical scenes, others more interested in history, and others drawn by the promise of unfamiliar topography and a social world far different from their own. William Holman Hunt, John Frederick Lewis, and James Tissot were among the Victorian artists who traveled there. Interest in Egypt was further stimulated by the opening of the Suez Canal in 1869, an event to which Lear's painting indirectly refers. A label on the back identifies the scene as "A view of the Pyramids Road at Gizah, with the avenue of Trees planted in 1868 by the Empress Eugenie, at the opening of the SUEZ CANAL."

In the fall of 1872, Lear's patron and friend Lord Northbrook, recently appointed viceroy of India, invited Lear to visit him. On his way to Suez, where he was to take a boat to India, he stopped in Cairo for a few days in October. In his correspondence, he

mentions that Northbrook commissioned two views of the pyramids and this painting may have been done in fulfillment of that request. Rather than focus on the pyramids themselves, Lear chose to depict the new pyramids road, which was an endless source of astonishment to him. In his diary he wrote "Nothing in all life is so amazingly interesting as this new road & avenue—literally all the way to the Pyramids!!! —I could hardly believe my own senses, remembering the place in 1867." He decided that the road would be an excellent subject: "The effect of this causeway in the middle of wide waters is singular . . . & were one sure of quiet, there is much of poetry in the scene, but it wants thought and arrangement." In his diary entry of 14 October 1872, he reported "I drew again at the head of the great Acacia avenue—but flies made the work *impossible*."[3] Within the year he had completed a watercolor of the avenue, presumably the model for the present oil.

Lear's painting both monumentalizes and naturalizes his subject. The trees arching over the road create an architectural grandeur that calls to mind Gothic cathedrals. Underneath

the leafy canopy, the road is dark with shadows and, although filled with people, the scene has a tone of solemnity. The foremost figure in the composition slowly makes his way forward, his head bowed. Rich and poor alike are gathered here as at a grand civic or religious institution. The significance of the figures, however, seems diminished, both literally and metaphorically, by the vaultlike grove of trees extending into the distance. The trees obliterate the bald newness of the road and integrate it with the sublime expanse of the landscape.

The painting has the loose, sketchlike quality of Lear's watercolors, and its bright, translucent colors also bear resemblance to the watercolor medium. Lear typically painted his oils from existing sketches and drawings, but always tried to maintain the freshness of his first impressions. A.H.

Notes
1. Noakes 1991, 8.
2. Letter to Chichester Fortescue, Rome, 12 February 1848, quoted in Strachey 1907, 9.
3. All diary entries quoted in Noakes 1985, 154. Lear's diary is in the collections of Houghton Library, Harvard University.

45

...

Samuel Luke Fildes

Applicants for Admission to a Casual Ward

c. 1872–1874, oil on canvas, 54 x 96 (137.2 x 243.8). *First exhibited*: Royal Academy 1874 (no. 504). *References*: Chapel 1982, 83–87 (no. 22); Treuherz 1987, 83–89 (no. 74)

Royal Holloway, University of London

Applicants for Admission to a Casual Ward exemplifies the social realist genre that developed in England during the last quarter of the nineteenth century. Contemporary critics praised the vivid realism of the scene:

this is the most notable piece of realism we have met with for a very long time. The painter has shirked nothing, he has set down the facts as he found them and has, as a result, produced the startling impression of all wayward and unlovely reality.[1]

Filling the breadth of Fildes' painting is a seemingly endless line of indigent Londoners, huddled against the

cold while waiting for admission to the equivalent of a modern-day homeless shelter. London's Houseless Poor Act of 1864 required those seeking temporary food and shelter to apply at a police station for a ticket of admission to the overnight lodgings, called casual wards, of a local workhouse, such as the one depicted in Hubert Herkomer's *Eventide* (cat. 50).

When exhibited at the Royal Academy in 1874, *Applicants for Admission to a Casual Ward* was accompanied by an extract from a letter by Charles Dickens, which conveys the shock Dickens felt when he encountered a crowd waiting for temporary housing in the impoverished Whitechapel district of London: "Dumb, wet, silent horrors! Sphinxes set up against that dead wall, and none likely to be at the pains of solving them until the *general overthrow*."[2] Fildes' painting transforms Dickens' words into a piteous image. The bowed heads and tattered clothing of the gathered poor quickly register their tragic circumstances. Posters on the wall behind the queue underscore society's indifference to those living on its margins: a poster offering £2 for a missing child

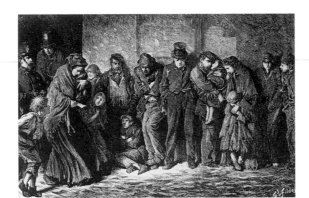

FIGURE 23

Luke Fildes, "Houseless and Hungry," *Graphic*, 12 April 1869

is juxtaposed with another offering £20 for a missing dog. The solid architecture of the police station, with its rusticated and barred gateway, suggests the hard face that Victorian society presented to its poor despite Britain's thriving economy and civic institutions.

The genesis of the painting was an illustration, "Houseless and Hungry" (fig. 23), that Fildes had made for the *Graphic*. It was based on a scene the artist had observed while strolling through London late on a snowy night. Fildes reportedly hired occupants of casual wards as models. His son recalls that the portly man in the center of the composition, wearing a top hat, was made "to stand on sheets of brown paper sprinkled with Keating's Powder" before each sketching session. Nevertheless, he eagerly participated in exchange for mugs of porter, "replenished at intervals by the pot-boy from the nearest pub."[3] There are at least half a dozen extant sketches related to "Houseless and Hungry," attesting to Fildes' repeated attempts to capture the appearance of his models. In the final image, each figure became recognizable as a social type. The text accompanying Fildes' print

identified the various figures, including a woman and two children forced to leave their home after her husband was imprisoned for assaulting her; an aged alcoholic, whose worn but well-to-do clothing indicates that he "has sacrificed comfort and position to drink"; and a laborer in a soft-peaked cap with his ill wife.

In 1872 Fildes translated his engraving into a large-scale oil painting, to which he added more figures and altered the pose of others. These changes encourage a more sympathetic reading. On the far left, Fildes added what was described as a "hungry, cold, and seedy, yet half-respectable adventurer listening to the directions of a good-natured policeman." The startled gaze of the "adventurer" quickly conveys to the viewer the dismal sight presented by the long line of applicants. Likewise, Fildes altered the gesture of the woman with the baby so that she looks away from the line of homeless, using her shoulder as if to shield her child from the sight. Her black dress led a reviewer to speculate that she was either a widow or a "female outcast" who, having given birth to an illegitimate child, has been evicted from her home. Her

fine clothes, as well as her daughter's leather slippers, suggest that they are unaccustomed to poverty. Similarly, the once fashionable dresses of the artisan's children are ill suited for a wintery night. Fildes also included less sympathetic types. At the far right, a "ruffian garotter or ticket-of-leave burglar" and a "professional beggar, with his crutch and red coat" cower in the shadows. As the *Illustrated London News* observed, the painting presented "a series of types of the most abject forms of London misery, whether rising from misfortune, crime, sickness, drunkenness, or ignorance."[4]

The dark palette of the painting, composed largely of grays, browns, and blacks, reinforces the theme of misery. Fildes retained the darkened atmosphere of his black-and-white print while suggesting the murky yellow light produced by the city's lanterns on a snowy night. The lantern light lifts the gray veil of gloom that suffuses the canvas to reveal the pallor of the faces in the waiting queue. Thickly textured brushwork registers the effect of objects seen through the darkened haze. Judiciously introduced spots of color act

as highlights and guide the viewer's eye across the painting. The red patterns of the young mother's shawl, for example, are picked up again by the red neckerchief of the "out of work artisan" and the beggar's red coat.

While critics praised the realism of *Applicants for Admission to a Casual Ward*, they debated whether such a subject was suitable for painting. The *Saturday Review* stated that the work was "too revolting for an art which should seek to please, refine, and elevate,"[5] while *The Academy* countered by claiming that "tender feeling" so abundantly filled the painting that the painter's choice of subject matter was completely justified.[6] The painting caused such excitement at its first exhibition at the Academy that a railing had to be erected to keep the crowds at a safe distance. It was purchased for the princely sum of £1250 by Thomas Taylor, a wealthy cotton manufacturer, who installed the work in the art gallery of his country house, Aston Rowant in Oxfordshire. A.H.

Notes

1. *The Art Journal*, July 1874, 201.
2. *Royal Academy* 1874, 22.

3. Fildes 1968, 25.

4. *The Illustrated London News,* 9 May 1874, 446.

5. *Saturday Review,* 2 May 1874, 562.

6. *The Academy,* 23 May 1874, 585.

46

..

James Tissot

The Ball on Shipboard

c. 1873/1874, oil on canvas, 33 ⅛ x 51 (84.1 x 129.5). *First exhibited*: Royal Academy 1874 (no. 690). *References*: Matyjaszkiewicz 1984, 69 (no. 66); Wentworth 1984, 114–116

Tate Gallery, London. Presented by the Trustees of the Chantrey Bequest 1937

In many ways the centerpiece of Tissot's work in Britain, *The Ball on Shipboard* shows to a high level of refinement the irony that suffuses his portrayal of fashionable society. His scenes from modern life are gentle comedies in paint, designed to make his viewers smile at their own foibles and vanities. He never sermonizes; nothing could be further from

his mind than the kind of moral indictment offered, for instance, by William Holman Hunt in *The Awakening Conscience* (cat. 16). He shows too evident a delight in beauty and pleasure, in his characters' finery and savoir faire, for his meaning to be taken as disapproval. Ever so gently he mocks what he loves, maintaining a cool, dandyish detachment from the sophisticated set while reveling in every detail of its appearance and behavior.

The shipboard ball is supposedly taking place during the week of the annual sailing regatta at Cowes on the Isle of Wight, which would mean that the ship is in the Solent, and the hills visible at left are on the island. Typically, Tissot shows little interest in the particulars of the place, focusing instead on the guests and their social interaction. The couples placed here and there on the decks impart an atmosphere of a *fête galante*, a distinctly French type of painting showing episodes of courtship in an idyllic setting. Tissot may even have had in mind the most famous example of the genre, Watteau's *Pilgrimage to the Island of Cythera* (Louvre); the idea of equating the Isle of Wight with the mythic Cythera, island of

romantic love, might well have appealed to his sense of humor.

The number of unattached young women at the ball gives an impression of flirtation and amorous possibility in the air. But although this is a party, there is no smiling and laughing in evidence: the blasé, slightly bored look was a vanity of the high life that Tissot always observed with relish. Neither is there much conversation going on, and the positions and gestures of most of the guests suggest disconnection rather than togetherness. The leading comic idea of the work is that the ball is so clearly an occasion for looking chic rather than enjoying oneself. His characters immaculately isolated within the crowd, attending a party they cannot leave—at least until the ship docks—perhaps Tissot even intended some wry reflection on life in general.

Tissot probably studied the setting from an actual ship, but added the figures, the costumes, and most of the props in the studio. Some of the models for the figures are from the group that appears like a repertory company throughout his modern-life pictures. The young woman holding a fan in the left foreground, for instance, plays the female lead

in *The Last Evening* (c. 1872/ 1873; Guildhall Art Gallery); she was Margaret Freebody, the wife of a ship's captain. She also appears, along with the elderly man in the boater, in the foreground of the concert scene known as *Hush!* (c. 1874/ 1875; Manchester City Art Galleries). Tissot used the striped outfit she is wearing, and that of the woman standing behind her leaning on the rigging, for the women in *London Visitors* (cat. 47). The chair by her side, and some of the other women's outfits, are also recognizable in other paintings.

More remarkably, some of the outfits appear more than once in *The Ball on Shipboard*. The scene contains three pairs of "twins" dressed identically: the pair in the boaters near the center, and those in pale blue and pale green, respectively, sitting together in the middle distance to the left; while the pink and brown ensemble worn by the woman ascending the stairs on the right reappears twice and possibly three times. This strange repetition may derive from fashion plates, which often show the same dress from different angles. Could it be a satirical comment on the conformity imposed by high fashion? Or is it a refer-

ence to the socialite's nightmare, which is to arrive at an event to find someone else wearing the same dress? Or a way of suggesting the same woman's movements to different parts of the ball over a period of time? Perhaps it is a piece of meaningless eccentricity. No one has advanced a satisfactory explanation; certainly it introduces an element of the absurd into what is otherwise a plausible, naturalistic account of this kind of occasion.

The painting is a tour de force of composition, in which a mass of color and detail, tending by its nature toward confusion, is kept deftly under control. The empty floor space in the right foreground, moving away to the left, establishes a firm perspective and provides pictorial relief from the busyness elsewhere. The apparently casual cutting-off of figures at the left is a device borrowed from French avant-garde art, recalling, in particular, the work of Tissot's friend Degas.

With its touches of cleverness and quirkiness, its fluent, deadpan technique, its bright color key, its lack of anecdote and moral content, *The Ball on Shipboard* was not at all what British critics and exhibition-goers were used to seeing in paintings of modern life. When shown at the Royal Academy of 1874, it struck some as willfully incomprehensible, a tease, others as "garish and almost repellent."[1] It was bought from the artist, despite the poor reviews, by Agnew's, the foremost dealers in modern British art. M.W.

Notes

1. *Illustrated London News*, 16 May 1874, 470.

47
..

James Tissot

London Visitors

c. 1873/1874, oil on canvas, 63 x 45 (160 x 114.3). *First exhibited*: Royal Academy 1874 (no. 116). *References*: Wentworth 1984, 117

The Toledo Museum of Art, Toledo, Ohio. Purchased with Funds from the Libbey Endowment, Gift of Edward Drummond Libbey

In another of Tissot's gently comic scenes from contemporary life, an elegantly dressed couple touring London consider what sight to see next after a visit to the National Gallery. The setting is the gallery's portico, with the church of Saint Martin-in-the-Fields in the background. From the clock on the steeple, we see that it is 10:35 in the morning, which means their visit to the gallery has been fairly short. The man hunts through his guidebook, while his companion looks directly out at us and points with her umbrella toward Trafalgar Square. Her gesture with the umbrella may be an invitation to meet her later, secretly, in the square. Certainly she seems little interested in the tour plans of the man she is with, whether he be her husband, lover, friend, or relative. Tissot delighted in giving his audience hints toward some narrative that might be unfolding in his pictures—the cigar on the portico steps, highly cluelike even if not actually smoking, is another instance—although he was careful never to spell things out fully, leaving the possibilities open and tantalizing. What he meant as playful ambiguity was taken by the critics as a fault, however, and the *Art Journal* was typical in upbraiding *London Visitors* for its lack of "distinct and intelligible meaning."[1]

The couple are probably intended to be British rather than foreign visitors. Tissot enjoyed painting what he regarded as classic British features, and in all likelihood thought of the ginger-bearded young man in tweeds as a distinct national type. He also liked wherever possible to put his male figures in uniform, and the boys on the portico are Bluecoat Boys, scholars at Christ's Hospital who served as informal guides to this area of town; the one in the foreground appears as a type too, his upturned nose and half-closed eyes the classic attributes of the juvenile British snob. The dresses of the two women in the painting both appear on the left side of *The Ball on Shipboard* (cat. 46); the woman in the stripes seems to be a different model, but the one in the background in each case, wearing a double-breasted jacket, may be the same.

The painting is composed as what Whistler might have called a symphony in gray, the all-over grayness relieved by the colors in the characters' faces, the yellow of the boys' stockings, the brown of the man's suit and the couple's gloves, the blue-gray outfit of the woman in the background, and the tinges of pink in the sky. No doubt Tissot intended his coloristic keynote as a wry

observation on the British weather, the general grayness that the visitor to London has to expect there. The composition is typically ingenious and daring, his principal figures placed well off-center and large areas occupied by stonework; the effect is that of a casual glimpse, although the play of horizontals and verticals, and the alternation of tones, is, in fact, highly calculated.

In 1878 Tissot made an etching of the same setting with a slightly different scenario: the Bluecoat Boys and the woman in the background are omitted, the tourist couple toned down, and the figure of his beloved Kathleen Newton, carrying a portfolio under her arm, shown descending the portico steps in the left foreground.[2] M.W.

Notes

1. *Art Journal*, n.s. 13, June 1874, 163.

2. Wentworth 1978, 178–181, no. 40.

48

..

James Tissot

On The Thames

c. 1875/1876, oil on canvas, 28½ x 46½ (72.4 x 118.1). *First exhibited*: Royal Academy 1876 (no. 113). *References*: Matyjaszkiewicz 1984, 114 (no. 81); Wentworth 1984, 107–109

Wakefield Museums and Arts

The single man with a pair of attractive young women was Tissot's favorite cast of characters, and in this case it is a sailor taking his lady friends for a pleasure-boat trip through the Pool of London, the busy stretch of dockland immediately downriver from the Tower. It would have been considered "fast" in the extreme for women to entrust themselves, unchaperoned, to the perils of a champagne picnic on the river with a young sailor. Whether they are a pair of sisters, friends, or merely rivals, the implication is that the sailor will be choosing one or the other, if not both, as the object of amorous advances; they will be as defenseless as their little pug dog would be

against an attack by the sailor's mongrel. When Tissot published a similar subject in the form of an etching,[1] he gave it the title *Entre les deux mon coeur balance*, "Between the two my heart swings." As if the situation alone were not suggestive enough, a scantily clad figurehead above the sailor seems to body forth his thoughts. As in Whistler's *Wapping* (cat. 27), the Pool is presented as a wonderfully picturesque modern environment where the usual standards of sexual morality do not apply. The general composition of the work also recalls *Wapping*, while the striking viewpoint, looking from inside the boat toward the stern, may owe something to paintings by Tissot's French contemporaries, including Manet's *En bateau* (1874; Metropolitan Museum of Art, New York).

Tissot showed *On The Thames*, along with his etching of the same subject,[2] at the Royal Academy in 1876. There the hedonism and suggestiveness of the work struck the critics as risqué bordering on the outrageous. *The Times* called the subject "questionable material," and the *Athenaeum* found the painting, as a whole, "thoroughly and wilfully vulgar." As before with Tissot's work, the

critics dwelled on its Frenchness. Although the young women were "rather more acceptable types of *belles anglaises* than the disdainful misses the artist usually selects," the *Illustrated London News* remarked, "The supercilious air of the sandy-haired officer seems to smack of French satire." Even the *Graphic*, usually a strong supporter, described the work as "hardly nice in its suggestions. More French, shall we say, than English?"[3] Though generally favorable, the British response to Tissot's art was often tinged slightly with resentment, and at its worst could slip into xenophobia. The humorous portrayal of British types was all very well in the work of a native painter such as William Powell Frith, but coming from a Frenchman it seemed more than a little presumptuous. Many suspected that Tissot might be making fun of them, of British manners and morals, even of Britishness itself, and they were probably quite right. In any case, the poor reception of *On The Thames* at the Academy must have helped Tissot in his decision to show his work in following years at the new, more sophisticated and cosmopolitan Grosvenor Gallery. M.W.

Notes

1. Wentworth 1978, 140–141,
 no. 30.
2. Wentworth 1978, 98–103,
 no. 20.
3. Reviews quoted from Went-
 worth 1984, 88, 108.

49

..

John Frederick Lewis

The Midday Meal, Cairo

1875, oil on canvas, 34½ x 45½
(87.6 x 115.6). *First exhibited*:
Royal Academy 1876 (no. 187).
References: Green 1971, 33 (no.
88); Thornton 1983, 68–69

Mrs. Bunny C. Price

J.F. Lewis was one of the best
known orientalist painters of
Victorian England, and his oils
and watercolors were held in
high regard by both patrons
and his fellow artists. Edward
Lear, in a letter to Lewis' wife,
asserted that Lewis painted
the Middle East with greater
fidelity than any other artist:
"There never have been, &
there never will be, any works
depicting Oriental life—more
truly beautiful & excellent—
perhaps I might say—*so* beauti-
ful & excellent. For, besides

the exquisite & conscientious
workmanship, the subjects
painted by J.F. Lewis were per-
fect as representations of real
scenes & people."[1] Unlike
most orientalists, Lewis was
not interested in the ancient
civilizations or biblical associ-
ations of the Middle East;
rather, he focused his attention
on its people.

In 1841 he traveled to Egypt
and settled in Cairo, where he
lived for ten years. This lengthy
stay was unusual; most orien-
talist painters visited the Mid-
dle East for only a brief period
of time. According to visitors,
Lewis lived "in the most com-
plete Oriental fashion" and
wore Eastern dress. *The Midday
Meal, Cairo* depicts his home in
the Ezbekiyah quarter of Cairo,
which was described by the
novelist William Makepeace
Thackeray, who visited Lewis
while on a tour of the eastern
Mediterranean in 1844:

My first object on arriving here
was to find out his house, which he
has taken far away from the haunts
of European civilization, in the
Arab quarter. It is situated in a
cool, shady, narrow alley. . . . First
we came to a broad open court,
with a covered gallery running
along one side of it. A camel was
reclining on the grass there; near

him was a gazelle to glad J. with
his dark blue eye; and a numerous
brood of hens and chickens, who
furnish his liberal table. On the
opposite side of the covered gallery
rose up the walls of his long, queer,
many-windowed, many-galleried
house. . . . Pigeons were flapping,
and hopping, and fluttering, and
cooing about. . . . The paint was
peeling off the rickety, old, carved,
galleries; the arabesques over the
windows were chipped and worn;
—the ancientness of the place
rendered it doubly picturesque.[2]

Every detail of the scene
is meticulously rendered.
The grapes, melons, oranges,
peaches, and pomegranates
are all identifiable, as are the
roses in the blue vase behind
the diners. The fruits and
flowers are presented as still
lifes, with painstaking attention
to the play of light across sur-
faces, and to the materiality
of objects such as smooth glass,
polished porcelain, and deli-
cate rose petals. It is a scene
of abundance: the table is
crowded with fruit and dishes,
and the diners, arrayed in gar-
ments of different hues and
patterns, take obvious pleasure
in their meal, as do the servants
standing behind them. Such
an image of luxury and insou-
ciance underscored the British

perception of oriental culture
as sensual, if not hedonistic,
and therefore vastly different
from their own. Indeed,
Thackeray claimed that Lewis
remained in Cairo, "away from
the decent and accustomed
delights" of England because
of the freedom from social con-
ventions that oriental culture
permitted him: "here he lives
like a languid Lotus-eater—a
dreamy, hazy, lazy, tobaccofied
life. He was away from evening
parties, he said: he needn't
wear white-kid gloves, or
starched neck-cloths, or read
a newspaper."[3]

The painting calls attention
to other aspects of oriental
culture that drew the interest
of the British. Reacting against
the spread of industrial, ma-
chine-made products, British
architects and designers turned
to Middle Eastern architecture
and decorative arts as models
of craftsmanship, praising their
textures, patterns, and colors.
Ornamental tiles, for example,
such as those shown at the
back of the gallery, were highly
prized; the painter Frederic
Leighton owned a collection
of tiles imported from the
Middle East that were used to
construct an "Arab Hall" in
his home (fig. 24).

The Midday Meal, Cairo is

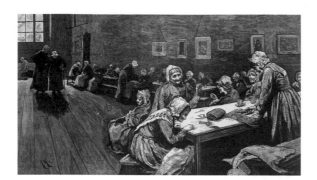

executed in Lewis' characteristic highly finished brushwork. He intended his paintings to be windows onto reality, and believed that a mirrorlike surface was required to sustain the illusion. He explained his ideas on this subject to John Everett Millais and William Holman Hunt as early as 1851, when he himself was still working in watercolor: "I am sure that oil painting could be made more delicate than either of you make it; not sufficient pains are taken to make the surface absolutely level. . . . I intend to take to oil colours myself, and, damme, I'll show you how it ought to be done. The illusion of all modern painting is destroyed by its inequality of surface."[4] A.H.

Notes

1. Letter to Mrs. Lewis, quoted in Noakes 1985, 21.
2. Thackeray 1991, 142–144.
3. Thackeray 1991, 146.
4. Hunt 1905, 270.

50

Hubert von Herkomer

Eventide: A Scene in the Westminster Union

c. 1877–1878, oil on canvas, 43 1/2 x 78 1/4 (110.5 x 198.8). *First exhibited*: Royal Academy 1878 (no. 1002). *References*: Edwards 1984, 226–242; Treuherz 1987, 53–64, 93–95 (no. 80a); Morris 1996, 212–215

The Board of Trustees of the National Museums and Galleries on Merseyside, Walker Art Gallery, Liverpool

Herkomer's *Eventide* reveals the significant role art played in articulating social issues of the late Victorian period. The painting depicts elderly female inmates of a workhouse, an institution devoted to the indigent. Intended to replace outdoor relief—abolished by the New Poor Law of 1834— workhouses provided the barest minimum of living conditions in exchange for useful labor, such as stone breaking, oakum picking, and needlework. To ensure that the workhouse would be used only as a last resort, draconian rules were enforced: families were broken up, no visitors were allowed, masters and matrons supervised all activities, and special workhouse dress was required. In an 1850 article in *Household Words*, Charles Dickens recorded the bleak scene at a workhouse he visited:

Generally, the faces . . . were depressed and subdued and wanted colour. Aged people were there in every variety. Mumbling, bleareyed spectacles, stupid, deaf, lame; vacantly winking in the gleams of the sun . . . leering at nothing, going to sleep, crouching and drooping in corners. . . . Upon the whole, it was the dragon, Pauperism, in a very weak and impotent condition; toothless, fangless, drawing his breath heavily enough, and hardly worth chaining up.[1]

Herkomer's painting began as a wood engraving, "Old Age—A Study at the Westminster Union," published in the *Graphic*, a magazine known for its treatment of social issues (fig. 25). The engraving captures the spirit of Dickens' description with its focus on dispirited, sunken-cheeked women either vacantly staring, sleeping, or struggling to perform needlework despite the infirmities of old age. It arose from Herkomer's visit to the Saint James' Workhouse at the Westminster Union on Poland Street, in the Soho section of London, where he found "these poor old bodies formed a most touching picture."

In the painted version, Herkomer both embellished his theme of impoverished old age and lightened the tone of his engraving. In the foreground, a group of women, clothed in their regulation blue dresses and numbered caps, gather around a table to read, do needlework, and take tea, a luxury permitted to only older inmates of the workhouse. In addition to the tea, Herkomer introduced other comforts in the painting, including a book in the lap of the woman seated with her back to the table and a fire around which inmates gather at the left. At the far right of the table Herkomer introduced a young undermatron. Her unlined face and smoothed hair contrast with the craggy features and ruffled bonnets of the inmates, whose gnarled fingers grasp their sewing implements with difficulty. The pathos of their situation is communicated by the poignant expressions of the two women who look directly at the viewer, their weary faces etched with the effects of time. But

there is a note of winsomeness in their expressions, especially in that of the older woman sipping tea from her saucer.

Despite such notes of humanity, the general tone of the work remains bleak. The "24" stitched on the cap of the woman vainly attempting to pick up a needle with her arthritic hands reminds viewers that these women have, in many ways, been reduced to numbers. The uptilted floor and elevated viewpoint create a cavernous space that almost overwhelms the huddled women and underscores their social insignificance. Herkomer's artful use of backlighting calls attention to the physical frailty of the women walking at the rear of the room. The somber coloring of the painting, relieved only by the background light and touches of red and white in the foreground, is in keeping with the gloomy theme. The strongly marked perspective, dark tonality, and attention to the materiality of paint and the objects it represents suggest that Herkomer was looking at seventeenth-century Dutch interiors, still lifes, and portraits, particularly those of Frans Hals and Rembrandt.

Homey details and vignettes relieve the dour interior. A black cat curls up in the left foreground, although one critic noted with surprise that "he is left uncaressed by any of the inmates."[2] Flowers decorate the foreground table and prints hang on the right wall, leading one critic to note happily that "the occupants are not altogether forgotten by the outer world."[3] Such decorative touches, while permitted in some workhouses, were criticized by workhouse inspectors, who argued that providing material comforts only encouraged workhouse inmates to stay rather than obtain gainful employment. They argued that fear and revulsion of the workhouse provided an inducement "to the young and healthy to provide support for their later years, or . . . to support their aged parents and relatives."[4]

The prints also add an autobiographical note to the work. Herkomer's fellow *Graphic* illustrator Luke Fildes is represented by a reproduction of his painting *Betty*, and there is also a study of two figures from Herkomer's painting *The Last Muster: Sunday in the Royal Hospital Chelsea* (1875), a depiction of elderly veterans attending a service at a hospital chapel. *Eventide* and *The Last Muster*

are often paired in critical discussions of Herkomer's oeuvre, as both explored contradictions inherent in modern Britain, which faced seemingly intractable social problems despite being the wealthiest nation in the world. A.H.

Notes

1. Crowther 1981, 193.
2. W.M. Rossetti, "The Royal Academy Exhibition, Second Notice," *The Academy*, 25 May 1878, 470.
3. *Athenaeum*, 4 May 1878, 577.
4. Longley 1874, 101.

51

...

Hubert von Herkomer

Hard Times

1885, oil on canvas, 34 $\frac{1}{16}$ x 44 $\frac{1}{8}$ (86.5 x 112). *First exhibited*: Royal Academy (no. 1142). *References*: Edwards 1984, 258–268; Treuherz 1987, 96–101 (no. 82)

Manchester City Art Galleries

A dispiriting treatise on the effects of the agricultural depression on the rural laboring class, *Hard Times* embodies many of the key tenets of the

social realist movement in British painting at the end of the nineteenth century. At the time of its first exhibition, the *Art Journal* labeled it a "study in modern sociology."[1] According to Lee Edwards, the origins of Herkomer's canvas can be traced to March 1884, when he urged his student Mary Godsal, who wished to paint a scene of rural poverty, to "get real tramps and really pose them under a hedge, and a sick child, and put them in several positions." As this advice indicates, Herkomer held up naturalism as the highest goal in art. For his own tramp picture, he used a local landscape—Coldharbour Lane in Bushey, Hertfordshire—and erected a glass hut from which to paint it. The Quarry family of Merry Hill Lane, Bushey, modeled for the figures, which were actually painted in the studio and laid in over the landscape.

Herkomer described the subject in his autobiography as expressing:

a distress amongst the labouring classes, poignantly felt by them that year. Hundreds of honest labourers wandered through the country in search of work; the man, with pickaxe and shovel tied together—his only stock-in-trade—

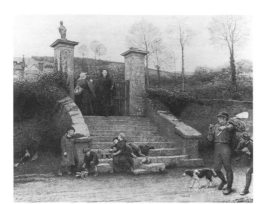

FIGURE 26

Frederick Walker, *The Old Gate*,
1869, oil on canvas. Tate Gallery

and his bulky bundle of household goods (that had escaped the pawn-broker) slung across his strong shoulders; the woman following, with smaller bundle hanging from the wrist of the arm that supported the babe wrapped in her shawl; and the other little ones trudging after mother and father as best they could, giving a diminishing line to the wretched procession.[2]

The distress to which Herkomer referred was caused by the depression that undermined British agriculture from the late 1870s to the mid 1890s. Historians have debated the extent and significance of this depression. Farmers blamed poor harvests caused by successive seasons of inclement weather, but when they took whatever grain they could harvest to market they discovered that the price of wheat was rapidly falling due to cheap imports from the United States and Australia.[3] Industrial innovations, such as mowing and reaping machines and the self-binding reaper, also conspired to eliminate the need for labor. Between 1871 and 1891 the number of agricultural laborers declined by almost a third. The "hundreds of honest laborers wandering the country in search of work" described by Herko-

mer were perhaps the most tragic signs of the depression.

The time of year Herkomer depicted is also significant. The bleak landscape not only underscores the desperate situation of the family, but also may signify the rural practice of ending contracts on March 25, "Lady Day." In *Tess of the D'Urbervilles* (1891), Thomas Hardy described how in the late nineteenth-century, large portions of the rural population moved on this day in search of better positions. If the laborer had already secured a contract, the employer usually sent a wagon for moving. Traveling on foot indicated unemployment.

Herkomer makes the plight of the family obvious by compositional and painterly means as well. The father, with his possessions wrapped in a bundle slung across his shoulders, looks piercingly down the road, hoping for signs of a more prosperous future in the farm buildings beyond. The mother, slumped to the side of the road with an exhausted expression, is burdened not only with a sack of her own, but also a small baby, who nurses at her breast. Her other child rests his weight against her knee. It is a family, one suspects, that has seen better

times: the mother wears a fine black hat that matches her dress and the father owns the tools of his trade. Placed at the lower left of the painting, the figures are balanced against the seemingly endless road that winds before them. Viewers are guided through this landscape by touches of red: the father's kerchief, berries in the hedge-row, the mother's cheeks, her bundle, the baby's cap, the boy's scarf, and the distant rooftops. The browns and dull greens suggest a dormant landscape, and the leafless trees underscore an impoverished image of the countryside.

As in *Eventide*, Herkomer strove for a tone of poignancy. His means of achieving this in *Hard Times* was much indebted to the formula developed by the highly influential landscape painter Frederick Walker. Herkomer often spoke warmly of Walker's positive influence on his work, and in the 1885 Royal Academy exhibition, along with *Hard Times*, he exhibited two prints after works by Walker, *The Old Gate* (fig. 26) and *Philip in Church*. As Herkomer himself explained in an 1893 article, Walker, who studied the Parthenon sculptures in the British Museum, combined "the grace of the antique with the realism

of our everyday life in England. His navvies are Greek gods and not a bit less true to nature." Although not to the same extent as Walker, Herkomer endowed his figures in *Eventide* with a monumentality that suggests classical models. The way the mother's gown drapes over her knees recalls the female figures of the east pediment of the Parthenon, and the father, despite his heavy bundle, stands broad-shouldered in a classical *contrapposto* pose. The nobility these figures display in spite of their straitened circumstances renders them sympathetic to the viewer. Several critics perceived the link to Walker and responded favorably; the reviewer for *Blackwood's Magazine*, for example, called *Hard Times* "a picture that echoes the cry of humanity in these bad times."
A.H.

Notes
1. *The Art Journal*, July 1885, 226.
2. Herkomer 1910, 250–251.
3. See Armstrong 1990, 1:113–114.

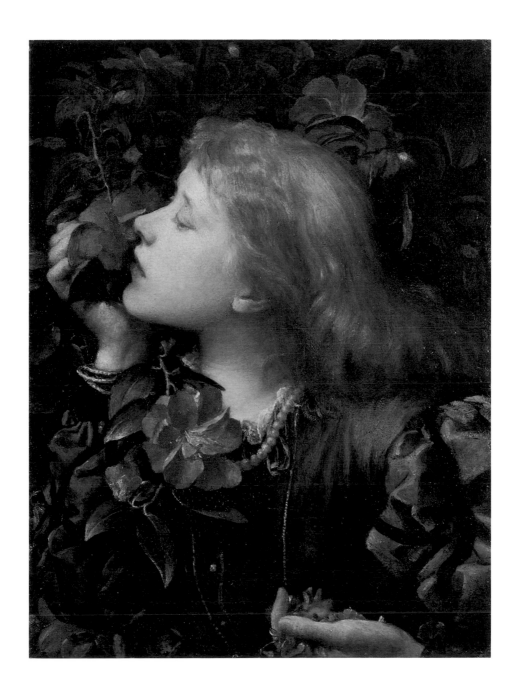

Paolo and Francesca
George Frederic Watts

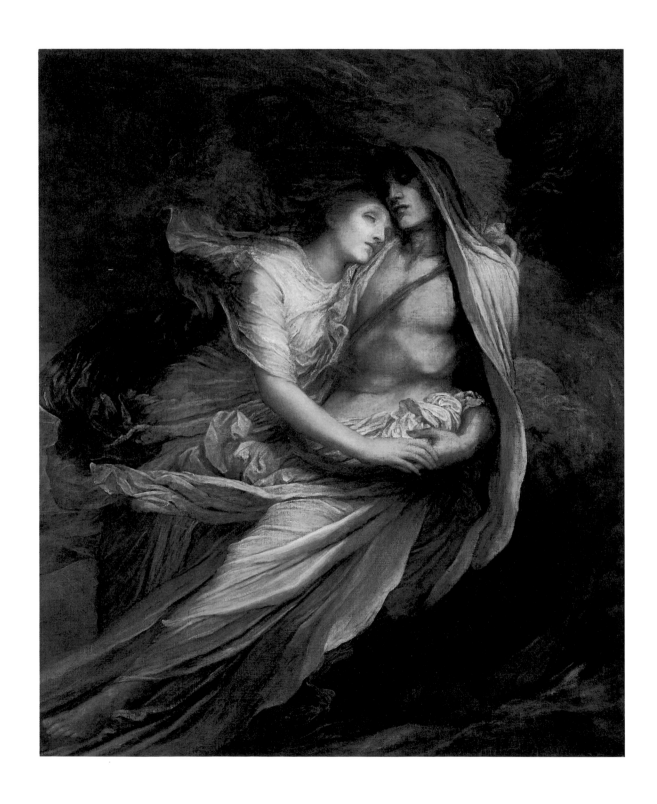

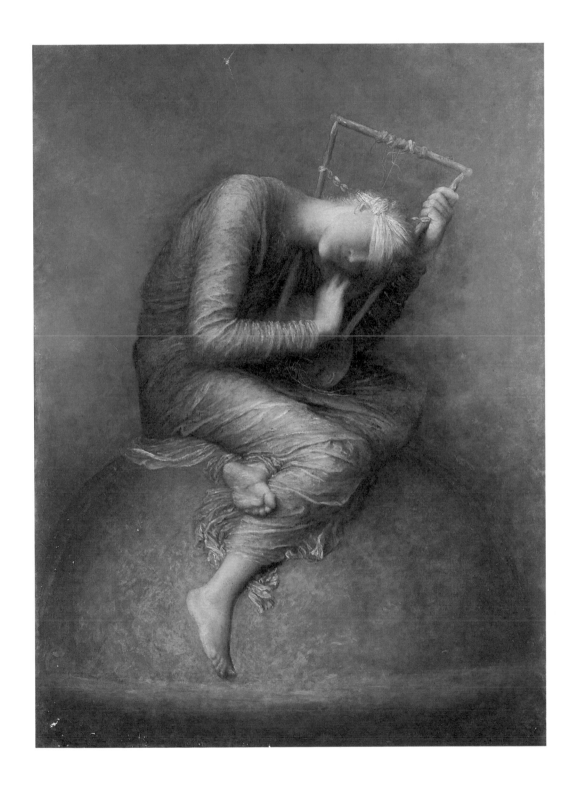

The Sower of the Systems
George Frederic Watts

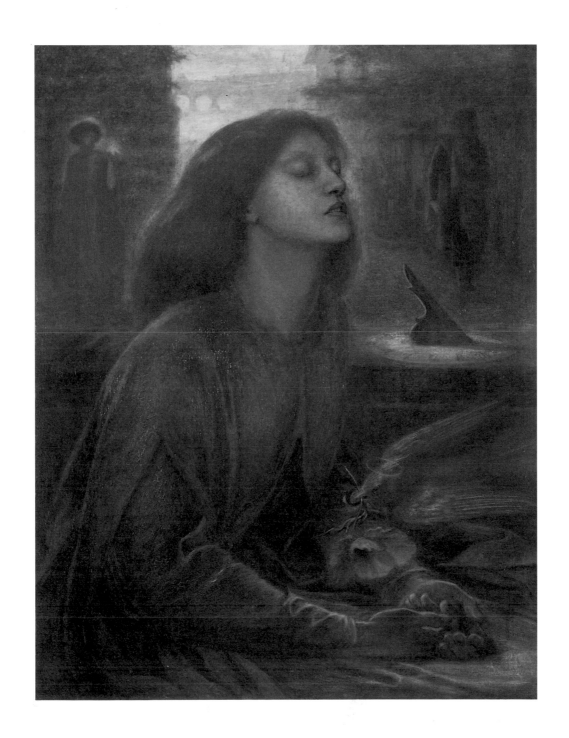

The Beloved (The Bride)
Dante Gabriel Rossetti

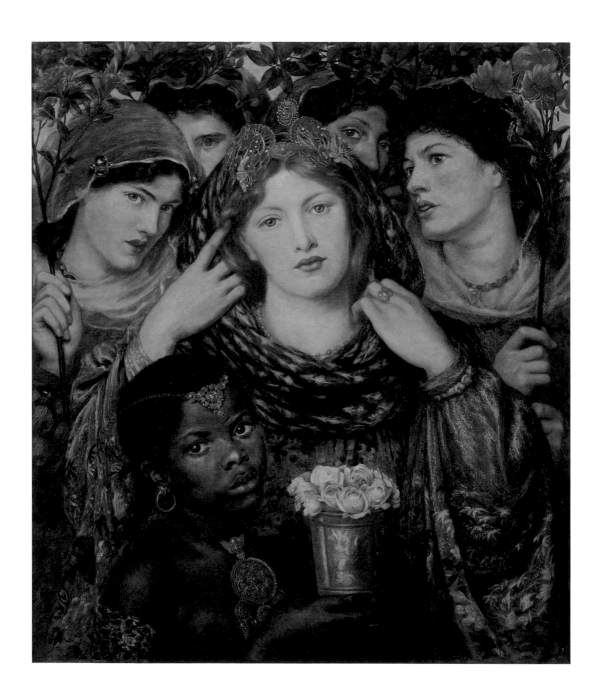

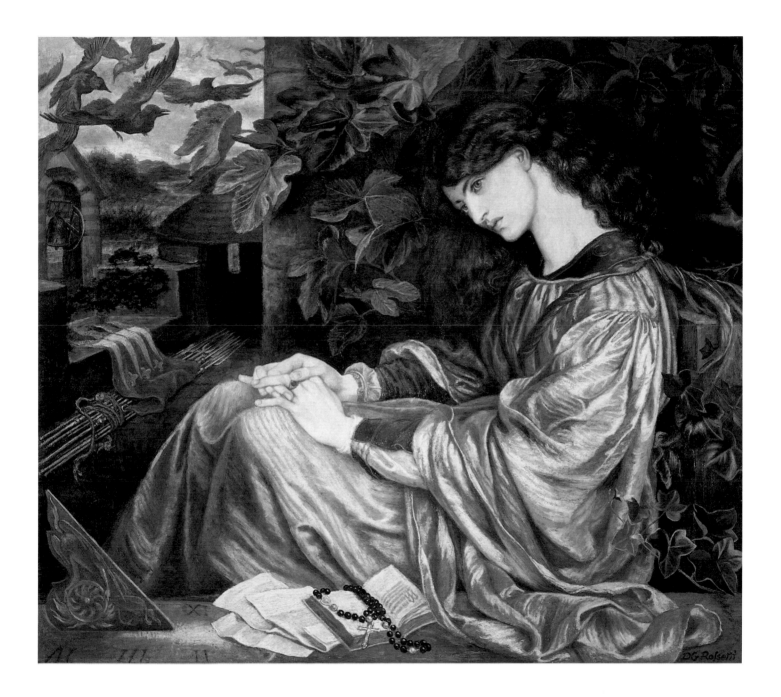

Le Chant d'Amour
Edward Burne-Jones

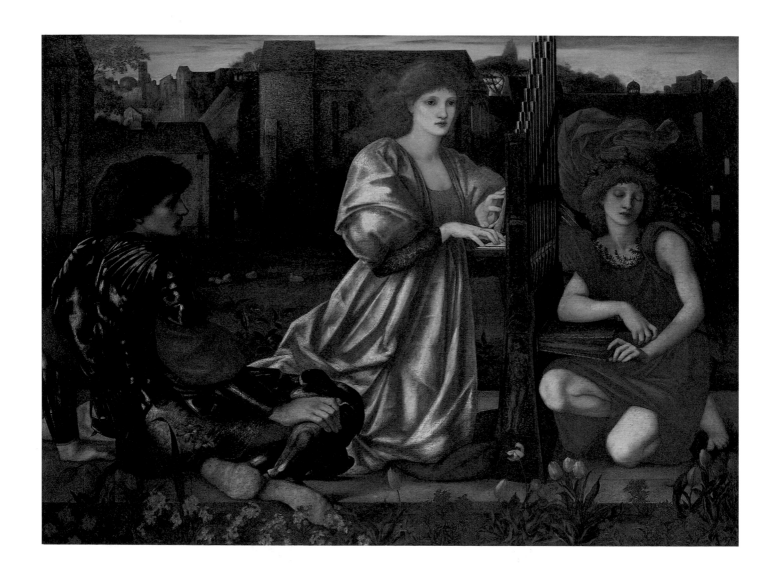

The Prince Enters the Wood

Edward Burne-Jones

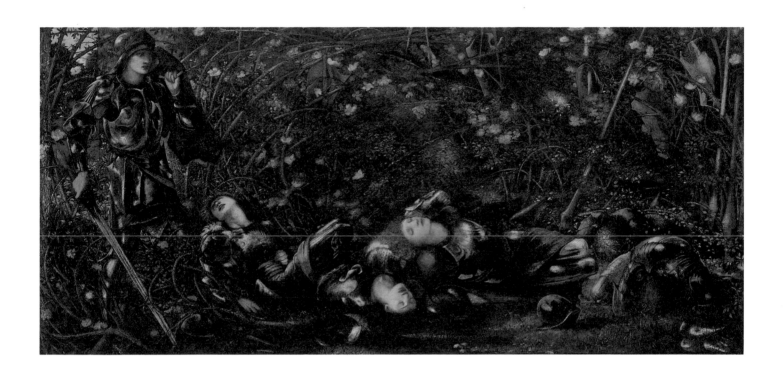

The Sleeping Beauty
Edward Burne-Jones

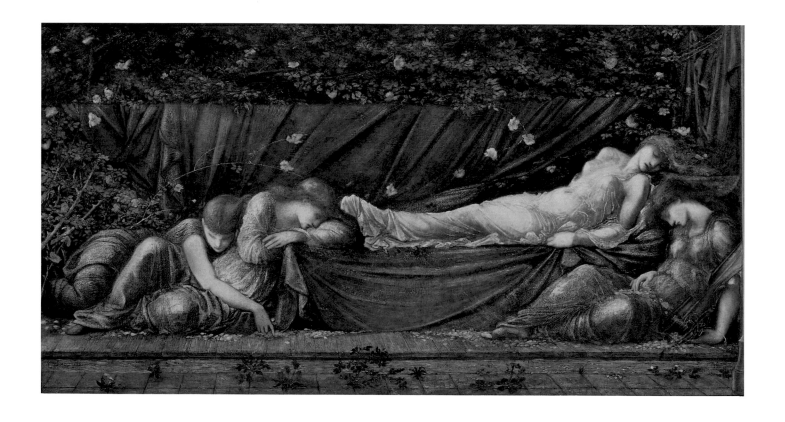

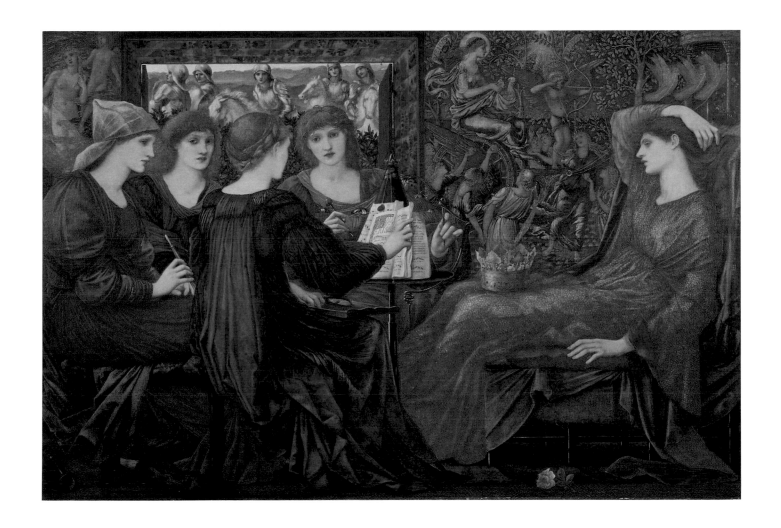

The Doom Fulfilled
Edward Burne-Jones

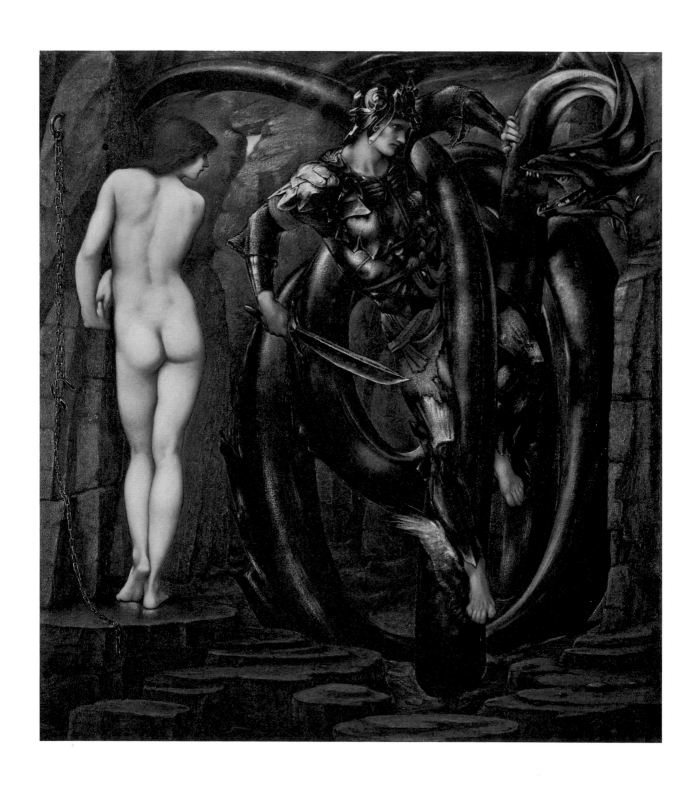

A Hymn to Spring
Cecil Gordon Lawson

The Pyramids Road, Gizah
Edward Lear

Applicants for Admission to a Casual Ward
Samuel Luke Fildes

The Ball on Shipboard
James Tissot

London Visitors
James Tissot

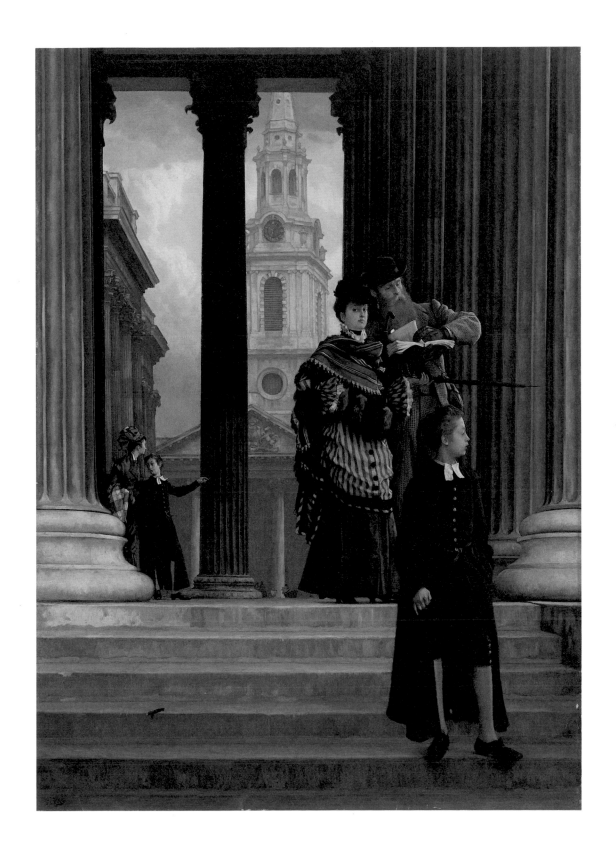

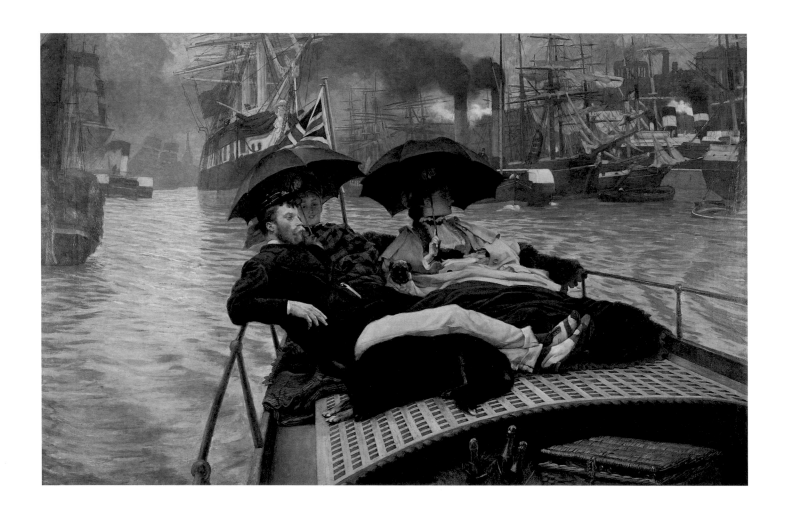

The Midday Meal, Cairo
John Frederick Lewis

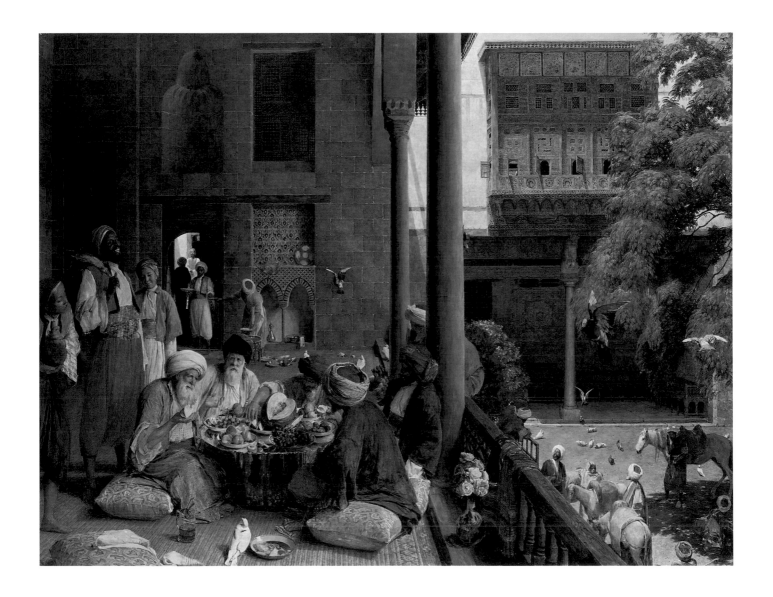

Eventide: A Scene in the Westminster Union
Hubert von Herkomer

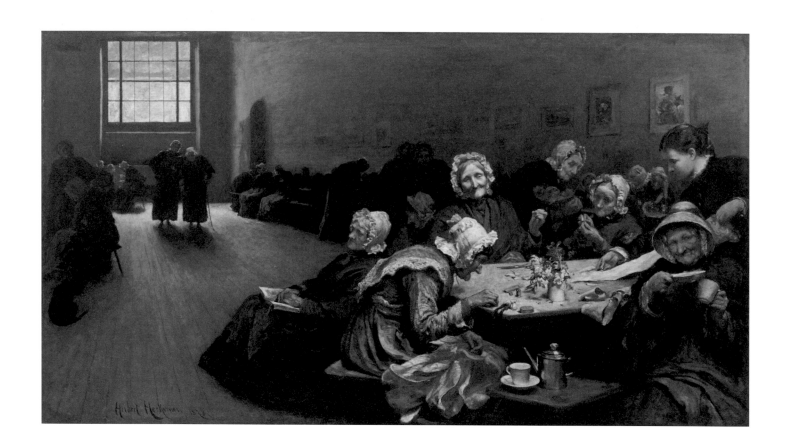

Hard Times

Hubert von Herkomer

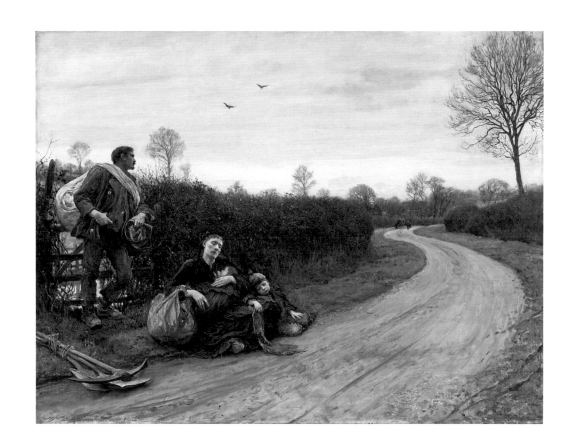

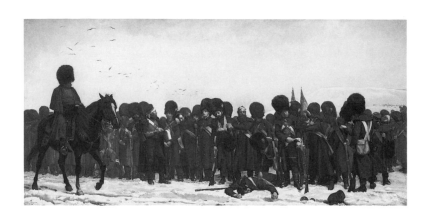

52

...

Elizabeth Thompson (Lady Butler)

Balaclava

1875–1876, oil on canvas, 40 ¹¹/₁₆ x 73 ¹³/₁₆ (103.4 x 187.5). *First exhibited*: Fine Art Society, April 1876. *References*: Usherwood and Spencer-Smith 1987, 64–66 (no. 25)

Manchester City Art Galleries

Like *The Roll Call* (fig. 27), which made Elizabeth Thompson's name at the Royal Academy exhibition of 1874, *Balaclava* is a scene of suffering and death among British troops in the Crimean War. The remnants of the Light Brigade of cavalry are shown returning after their famous, disastrous charge of 25 October 1854. After the British had repulsed a Russian attack on their base at Balaclava, their commander in the Crimea, Lord Raglan, ordered a cavalry advance to recover certain British-made guns captured by the Russians from Britain's allies in the war, the Turks. His instructions were misunderstood, however, and the Light Brigade, a force of more than six hundred of

the finest British cavalry, was dispatched instead to seize the main Russian position. The position was taken, but a third of the men were killed or wounded. For many the incident came to epitomize the ridiculous blundering on the part of the commanders, and great valor on the part of the ordinary soldiers, that marked Britain's involvement in the Crimean War. It was the subject of one of Tennyson's best known poems, "The Charge of the Light Brigade," some lines of which were quoted in the catalogue when *Balaclava* was first exhibited:

Storm'd at with shot and shell,
While horse and hero fell,
They that had fought so well
Came through the jaws of Death,
Back from the mouth of Hell,
All that was left of them,
 Left of six hundred.

As usual, Thompson went to considerable pains to ensure the accuracy of her reconstruction of the event, consulting veterans who had taken part in the charge twenty years before. She also sought out suitable models among military men: for the mounted troop sergeant in the left foreground, for instance, she used Major George

L. Smith, an officer of the 107th Foot (Bengal Infantry). The model for the hussar on foot near the center, whose expression of horror bordering on derangement speaks powerfully for the experience of all the men involved, was the actor W.H. Pennington. As a young man Pennington had seen service in the Crimea as a trooper of the 11th (Prince Albert's Own) Hussars, one of the five regiments that took part in the charge of the Light Brigade, and his combination of military and theatrical experience made him a natural choice for this leading role in the picture. Unfortunately for Thompson, the fact of his being an actor, along with the unusual strength of emotion about the figure compared to those in previous pictures such as *The Roll Call*, prompted some of the reviewers to criticize this element of the work as melodramatic.

Balaclava was a remarkable popular success. Its debut was a private, one-picture exhibition at the Fine Art Society, which opened shortly before the annual exhibition of the Royal Academy and attracted some fifty thousand visitors. The Society paid Thompson £3,000 for the copyright to the work, and published a repro-

ductive engraving during the exhibition. Afterwards it was toured around the country for a year, with showings in Newcastle upon Tyne, Scarborough, Birmingham, Leeds, Huddersfield, Liverpool, and Manchester, each of them a box-office success. The tour was interrupted briefly for a special showing of the picture at the Balaclava Banquet, a reunion of survivors held at the Alexandra Palace on the twenty-second anniversary of the battle, 25 October 1876. Pennington attended, and gave a recitation of Tennyson's poem. M.W.

53

...

Benjamin Williams Leader
February Fill Dyke

c. 1880–1881, oil on canvas, 47 x 71 ½ (119.4 x 181.6). *First exhibited*: Royal Academy 1881 (no. 42). *References*: Treble 1978, 49 (no. 27)

Birmingham Museums and Art Gallery

In the late Victorian period, a number of painters adopted the theme of the bleak landscape, and *February Fill Dyke* is per-

FIGURE 27

Elizabeth Thompson (Lady Butler), *Calling the Roll After an Engagement, Crimea (The Roll Call)*, 1873–1874, oil on canvas. The Royal Collection, © Her Majesty Queen Elizabeth II

FIGURE 28

John Constable, *Dedham Lock and Mill*, 1820, oil on canvas. Victoria and Albert Museum

haps one of the best known examples of this genre, which combined sentiment and naturalism. The title is from a popular English nursery rhyme, "February fill the dyke / Be it black or be it white; / But if it be white / It's the better to like," referring to farmers' hopes for snow or rain to fill the dikes or canals that watered their fields. Rather than a dike or canal, Leader painted water-soaked fields near a small village. In the foreground, large pools of water reflect the sky and nearby trees, and provide a feeding ground for ducks. A boy and girl walk along a rutted road with their dog. An old woman gathers sticks behind her cottage, beyond which stretches a village, marked by the church tower and rooftops. Trees fan out against the sky, their feathery branches backlit by the evening glow, and the clouds follow the path of the road.

In 1865, *The Art Journal* declared that Britain's "native school of landscape" had become "directly and dogmatically naturalistic." Leader was a key figure in this school because his work showed "truth delivered from eccentricity," in other words everyday landscapes unencumbered by sym-

bolic references.[1] Leader himself wrote, in a diary entry of 1859, that he strove to "faithfully and simply copy nature."[2] While obviously the product of the close study of nature prescribed by John Ruskin (Leader often sketched out-of-doors), *February Fill Dyke* is not painted with the sharp-edged, enamellike clarity associated with Pre-Raphaelite landscapes, but with flowing strokes of creamy paint. On the other hand, Leader's surfaces retain a sharpness of form and translucency of atmosphere vastly different from the diffused atmospheric tones of Leader's contemporary George Clausen.

February Fill Dyke harks back to a type of landscape painting developed by John Constable. In the 1820s, Constable produced a series of paintings based on the landscape of his native Stour Valley, the best known of which is *The Hay Wain* (1821; National Gallery, London). Leader owned a study of that painting. The church spire nestled among the trees, low-lying fields, diminutive figures, and looming trees of Leader's piece can be found in such Constable paintings as *Dedham Lock and Mill* (fig. 28), which was presented to the South

Kensington Museum in 1857 by John Sheepshanks. Although Constable's reputation was uncertain in his lifetime, by the 1860s he was regarded as the father of modern landscape painting, in part because of his marked influence on mid-century French Barbizon school painters. Loan exhibitions and sales, as well as gifts and bequests to London museums, brought Constable's work further popularity with British audiences in the late 1870s and 1880s.

Unlike Constable, who generally portrayed lush, productive landscapes, Leader has depicted a bleak wintery scene, relieved only by the blaze of color in the sky. The foreground is a marshy waste, the old woman is forced to pick up sticks for fuel, and exposed brickwork is visible in the cottage behind her. Critics did not comment on these expressions of the agricultural depression of the last quarter of the nineteenth century. Rather than deplore the signs of disrepair in Leader's painting, critics praised them: as the *Graphic* remarked, *February Fill Dyke* was "remarkable not less for its comprehensive truth of effect than for the fidelity with which the individual facts of nature

are rendered."[3] In the *Magazine of Art*, the work was described as an "exceedingly real" example of the literal school in painting because of the "illusory perspective of wet road stretching flatly away," the "fresh" and "exceedingly honest" execution, and the homeliness of the rural scene.[4] Moreover, according to *Art Journal*, the painting was "thoroughly English." Leader's "overflowing ponds," "plashy roads," "lowly cottages," "village church spire," and "pale, streaked sky" were greeted by critics as signs of landscape that could only be found in the English countryside. At a time when many art critics feared the influence of French painting techniques and subjects, Leader's painting must have struck a reassuring chord.

In 1884, Leader's dealers Arthur Tooth & Sons issued an etching of *February Fill Dyke* by Théophile Chauvel. Leader himself painted a second, reduced version (dated 1881), now in the Manchester City Art Galleries. A.H.

Notes

1. *The Art Journal*, June 1881, 186.
2. Quoted in Dean 1991, 6.
3. *Graphic*, 21 May 1881, 503.
4. *Magazine of Art*, August 1881, 398.

FIGURE 29

George Clausen, modern print of
academy plate, c. 1883. The Royal
Photographic Society, Bath

54

George Clausen

A Spring Morning, Haverstock Hill

c. 1880/1881, oil on canvas,
40 x 53 (101.6 x 134.6). *First
exhibited*: Royal Academy
1881 (no. 100). *References*:
McConkey 1980, 27–28
(no. 20)

Bury Art Gallery and Museum

One of several street scenes
Clausen painted around this
time, *A Spring Morning, Haverstock Hill* depicts a main road in
the Belsize section of southern
Hampstead, a suburb north
of London. Clausen had moved
to Hampstead, to the Mall
studios on Tasker Road near
Haverstock Hill, in 1877. He
remained there until 1881,
when he moved to Childwick
Green in Berkshire. In this
work, Clausen brings his characteristic interest in rural life
to the depiction of an urban
scene. The freshness and immediacy of the painting owes
much to his study of Dutch
naturalism and his adoption of
plein-air techniques associated
with French art. Clausen was a
key figure in the development

of early modernism in Britain,
and his subject of the relationship between city and country
was one that preoccupied many
of his colleagues working in
what can be defined loosely as
British impressionism.

In the immediate foreground
is a young woman with a wan
expression, wearing a fashionable mourning dress with matching cape and hat. The young
girl, presumably her daughter,
is shown in an equally fashionable costume, with a soft black
bonnet and an ermine-trimmed
coat. Her sober expression suggests that she, too, is in mourning. Seemingly unconscious of
their own beauty, this striking
couple not only captures our
attention, but also that of other
figures in the painting. The
roadmender at right looks to
the strolling woman and child,
as does the flower seller, who
wistfully puts a hand to her
cheek as she watches the retreating backs of her recent customers, who are perhaps on their
way to lay flowers on a grave.

The vivid impression made
by the well-dressed mother and
daughter is underscored by the
sharp contrast between them
and the surrounding occupants
of the street. To the left of
the mother, stoically seated on
a bench, is a young woman

whose dress is far less stylish
than that of the mother. Nevertheless, both costumes suggest
a calculated outward display—
note the lace collars worn
by both women—and are distinctly different from the ragged
shawl and apron of the flower
seller, who resembles the rural
working women Clausen photographed and painted in
the early 1880s (fig. 29). The
difference between the well-
dressed couple and the others
is also marked by Clausen's
handling of paint: the young
woman is finely painted, while
the roadmender just behind her
is rendered far more roughly,
with little detail.

Hampstead had developed
rapidly in the nineteenth century, becoming a liminal zone
where rural and urban, and rich
and poor met. The modern city
and its culture of consumerism
and fashion is represented by
the mother and child, while the
countryside, with its cycle of
daily labor and annual harvest,
is invoked by the roadmenders
and the flower seller.

Clausen conveys the impression that he has accurately
recorded a spring morning on a
Hampstead street not only by
his careful observance of social
type, but also by his pictorial
techniques. He uses the device,

borrowed by the French impressionists from Japanese art,
of cropping his composition
to give the sense that he has
captured "a slice of life." This
technique also owed a great
deal to contemporary developments in photography, and
Clausen often used photographs to construct his paintings. In accordance with the
aesthetic of *plein-air* painting,
which held that the effects of
changing light on colors and
surfaces should be rendered as
the eye sees them, Clausen
paid close attention to the contrast provided by the shadowed
foreground and the brightly
lit background. In the foreground, he uses large areas of
dark underpainting that deepen
the tones of the successive layers of paint, while in the background he uses a white ground,
which gives luminosity to the
blues, browns, and greens. In
the far distance, the hazy blue
atmosphere of morning obscures
the dimly realized outlines of
trees and buildings. While
sensitive to the effects of atmosphere, Clausen also endows
objects with a palpable presence
by carefully building up his
paint surfaces, often through
the use of a palette knife. The
lamp post, for example, is composed of square touches of

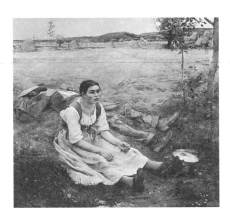

FIGURE 30

Jules Bastien-Lepage, *Les Foins*
(Hay Harvest), 1878, oil on canvas.
Musée d'Orsay, Paris

paint smoothed with a palette knife, and the sky is a mottled build-up of blues and whites suggestive of patchy morning clouds.

Clausen's skill in conveying immediacy tends to forestall consideration of how carefully he designed his composition. The passage from foreground to background is facilitated by the lines of the sidewalk and street, which sharply recede into the distance. Judiciously placed spots of color reinforce the shift from foreground to background and encourage the viewer to contemplate the relationships between figures. The bright red of the child's bow is found again in the lit match held by the roadmender at her right, the red scarf of the laborer wielding a pick axe, and the ribbon in the flower seller's hat. Similarly placed touches of yellow—the daffodils held by the mother, the ribbon of the seated woman's hat, and the flowers in the seller's basket— underscore the viewer's sense of moving through the street and experiencing directly the early morning activities of Haverstock Hill. A.H.

55

George Clausen
Bird Scaring

1896, oil on canvas, 39⁹/₁₆ x 49⁷/₁₆ (100.5 x 125.5). *First exhibited*: Royal Academy 1896 (no. 21). *References*: McConkey 1980, 69–70 (no. 81)

Harris Museum and Art Gallery, Preston

In its review of *Bird Scaring*, *The Art Journal* described Clausen as "a follower of the French school of rustic realism," referring to late nineteenth-century French *plein-air* or naturalist painting. Rejecting the worship of pastoral pleasures that characterized many nineteenth-century paintings of the countryside, these artists claimed to represent the harshness of rural life truthfully. They shared an interest in painting out-of-doors directly from the observed motif, and adopted techniques that marked them as a distinct new school of landscape painters.

In England much of the impetus toward naturalism can be traced to the work of Jules Bastien-Lepage, the French painter of peasant scenes. In 1880 the Grosvenor Gallery held a small retrospective of his work, including *Les Foins (Hay Harvest)* (fig. 30), which caused a great stir. A number of British artists, including George Clausen, adopted Bastien-Lepage's work as a model.

Bird Scaring owes much to the precedent of Bastien-Lepage, as well as to the investigations of the harsh realities of the countryside conducted by contemporary British artists and authors. Clausen immediately engages the sympathies of the viewer with the contorted figure of the small boy charged with rattling a clapper to scare birds from the unreaped winter wheat. Rooted to the ground by his heavy, muddy boots, the boy turns awkwardly to look up, open-mouthed, at the incoming birds. Clausen's close study of the human figure is revealed by his uncanny ability to suggest movement and fragility in the folds of cloth that pull over the boy's slender legs. The cold, windswept atmosphere of this March afternoon is sharply conveyed by the boy's attempts to ward off the damp chill by thrusting his hand in his pocket and knotting a length of sackcloth over his thin coat. The land-scape is wrapped in a mist; the outlines of the distant trees and birds are blurred and the far hills are a mere band of color. Delicate hints of color and spring relieve the gray atmosphere.

Clausen's handling of paint gives the scene an almost visceral feel. The sky, for example, is composed of thick layers of paint smoothed over with a palette knife, and the background trees are thinly painted with soft-edged, broken strokes of paint, occasionally washed over with white, so that they appear almost dissolved by the dense atmosphere. The boy is composed of short quick strokes that create a flickering surface and render him almost insubstantial. The grassy area, in contrast to the sky, is heavily textured with touches of impasto and perceptible imprints of the canvas weave. Over this textured surface, Clausen dragged narrow brushstrokes of dry paint to render the thin, brittle stalks of dead grass.

Bird Scaring amply demonstrates Clausen's thesis, articulated in his *Six Lectures on Painting* (1904), that "a landscape should not be so much an inventory as a transcript or translation of a mood of nature." In *Bird Scaring* Clausen went

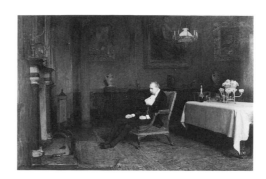

FIGURE 31

William Quiller Orchardson, *Mariage de Convenance — After!*, 1884, oil on canvas. City of Aberdeen Art Gallery and Museums Collection

beyond merely describing a wheatfield in March, he invoked the cloying feel of the cold, damp air and, perhaps more importantly, invited viewers to contemplate the fate of the child laborer. In tone, his painting is like the later novels of Thomas Hardy, such as *Tess of the D'Urbervilles* (1891), that sharply indicted the often inhuman treatment of rural laborers. Standing out in the cold, the bird scarer is reminiscent of Tess, forced to top turnips in a wintery landscape Hardy described as "almost sublime in its dreariness."

Rural child labor was a contentious issue and several legislative acts were passed at the end of the nineteenth century to eliminate what was increasingly regarded as a threat to the proper upbringing of children. With the Gangs Act (1869), the Education Act (1870), and the Agricultural Children's Act (1873), rural child labor, once an essential source of income for the family, gradually diminished, although in 1901 a Somerset farmer could still recall, in recent memory, boys leaving school "at the age of nine or ten years . . . to earn fivepence or sixpence a day scaring birds."[1]

As might be anticipated,

Clausen's depiction was regarded as distasteful by many critics. *The Times* declared that "the boy's figure is simply ugly—there is no other word for it." *The Athenaeum* concurred, criticizing Clausen's rough handling of paint, arguing instead for beautiful, pleasing subjects and thorough finish—the very qualities of Victorian art that the painter rejected. *The Magazine of Art*, by contrast, drew attention to Clausen's "rugged but wholly convincing transcripts of peasant life." A.H.

Notes
1. Horn 1984, 162.

56

William Quiller Orchardson

Mariage de Convenance

1883, oil on canvas, 41 ¼ x 60 ¾ (104.8 x 154.3). *First exhibited*: Royal Academy 1884 (no. 341). *References*: Hardie 1972 (no. 40)

Glasgow Museums: Art Gallery and Museum, Kelvingrove

The marriage of convenience, to which the young woman has brought her beauty and the aging man his wealth, has

brought neither party happiness. The husband looks intently along his impeccably appointed dinner table toward his wife, and trophy, who looks down at the floor in deep boredom. It is after ten o'clock in the evening, and the butler is pouring his master some afterdinner port; they seem to belong to one formal, joyless world, and the wife to another. Like the potted plant behind her, she has been removed from her natural element and installed as an ornament. The furniture and fittings of the interior are fashionable, showing the taste for eighteenth-century art and design that prevailed in later Victorian high society. Orchardson was a keen theater-goer, and *Mariage de Convenance* has the air of a silent but charged moment in a play; the viewer is invited to imagine the larger plot to which it belongs.

The French title Orchardson gave this painting is an homage to William Hogarth's great narrative series *Marriage à la Mode* (c. 1743; National Gallery, London), which also deals with a marriage contracted for reasons other than love. The Hogarthian tradition of social commentary in painting underwent a revival in the

Victorian period, and *Marriage à la Mode* was Augustus Egg's model for his *Past and Present* series (cat. 24). Whereas Hogarth and Egg filled their compositions with objects of discrete narrative and symbolic meaning, however, Orchardson aimed for strong effects of space and atmosphere, and the suggestion of inner drama and emotional tension rather than storytelling and the pointing of a moral. He was a master of expressive space, and uses the distance between the couple and the spaciousness of their dining room to convey the echoing emptiness in their marriage. The fluent, all-over stroking and hatching of the paint, especially in the shadowy areas of the wall and the reflection in the mirror, capture that slight vibration that hangs in the air under fairly low illumination, giving the atmosphere a somber presence of its own.

The sensitive and delicate painting of the still life on the table shows Orchardson's remarkable, but probably coincidental technical kinship with the French painter Henri Fantin-Latour. On the whole, modern French painting seems to have held no particular interest for him, and the painter he most admired was the

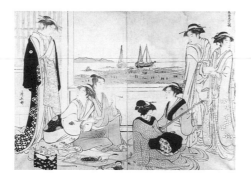

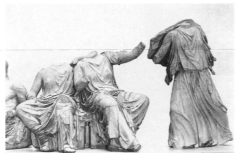

eighteenth-century British portraitist Thomas Gainsborough. The model for the millionaire in the painting was Orchardson's friend and fellow artist Tom Graham, although the features, and especially the heavy moustache, bear some resemblance to his own. Since his wife was some twenty years his junior, he may to some degree have identified with the character, although by all accounts he enjoyed a happy married life.

In 1886 he painted a sequel to *Mariage de Convenance*, using the same title with the word "After!" attached (fig. 31). The husband, looking slightly older, gazes ruefully into the fire in the same dining room, after a meal he has eaten alone. Clearly his wife has left, and the careful placement of her portrait above and behind his head shows that his thoughts are of her. Orchardson's first idea was to call this *Ichabod*, an Old Testament name meaning "the glory is departed."[1] M.W.

Notes

1. Hardie 1972 (no. 47).

57

..

Albert Moore

Reading Aloud

c. 1883/1884, oil on canvas, 42 1/4 x 81 (107.3 x 205.7). *First exhibited*: Royal Academy 1884 (no. 416). *References*: Baldry 1894, 55–56, 69–78; Robertson 1945, 61–62

Glasgow Museums: Art Gallery and Museum, Kelvingrove

The disposition of classically draped women along a narrow bench, swathed in luxurious fabrics and framed by decorative objects, was a favorite compositional formula of Albert Moore. In such paintings as *Reading Aloud*, Moore brought to his classical motifs an aesthetic sensibility shaped by the arts of Japan and the Middle East. Unlike more literal-minded Victorian classicists such as Lawrence Alma-Tadema, who brought scrupulous archaeological detail to his paintings, Moore was willing to blend different cultural sources in an effort to arrive at what his biographer A.L. Baldry called "art as decoration pure and simple."

Both Japanese art and clas-

sical art were popular in late Victorian England. An almost faddish cult for things Japanese developed in the 1860s, in response to the Japanese Court at the 1862 London International Exhibition. Whistler brought an interest in *Japonisme* to his artistic circle, which included Moore. Moore's awareness of *ukiyo-e* prints (fig. 32), which often depict elaborately draped figures arranged in broad patterns, is manifest in this composition.

The sculptures of the Parthenon in Athens had been in England since the early nineteenth century, when the earl of Elgin had shipped them from their ruinous site at the Acropolis and eventually installed them in the British Museum. Sought after by artists as examples of ideal beauty, the marbles became particularly popular in the last quarter of the nineteenth century. In Moore's painting the clinging draperies and the poses of the figures can be traced to the three goddesses of the east pediment (fig. 33). The decorated ceramics in *Reading Aloud* take up the classical theme with motifs associated with Greek culture, such as the owl (emblem of Athena).

To this combination of

Japonisme and classicism, Moore added a third ingredient, orientalism. The subject of languid women lounging in beautifully appointed interiors was characteristic of contemporary artists' representations of the Middle East. Such Middle Eastern–inspired interior decoration was fashionable in England in the late nineteenth century, and Frederic Leighton's Arab Hall (fig. 24), built by George Aitchison between 1877 and 1879, is perhaps the most famous example. Not incidentally, Moore lived near Leighton in Holland Park, and his painting recalls the decorative tilework and patterned carpets prized in such interiors.

Traces of Moore's working process are still visible in *Reading Aloud*. He began a work by applying a series of pencil cartoons or studies on the canvas, to serve as underdrawings, and the detectable pinholes in the surface of *Reading Aloud* may be from this process. Some of the pencil underdrawings are still visible, although each was typically covered by a priming of lead white. The diagonal lines of the underdrawings, visible above and below the figures, provided a framework against which the major forms could be plotted. After establishing

FIGURE 34

Tanagra statuette, from a photograph album of the Ionides Collection owned by James McNeill Whistler. Hunterian Art Gallery, University of Glasgow, Birnie Philip Bequest

the ground layer and the structure of his painting in line and in color, Moore worked up the composition in a silvery gray monochrome. A final cartoon, in color, was then transferred to the canvas and, as Baldry explains, "by cutting it away bit by bit as he worked, he was able to keep the surface upon which he was actually engaged surrounded always with color of the same force and brilliancy as he was applying to the canvas."

The ethereal pink and gray tones and shimmering highlights of the painting mute the monumentality of the three women. The fragility of this harmony of color is underscored by the effects of translucency and reflection, such as the pink drapery seen in the wings of the tiny bee hovering on the lip of the vase. Moore used extremely thin paint; nevertheless, his passages of impasto enabled him to suggest convincingly the weight and texture of surfaces without losing the overall delicacy and luminosity of the image. A.H.

58

Albert Moore

Midsummer

c. 1886/1887, oil on canvas, 61 x 56 (154.9 x 142.2). *First exhibited*: Royal Academy 1887 (no. 394). *References*: Baldry 1894, 60–61; Green 1972, 27 (no. 70); exh. cat. Manchester 1978, 153 (no. 83)

Russell-Cotes Art Gallery and Museum

Like many of Moore's paintings, *Midsummer* hints at a narrative or symbolic content while dazzling the viewer with a decorative arrangement of colors and forms. The nearly symmetrical composition is defined by the three women, dressed in thin, white gauze covered by contrasting orange-red draperies. Fanned by two flanking attendants, the central figure slumbers. Her thronelike chair, with its raised dais and an elaborately carved back, suggests that she is the object of veneration, like a goddess or a queen. The garland of marigolds, symbols of grief, perhaps explains her pose, but the title simply suggests a mood or atmosphere; her story, if she has

one, is left to the imagination.

Such enigmatic subjects were characteristic of the aesthetic movement, which, like the closely associated classical revival, sought to create a world of ideal beauty that could soothe, and possibly refine, the viewer's sensibilities. The sleeping figure was often used by aesthetic painters to invoke this world of beauty and its separateness from the realm of daily existence. Moore's ambiguous title reinforces the mood of repose; as a critic explained in 1891: his pictures "need names no more than do the individual jewels in the necklace of a queen. They are things of restful beauty, and describe themselves. . . . You could never dream of such a thing as asking them for a story."[1]

Moore draws his viewers away from considering any potential narrative too deeply by focusing on the decorativeness of his composition. Nearly square in format, the seemingly simple arrangement of the three figures is organized by a complex system of colors and lines. The columnar bodies of the women create vertical divisions in the canvas that are counterbalanced by the horizontal divisions in the room,

marked by the carpet, floor tiles, stone bench, and architrave. The central figures are united in a loose circle of bright color created by the orange-red dresses, green fans, and yellow flowers. Moore's brilliant hues are underscored by the somber background of grays and reinforced by the band of carpet in the immediate foreground, which repeats the colors of the central figures. Patterns are echoed from one object to the next: the sinuous striations in the stone bench are carried over to the curved patterns of the draped gowns, the garland wound about the chair back, and the wavelike patterns marking the women's coiffure. The rhythmic balance of color and line is enhanced by the shallow, compressed pictorial space, which forces together the figures and surrounding objects.

The notion of devoting a work of art largely to decorative patterns was one that Moore, like his friend Whistler, learned in part from Japanese prints. While Moore's composition cannot be traced to any specific source, he drew inspiration from *ukiyo-e* printmakers. The poses of the figures and the flow of the draperies also show the influence

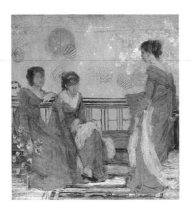

FIGURE 35

James McNeill Whistler, *Harmony in Flesh Colour and Red*, c. 1869, oil and wax crayon on canvas. Courtesy, Museum of Fine Arts, Boston. Emily L. Ainsley Fund

of Greek art, such as the Parthenon marbles and Tanagra statuettes—Hellenistic polychromed terracotta figurines. These statuettes became collectors' items in the late Victorian period. Whistler's friend and patron Alexander Ionides possessed a collection (fig. 34), as did the British Museum.

During the period of Whistler's and Moore's closest working relationship, 1865–1870, Whistler attempted a similar amalgam of classical and *Japoniste* sources in his study *Harmony in Flesh Colour and Red* (fig. 35). The brilliant red of the dresses worn by the women in that work may have been an inspiration for *Midsummer*, which is uncharacteristically strong in coloration for Moore's oeuvre. Moore's painting may, in turn, have played some part in the genesis of Frederic Leighton's *Flaming June* (cat. 66).

Critics of the Royal Academy exhibition were sharply divided over this work: *The Times* charged that the robes were a dreadful color that undermined any decorative potential of the painting,[2] whereas *The Spectator* declared *Midsummer* "a very elaborate and delightful piece of decorative painting, artistic in its

every touch, and admirable in the attainment of the desired purpose in the most direct way."[3] The painting was purchased by one of Moore's most loyal patrons, William Connal of Glasgow, who also purchased *Reading Aloud* (cat. 57), *White Hydrangeas* (unlocated), and *An Idyll* (1893; Manchester City Art Galleries). A.H.

Notes

1. Harold Frederic, *Scribner's Magazine*, December 1891, quoted in Baldry 1894, 91.
2. *The Times*, 21 May 1887, 8.
3. *The Spectator*, 30 April 1887, 591.

59

John Lavery

The Tennis Match

1885, oil on canvas, 29 13/16 x 71 15/16 (75.8 x 182.8). *First exhibited*: Royal Academy 1886 (no. 740). *References*: McConkey 1984, 28–30 (no. 16); McConkey 1993, 42–46

City of Aberdeen Art Gallery and Museums Collections

Lavery painted *The Tennis Match* during the summer of 1885 on the Cathcart estate,

near Paisley, a few miles outside Glasgow in Scotland. There, he and fellow artists of the group known as the "Glasgow Boys" would play tennis on weekends. He began, in accordance with the common academic procedure, by making a brief oil sketch;[1] this served as his guideline for the final, much larger picture. Rather than painting the large canvas in the studio, however, he followed the avant-garde practice that he had learned in Paris and at the artists' colony of Grezsur-Loing, of completing the work mainly, perhaps even entirely, outdoors on site. Like many of his British contemporaries, including Stanhope Forbes for instance, and indeed artists from all over Europe, Lavery was deeply affected by the brand of naturalistic, outdoor painting developed by the French painter Jules BastienLepage. With their rugged, blocky brushwork and keen eye for the subtleties of light, combined with a preference for overcast days, shade, and an overall, unifying grayness, Bastien-Lepage and his followers offered a conservative, predominantly tonal version of impressionism.

When first exhibited at the Royal Academy in 1886, *The*

Tennis Match was received without enthusiasm. For people who admired the detailed and anecdotal scenes of William Powell Frith and other popular painters of the age, a canvas so lacking in definition and "finish" appeared more like a large-scale sketch than an exhibition piece. Even in comparison to paintings by James Tissot, which challenged British expectations of the modern-life subject in the 1870s, the work appeared strange and extreme. In such a scene of pleasant, middle-class recreation the Victorian viewer looked for hints of interesting stories in the making, perhaps suggestions of romantic feelings between the members of the mixed-doubles teams, or little dramas unfolding among the spectators. *The Tennis Match* is unreadable in that way. There are many figures, but not one legible facial expression, and the body language suggests nothing more personal than playing and watching tennis.

Clearly the scene appealed to Lavery for reasons other than its human interest. What it offered him was the chance to display his mastery of light, distance, and movement, the sense of a moment captured. It is set on a sunny summer's day

yet almost entirely in shade, and he took an evident delight in the exact judgment of tones within the shade, especially the variety to be seen across the surface of the grass, setting them off against the occasional lively touch of dappled sunlight. The overall design of the work appears casual at first glance, but was composed with great care, as the several shifts in the position of the figures between oil sketch and final painting would suggest. As the most defined and brightly lit element of the composition, the open gate serves as the viewer's natural way into the scene, providing a starting point from which things become gradually more diffuse into the distance. The actions of the tennis players in mid-rally affirm the idea of an instantaneous rather than long-studied view of the scene, and the ball is caught at the very moment it strikes the racquet, as the player makes a volley close to the net. Lavery claimed that *The Tennis Match* resulted from the advice given him by Bastien-Lepage to train his visual memory to retain impressions of movement. "Always carry a sketchbook," the older artist told him. "Select a person —watch him—then put down

as much as you remember. Never look twice. At first you will remember very little, but continue and you will soon get complete action."[2]

The Tennis Match was the title under which the work was first exhibited, although since that time it has commonly been known as *The Tennis Party*. For a British painting it had an unusually international early history, bearing witness to the high reputation Lavery enjoyed on the Continent. It was exhibited at the Paris Salon in 1888, at the Munich Glaspalast in 1890, and at the Munich Secession in 1901, where it won a gold medal. At some point it entered the permanent collection of the Munich Pinakothek, but was later deaccessioned and acquired by Sir James Murray, who presented it to Aberdeen Art Gallery in 1926. M.W.

Notes

1. McConkey 1984, 29–30 (no. 16a).

2. Lavery 1940, 57.

60

...

Stanhope Forbes

A Fish Sale on a Cornish Beach

1884–1885, oil on canvas, 47 7/8 x 61 (121.6 x 154.9). *First exhibited*: Royal Academy 1885 (no. 1093). *References*: Fox and Greenacre 1985, 22, 54, 108– 109 (no. 3)

Plymouth City Museum and Art Gallery

This painting was the first to bring the activities of the artists' colony at Newlyn, a fishing village in southwest England, to public attention. Forbes moved to Newlyn in 1884 in search of an atmosphere akin to what he had experienced in the coastal villages of France. Along with many other late nineteenth-century artists, such as Paul Gauguin and Vincent van Gogh, Forbes felt that the artistic life of big cities was a dead end. Turning their backs on the rapidly changing urban scene, they sought refuge in the countryside, where they believed life to be elemental and unchanging, governed by the fixed cycle of the seasons. French painters had been leaving the city for the country throughout the

century, and these later nineteenth-century painters recognized their particular debt to the pioneers of *plein-air* painting. Forbes and his fellow Newlyners admired the work of Jean-François Millet, as well as that of Jules Bastien-Lepage, for its truthfulness to nature, sincerity, and ability to distill poignant moments from the daily lives of the peasantry.

When Forbes returned to England from France in 1884, he claimed that to emulate the rustic naturalism of Millet and Bastien-Lepage, he had to live where he worked. When searching England for a suitable location, he alighted upon Newlyn, where the painters Walter Langley and Edwin Harris had already begun to practice a version of *plein-air* naturalism. Selecting the right site was crucial because the local light and atmospheric conditions would dictate the tone of the canvases, and because Forbes used local people as models. It was with great disappointment, therefore, that he told his father in a letter of 1884 that although the residents of Newlyn were "very good samples of fisher folk in outward appearance . . . they revel in fringes [bangs], pigtails, crinolettes and other

freaks of fashion all very well on stylish London beauty, but appalling with these surroundings of sea, boats, fish, etc."[1] For naturalistic painters such as Forbes, such signs of modernity did not accord with the notion that the rural working classes possessed a dignity and purity of purpose lost to modern men and women. In *A Fish Sale*, he eschews any reference to modern garb and represents his figures in traditional working-class dress, with a substantiality and solemnity associated with classical sculpture.

Forbes began the painting just after his arrival in Newlyn; in a letter to his mother dated 14 February 1884, he wrote that he had decided on the theme of "The Arrival of the Boats with the Fish and the People crowding Round on the Wet Sand."[2] Fishing was the primary industry of Newlyn and the chief harvest was mackerel, herring, and pilchard. Some of the catch was sent directly from sailing vessels to Plymouth via steamer, and the rest was brought ashore to be auctioned off and sold. The subject of the fish auction, in addition to illustrating the day-to-day activities of the fishing village, also gave Forbes the opportunity to display his technical facility, as he explained in a letter to his mother in the spring of 1884:

I think I have struck oil down here in the way of subjects. I have not however, commenced anything very important yet—but see my way to do good and new things. The thing that pleases me is the wet sand. Anything more beautiful than this beach at lower water I never saw and if I can only paint figures against such a background as this shining mirror-like shore, the result should be very effective. I am experimenting now getting used to the people, the moisture, the difficult effect, the tides, etc., playing on this delightful stuff. But when I am more at home on the beach I am thinking of starting a real big thing with lots of figures, fish being brought in boats, etc. It will be a terrible thing to undertake but I am sure worth trying. I believe no one here has tackled such subjects before.[3]

Forbes' initial enthusiasm gradually wore away as he was faced with the difficulties of organizing his models (most of whom refused to pose on Sundays, and were unused to standing still for long periods) and dealing with the fickle English weather. In June he wrote his mother "painting out of doors in England is no joke and this picture will be a long weary job," and in December he complained "I sallied forth to have another go at the large picture. I got blown about and rained upon, my model fainted, etc."[4]

The result was a canvas of remarkable freshness and vitality. In the foreground, fish are scattered on the beach. The pointed, whiplike tails of the skates lead our eye through the scene. At right, a woman in a straw hat and plaid shawl is seated on a large basket or "cowal" used for carrying fish. She and another woman address the grizzled fisherman, perhaps inquiring about the day's catch. Behind him, the last of the fish is being sold. The women gather around, inspecting the small pile, while an auctioneer, ringing a bell, conducts the sale. A donkey cart, used for carrying the fish from the sandy beach up the steep rise into the town, stands at far right. The fish are brought to shore by the small skiffs seen in the background. The fishing vessels remain in deeper waters, their dark sails silhouetted against the light gray clouds overhanging the calm sea. The high horizon line, which Forbes may have adopted from Bastien-Lepage, causes the beach and sea to fill almost the entire canvas. The grayness of the sky permeates the composition, a harmony of dark browns, dusky blues, and blacks, with touches of white tinged with gray and blue.

The damp seaside atmosphere is rendered almost palpable by both the deep, subdued palette of the work and Forbes' characteristic squarish brushwork. The canvas is carefully built up with layers of paint, the uppermost layer often dryly applied so that the colors beneath are revealed. This mode of painting, combined with his broken-edged technique, is excellent for rendering, for example, the water receding from dampened sand, the iridescent fish scales, or the peeling paint of the wooden rowboat.

Critics at the time recognized that Forbes' technique was French in origin, and while most agreed that it was entirely compatible, if not advantageous, for representing the rural landscape with fidelity and sensitivity, some in the British art world felt threatened by its pointed disavowal of academic and studio conventions. The *Magazine of Art* reported that *A Fish Sale* was

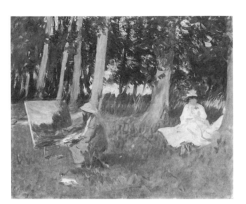

proposed for purchase by the Chantrey Bequest, a fund dedicated to the purchase of paintings executed in Britain, but that "the picture was thrown out, not, as some have suggested, because it is a good one, but because it is too positively the outcome of a foreign school."[5] It was eventually bought by a private collector, J.J. Brown of Reigate. A.H.

Notes

1. Bendiner 1985, 111.
2. Fox and Greenacre 1985, 108–109.
3. Fox and Greenacre 1985, 108–109.
4. Fox and Greenacre 1985, 109.
5. *Magazine of Art,* June 1885, xxxiii.

61

..

John Singer Sargent
Carnation, Lily, Lily, Rose

1885–1886, oil on canvas, 68½ x 60½ (174 x 153.7). *First exhibited*: Royal Academy 1887 (no. 359). *References*: Olson 1986, 19–22, 63–74 (pl. xix)

Tate Gallery, London. Presented by the Trustees of the Chantrey Bequest 1887

Sargent began *Carnation, Lily, Lily, Rose* in the summer of 1885 at the home of Francis David Millet, an American painter who had taken up residence in the Cotswold town of Broadway to find materials for his paintings and illustrations of "old England." Edwin Austin Abbey, Henry James, and Alfred Parsons, among others, came to Broadway for extended stays, and Lawrence Alma-Tadema was a frequent visitor. While on a boating trip on the Thames with Abbey earlier in the summer, Sargent had glimpsed some girls lighting lanterns in a garden and decided that the subject would be ideal for a painting.[1] When he arrived at the Millet's home, he soon engaged the entire household in assisting in his re-creation of the scene.

In this period Sargent was deeply committed to *plein-air* painting—working outdoors directly from the observed motif—as well as impressionism. He had met Claude Monet in 1876 and visited him at Giverny sometime during 1885, producing the oil sketch *Claude Monet Painting in a Meadow near Giverny* (fig. 36). In order to paint *Carnation, Lily, Lily, Rose* out-of-doors, he arranged for two models—the daughters of the American painter Frederick Barnard—to pose for him in the Millet's garden. Although Sargent strove to paint directly from nature, keeping the garden and models fresh presented difficulties, as he explained to Robert Louis Stevenson in a letter of November 1885: "my garden is a morass, my rose trees black weeds with flowers tied on from a friend's hat and ulsters protrude from under my children's white pinafores." Nevertheless, he was still quite taken with his theme and told Stevenson "I wish I could do it! With the right evening and the right season it is a most extraordinary sight and makes one rave with pleasure."[2] Sargent no doubt hoped that British art critics would concur. His reputation in Paris was in ruins following the scandal of his portrait of Madame Gautreau, whom he had portrayed in a low-cut gown, and he turned his sights to London at the suggestion of Henry James. Sargent had exhibited in London since 1882, but many critics were highly critical of his painting technique, which they regarded as too French, sensational, and overly clever.

Visitors to the Millet household provide reports of how Sargent advanced his painting. He worked on it in the twilight hours, building up and scraping down paint in an effort to capture correctly the evening light and its effect on the multicolored flowers.[3] The title of the painting was taken from the refrain of an old song— *Flora's Wreath* by Joseph Mazzinghi—that the historically minded Broadway circle had resurrected.

When the work was exhibited, most critics responded favorably despite long-standing suspicions of French impressionist influence. *The Spectator,* which had treated Sargent harshly on previous occasions, reacted enthusiastically and called the painting the triumph of the Academy. The reviewer readily appreciated that the

paramount concern of Sargent's painting was "to show the conflict of lights between the fading day and the lanterns, and its effect upon the various coloured flowers." The attention Sargent paid to the play of light upon surfaces linked him to the impressionists, but critics recognized that his work was not an imitation of their paintings. *The Spectator* praised the painting's air of mystery, as well as its beauty of color.[4] Other critics noticed how Sargent combined realism with, as *The Saturday Review* put it, "an excellent feeling for decoration."[5]

Decorativeness was a key aspect of British aestheticism, and *Carnation, Lily, Lily, Rose* owed a clear debt to such painters as Moore and Whistler, in addition to Monet. Like Whistler, Sargent used thinly applied layers of paint, with only hints of impasto, to achieve his unifying atmosphere. He also borrows Whistler's device of a sharply uptilted perspective, which blurs the boundary between ground and background and flattens the pictorial space, so that objects are brought to the fore of the picture plane where they form a unified pattern. The lilies, for example, are rendered as stylized forms against a

stark, flat green ground and, in fact, resemble those found in Japanese prints collected by Whistler and Rossetti. The Japanese lanterns hanging in the garden reinforce the associations with *Japonisme*. In addition, Sargent's composition is dictated by a patterning of color often found in Moore's work. Touches of burgundy, pink, and yellow are repeated across the horizontal and vertical axes of the painting. Even the title suggests a deliberate repetition of flowers and colors. Perceptive critics easily grasped the influences shaping Sargent's work: *The Saturday Review* claimed he had "attempted to give us the artistic confusion of a Japanese fan with a true account of the atmospheric and colour conditions of the scene portrayed."[6]

The painting was purchased by the Chantrey Bequest, charged with buying works of art "entirely executed within the shores of Great Britain" for the express "purpose of forming and establishing a Public National Gallery of British Fine Art in Painting and Sculpture." These paintings, in combination with Sir Henry Tate's personal collection, formed the core of the Tate Gallery's collections when it

opened in 1897. This purchase improved Sargent's reputation in England immensely; as *The Spectator* noted, Sargent "has proved himself capable of producing a beautiful thing, and so given hostages to fortune." A.H.

Notes

1. Letter from E.A. Abbey to Charles Parsons, 28 September 1885, quoted in Lucas 1921, 151.
2. Letter from John Singer Sargent to Robert Louis Stevenson, c. November 1885, Beinecke Rare Book and Manuscript Library, Yale University Library, Stevenson Papers, RLS 5427.
3. Blashfield 1925, 643–644.
4. *The Spectator,* 30 April 1887, 591.
5. *Saturday Review,* 14 May 1887, 685.
6. *Saturday Review,* 7 May 1887, 650.

62

John Singer Sargent
Lady Agnew of Lochnaw

1892/1893, oil on canvas, 49 1/2 x 39 1/2 (125.7 x 100.3). *First exhibited*: Royal Academy 1893 (no. 30). *References*: Ormond 1970, 46, 54, 247 (pl. 67); Lomax 1979, 55–57 (no. 37)

National Galleries of Scotland, Edinburgh

Sargent's reputation as the preeminent portraitist of late Victorian and Edwardian English society was secured with this portrait of Lady Agnew, which was exhibited to great acclaim in the Royal Academy exhibition of 1893. The *Magazine of Art* described it as a "work so subtle and refined, so exquisite in colour, so dignified in repose and grace, so individual in its manner, so masterful in technique, that it will be held by many to be the finest canvas ever put forth by Mr Sargent and one of the best portraits of the day."[1]

Lady Agnew (born Gertrude Vernon) was the wife of Sir Andrew Noel Agnew of Lochnaw, who succeeded to

the baronetcy in March 1892; his coming into the family title may have been the impetus for this portrait. Miss Helen Dunham, an American living in London, apparently introduced her friend Lady Agnew to Sargent, who had painted Dunham's portrait in 1892. Yet, Lady Agnew was still taking something of a risk to have her portrait painted by Sargent: his portrait of Madame Pierre Gautreau had caused a minor scandal in Paris when it was exhibited in 1884, and two years later, in England, his portrait of the three daughters of Colonel Thomas Vickers (Sheffield City Art Gallery) was harshly reviewed by the critics despite being well placed in the exhibition.

Lady Agnew is arranged so that she looks directly out at the viewer. Shown seated in a French rococo chair against a draped backdrop and holding a flower in the right hand, Lady Agnew displays many of the conventions of eighteenth-century portraiture. Carter Ratcliff has noted that her dress is similar in style to those found in eighteenth-century portraits by Joshua Reynolds and Thomas Lawrence.[2] The association to Lawrence is particularly strong because Law-

rence was known for his silvery impasto, used to capture the look and feel of lustrous fabrics, as demonstrated in his portrait *Miss Farren* (1790; Metropolitan Museum of Art), and Sargent evidences an equal adeptness in *Lady Agnew*, painting her white gown with vivid passages of highlight to give the illusion of sheen and translucency. Her direct gaze and idealized beauty also endow her with an assuredness in keeping with the grand manner portrait. Sargent's canvas thus ennobles his sitter, who was not born into the same level of aristocratic privilege as her husband. Her father, Gowran Charles Vernon, was the second son of Robert Vernon Smith, Baron Lyveden, who had served on the board of control for the affairs of India for several decades, as well as M.P. for Northampton, and was raised to the peerage in June 1859. The Agnews of Lochnaw, by contrast, had held their title since 1629, when Sir Patrick Agnew was created a baronet.

Yet, there are elements of the portrait that unmistakably mark it as a work of the 1890s and not the 1790s. With his deft touches of paint, Sargent has constructed a persona for his sitter. Her frank gaze, with

one heavy-lidded eye and the other cast in shadow, has the address of a femme fatale that is underscored by the half smile that plays about her full red lips. It is her gaze, and her right arm as it grasps the edge of the chair, that ensure her physical presence, almost undone by Sargent's bravura brushwork that renders objects and colors into surface patterns. The floral motifs and Japanese-like characters of the backdrop almost seem to float above the fabric, as do the flowers on the chair. This attention to pattern, expressed in exquisite, almost ephemeral brushstrokes, combined with the cool, blue-green palette of the work, with its contrasting mauves, pinks, and dusty reds, link this work with aestheticism and paintings such as Whistler's *White Girl*, and distinguish it from the grand manner of Lawrence and Reynolds.

After the warm reception of *Lady Agnew*, Sargent had an almost endless stream of commissions and he adapted the pose of the seated figure looking out engagingly at the viewer in several subsequent works, such as *Mrs. Carl Meyer and Her Children* (1896; private collection), and *The Wyndham Sisters: Lady Elcho, Mrs. Adeane,*

and Mrs. Tennant (1899; Metropolitan Museum of Art). A.H.

Notes
1. *The Magazine of Art*, June 1893, 258.
2. Ratcliff 1982, 161.

63

John William Waterhouse
The Lady of Shalott

c. 1887/1888, oil on canvas, 60 1/4 x 78 3/4 (153 x 200). *First exhibited*: Royal Academy 1888 (no. 500). *References*: Hobson 1980, 51–56

Tate Gallery, London. Presented by Sir Henry Tate 1894

With this painting, Waterhouse reinvigorated the literary themes associated with the Pre-Raphaelites by portraying the Lady of Shalott in a landscape shaped by the open-air painting practices associated with French naturalism. The Lady of Shalott is a tragic figure from the Arthurian legend, whose story was popularized by an Alfred Tennyson poem of 1842. The story was a prominent theme in Victorian art, particularly in the work

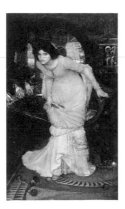
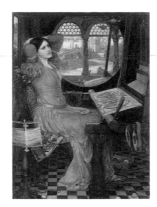

FIGURE 37

John William Waterhouse, *The Lady of Shalott*,
1894, oil on canvas. Leeds City Art Gallery

FIGURE 38

John William Waterhouse, *"I am Half Sick of
Shadows" Said the Lady of Shalott (The Lady of
Shalott, Part II)*, 1915, oil on canvas. Art Gallery
of Ontario, Toronto, Gift of Mrs. Phillip B.
Jackson, 1971

of the Pre-Raphaelites, and Waterhouse himself returned to this subject at least twice. She is typically shown as a powerful, mysterious femme fatale, as in William Holman Hunt's illustration for the Moxon edition of Tennyson's poems (1857) and his subsequent painting (cat. 18).

In this version of the tale, Waterhouse illustrates the fateful moment just before her death and depicts her not as a powerful witch, but as a sorrowful maiden dressed in virginal white. She is shown seated, allowing viewers to contemplate her tortured, abstracted gaze. The boat is duly inscribed with her name, and Waterhouse even included the water lilies that "blow round . . . the island of Shalott." The "gray walls" of the castle are visible just to the left of the stone stairs from where she has launched the boat. Details added by the painter amplify the story. She sits on a pink robe decorated with roundels depicting life at Camelot. Near the prow of the boat are three candles, only one of which is lit, implying that her life will soon be snuffed out. Next to the candles lies a crucifix, suggestive of both her spirituality and her martyrdom. Her long

flowing hair, full red lips, low-slung belt, and snug bodice—reminiscent of Rossetti's *Beata Beatrix* (cat. 35)—express the sensuality that she was forbidden to act upon.

Although she seems oblivious to her surroundings, the landscape is an essential element of the composition and it indicates a significant change in Waterhouse's style. While the theme and the figure bear a close relationship to Pre-Raphaelite works and may indeed have been directly inspired by Millais' *Ophelia* (cat. 9), the landscape reveals the influence of contemporary French painting as the *Art Journal* explained: "the almost impressionary delicacy of the rendering of willows, weeds, and water is such as claims harmony with French work rather than with what was so intensely English."[1]

Frenchness, in this instance, refers to the practice of painting landscapes outdoors directly from nature. Although little evidence of the preparatory work for this painting survives, Waterhouse adopted the loose, broad handling of paint associated with *plein-air* painters of the mid-1880s, such as George Clausen, John Singer Sargent, and Stanhope

Forbes. His landscape, therefore, has the appearance of spontaneity and directness. Waterhouse exploits paint not to record minutely the scene, as in many Pre-Raphaelite works, but to approximate a quickly glimpsed impression of the landscape, as in the long, thin strokes used to render the grasses on the distant shore. The lilies in the foreground are roughly sketched, adding to the sense of spontaneity. Here, Waterhouse has successfully combined the imaginative power of the Pre-Raphaelites with the realism of *plein-air* painting.

In his subsequent depictions of the Lady of Shalott, Waterhouse abandoned the innovation of bringing modernist painting techniques to bear on this well-known theme. His *Lady of Shalott* of 1894 (fig. 37) shows her rising up from her chair at the moment she glances out the window. She gazes at the viewer with a penetrating expression unlike the heavy-lidded visage in the 1888 version. His third painting of the subject, executed in 1915, shows her just as she glimpses two newly wed lovers in her mirror and mutters to herself "I am half sick of shadows" (fig. 38). As in the 1894 paint-

ing, the interior is sumptuously appointed in a medievalizing style, and the figure has more the bearing of a femme fatale than that of a tragic heroine.
A.H.

Notes
1. *Art Journal*, May 1889, 142.

64

.......................................

Frederic Leighton
Idyll

1880/1881, oil on canvas, 41 x 83 ½ (104.1 x 212.1). *First exhibited*: Royal Academy 1881 (no. 197). *References*: Ormond and Ormond 1975, 130, 165 (no. 276); Jones et al. 1996, 196 (no. 86)

Mr. and Mrs. Henry Keswick

The term "idyll" was used by the ancient Greek poet Theocritus for his descriptions of the lives, loves, and rustic arts of shepherds on his native Sicily; these and the "eclogues" of the Roman poet Virgil established the literary genre known as the pastoral. Though not an illustration to any poem or story in particular, Leighton's picture is a pastoral in paint, offering

his audience an escape to the same magical world of music-making shepherd boys, charming nymphs, and pleasant scenery. The sun-bronzed shepherd with his flute appears almost as an emanation from the landscape, embodying nature and art in the same figure, while the nymphs listen dreamily to his playing, the forms of their bodies echoing those of the river, plains, and mountains behind. Art, nature, and beauty seem to exist in perfect harmony. Leighton once wrote that "Art is the utterance of our delight in the phenomena of Life and Nature and an endeavour to communicate to others and perpetuate that delight."[1] For him, to delight in life and nature meant to experience them through the literary and artistic culture of ancient Greece, and *Idyll* shows him at his most voluptuous.

The poses of the nymphs and the flowing, eddying forms of their draperies allude to the sculptures of goddesses from the east pediment of the Parthenon, part of the Elgin Marbles in the British Museum; these were a favorite source of inspiration for painters of the aesthetic movement, and deliberate references to them are also to be found in the work of

G. F. Watts, Edward Burne-Jones, Albert Moore, and others. Some of the aesthetic painters responded with enthusiasm to the simplifying, decorative art of the Japanese woodblock print, and the compositional device of the branches and leaves entering the painting from above brings to the essentially Greek world of Leighton's paintings a touch of Japanese design. His painting is musical in the literal sense, since it features music-making, and also in its dependence upon harmonies of form and color rather than storytelling or moral content for its appeal. In these respects it belongs to a tradition in British painting that originated in the 1860s; the *Chant d'Amour* of Burne-Jones (cat. 38) is a similarly "subjectless," musical mood-painting, though in the medieval rather than the Greek mode.

The model for the nymph on the right was the celebrated beauty Lillie Langtry. She had made a sensational entrance into London society in 1876, sat for portraits by a number of prominent artists, including John Everett Millais (1878; States of Jersey) and Watts (1879; Watts Gallery), and become the mistress of both the Prince of Wales and Prince

Louis of Battenberg. Her features were considered the living embodiment of classical Greek beauty—Oscar Wilde took her to lectures on Greek art at the British Museum— and this made her a natural choice of model for classicizing painters. When she sat for *Idyll* she had recently been dropped by both her royal protectors, was hard-pressed financially, and pregnant with Prince Louis' child; she gave birth to a daughter in Paris early in 1881. Stephen Jones has suggested that Leighton's employing her as a model was his way of helping her out of her troubles, and that her appearance in *Idyll* at the Royal Academy exhibition of 1881 helped launch her second career as an actress.[2] M.W.

Notes
1. Ormond and Ormond 1975, 84.
2. Jones et al. 1996, 196.

65

Frederic Leighton
The Return of Persephone

1890–1891, oil on canvas, 80 x 60 (203.2 x 152.4). *First exhibited*: Royal Academy 1891 (no. 232). *References*: Ormond and Ormond 1975, 127, 171 (no. 360); exh. cat. Manchester 1978, 121–122 (no. 58); Jones et al. 1996, 215–216 (no. 109)

Leeds City Art Gallery

In Greek myth, Persephone is the daughter of Demeter, goddess of the earth, agriculture, and fertility. While picking flowers in a meadow she is abducted by Hades, god of the underworld, who takes her as his wife. Demeter pleads with Zeus for her return, and eventually she is allowed to ascend to the upper world for six months of each year, escorted by Hermes, messenger and guide of the gods. For the Greeks the myth represented the cycle of the seasons, the annual return of Persephone a symbol of the stirrings of growth in the springtime. At the famous shrine of Eleusis in Attica, the center of the cult of Demeter, they enacted the

story as a rite to promote the fertility of the land.

Leighton addressed the subject with its original, seasonal meaning foremost in his mind. The almond blossoms near the entrance to the underworld show that it is spring. Persephone rises out of the darkness but her flesh is deathly pale, etiolated after months without sunlight. Even her draperies appear faded, as though they will need to ripen in the sun before achieving the rich, mature color of her mother's. Her arms and fingers reach up toward her mother and the light like fresh white shoots coming out of the earth. The model for Persephone was Dorothy Dene, who appears in a number of Leighton's later, more serious mythic compositions. He developed a tender affection for Dene, helped her in her aspirations to become an actress, and cast her in some of the most emotional, gestural roles in his paintings.

For the Victorians, and for Leighton in particular, myths such as that of Persephone attracted meanings to themselves beyond those they held for the Greeks. Erudite though he was in the classics, he was no mere antiquarian; he wished his paintings to speak to people of

his own time, and chose his subjects for the overtones they would carry for a nineteenth-century, British, and largely Christian audience. The return of Persephone is a type of resurrection from the dead, and this was one of the associations he could expect his subject to arouse. It is certainly a leading idea of Tennyson's near-contemporary poem on the same theme, "Demeter and Persephone" (begun 1886). The poet begins with a description of Persephone's return, "Faint as a climate-changing bird that flies / All night across the darkness, and at dawn / Falls on the threshold of her native land," and concludes with Demeter's vision of an epoch of light and love, when the power of the old gods will be stopped, and Persephone and the souls of men will live eternally above ground. Leighton may well have hoped his painting would lead to similar trains of thought. On further symbolic levels, the work could be read as an emblem of Britain reaching for the sunlight and culture of Greece, an idea close to the artist's heart, or of beauty rescued from the ugliness of the industrial age. M.W.

66

Frederic Leighton

Flaming June

1894/1895, oil on canvas, 47 1/2 x 47 1/2 (120.7 x 120.7). *First exhibited*: Royal Academy 1895 (no. 195). *References*: Ormond and Ormond 1975, 130–131, 172–173 (no. 388); exh. cat. Manchester 1978, 124–125 (no. 61); Jones et al. 1996, 236–237 (no. 121)

Museo de Arte de Ponce, The Luis A. Ferré Foundation, Inc., Ponce, Puerto Rico

Flaming June is Leighton's most celebrated work, and one of the most familiar of all Victorian paintings. The title seems to have been coined by the artist, although it has the ring of a literary quotation. The "flaming" part refers both to the heat of summer and to the appearance of the young woman's drapery, hot in color and full of writhing, flamelike folds. The painting of figures and scenes that distilled the mood of certain times of year, usually seasons, had gained currency in Britain with the beginnings of the aesthetic movement in the 1860s. It was a

resonant type of subject, with a rich pedigree in the history of art, and it lent itself well to "aesthetic" treatment because by nature it was neither narrative nor moral; the painter could suggest ideas and feelings through harmonies of form and color, with no distracting movements, gestures, or facial expressions required of his figures. He could work on the abstract and sensual level, and this was clearly Leighton's thinking in *Flaming June*. Without following an obvious geometric plan, he arranges the lines of the figure and drapery to imply a circle, setting them off against the strict horizontals of the marble seat, awning, and landscape view behind. The circle suggests the inwardness of the woman's sleeping and dreaming, and at the same time subtly likens her "flaming" drapery to a sun. Clearly she is more than a mere genre subject; she may be a beautiful woman who has fallen asleep on a hot day, but beyond that she is an emblem or allegory of summer languor.

The sleeping female figure was a favorite motif of later Victorian painters. The woman in *Flaming June* belongs to a sisterhood of sleeping beauties to be found in paintings by

Leighton, Edward Burne-Jones, Albert Moore, and many other artists associated with the aesthetic movement, from the 1870s onward. By the 1890s Leighton was working within a tradition of such subjects, although as an image of a sleeping woman in orange drapery suggestive of summer heat, *Flaming June* clearly owes a debt to Moore's *Midsummer* (cat. 58). On a practical level, the state of sleep made for an easy, relaxed pose on the part of the model. The sight of a model resting, even dozing off while sitting, was common enough in the studio; and given the taste of the aesthetic painters for an air of studio artifice about their works, along with the mystique surrounding the beautiful women who sat for them, the theme of the sleeping model came naturally to them. Of *Flaming June*, Leighton stated that "The design was not a deliberate one, but was suggested by a chance attitude of a weary model who had a peculiarly supple figure."[1] The model has been identified as Mary Lloyd; though brought up as the daughter of a well-to-do country squire, she was forced to work for a living after her family fell on hard times.[2]

The painters of the aesthetic movement believed that marked facial expression was antipathetic to beauty, and the state of sleep also recommended itself from that point of view. On the moral plane, they wished to distance themselves from Victorian puritanism and the Protestant work ethic, "Thor worship" as it was sometimes called,[3] celebrating the Cytherean pleasures of sensuality and idleness instead. We assume their beautiful sleepers to be having beautiful dreams, and might read the shimmering seascape behind the model's head in *Flaming June* as her dream of the faraway Mediterranean; when she wakes up, we might imagine, the enchantment will disappear and she will find herself back in the artist's studio in smoggy London. The dreamlike effect is enhanced by the soft, melting look of the head; typically for Leighton, the flesh is painted in a diffuse technique that sets it apart, quite abruptly, from the fluently stroked-in areas of surrounding drapery.

There is a monumentality about the figure that inevitably recalls Michelangelo, whom Leighton revered. The sleeping figure of *Night* from the Medici Chapel comes to mind, and perhaps some of the *ignudi* from the Sistine Chapel ceiling. The correspondence of pose is in no case close enough to be called an allusion or quotation, however, and Leighton's figure emerges from the comparison looking even more emphatically closed and static than before, not to mention antimuscular. There is an interesting similarity in the pose to Watts' *Hope* (cat. 33), an oil sketch of which Leighton owned, although this may be more to do with common sources in Michelangelo, whom Watts also admired and studied, than with any direct borrowing on Leighton's part. Like much of Leighton's painting, *Flaming June* plays off the conventions of classical relief sculpture: the figure occupies a relatively shallow space and is set among planes parallel to the picture surface, notably those of a marble seat, as though to imply that she might be a carved design rather than a figure fully in the round. It was as a fictive relief sculpture, in fact, that she made her first appearance in Leighton's art: a miniature version of *Flaming June* is carved on the side of a stone fountain in *Summer Slumber* (exhibited Royal Academy 1894; private collection). The

overall effect of flatness and abstraction accords completely with his tendencies as an artist. But at some level he must have been drawn by the poetry of the metamorphosis too: as sculpture becomes painting, cold marble becomes flaming drapery and living flesh.[4] M.W.

Notes
1. Staley 1906, 159.
2. Postle 1996, 27–29.
3. See Houghton 1957, 200.
4. For further discussion of the meaning of *Flaming June* and its position in Victorian art, see Bendiner 1985, 121–143.

67

Lawrence Alma-Tadema
Sappho and Alcaeus

1880/1881, oil on canvas, 26 x 48 (66 x 121.9). *First exhibited*: Royal Academy 1881, no. 269. *References*: Lovett and Johnston 1991, 79–80 (no. 26); Swanson 1990, 213–214, no. 266

The Walters Art Gallery, Baltimore, Maryland, 37.159

According to Alma-Tadema's nineteenth-century biographer

Georg Ebers, this painting of the poets Sappho and Alcaeus illustrates a lyric by Colophon, a poet of the early fourth century BC: "As for the Lesbian Alcaeus, thou knowest in how many revels he engaged, when he smote his lyre with yearning love for Sappho. And the bard who loved that nightingale caused sorrow, by the eloquence of his hymns to the Teian poet." Alcaeus is shown seated, silhouetted by the bright blue sea, and facing Sappho, who listens intently as does her daughter Kleis, who wears a garland of jonquils and daffodils. Behind them, seated in the upper tiers, are three pupils of Sappho: the woman in the lilac gown leans forward in concentration, unaware of the woman to her left cautiously gazing upon her; another woman, in a dusty orange gown and headband, gazes out to the distant landscape, seemingly detached from the rest of the group, perhaps induced to a dreamy mood by Alcaeus' music. This last figure, in particular, reveals Alma-Tadema's ties to the developing movement of aestheticism and its recurrent themes of music, languid leisure, and sensual pleasure, as exemplified in such works as Albert Moore's *Midsummer* (cat. 58) and Fred-

eric Leighton's *Flaming June* (cat. 66). The painting is set on the island of Lesbos, where Sappho was born, a trading center with a long tradition of cultural sophistication.

Characteristically, Alma-Tadema filled his painting with archaeological details to signal that the scene was set in antiquity. The participants are gathered in an exedra, examples of which were well represented in Alma-Tadema's photographic collection of archaeological sites. The seats closely resemble those in the Theater of Dionysus in Athens, but instead of reproducing the names of the honored officials actually inscribed there, Alma-Tadema substituted those of Sappho's sacred sorority or *thiasos*— all female communities for the education of girls. On the lower level, from the left to right, are visible Errina of Telos (under which is carved a laurel wreath), Gyriano, and Anactoria of Miletos, and on the upper level, [Mnasi]dika, Gongyla of Colophon, and Athis. Such substitutions were typical of Alma-Tadema, who meticulously copied ancient artifacts in his paintings, but often reworked them for his own purposes. He also mixed motifs from different sites

and eras for the sake of his compositions. The names on the seats, for example, were written in archaic Attic, rather than the Lesbic form of the Greek alphabet, which a critic in 1886 pointed out would have been more appropriate for the painting's theme.[1] For the figure of Sappho, Alma-Tadema turned to a fifth-century marble statue in the Villa Albani identified as Sappho or Kore Albani. The lectern on which she leans was composed from two sources: winged victory on a globe, a popular motif in nineteenth-century decorative arts, and a lampstand from Pompeii. Alcaeus plays a lyre known as a kithara, and the scene of Apollo and Artemis that decorates the lower portion of the kithara was taken from a Greek fifth-century BC jar in the collections of the British Museum; Alma-Tadema translated the scene into mother-of-pearl inlay. The shimmering colors of the shells complement the marble setting, its bright whiteness mottled with veins of gray.

Most critics were not put off by Alma-Tadema's historical inconsistencies; instead, they marveled at his technical facility, brilliant palette, and faithful representation of a variety of

surfaces and materials. As the *Art Journal* noted upon the painting's exhibition at the Grosvenor Gallery, "the reproduction of surfaces, the completeness of execution which gives almost illusory effects of texture will always command a delighted admiration."[2] Perhaps the most exceptional aspect of Alma-Tadema's ability to simulate appearances, according to this critic, was his attention to the effects of light, and, in particular, the bright, unrelenting sunshine of the Mediterranean: "An equal definite and supreme success crowns his other intention— that of painting light and the very vitality of climate and air. . . . It is, indeed, as a painter of Italian atmosphere, with all its life and warmth, that Mr. Alma-Tadema is most evidently inimitable." Although he found the sky in *Sappho and Alcaeus* cold, he praised "the magnificent sea" for being "radiant with illumination and profound with colour." With a discernable note of sadness the writer noted that the painting had been purchased by an American collector, W.T. Walters of Maryland: "As regards the 'Sappho' the light of that summer-blue sea, the gold of the poet's lyre, and the white of the

sun-warmed marble are now only memories in England, for the picture has found a far-away home."[3] Walters purchased the painting through the dealer Deschamps in 1883 for £2500.

Close examination of the canvas reveals that Alma-Tadema used extensive pencil underdrawings to establish the outlines of his forms. The composition was reworked at several points; pentimenti are visible around the kithara, suggesting that the artist adjusted its placement, and infrared photography has established that Alcaeus was originally seated on a raised dais rather than at eye level as he is now presented. A.H.

Notes

1. *Nation* 43 (16 September 1886), 235–240.
2. "The Works of Lawrence Alma-Tadema, R.A.," *Art Journal* 45 (February 1883), 33.
3. "Alma-Tadema" 1883, 65–68.

68

..

Walter Sickert

The Gallery of the Old Bedford

c. 1894/1895, oil on canvas, 29 x 24 ½ (73.7 x 62.2). *First exhibited*: New English Art Club, winter exhibition, 1895 (no. 73). *References*: Baron 1973, 40–42, 310–311 (no. 73); Baron and Shone 1992, 96 (no. 16)

The Board of Trustees of the National Museums and Galleries on Merseyside, Walker Art Gallery, Liverpool

The Old Bedford in Camden Town, opened in 1860, was one of the music halls or "varieties" that provided inexpensive entertainment for a largely working-class audience in Victorian Britain. Offering mostly singing and comedy acts, the music halls had their heyday in the 1890s and the first decade of the twentieth century. When first exhibited in 1895, Sickert's painting appeared under a title borrowed from one of the most popular and enduring of all music-hall songs, *The Boy I Love is Up in the Gallery*. This was a catchy number, with which it was easy for the audi-

ence to sing along, and the lyrics lent themselves perfectly to the kind of singer-audience banter and flirtation that was the stuff of a music-hall evening. Like many of the best music-hall songs, it contained an element of self-mockery combined with sentimentality; the gallery held the cheapest seats, and the boy up there "a-waving of his handkerchief" was presumably poor. At the Old Bedford the song was associated with the performer Little Dot Hetherington. Sickert painted her singing and gesturing to the gallery in an earlier picture (private collection), one that he showed at his "London Impressionists" exhibition at the Goupil Gallery in 1889. *The Gallery of the Old Bedford* may be a kind of companion piece; it is the same width though taller, and placed to the right of the *Little Dot Hetherington* would complete the narrative by showing the cockney "boys" to whom she gestures as she sings.

The composition seems calculated to disorient the viewer at first, coming together with more considered inspection. The key element in this is the mirror on the left: what might appear initially as a second balcony at a curious angle

to the first, suddenly makes sense as a reflection of the same balcony and its occupants. To the mirror and the fanciful theatrical architecture is added a further complication in the form of the lighting from the stage below, which throws shadows upward and distorts the men's faces. A former actor, Sickert shows his affection for the magical, transforming atmosphere of the theater. In the spontaneous look of the work, the sense of loaded brushes moving rapidly to create the image, he also suggests a delight in the materials of painting. When *The Gallery of the Old Bedford* was first exhibited, it was reviewed by George Moore, a friend of the artist:

I like it because of its beauty; it has a beauty of tone, colour, and composition. I admire it for the fine battle the painter has fought against the stubborn difficulty of the subject. For to have discovered that architecture and to have fitted it into his canvas was no little feat —that grey space of ceiling with its coloured panel, and that space of grey-blue beneath the gallery with just sufficient pillar to explain, are they not admirably balanced? That pilaster, too, about which the boys crowd and cling keeps its place in the composition—the

red paint with which it is decorated
is low in tone and harmonious;
the shadow, too, that floats over the
gold ornaments is in its right place:
it is as transparent as a real shadow,
and therefore redeems the vulgar
painting and gilding. . . . The great
mirror in which vague shadows
are reflected, is it not a triumph?[1]

The Gallery of the Old Bedford
was to prove one of Sickert's
favorites among his own com-
positions; there are not only
preparatory oils, and related
drawings and etchings, but also
several later, slightly different
versions, the largest of them
at the National Gallery of
Canada, Ottawa. m.w.

Notes
1. *Speaker*, 23 November 1895,
 quoted in Baron 1973, 40.

Balaclava

Elizabeth Thompson (Lady Butler)

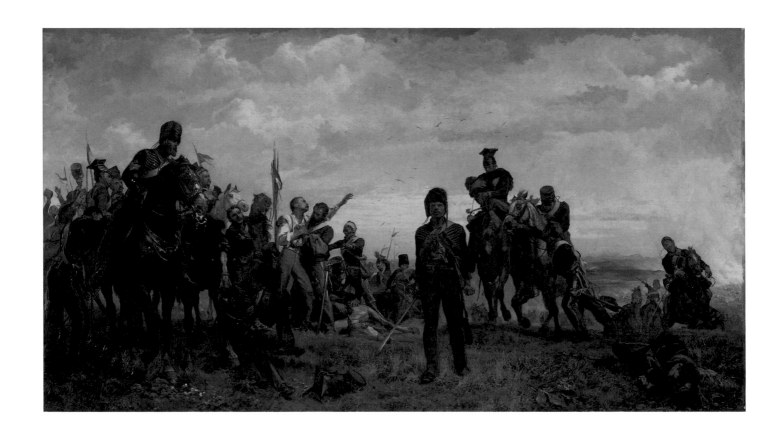

February Fill Dyke

Benjamin Williams Leader

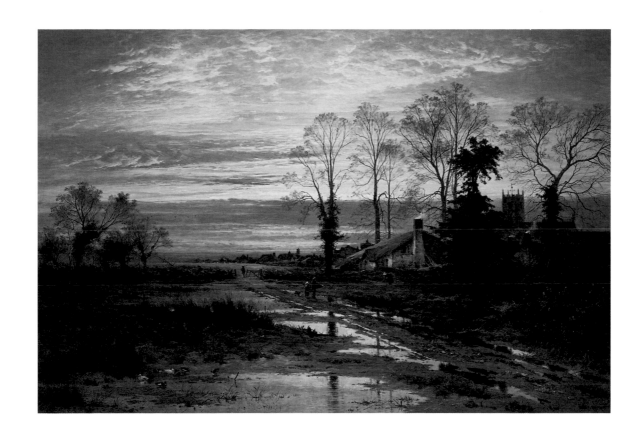

A Spring Morning, Haverstock Hill
George Clausen

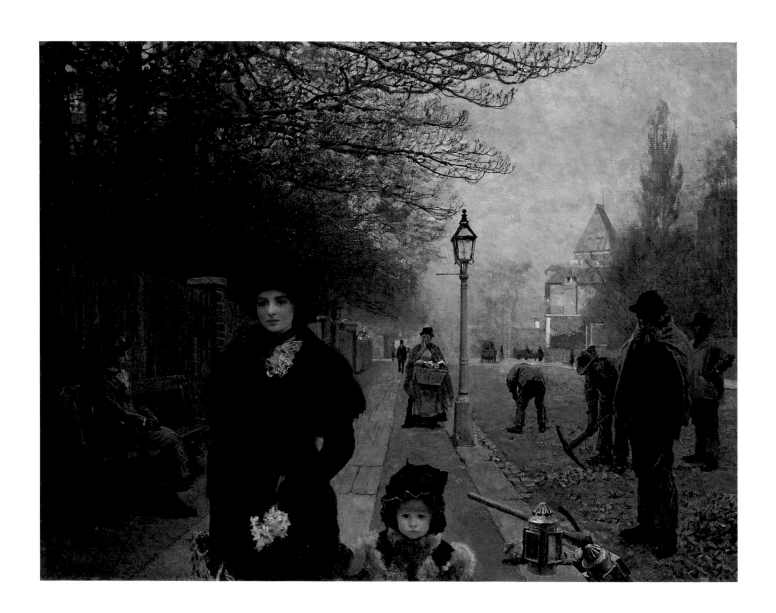

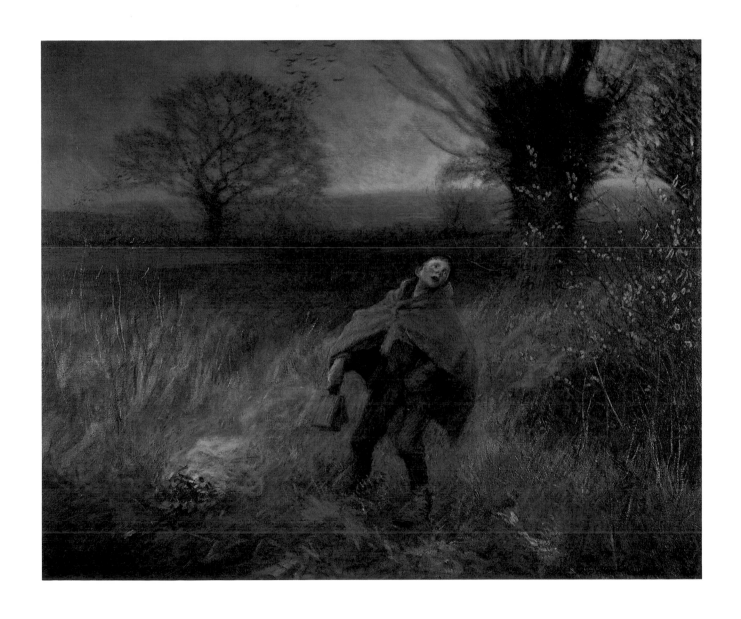

Mariage de Convenance

William Quiller Orchardson

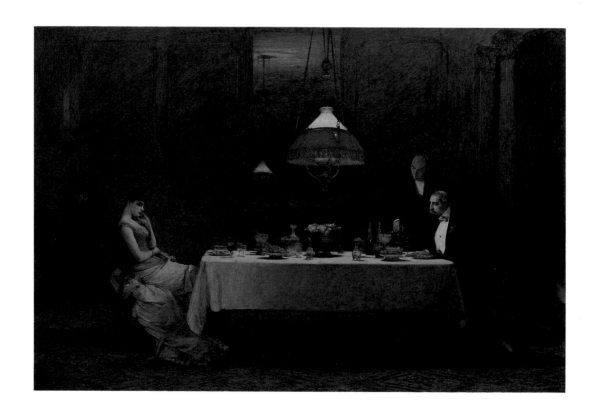

Midsummer
Albert Moore

The Tennis Match
John Lavery

A Fish Sale on a Cornish Beach
Stanhope Forbes

Carnation, Lily, Lily, Rose
John Singer Sargent

Lady Agnew of Lochnaw
John Singer Sargent

Idyll
Frederic Leighton

Flaming June
Frederic Leighton

Sappho and Alcaeus
Lawrence Alma-Tadema

The Gallery of the Old Bedford
Walter Sickert

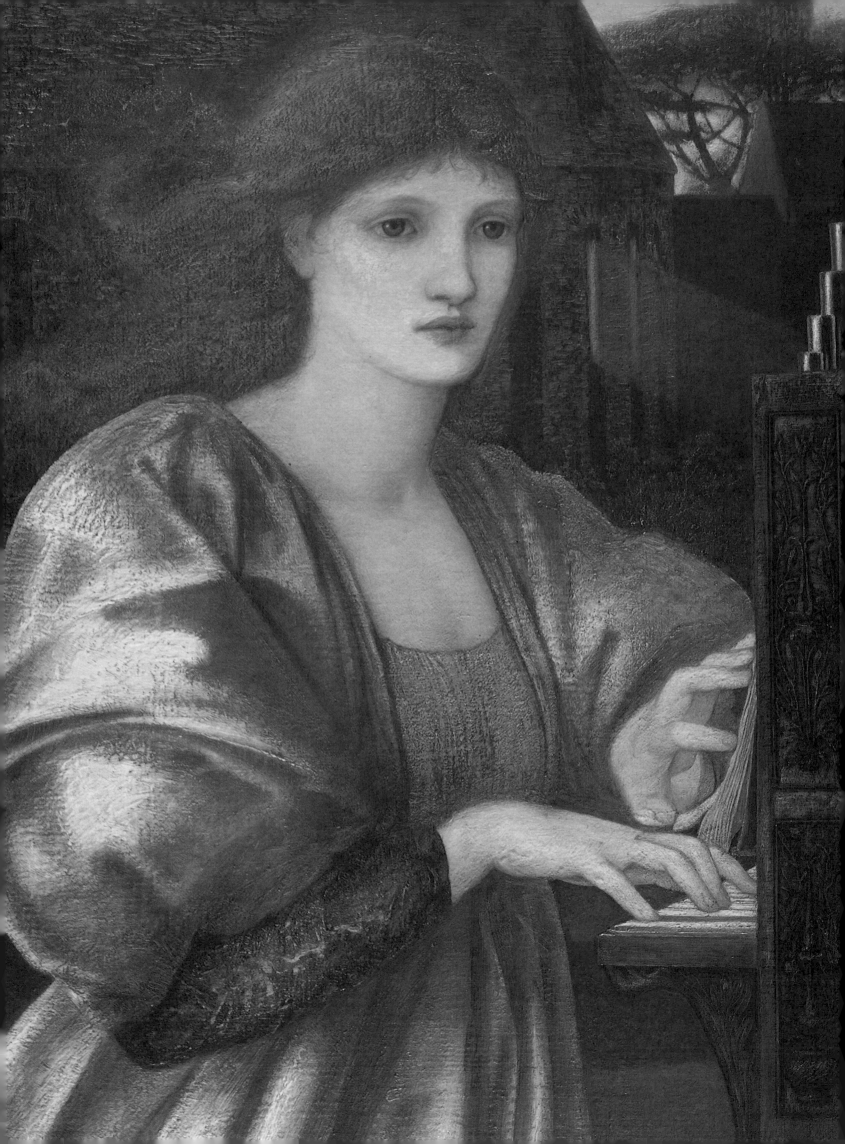

ALMA-TADEMA BROWN BURNE-JONES

Lawrence Alma-Tadema
1836–1912

Classical revival painter known for his archaeological research and detail. Of Dutch origin, Alma-Tadema was born in the village of Dronrijp, in Friesland. From 1852 to 1856 he attended the Academy of Fine Arts in Antwerp, where he was encouraged to paint subjects from Dutch and Flemish history. From 1857 to 1858, he resided with the archaeologist Louis de Taeye, who encouraged him to paint with historic accuracy, and to take up Merovingian legends as well as scenes of Egyptian history. He was elected a member of the Academy of Antwerp in 1861 and received a gold medal at the Paris Salon of 1864 for *Pastimes in Ancient Egypt* (Harris Museum and Art Gallery, Preston). He married Marie Pauline Gressin in 1863 and on their honeymoon they traveled to Italy, where Alma-Tadema became fascinated with the ruins of Roman civilization, particularly Pompeii, where he returned in 1878. With these trips, Alma-Tadema built up his collection of site drawings and photographs of archaeological remains, and commenced painting subjects of ancient

Rome. Despite his concern for accuracy, however, his paintings tend to show the ancient world through the lens of Victorian interests and concerns.

In 1864 he met the London art dealer Ernest Gambart, who commissioned twenty-four oil paintings and sold them at his French Gallery in London. In 1865, Alma-Tadema moved to Brussels and was named a knight of the Order of Leopold I after the success of his *Preparations for the Festivities* (Sterling and Francine Clark Art Institute), a domestic scene of ancient Rome, at the 1866 Exposition Général. Four years later, Alma-Tadema moved to London where his paintings were appreciated for their skilled workmanship and delicate handling of color. Alma-Tadema's wife died in 1869, and in 1871 he married Laura Epps, a painter who had been his student. He continued his working relationship with Gambart, who in 1874 commissioned *A Picture Gallery* (private collection) for £10,000. Alma-Tadema enjoyed a rapid ascendency into the upper ranks of the Victorian art world: he was made an associate of the Royal Academy in 1876, a full member in 1879, and was awarded

a knighthood in 1899. He also had ties with the Grosvenor Gallery, where he held a one-man exhibition in the winter of 1882–1883, concurrently with a retrospective of Cecil Lawson's work.

In the 1880s and 1890s, he designed stage sets, as well as props and costumes, including several for the famed Victorian actor Henry Irving. During this period he painted a number of outdoor scenes of ancient Rome and contemporary portraits. Alma-Tadema received the Order of Merit in 1905. A year after his death, a memorial exhibition of his work was held at the Royal Academy.

Ford Madox Brown
1821–1893

Painter of historical and modern-life subjects, as well as landscapes. Brown was born in Calais, where his father, a former naval officer, had settled. In 1835 he enrolled at the Bruges Academy of Painting, Sculpture, and Architecture, where he studied under Albert Gregorius, a former pupil of Jacques-Louis David. The following year he enrolled at the Academy in Ghent in preparation for attending the Antwerp

Academy in 1838. There he studied with the historical painter Gustave, Baron Wappers. In 1841, after marrying his cousin, Elisabeth Bromley, he moved to Paris, where he studied the works of Rembrandt and Spanish masters, such as Velázquez, as well as contemporary artists such as Delacroix and Delaroche. In 1844 he submitted cartoons to the mural competition for the Houses of Parliament and moved to London.

In 1845 Brown and his wife traveled to Rome via Basel for her health (she died in Paris the following year). His exposure to the work of Hans Holbein, the German Nazarenes, and Italian masters had a profound effect on his style, and he began to paint in a linear, realist manner with fresco-style coloring, as exemplified in *Wycliffe Reading His Translation of the Bible to John of Gaunt* (Bradford City Art Gallery). In March 1848, Dante Gabriel Rossetti wrote to Brown asking if he could become Brown's pupil. Although Brown was never an official member of the Pre-Raphaelite Brotherhood, he was close with Rossetti, William Holman Hunt, and John Everett Millais, and shared their preoccupation with the early masters and the faithful observation of nature represented in bright colors and minute detail. Brown also contributed to the Pre-Raphaelite journal *The Germ*.

Brown's early works at the Royal Academy, such as *Geoffrey Chaucer Reading the "Legend of Custance"* (1851; Sydney, Art Gallery of New South Wales), were generally well received, but his submissions of 1852, *The Pretty Baa-Lambs* (Birmingham Museums and Art Gallery), a landscape painted out-of-doors, and *Jesus Washing Peter's Feet* (Tate Gallery), a realist depiction painted in the "wet white" technique he learned from Millais, were ill-placed. After his submission of 1853, *Waiting* (private collection), failed to attract a buyer, Brown no longer exhibited at the Royal Academy, but continued to show work at provincial exhibitions.

In 1852, Brown began his two great modern-life subjects, *Work* (cat. 19) and *The Last of England* (1852–1855; Birmingham Museums and Art Gallery), both of which included his model Matilda (Emma) Hill, whom he married on 5 April 1853. In the 1850s, he painted several landscapes, including *An English Autumn Afternoon* (1852–1854; Birmingham Museums and Art Gallery), and produced numerous replicas to support his family, who were often in straitened circumstances. Brown's financial condition improved in 1856 when he was awarded a prize at the Liverpool Academy for *Jesus Washing Peter's Feet*. By the late 1850s he had established several patrons, including T. E. Plint, who commissioned *Work*, James Leathart of Newcastle, and George Rae of Birkenhead. In 1857 he helped to organize the Pre-Raphaelite exhibition at 4 Russell Place, Fitzroy Square. In 1858, along with Rossetti, Hunt, and others, Brown founded the Hogarth Club (1858–1861), an alternative exhibition space to the Royal Academy. In the fall of 1858 he joined the staff of the Working Men's College, remaining until the spring of 1861. In 1861 he became a founding member of the arts and crafts firm Morris, Marshall, Faulkner, & Co., and produced designs for stained glass and, later, furniture. In 1865, Brown held a one-man exhibition featuring *Work*, which brought him to the attention of wealthy patrons such as the Liverpool banker Frederick Leyland. In the 1870s interest in Brown's work declined, and beginning in 1878, he devoted much of his energy to a series of murals for Manchester Town Hall based on local historical events. He also produced decorations for the Art Treasures Exhibition, held in Manchester in 1887. He died in 1893.

Edward Burne-Jones

1833–1898

Painter of wistful, dreamlike scenes from medieval legend and classical myth, and a leading figure in the aesthetic movement. Burne-Jones was born in Birmingham to a gilder and framemaker. In 1853 he enrolled at Exeter College, Oxford, intending to enter the church. At Oxford he met his lifelong friend and collaborator William Morris. After a tour of the cathedrals of northern France in the summer of 1855, he and Morris decided upon artistic careers and left Oxford without taking their degrees. In 1856 he settled in London, sharing rooms with Morris. There he met Dante Gabriel Rossetti, who gave him a few informal lessons in art—apparently the only training he received. His early efforts, small ink drawings and watercolors,

CLAUSEN DADD DYCE

show Rossetti's influence. In 1857 Burne-Jones joined Rossetti and other young artists, including Morris and Arthur Hughes, in painting murals for the Oxford Union.

In 1859 he made his first visit to Italy, and the following year he married Georgiana Macdonald, daughter of a Methodist minister. In 1861 Burne-Jones helped Morris set up the decorative arts firm of Morris, Marshall, Faulkner, & Co., to which he contributed hundreds of designs for stained glass, tapestries, tiles, etc. In 1862 he and Georgiana visited Italy with friend and patron John Ruskin, who encouraged him to study Venetian art. Most of his paintings of this period were in watercolor and bodycolor, and he was elected associate of the Old Water Colour Society in 1864. In 1870 he resigned from the OWCS over criticisms of the nude figures in *Phyllis and Demophoön* (Birmingham Museums and Art Gallery). From around this time he concentrated increasingly on oil painting. He traveled again to Italy in 1871 and 1873, studying the artists who inspired his mature painting style: Mantegna, Botticelli, and Michelangelo. He achieved sudden fame with eight of his

pictures at the first Grosvenor Gallery exhibition in 1877. The following year he appeared as a witness for Ruskin in the Whistler-Ruskin trial.

From about 1880 Burne-Jones painted large-scale oils, some based on earlier designs for stained glass and tapestries, helped by his studio assistant Thomas Matthews Rooke. His masterpiece, the *Sleep of Arthur in Avalon* (Museo de Arte de Ponce, The Luis A. Ferré Foundation, Inc., Ponce Puerto Rico), was begun in 1881 and left unfinished at his death. He was elected associate of the Royal Academy in 1885, but exhibited there only once (1886) before resigning in 1893. He exhibited regularly at the Grosvenor Gallery until 1887, after which he transferred his allegiance to the New Gallery, where a retrospective of his work was held in 1892–1893. In 1894 he was created a baronet. Burne-Jones also illustrated books published by Morris at the Kelmscott Press, including the famous "Kelmscott Chaucer" of 1896. By the end of his life he enjoyed a considerable reputation in France as well as Britain.

George Clausen
1852–1944

A leading figure in early British modernism. Clausen was born in London in 1852 and attended Saint Mark's College, Chelsea. In 1867 he enrolled in evening classes at the National Art School (now the Royal College of Art), South Kensington, while working in the drawing office of Messrs. Tollope, builders and decorators. From 1873 to 1875 he attended National Art School, where he worked with Edwin Long, a painter of Middle Eastern scenes. In 1875 he traveled to Holland and Belgium, where he developed an interest in Dutch naturalism, and in 1876 he visited Paris studios, including that of Carolus Duran. He was elected associate of the Royal Institute of Painters in Water Colours in 1876 and full member in 1886. In 1881 he married Agnes Webster and moved to Childwick Green, Berkshire, which provided him with rural subjects. In 1882 he began to exhibit works visibly influenced by Jules Bastien-Lepage, and in the fall of that year he went to Quimperlé, France, to paint French rustic scenes. Clausen wrote in support of the French

artist in "Bastien Lepage and Modern Realism," published in *The Scottish Art Review* (1888). In 1883 he briefly attended the Académie Julien in Paris. His 1884 submission to the Royal Academy, *Labourers after Dinner*, was sharply criticized. Rejecting the British academic style in favor of contemporary French painting techniques, he helped found the New English Art Club in 1886. The next year he exhibited *The Stone-pickers*, one of his closest studies after Bastien-Lepage, at the New English Art Club. *Girl at the Gate* (1889; Tate Gallery) was purchased for the nation by the Chantrey Bequest in 1890. He was elected associate of the Royal Society of Painters in Water Colours in 1889 and a full member in 1898. In 1895 he was elected an associate of the Royal Academy of Arts and a full member in 1908.

Clausen began to develop a more luminescent, impressionist palette around the turn of the century, perhaps due to his extensive work in pastels. In 1893 he was elected to honorary membership in the Art Workers' Guild. Clausen received numerous medals in international exhibitions, beginning in 1889. In 1902 he held the first of several one-man exhibitions at the Goupil and Leicester galleries. From 1904 to 1906 he taught at the Royal Academy of Arts, which required that he move to London, and subsequently published *Six Lectures on Painting* (1904) and *Aims and Ideals in Art* (1906). During World War I he served as an official war artist, and in 1923 he designed posters for the London Midland and Scottish Railway. He was knighted in 1927. Retrospectives of his work were held in 1928 and 1933 (Barbizon House, London).

Richard Dadd
1817–1886

Painter of fairy and literary subjects. Dadd was born in Chatham, where his father worked as a chemist and served as the first curator of the museum of the Chatham and Rochester Literary and Philosophical Institution. In 1834 the family moved to London, where in 1837 Dadd entered the Royal Academy schools. His painting professor, Henry Howard, specialized in fairy subjects. In the late 1830s, Dadd, Augustus Egg, William Powell Frith, John Phillip, and several other artists formed a sketching club called The Clique, and Dadd led a committee to investigate alternate forms of exhibiting outside the Royal Academy. In this period, he exhibited at the Society of British Artists (Suffolk Street) and the British Institution. In 1841, he exhibited *Titania Sleeping* (private collection) at the Royal Academy, signaling his developing interest in fantasy and Shakespearean themes. In the early 1840s he provided illustrations for several books, including S.C. Hall's *Book of British Ballads* (1842), and helped establish the Painter's Etching Society with Frith, Egg, and others.

In 1842, Sir Thomas Phillips, a solicitor, hired Dadd to accompany him on his Grand Tour and provide sketches of the Continent and Middle East. On the return home, Dadd exhibited signs of mental illness, and in May 1843 he left Phillips in Paris to return to London. In August Dadd murdered his father; he was committed to the Kensington House Asylum and then transferred to Bethlem Hospital. He took up painting again within a year of his admission, executing primarily travel scenes. In the early 1850s, he returned to his fairy subjects, perhaps due to the influence of a new physician, Dr. William Charles Hood, to whom he dedicated *Oberon and Titania* (1854–1858; private collection). In 1864, he was transferred to Broadmoor Hospital, in Berkshire, where he painted a large mural decoration (now destroyed) for the theater, as well as small watercolors of mystical subjects. After he was declared insane, he rarely exhibited publicly, and many of his works were given as gifts to hospital employees.

William Dyce
1806–1864

Painter of murals and landscapes. Dyce was born in Aberdeen, Scotland; from his father, a lecturer in medicine, he acquired intellectual and scientific interests that he maintained throughout his life. Dyce studied art briefly at the Royal Academy schools. He became impressed by the work of the Nazarenes while visiting Rome. By 1829 he was back in Scotland practicing as a portraitist, first in Aberdeen, then in Edinburgh. In 1830 he wrote a prize-winning treatise on electromagnetism, but turned increasingly to issues of art education and the applied arts. In 1837 he was appointed

EGG EGLEY FILDES FORBES

superintendent of the newly opened Government School of Design in London, but he resigned in 1843, worn down by controversy and a meddlesome governing body. His feelings of liberation, as well as his desire to become a serious religious painter, are apparent in *Joash Shooting the Arrow of Deliverance* (1844; Kunsthalle Hamburg).

In 1844 he was successful in one of the competitions to select artists to decorate the New Palace of Westminster (Houses of Parliament). His frescoes there, mostly Arthurian in subject, were his main occupation for the rest of his career; the crowning achievement, with its many layered symbolism, is *Religion: The Vision of Sir Galahad and His Company* in the Queen's Robing Room (completed 1851). Dyce enjoyed the patronage of Prince Albert, who commissioned a Raphaelesque fresco for Osborne House, *Neptune Resigning His Empire of the Seas to Britannia* (1847). He was elected royal academician in 1848. In 1850 he married Jane Brand. Dyce admired the controversial paintings of the Pre-Raphaelites, who were a generation younger, and at the 1850 RA exhibition persuaded Ruskin to seriously consider their work for the first

time. He began his own ventures into the Pre-Raphaelite style with *Titian Preparing to Make His First Essay in Colouring* (1857; Aberdeen Art Gallery). A devout, high church Anglican with a strong interest in theology, Dyce was also an authority on church ritual and a composer of liturgical music. He died at his home in Streatham, at the age of fifty-seven.

Augustus Leopold Egg
1816–1863

Painter of historical genre scenes and modern-life subjects. Egg was born on 2 May 1816 in London, where he attended Henry Sass' drawing school in preparation for entering the Royal Academy in 1836. Two years later he submitted his first work to the annual exhibition of the Royal Academy—*A Spanish Girl*. In the late 1830s, he helped form The Clique, a sketching club including William Powell Frith and Richard Dadd. His early works were Shakespearean subjects or historical narratives, such as *The Life and Death of Buckingham* (1855; Yale Center for British Art). *Past and Present* was his first modern-life subject exhibited at the Academy, where he was made an associ-

ate in 1848 and a full member in 1860. He also exhibited with the Society of British Artists (Suffolk Street), the British Institution, and provincial exhibitions in Birmingham, Liverpool, and Manchester. In addition to his friendship with Frith and Charles Dickens (who invited Egg to participate in the amateur theatricals staged at his home), Egg knew the Pre-Raphaelites, including William Holman Hunt, and purchased a number of their works. He and Hunt shared ideas about color theory and studio practices, and Hunt published a brief history of Egg's life in *The Reader: A Review of Literature, Science, and Art* in 1863 and 1864. In the mid-1840s and in 1850, Egg accompanied Frith on a trip to Belgium, Holland, and the Rhine. In 1863 Egg traveled to Africa for his health, but died in Algiers.

William Maw Egley
1826–1916

Painter of historical and modern-life subjects. His father (1798–1870) was a miniature painter. In his diaries, now in the National Art Library at the Victoria and Albert Museum, London, Egley encapsulated

his career thus: "assisted his father as a miniature painter in the early portion of his career. Exhibited at the Westminster Hall Competition in 1847. Known as a painter of figure pictures in oil, illustrating History, Shakespeare, Molière, Tennyson, & the literature of the last century; also fancy subjects chiefly female figures." Egley exhibited at the Royal Academy, the British Institution, and the Society of British Artists (Suffolk Street). He was a friend of William Powell Frith and assisted in painting the backgrounds to several of his works. He also earned money through art instruction, mostly to amateur female students, who formed a society in 1873 called The Grosvenor Hill Scratch Club. Egley kept a catalogue of his paintings, which is in the collections of the National Art Library, Victoria and Albert Museum, London, England.

Samuel Luke Fildes

1843–1927

Born in Liverpool in 1843, Fildes moved to Chester at a young age to be raised by his grandmother, a member of the Chartists and the president of the female reformers of Manchester. At seventeen he entered the Warrington School of Art, outside Liverpool. In 1863 he moved to London to attend the South Kensington School of Art, and, a year later, the Royal Academy schools.

In 1869, Fildes became a staff artist at the *Graphic*, an illustrated general-interest magazine founded by William Luson Thomas. This work brought him to the attention of John Everett Millais, who recommended him to illustrate Charles Dickens' novel *Edwin Drood*, left uncompleted at Dickens' death. Around 1870, Fildes gave up illustration and turned his full attention to oil painting.

Several of his earlier engravings became the basis for subsequent Royal Academy pictures. Fildes' submissions of the 1870s and 1880s alternated between social realist works, such as *The Widower* (1876; National Museums and Galleries on Merseyside), and pastoral scenes, such as *The Village Wedding* (1883; The Manney Collection). A trip to Venice in 1874 inspired idyllic depictions such as *Venetians* (1885; Manchester City Art Galleries), which proved to be highly popular.

In the 1880s, Fildes turned to portraiture, including images of the royal family. At one point Fildes was among the most highly paid portrait painters in England. In 1887, he was elected to full membership in the Royal Academy of Arts. In that same year he promised Henry Tate "an English subject of importance," which eventually led to *The Doctor* (1890–1891; Tate Gallery). The painting has been interpreted as an autobiographical statement on several levels, representing the death of Fildes' eldest son in 1877, as well as Fildes' own thoughtful dedication to his profession. In 1906 Fildes was knighted and in 1918 created KCVO.

Stanhope Forbes

1857–1947

Plein-air genre painter and leading figure in the Newlyn School. Forbes was born in Dublin, and both his father and his uncle, a collector of contemporary British art, were managers for the Great Western Railway of Ireland. He studied drawing at the Dulwich College, with John Sparkes, and then at the Lambeth School of Art. In 1876 he became a student at the Royal Academy schools, and two years later began exhibiting portraits at the Academy. In 1880, he traveled to Paris (his mother was French) to study art in Léon Bonnat's studio. In July 1881, Forbes, along with his friend Arthur Hacker, traveled to Brittany to learn the progressive French practice of *plein-air* painting. There, in the fishing village of Cancale, Forbes began *A Street in Brittany* (Walker Art Gallery), which he exhibited with much success at the Royal Academy of 1882. Over the winter of 1881, Forbes worked in Paris and London. The following summer, he worked in the town of Quimperlé and revisited Brittany, a popular painting region for a number of French artists, including Emile Bernard and Paul Gauguin. Forbes exhibited paintings of Quimperlé in the Royal Academy exhibitions of 1883 and 1884.

In January of 1884, Forbes explored the Cornish coast of England for a new sketching ground and decided upon the village of Newlyn, where several other artists influenced by new developments in French painting had settled. *A Fish Sale on a Cornish Beach* (cat. 60) brought this group to the attention of Royal Academy critics and audiences when it was

FRITH HERKOMER HUGHES HUNT

exhibited to much acclaim in 1885. In subsequent years the Newlyn colony grew. The painter Elizabeth Armstrong (1859–1912) moved there in the mid-1880s, and she and Forbes were married in 1889 following the sale of his painting *The Health of the Bride* (1889; Tate Gallery) to Henry Tate. The couple remained in Newlyn, with intermittent trips to London, for the rest of their lives.

Forbes declined to support the New English Art Club, an organization formed by artists sympathetic to French painting techniques, despite the fact that a number of his close friends belonged. Instead he joined a provisional committee for reforming the Royal Academy, in keeping with his continued loyalty to that institution. In 1892 he was elected an associate of the Royal Academy and a full member in 1910. In the 1890s, after sending mostly genre paintings to the Academy in the 1880s, he submitted a number of portraits. In 1899, he and his wife founded a painting school in Newlyn.

William Powell Frith
1819–1909

Painter of genre and modern-life subjects. Frith's parents were domestic servants, and when the artist was seven years old his father became an inn-keeper. After some training in art at Saint Margaret's School, Dover, Frith attended Henry Sass' Academy in London in preparation for the Royal Academy schools. While a student, Frith earned money painting portraits. He submitted his first work to the Academy, a Shakespearean theme, in 1840. For the next decade he painted largely historical and literary subjects from Dickens, Goldsmith, Molière, and Shakespeare. He was a member of The Clique, a sketching society that included Richard Dadd and Augustus Egg. In 1845 he was appointed an associate of the Royal Academy and was made a full member in 1853. He also exhibited at the British Institution and the Society of British Artists (Suffolk Street).

In 1854 he exhibited the first of his three great modern-life subjects, *Life at the Seaside (Ramsgate Sands)* (Collection of the Queen), at the Royal Academy. This was followed by

Derby Day (cat. 22) in 1858 and *The Railway Station* (Royal Holloway College) in 1862. These paintings and the engravings executed after them were immensely popular. Frith worked closely with art dealers, such as Ernest Gambart, to ensure lengthy public viewing of his paintings and lucrative contracts for selling and publishing his work. In 1875 his painting *Before Dinner in Boswell's Lodgings* (1868) sold for £4,567 10s at Christie's, the highest sales-room price paid to date for the work of a living artist. Frith continued to paint crowd scenes, as well as literary subjects, but by the end of his career his images and painting techniques were regarded as old-fashioned.

Hubert von Herkomer
1849–1914

Social realist painter and portraitist. Herkomer, born in Germany in 1849, came to Southampton in 1857 after his father, a skilled craftsman, emigrated first to America (in 1851) and then England. His early artistic education came largely from his father, and in 1863–1864 he attended classes at the Southampton School of Art to prepare for the Munich

Academy, which he attended briefly in 1865. The following year Herkomer entered the South Kensington art schools and came under the influence of the landscape painter Frederick Walker. In 1870 he began contributing to the *Graphic*, later reworking several of his engravings into large-scale oils, including *The Last Muster: Sunday at the Royal Hospital, Chelsea* (1875; Lady Lever Art Gallery, Port Sunlight). That painting marked his first academy success and was awarded a grand medal of honor at the Paris International Exhibition. *Last Muster* was bought for £1,200 by Clarence Fry, a businessman from the town of Watford near the village of Bushey in Hertfordshire, where Herkomer and his family moved in 1872.

In 1879 Herkomer was elected an associate of the Royal Academy and a full member in 1890. In the 1880s he turned increasingly to the financially lucrative area of portraiture, but continued to paint social themes, such as immigrants waiting to be processed in *Pressing to the West: A Scene in Castle Garden, New York* (1884; Leipzig Museum) and a striker and his sorrowful family in *On Strike* (1891; Royal Academy of Arts).

The latter was Herkomer's diploma work and suggests that he wanted to be remembered as a painter of social themes rather than as a society portraitist. Herkomer made two tours of America in the 1880s to paint and promote his portraits. In 1883 he opened an art school and matriculated more than five hundred students between 1883 and 1904. He served as Slade Professor of Art at Oxford from 1885 to 1895.

In addition to oil, Herkomer worked in enamel, taught himself printmaking, and wrote and directed "pictorial music plays." In the early twentieth century he became involved in the nascent film industry and formed the Herkomer Film Company with his son Siegfried in March 1913. At his death, Herkomer had an international reputation: his engravings in the *Graphic* were collected by Van Gogh, his work had won recognition in France and America, in 1899 he was awarded the German Order of Merit, and in 1907 he received an English knighthood.

Arthur Hughes
1832–1915

Hughes was among the most gifted of the many young painters who came to maturity under the influence of the Pre-Raphaelites in the 1850s. He came from a Welsh background. He studied at the School of Design from 1846, and the Royal Academy Schools from 1847. He admired the Pre-Raphaelites after reading their magazine *The Germ* in 1850, and met William Holman Hunt, Dante Gabriel Rossetti, and Ford Madox Brown that year. His *Ophelia* (Manchester City Art Galleries) attracted the attention of Millais, whose own *Ophelia* (cat. 9) was in the same Royal Academy exhibition (1852), and they became friends. From 1852 to 1858 he shared a studio with the sculptor Alexander Munro, another member of the Pre-Raphaelite circle. Hughes painted distinctly Millaisian pictures of troubled lovers, notably *The Long Engagement* (c. 1853/1859; Birmingham Museums and Art Gallery) and *April Love* (1855/1856; Tate Gallery). In 1855 he married Typhena Foord, and they had six children. From 1855 he was active

and successful as an illustrator, contributing designs to works by Tennyson, Christina Rossetti, and many others. In 1857 he painted *The Death of Arthur* as part of Rossetti's scheme of mural decorations at the Oxford Union. In 1863 he visited Italy. He exhibited at the Royal Academy for the last time in 1911.

William Holman Hunt
1827–1910

Founding member of the Pre-Raphaelite Brotherhood and the foremost religious painter of the Victorian period. Hunt, the son of a warehouse manager in London, entered the Royal Academy schools in 1844, where he befriended fellow student John Everett Millais. Reading the first two volumes of Ruskin's *Modern Painters* in 1847 deepened his conviction that British art must be reformed and brought more in touch with nature. In 1848 he met Dante Gabriel Rossetti, and in September of that year he founded the Pre-Raphaelite Brotherhood, with Millais, Rossetti, and four others. His first essay in Pre-Raphaelitism, *Rienzi* (private collection), a rebellious picture in both subject and technique, was shown

LANDSEER LAVERY LAWSON

at the RA exhibition of 1849. His maturing style combined meticulous attention to detail and intricate symbolism. He experimented with sacred subject matter in *The Light of the World* (1851–1853; Keble College, Oxford) and modern life in its secular counterpart, *The Awakening Conscience* (cat. 16).

In January 1854 Hunt left England for a two-year stay in Egypt and the Holy Land, determined to paint biblical subjects with authentic topographical and archaeological details. The reception of *The Scapegoat* (cat. 17) at the RA exhibition of 1856 was disappointing. But with *The Finding of the Saviour in the Temple* (1854–1860; Birmingham Museums and Art Gallery), exhibited all over the country in 1860 and published as an engraving in 1867, he made his name with critics and the public alike. In 1865 he married Fanny Waugh, and the following year they set out for the Holy Land. They only reached Florence, however, where Fanny gave birth to a son, contracted miliary fever, and died. Visits to Jerusalem in 1869–1872, 1875–1878, and 1892 resulted in inspired biblical paintings, notably *The Shadow of Death* (1870–1873; Manchester City Art Galleries)

and *The Triumph of the Innocents* (1876–1887; Walker Art Gallery, Liverpool).

Hunt worked in a painstaking manner, and most of his major pictures took years to complete. Never elected to the RA, he ceased to exhibit his work there after 1874, preferring the Grosvenor Gallery, the New Gallery, and one-picture exhibitions. A large retrospective exhibition of his work was held at the Fine Art Society in 1886. By 1899 his eyesight had seriously deteriorated, but Hunt continued painting with studio assistance. He was awarded the Order of Merit in 1905. His two-volume autobiography, *Pre-Raphaelitism and the Pre-Raphaelite Brotherhood*, appeared later that year. Hunt died at Melbury Road; his cremated remains are buried in Saint Paul's Cathedral.

Edwin Landseer

1802–1873

Romantic painter of animal subjects, a favorite of Queen Victoria, and the most popular artist of the early Victorian period. Landseer's father John and brother Thomas were engravers, and another brother, Charles, was a painter and eventually keeper of the Royal

Academy schools. With his brothers, he studied under the high-minded history painter Benjamin Robert Haydon from 1815, though even at this early stage he was interested primarily in painting and drawing animals. In 1816 he entered the Royal Academy schools, and by the age of sixteen he enjoyed critical and financial success, exhibiting at the RA and attracting prominent patrons. He made the first of many trips to Scotland in 1824, visiting Walter Scott, and returned every autumn to fish, shoot, stalk deer, and sketch. In 1825 he moved to 1 Saint John's Wood Road, which remained his home for the rest of his life.

In 1826, at the age of twenty-four, Landseer was elected associate of the RA. His most important early patrons were the duke and duchess of Bedford, and he participated regularly in their hunting and shooting parties in the Cairngorms. He was rumored to have had an affair with the duchess, and to have fathered at least one of her children. In 1831 he was elected full academician. Landseer met Queen Victoria in 1837, the year of her accession to the throne, and received commissions to paint her dogs and other pets,

as well as the members of the royal family. His most ambitious royal commission, an equestrian portrait of the queen begun in 1838, remained unfinished at his death. In 1840 he suffered a nervous collapse, and for the rest of his life was subject to depression, alcoholism, hypochondria, paranoia, and mental breakdowns. He was helped through his many crises by his successive business managers, Jacob Bell and Thomas Hyde Hills. In 1850 he was knighted by Queen Victoria. The great work of his later career was the sculpting of the four bronze lions at the base of Nelson's Column in Trafalgar Square, commissioned in 1857 and unveiled in 1867. In 1866 he declined the presidency of the RA. He died in 1873, after his worst bout of mental illness, and is buried in Saint Paul's Cathedral.

John Lavery

1856–1941

Pioneer in Britain of French-influenced, avant-garde painting, and a fashionable portraitist. Lavery was born in Belfast, orphaned at an early age, and raised by relatives in Ireland and Scotland. After periods working for a photographer in Glasgow, attending the Haldane Academy there, and studying at Heatherley's School of Art in London, he traveled to Paris in 1881 to study at the Académie Julien. From 1883 he joined the community of British, Irish, and American artists who painted scenes of country life at the village of Grez-sur-Loing. At the beginning of 1885 he returned to Glasgow and with like-minded artist friends formed the group known as the Glasgow Boys. In 1887–1888 he showed works at the New English Art Club. He was commissioned in 1888 to paint a large, many-figured composition recording the state visit of Queen Victoria to the Glasgow International Exhibition of that year, which marked the beginning of his serious career in portraiture. In 1890 he made the first of many visits to Morocco, and in the summer of 1892 he toured the Continent, making special study of Velázquez in Spain. In 1896 he settled in London, where he served under Whistler as vice president of the International Society of Sculptors, Painters and Gravers.

Lavery enjoyed close relations with prominent families, including the Churchills and the Asquiths, whose portraits he painted, and made his name in Europe through exhibitions and portrait-painting visits. He was slow to achieve professional recognition at home, however. Only after the successful exhibition of fifty of his works at the 1910 Venice Biennale was he elected an associate of the Royal Academy. He married Hazel Trudeau, daughter of a Chicago industrialist. In 1912 he was commissioned to paint the royal family for the National Portrait Gallery. Lavery served as official war artist to the Royal Navy from 1917 to 1918, and was knighted in 1918. In 1921 he was elected full royal academician. He traveled widely in the 1920s and painted "portrait interiors" for the rich and famous of the world. In 1940 he published his autobiography.

Cecil Gordon Lawson

1851–1882

Landscape painter, illustrator, and watercolorist. Lawson was born in Wellington, Shropshire, on 3 December 1851, and moved to London with his family in 1861. He received his art training from his father, William Lawson, a portrait painter, and his elder brother. His earliest works were small studies of fruit and flowers in the manner of William Holman Hunt. In 1869 his family moved to Cheyne Walk, Chelsea, and for the next several years he depicted the Thames. In 1871 *The River in Rain* and *Summer Evening in Cheyne Walk* were hung prominently in the RA exhibition and sold. Despite this initial success, Lawson's paintings were rejected by the Academy on occasion, as in the case of *Hymn to Spring* and *Hop Gardens.* The latter was accepted only on the second try in 1875. In 1874, he traveled briefly to Holland, Belgium, and Paris.

The high point of Lawson's career came in 1878, when *The Minister's Garden* (Manchester City Art Galleries) was exhibited at the Grosvenor Gallery and purchased at the private view for £1,200. Inspired by the Oliver Goldsmith poem "The Deserted Village" (published 1769), *The Minister's Garden* depicted a pastoral landscape framed by an old-fashioned cottage garden. His biographer Edmund Gosse declared it to be "probably the greatest English landscape of the second half of the nineteenth century." Lawson exhibited with the Grosvenor from

LEADER LEAR LEIGHTON

1879 to 1882. He also exhibited at the RA during this period, although his works were often ill placed. In 1879 he married Constance B. Philip, a flower painter who also exhibited at the Grosvenor. In 1880, Lawson enjoyed another success at the Grosvenor with *August Moon* (Tate Gallery). Around this time, Lawson executed a series of Yorkshire landscapes for his patron Henry Mason. In December 1881, following a series of health problems, Lawson went to the Riviera, which provided the subject for one of his last exhibited pictures at the Grosvenor, *On the Road to Monaco from Mentone, January 1882*. In the winter of 1882–1883, after Lawson's death, the Grosvenor Gallery presented a retrospective exhibition of his work.

Benjamin Williams Leader

1831–1925

Landscape painter. Leader was born Benjamin Leader Williams in 1831. His father, E. Leader Williams, was a civil engineer and amateur painter. In 1854, after training as an engineer, Leader attended the Royal Academy schools, where he changed his name to Benjamin Williams Leader to distinguish himself from another artist named Williams. He exhibited at the annual Royal Academy exhibitions from 1854 until 1904, favoring rustic genre scenes and landscapes. In 1863 he moved to Whittington, near Worcester, and Worcestershire and Wales became his major painting sites. In the early 1860s he enjoyed success with his landscape *The Churchyard at Bettws-y-Coed* (1863; Guildhall Art Gallery, London), which was purchased by Prime Minister William Gladstone. In 1876 he married Mary Eastlake, niece of Royal Academy President Charles Lock Eastlake and a fellow Royal Academy exhibitor who specialized in flower paintings. In 1883 Leader was voted an associate of the Royal Academy and became a full member ten years later. His paintings were

handled by the dealers Agnew and Sons, M. Newman Ltd, and Arthur Tooth and Sons, who often obtained the copyrights to Leader's images, enabling them to issue popular prints after his works.

Leader collected numerous honors, including a medal in the 1882 Paris Salon, the Chevalier of the Legion of Honor in 1890, and a medal at the Chicago World's Fair of 1893. In 1888 he moved to London, and then to a Norman Shaw house at Burrow's Cross, Shere, near Guildford Surrey, in 1889. His later landscapes depict the Surrey countryside. By the time of his death, Leader had executed more than eight hundred landscape paintings. In 1901, the *Art Journal*, in surveying his career, claimed that in providing a "broad and strong treatment of our insular landscape" Leader had become "one of the most truly national painters which the British Isles have ever produced."

Edward Lear
1812–1888

The twenty-first of twenty-two children, Lear was raised by his sister Ann, who provided his early instruction in drawing and painting. At age sixteen, Lear began work as an ornithological and zoological illustrator. In 1837 he left London for Rome, with funds provided by Robert Hornby and Lord Derby, president of the Zoological Society for whom Lear had produced natural history illustrations. In Rome, Lear earned a living giving lessons and selling drawings inspired by the landscapes of Claude Lorraine. In 1841 he published a set of travel images, *Views in Rome and its Environs*, followed by *Illustrated Excursions in Italy*, in 1846. His *Book of Nonsense* was first published in 1846. During this period he also received commissions for oil paintings.

In 1847, he took a tour of the Mediterranean region, returning to England in 1849. The following year, out of a desire to learn the fundamentals of painting, Lear enrolled at the Royal Academy schools, which he attended for one year. He began exhibiting at the Royal Academy and the British Institution, where his works sold well. In 1852 he was introduced to William Holman Hunt, who assisted him in developing his oil technique. The next year Lear traveled to Egypt, briefly meeting Hunt in Cairo. In the next few years he traveled quite frequently—to Switzerland in the summer of 1854, to Corfu and Greece in 1855 and 1856, and to the Holy Land and Corfu in 1858 —and recorded his visits in topographical watercolors as well as commissioned oils. He returned to England in 1860, at which time he produced his ambitious, large-scale oil *The Cedars of Lebanon* (private collection), which was not well received by critics. In 1861, at the behest of his patron Lady Waldegrave, Lear traveled to Florence to produce a Florentine landscape. The following year he returned to Corfu, where he systematized his method of painting landscape watercolors (which he referred to as his "Tyrants"). In 1863 he published his lithographic series *Views in the Seven Ionian Islands*. Over the next few years he traveled to Corfu, Athens, Crete, Nice, Venice, Malta, Cairo, Cannes, and Corsica; the last-named was the subject of his last travel book, *Journal of a Landscape Painter in Corsica* (1870). In 1872 he accepted an invitation from Lord Northbrook to paint subjects in India and during a stop in Suez painted *The Pyramids Road, Gizah* (cat. 44). In addition to letters documenting his travels, thirty-five volumes of Lear's diaries are extant in the collections at the Houghton Library at Harvard University.

Frederic Leighton
1830–1896

German-trained artist who helped nurture the aesthetic movement in the 1860s and became Britain's leading painter of subjects from classical history and myth. Leighton was born in Scarborough, but his family traveled widely during his youth and lived in several European cities. In Frankfurt in 1846–1848 and 1850–1852 Leighton studied at the Städelsches Kunstinstitut and became friendly with the Nazarene painter Edward von Steinle. From 1852 to 1855 he was based in Rome, where he met other Nazarenes and began an intimate, long-lasting friendship with the former opera singer Adelaide Sartoris. In Rome he painted *Cimabue's Celebrated Madonna is Carried in Procession through the Streets of Florence* (1853–1855; Royal Collection), a monumental, friezelike composition that made his name at the 1855 RA exhibition and was bought by Queen Victoria.

During the next four years he lived in Paris, and again in Rome. From 1859 he was resident in London, though still traveling abroad almost every year. In 1864 he was elected associate of the Royal Academy. In 1866 he moved into a house in Holland Park Road, Kensington, where he remained for the rest of his life (now a museum); there he built the famous "Arab Hall" to display Islamic tiles collected on visits to the Middle East. In 1868 he was elected royal academician. From 1870 to 1885 he worked intermittently on a pair of frescoes in the South Kensington (Victoria and Albert) Museum. He also painted further large, processional pictures, notably *The Daphnephoria* (Lady Lever Art Gallery, Port Sunlight) and *Captive Andromache* (Manchester City Art Galleries), exhibited in 1876 and 1888, respectively; the latter was arguably his masterpiece. In 1877 he exhibited his first sculpture, *Athlete Wrestling with a Python*; though small in number, his

sculptures played a key part in the growth of the New Sculpture movement.

Elected president of the Royal Academy in 1878, Leighton carried out his duties with polish, moving easily in high society, and encouraged the efforts of young, innovative artists. He was created a baronet in 1886, and in the New Year Honours List of 1896 was created Baron Leighton of Stretton, the first artist ever raised to the peerage. He died on 25 January 1896 and is buried in Saint Paul's Cathedral.

John Frederick Lewis
1805–1876

Painter of orientalist subjects. Lewis received his art instruction from his father, an engraver and landscape watercolorist. His early work, exhibited at the British Institution and the Royal Academy, focused on animal subjects in the manner of his friend Edwin Landseer. In 1827 he was elected an associate of the Old Water Colour Society, and a full member in 1829. In the late 1820s he toured Europe and Scotland and produced watercolors of his travels. In 1832 he traveled to Spain,

including Madrid, Toledo, Granada, Cordova, Seville, as well as Morocco, returning to England in 1834. The studies he produced there provided him with subjects for his submissions to Royal Academy and owcs exhibitions of the mid-1830s, and two books of lithographs, *Sketches and Drawings of the Alhambra* (1835) and *Lewis's Sketches of Spain and Spanish Character* (1836).

In 1837 Lewis traveled to Paris and Italy. In early 1840 he traveled to Greece, the Levant, and Egypt, settling in Cairo in 1841. During the 1840s he produced drawings and watercolors of people and buildings in Cairo, but did not exhibit in England. He married Marian Harper in 1847. In 1850 he exhibited the first of many harem subjects at the owcs, *The Hhareem* (Victoria and Albert Museum), which was well received and sold for £1000. The following year, he and his wife returned to England. He became president of the owcs in 1855. *Frank Encampment in the Desert of Mount Sinai* (Yale Center for British Art), exhibited at the owcs exhibition of 1856, was praised by Ruskin for its attention to detail and innovative presentation of a meeting between East and

West. Lewis began exhibiting orientalist subjects at the Royal Academy in 1854; he was made an associate of the Academy in 1859 and a full member in 1865. He resigned his membership and presidency of the owcs in 1858, citing insufficient financial remuneration for watercolor, and turned his full attention to oil painting. His oil paintings, like his watercolors, were of Levantine subjects and displayed meticulous attention to qualities of surface, light, and color, as seen in *The Midday Meal, Cairo* (cat. 49).

John Everett Millais
1829–1896

Founding member of the Pre-Raphaelite Brotherhood, and, in the 1870s and 1880s, the most popular painter in Britain. His father was a man of independent means from Jersey in the Channel Islands. Millais spent his childhood in Southampton, Jersey, Dinan, and London, where his parents brought him in 1838 to be trained as an artist. A child prodigy, he entered the Royal Academy schools in 1840, at the age of eleven, to become the RA's youngest ever student. He debuted at the RA exhibi-

tion in 1846 with *Pizarro Seizing the Inca of Peru* (Victoria and Albert Museum). He became friends with fellow student William Holman Hunt, with whom he developed radical ideas about the state of British art. In September 1848, Millais, Hunt, Dante Gabriel Rossetti, and others formed the Pre-Raphaelite Brotherhood, dedicated to treating serious subjects as naturally and truthfully as possible, rejecting the conventions of ideal beauty and painterly bravura. His first Pre-Raphaelite painting, *Isabella* (cat. 6), was well received at the RA exhibition of 1849, but his main work of the following year, *Christ in the Carpenter's Shop* (cat. 7), provoked hostile reviews. In 1852 he won acclaim with *A Huguenot* (cat. 10), his first picture to be published as an engraving, and the following year was elected associate of the Royal Academy.

Millais was taken up by the critic John Ruskin, whom he joined for a holiday in Scotland in 1853. There he fell in love with Ruskin's wife Effie; she was granted an annulment in the following year, and married Millais on 3 July 1855. For six years he lived in Perth, Scotland, painting dreamy pictures on the theme of mortality, be-

ginning with *Autumn Leaves* (cat. 12). He also worked prolifically on illustrations to books and magazines, including the Moxon Tennyson (published 1857), *Once a Week* (from 1859), *Framley Parsonage* (1860–1861) and several other Trollope novels, and *The Parables of Our Lord* (1863).

In 1863 he exhibited *My First Sermon* (Guildhall Art Gallery), the first of many charming studies of pretty children, often from among his own four sons and four daughters, that sold widely in the form of engravings. That year he was elected royal academician. His style became more painterly, and the artistic heroes of his later career were Hals, Velázquez, and Reynolds. His RA diploma picture was a broadly executed study of a girl in costume, *A Souvenir of Velasquez* (1868; Royal Academy). Another child subject, *Bubbles* (1886; A. & F. Pears Ltd), became famous as an advertisement for Pears Soap.

From the 1870s, Millais built up a prestigious practice as a portraitist. His sitters included some of the most prominent figures of the Victorian age: Thomas Carlyle (1877), Lillie Langtry (1878), William Gladstone (1879 and 1885),

Benjamin Disraeli (1881), Alfred Tennyson (1881), Henry Irving (1883), the earl of Rosebery (1886), and Arthur Sullivan (1888). With *Chill October* (1870; Sir Andrew Lloyd Webber) he began a series of large, bleak landscapes, mostly scenes around Birnam and Dunkeld in Scotland, where he rented various houses each autumn and winter for family holidays, fishing, and shooting. In 1885 he was created a baronet. Millais was elected president of the Royal Academy in 1896; he died later that year, and is buried in Saint Paul's Cathedral.

Albert Moore
1841–1893

Key figure in the classical revival and aesthetic movements. Moore was born in York, where his father was a portrait and landscape painter; his two brothers also became artists. In 1855 he moved to London. He submitted his first two works to the Royal Academy, *A Goldfinch* and *A Wood Cock*, done in the Pre-Raphaelite spirit of study after nature, in 1857. In May 1858 he entered the Royal Academy schools, staying only a short period, during which time he formed a

sketching society with Simeon Solomon, Henry Holiday, William Blake Richmond, Marcus Stone, and Frederick Walker. In 1859 he traveled to France with the architect William Eden Nesfield, and in 1862–1863, according to his biographer A.L. Baldry, visited Rome, where he first became interested in classical sculpture.

In the 1860s he executed designs for decorative objects and completed a series of commissions for ceiling and wall paintings. He also submitted paintings of biblical themes, such as *Elijah's Sacrifice* (1865), to the Royal Academy, as well as his characteristic subjects of women in classical draperies. One of his early submissions to the Royal Academy, *The Marble Seat* (1865), based loosely on the Elgin Marbles, brought his work to the attention of James McNeill Whistler. In an 1865 letter to the French painter Henri Fantin-Latour, Whistler proposed replacing Alphonse Legros with Moore in their Société des Trois. Over the next few years Whistler and Moore explored a new form of modern art based on classicism and *Japonisme*. In September 1870, Whistler grew anxious over the similarities between his work and that of Moore

ORCHARDSON ROSSETTI SARGENT

and asked Nesfield to mediate; Nesfield replied that while Whistler had obviously borrowed from Moore's interest in Greek classicism and Moore from Whistler's harmoniously balanced palette, the two artists' work was clearly distinguishable. After the 1860s, the two artists continued to pursue the decorative possibilities of painting, although along different paths: Whistler largely dropped references to classical art and turned to modern-life subjects, while Moore continued to pursue classical themes.

In 1877, Moore submitted three paintings to the first exhibition at the Grosvenor Gallery, which helped to establish him as a leading figure in British aestheticism. He moved his studio to Holland Lane, Kensington, remaining there until Christmas 1891. In 1878 he testified on Whistler's behalf at the Whistler-Ruskin trial. In 1884, he became a member of the Royal Water Colour Society. His later works, such as *An Idyll* (1893; Manchester City Art Galleries), a depiction of a lovers' quarrel, became more narrative in content. Although reclusive, Moore had loyal patrons and several students. He died in September 1893, after a long illness.

William Quiller Orchardson
1832–1910

Painter of historical costume pieces, scenes from contemporary life, and portraits. Orchardson was born in Edinburgh, son of a tailor; his mother was Austrian. From 1845 he attended the Trustees' Academy in Edinburgh, where he became part of a rising generation of talented young Scottish painters studying under Robert Scott Lauder. He moved to London in 1862, and debuted at the Royal Academy exhibition in 1863. His early work shows his admiration for the Pre-Raphaelites, especially Millais. In London he became closely associated with his compatriots and fellow students of Lauder, John Pettie and Tom Graham. In 1870 he visited Venice, where he returned for his honeymoon following his marriage to Ellen Moxon in 1873. His beloved daughter and future biographer, Hilda, was born in 1875. In 1877 he was elected to the Royal Academy. In the later 1870s he moved from literary subjects to celebrated episodes from history and glimpses into the lives of the rich. From this time onward he was popular and moderately wealthy him-

self. His most successful historical painting shows Napoleon sailing to exile on Elba, *On Board HMS Bellerophon* (Tate Gallery); in 1880 this was bought for the nation through the Chantrey Bequest for the impressive sum of £2,000. Orchardson was knighted in 1907.

Dante Gabriel Rossetti
1828–1882

Pre-Raphaelite painter and poet. In 1824 Rossetti's father, Gabriel Pasquale Rossetti, an Italian political exile, settled in London, where he was appointed professor of Italian at King's College in 1831. Gabriel Rossetti devoted much of his life to the Florentine poet Dante Alighieri, whose writings inspired many of his son's paintings. Dante Gabriel, originally named Charles Gabriel Dante, was the second child, born in London on 12 May 1828. He had three siblings: Maria, an Anglican nun; William Michael, a member of the Pre-Raphaelite Brotherhood and an art critic; and Christina, a poet and contributor to the Pre-Raphaelite journal *The Germ.*

Dante Gabriel briefly attended the King's College school and then began his art

education at Henry Sass' Academy in London in preparation for entering the Royal Academy schools. He attended the antique school of the Royal Academy, but left the institution before moving to the life school. He briefly worked in Ford Madox Brown's studio in March 1848, but became more interested in the work of William Holman Hunt, with whom he soon shared a studio. In the fall of that year, he helped found the Pre-Raphaelite Brotherhood. In March 1849, Rossetti exhibited *The Girlhood of Mary Virgin* (signed PRB) at the Free Exhibition, and with the proceeds from the sale traveled to France and Belgium with Hunt. In January 1850, he helped to found *The Germ*. By this date, Rossetti had met Elizabeth Siddall, who became an important figure in many of his works as well as those of other Pre-Raphaelite artists. In 1853, the harsh reception of *Ecce Ancilla Domini!* (1849–1850; Tate Gallery) at the National Institution discouraged Rossetti from exhibiting publicly in the future. For the rest of the decade he worked largely in watercolor and also produced woodcut illustrations for Edward Moxon's pub-

lication of Tennyson's poems (1857). He also published poems in the *Oxford and Cambridge Magazine*.

In 1855 he attended the Exposition Universelle in Paris. Between 1854 and 1859, he attempted a modern-life subject, *Found*, left unfinished (Delaware Art Museum). In this period, he also developed close friendships with Edward Burne-Jones and William Morris, which led to their work on the murals in the Oxford Union (1857). In April 1858 he helped to found the Hogarth Club, an exhibiting and social club that included Brown. He met Fanny Cornforth, who became his model and mistress, appearing in one of his first works inspired by the sixteenth-century Venetian school, *Bocca Baciata* (1859; private collection). In 1860, after a prolonged engagement, he married Elizabeth Siddall and on his honeymoon traveled to Paris. In 1861 he was a founding partner in the London decorating firm of Morris, Marshall, Faulkner, & Co., which also included William Morris, Burne-Jones, and the architect Philip Webb. In this same year he published his translation of *The Early Italian Poets from Ciullo d'Alcamo to*

Dante Alighieri . . . together with Dante's "Vita Nuova." The following year his wife died of an overdose of laudanum, and he later painted *Beata Beatrix* (cat. 35) as a tribute to her. He moved to 16 Cheyne Walk, briefly sharing a house with the poet Algernon Swinburne, eight months after her death. Whistler lived in this neighborhood and through him Rossetti met Alphonse Legros and Henri Fantin-Latour, who provided Rossetti with introductions to Edouard Manet and Gustave Courbet during his trip to Paris in 1864.

In 1863 he assisted with the publication of Gilchrist's life of William Blake, whom he had admired since he was a student. His painting production in this period was slowed by eye trouble and bouts of insomnia and paranoia. Jane Burden Morris, wife of William Morris, began to appear in Rossetti's portrayals of women in the mid-1860s, as in *La Pia de'Tolomei* (cat. 37), and from 1871 to 1874 he shared the tenancy of Kelmscott Manor in Oxfordshire with William Morris. In 1869 he had Elizabeth Siddall's body exhumed to retrieve a manuscript of poems, which he published in 1870. In 1871, he suffered a breakdown

of health following a published attack on his poetry. In the last decade of his life he severed ties with earlier friends, with the exception of Brown. He died 9 April 1882 at the resort of Birchington-on-Sea.

John Singer Sargent
1856–1925

Portraitist and genre painter. Sargent was born in Florence of American parents, and was educated in Europe. In 1874 he joined the Paris atelier of the French painter Carolus Duran, who admired the Spanish seventeenth-century painter Velázquez. He also studied academic drawing with Adolphe Yvon at the Ecole des beaux-arts. In 1876, he visited the United States for the first time, attending the Centennial Exhibition in Philadelphia. In 1877, he submitted his first work, *Miss Frances Sherborne Ridley Watts* (The Philadelphia Museum of Art), to the French Salon in hopes of obtaining portrait commissions. The next year he submitted a genre painting, *Oyster Gatherers of Cancale* (Museum of Fine Arts, Boston), establishing an exhibiting pattern that he followed for several years.

In the late 1870s and 1880s,

SICKERT

THOMPSON

TISSOT

Sargent became interested in exotic picturesque locales and themes, and traveled to Spain, Holland, and Morocco in 1879 and 1880. While in Spain and Holland he copied works by Velázquez and Frans Hals. His travels in Spain contributed to his 1882 submission to the Paris Salon, *Jaleo: danse des Gitanes* (Isabella Stewart Gardner Museum). In the early 1880s, he painted a series of Venetian subjects after spending the winter of 1880–1881 and summer of 1882 in Venice. In 1884, his upward climb in the estimation of French art critics and audiences abruptly halted with his portrait of *Madame Pierre Gautreau* (The Metropolitan Museum of Art), exhibited at the Paris Salon. Viewers were scandalized by her décolleté gown, which Sargent later repainted.

In May 1885, after receiving commissions for portraits in England, he left Paris to settle permanently in London. In this period, he experimented with impressionism, especially in the works painted in the English countryside in the summers between 1885 and 1889. He participated in exhibitions of the New English Art Club in the late 1880s and 1890s, as well as the Grosvenor Gallery and the

Fine Art Society in London. In 1887–1888 he traveled to Newport, Boston, and New York, where he fulfilled significant portrait commissions. By the 1890s, Sargent was recognized as a highly successful artist in France, Britain, and America, and paintings such as *Ellen Terry as Lady Macbeth* (Tate Gallery) were exhibited in London, Paris, and the United States. His portrait of Lady Agnew (exhibited in London) was regarded as one of his finest works (cat. 62). Many of his portraits of London's wealthy elite date from around the turn of the century, as do many of his watercolors, often executed as traveling sketches. In 1894 he was elected an associate of the Royal Academy and a full member in 1897; he also served as a visiting instructor at the Royal Academy schools. After 1907, Sargent cut back drastically on his portrait commissions to focus on his murals for the Boston Public Library (commissioned in 1890), decorations for the rotunda of the Museum of Fine Arts in Boston (commissioned in 1916), and his work as a war artist for the British government, which included *Gassed* (1918–1921; Imperial War Museum, London).

By World War I, Sargent's

painting methods and style were out of step with the growing fascination with post-impressionism displayed by the progressive factions of the British art world. By the time of Sargent's memorial art exhibition in 1926, critics such as Roger Fry declared that when compared to painters such as Walter Sickert, Sargent was not an artist but "an illustrator." Although Edward VII offered Sargent a knighthood in 1907, he never surrendered his American citizenship.

Walter Sickert

1860–1942

Sickert was the outstanding figure in British impressionism. He was born in Munich, the son of a painter of Danish descent. The family moved to London in 1868. His father having discouraged him from pursuing art, he began a career on the stage. From 1881 to 1883 he attended the Slade School of Art, and afterwards became the pupil and studio assistant of Whistler. In 1883 he visited Paris, escorting Whistler's famous portrait of his mother to the Salon, and from 1885 made regular visits to Dieppe on the north coast of France. He met many avant-

garde French painters including Degas, Monet, Pissarro, and Gauguin. From 1888 he showed his paintings at the New English Art Club, and the following year joined Philip Wilson Steer in organizing an exhibition of the "London Impressionists" at the Goupil Gallery. He began painting music-hall subjects, which were both an expression of his love of the theater and a British response to the Parisian *café-concert* scenes painted by French artists, especially Degas. In 1893 he opened the first in a series of private art schools. From 1898 to 1905 he lived mainly in Dieppe, with periods in Venice.

In 1907 Sickert formed the Fitzroy Street Group with Spencer Gore, Harold Gilman, and other younger artists, painting scenes from working-class life in London, including a series dealing with a murder that took place in Camden Town. In 1911 the more advanced Fitzroy Street painters re-formed themselves under Sickert's leadership as the Camden Town Group; between 1911 and 1913 there were three group exhibitions. From 1916 to 1917 he lived in Bath, and in 1919 returned to Dieppe for several years before

settling in England in 1926.

Much of his later painting is based on photographs from newspapers and magazines, and on Victorian engravings. He was elected a royal academician in 1934, but resigned the following year. He retired from painting in 1940. A collected edition of his art criticism was published as *A Free House!* (1947). In the 1920s he was one of the few serious writers on art to defend Victorian paintings, including William Powell Frith's *Derby Day* (cat. 22), against the scorn of the Bloomsbury modernists.

Elizabeth Thompson (Lady Butler)
..
1846–1933

Painter of carefully researched historical battle scenes that show sympathy for ordinary soldiers, and one of the few Victorian women artists to win critical and popular acclaim. Born in Lausanne, Switzerland, to parents of independent means and artistic interests, Thompson and her younger sister, who was to become the poet, essayist, and critic Alice Meynell, enjoyed an idyllic childhood, with summers in England and winters in Italy. They were educated by their

father. From 1862 she took private lessons in painting, and from 1866 attended advanced classes at the Female School of Art in South Kensington, the country's only women's art school of any size. Along with her mother and sister, she converted to Roman Catholicism. In 1869 she spent several months at the Academy of Fine Arts in Florence, studying drawing under Giuseppe Bellucci. Even as a student she was interested primarily in subjects from military history. From 1872 she was a member of the newly formed Society of Lady Artists. She admired the French battle painters Edouard Detaille and Alphonse de Neuville, whose influence was apparent in *The Roll Call* (Royal Collection), a scene from the Crimean War; this was the toast of the Royal Academy exhibition of 1874, and bought by Queen Victoria. From 1874 to 1881 Thompson was at the height of her success, and engravings after *The Roll Call* and other pictures, published by the Fine Art Society, sold in large numbers.

In 1877 she married Major William Butler of the 69th Regiment, an Irish Roman Catholic. In 1879 she stood for election to the Royal Academy

as an associate, but was passed over in favor of Hubert von Herkomer, and never nominated again. She accompanied her husband on postings overseas, and raised five children; he became a lieutenant-general and was knighted. She managed to continue painting despite family obligations, and was still active in the 1920s. She published two books of illustrated travel writings (1903 and 1909), and her autobiography (1922).

James Tissot
..
1836–1902

French painter working in London in the 1870s and early 1880s, an urbane observer of the manners and fashions of the time. Born Jacques-Joseph Tissot in Nantes, he studied at the Ecole des beaux arts in Paris. There he met Whistler and became friends with Degas. In 1859 he traveled to Antwerp to visit Henri Leys, a Belgian painter whose technically immaculate, carefully reconstructed historical subjects he admired and imitated. In the same year he debuted at the Salon, but reviewers of his early work lamented its archaism and dependence on Leys. From 1864 he painted

TURNER WALLIS WATERHOUSE

scenes of Parisian life, which brought him critical and financial success. He began collecting Japanese art and artifacts, which appear often in his pictures. His masterpiece of the 1860s was *Le Cercle de la rue Royale* (1868; private collection), a portrait of twelve members of an aristocratic men's club, among them the original of Marcel Proust's Swann.

In June 1871, following the Franco-Prussian War and the fall of the Paris Commune, Tissot moved to London. There he stayed for a time with Thomas Gibson Bowles, editor of *Vanity Fair*, to which he contributed caricatures. In 1873 he settled at 17 Grove End Road, Saint John's Wood. In 1874 he declined Degas' invitation to participate in the first impressionist exhibition. His success in London was the envy of his Parisian friends. His paintings were well reviewed at the Royal Academy exhibitions and sought after by British collectors; his etchings after them, published from 1876 onward, also proved lucrative. His beloved mistress and favorite model was Kathleen Newton, a beautiful Irishwoman eighteen years his junior, whose marriage to a surgeon in the Indian Civil Service had ended

in almost immediate separation and divorce. She moved into Tissot's house shortly before or after giving birth to an illegitimate son, presumably his, in 1876. At the inaugural exhibition of the Grosvenor Gallery in 1877, Ruskin described his pictures as "mere colored photographs of vulgar society." Toward the end of his London period he tackled more ambitious subjects, and in 1882 exhibited at the Dudley Gallery a series of paintings and etchings showing *The Prodigal Son in Modern Life*.

In November 1882 Kathleen Newton died of consumption, leaving him devastated. Soon afterwards he returned to Paris. While at work on a painting with a church setting, one of a series of fifteen large canvases on the theme of *La Femme à Paris (Woman in Paris)* (exhibited 1885), he experienced a religious vision. He abandoned secular subjects and devoted the rest of his career to biblical illustration, making three visits to the Holy Land in pursuit of topographical and archaeological accuracy. The 365 drawings he made for his illustrated New Testament, published in 1896–1897, were exhibited to popular acclaim in Paris, London, and North

America, and in 1900 bought by public subscription for the Brooklyn Museum. He died while at work on an illustrated Hebrew Bible, which was completed by others and published in 1904.

Joseph Mallord William Turner

1775–1851

Romantic landscape and seascape painter. Turner was technically brilliant and enormously ambitious, and his work addresses such themes as the fate of empires, the vanity of human endeavor, and the transience of life. Son of a barber and wigmaker in Covent Garden, London, Turner attended the Royal Academy schools from 1789, showing a watercolor at the RA exhibition of 1790. He made his name in the early 1790s as a topographical watercolorist. Throughout his life he made extensive sketching tours in Britain and on the Continent, visiting Wales for the first time in 1792, France and Switzerland in 1802, and Italy in 1819–1820. He made his debut with an oil painting at the RA exhibition in 1796. He was elected associate of the RA in 1799 and full academician in 1802, remaining a staunch sup-

porter of the RA throughout his career. In 1804 he completed a gallery in Queen Anne Street, attached to his house in Harley Street, for the display of his own works; in 1819–1821 he enlarged the house and built a new gallery. In 1807 he was elected an RA professor of perspective; he gave his last lectures in 1828, and resigned in 1837. From 1812 his paintings at the RA exhibition were sometimes accompanied by quotations from his poem "Fallacies of Hope."

Turner attracted generous and devoted patrons, including Walter Fawkes of Farnley Hall, Sir John Leicester of Tabley House, and the 3d earl of Egremont. In 1840 he met his most influential admirer, the young John Ruskin. The first volume of Ruskin's *Modern Painters*, a defense of Turner against his critics, appeared in 1843. In 1845, as eldest academician, Turner was chosen to carry out the duties of president during the illness of Martin Archer Shee.

Much of Turner's mature work shows a self-conscious allusion to his predecessors in landscape painting, the Dutch masters of the seventeenth century and Claude Lorraine. The oils and watercolors of his middle to late career, from the 1820s onward, suggest a world in spectacular dissolution, and some of his last paintings treat subjects of a visionary nature. He died at his cottage on the Thames at Chelsea, and is buried in Saint Paul's Cathedral. His bequest to the nation of some three hundred of his own paintings and nineteen thousand watercolors and drawings is now at the Tate Gallery.

Henry Wallis
1830–1916

Genre and history painter affiliated with the Pre-Raphaelites. Born in London on 21 February 1830 to Mary Ann Thomas, he took the name Wallis in 1845, when his mother married Andrew Wallis. His first formal art training was with F.S. Cary's Academy, and in January 1848 he was admitted to the Royal Academy schools. Sometime in the late 1840s or early 1850s, Wallis reportedly studied art in Paris at the studio of orientalist painter M.G. Gleyre and at the Académie des beaux-arts. His first exhibited work appeared in 1853 at the Royal Manchester Institution, and the following year he submitted his first works to the Royal Academy, including *The Room in which Shakespeare was Born* (Tate Gallery). Two years later he exhibited his portrait of Thomas Chatterton at the Royal Academy with much success (cat. 20). His submission of 1858, *The Stonebreaker* (Birmingham Museums and Art Gallery), a social realist work, was also a sensation. He exhibited with the Hogarth Club in 1860, and knew the Pre-Raphaelites, including William Holman Hunt, with whom he corresponded for a number of years.

Wallis also exhibited at the British Institution, the Society of British Artists, and the Old Water Colour Society, which made him an associate in 1878 and a member in 1880. In the late 1850s he became involved with Mary Ellen Meredith, wife of George Meredith, and she bore him a son in April 1858. In 1859 his stepfather passed away, leaving Wallis a small inheritance that permitted him financial independence. He continued to exhibit at the Royal Academy through 1877, but with none of the success of his earlier submissions. Later in his life he traveled extensively to Italy, the Mediterranean, and Egypt; from 1879 to 1892, he was Hon. Secretary of the Committee for the Preservation of Saint Mark's Venice. He collected Italian, Egyptian, and Persian ceramics and, at the end of the century, published a number of volumes on his collection and the history of ceramics.

John William Waterhouse
1849–1917

Painter of classical, historical, and literary subjects. Waterhouse was born in 1849 in Rome, where his father worked as a painter. In the 1850s the family returned to England. Before entering the Royal Academy schools in 1870, Waterhouse assisted his father in his studio. His early works were of classical themes in the spirit of Alma-Tadema and Frederic Leighton, and were exhibited at the Royal Academy, the Society of British Artists (Suffolk Street), and the Dudley Gallery. In the late 1870s and the 1880s, Waterhouse made several trips to Italy, where he painted genre scenes. After his marriage in 1883, he took up residence at the Primrose Hill Studios. He was elected to the Royal Institute of Painters in Watercolour in 1883 and resigned in 1889. In 1884, his Royal Academy

WATTS WHISTLER

submission *Consulting the Oracle* brought him favorable reviews; it was purchased by Sir Henry Tate, who also purchased *The Lady of Shalott* (cat. 63) from the 1888 Academy exhibition. The latter painting reveals Waterhouse's growing interest in themes associated with the Pre-Raphaelites, particularly tragic or powerful femmes fatales, as well as *plein-air* painting. In 1885 he was elected an associate of the Royal Academy and a full member in 1895.

In the mid-1880s Waterhouse began exhibiting with the Grosvenor Gallery and its successor, the New Gallery, as well as provincial exhibitions in Birmingham, Liverpool, and Manchester. Paintings of this period, such as *Mariamne* (1889; Forbes Magazine Collection), were exhibited widely in England and abroad as part of the international symbolist movement. In the 1890s Waterhouse began to exhibit portraits. In 1901 he moved to Saint John's Wood and joined the Saint John's Wood Arts Club, a social organization that included Lawrence Alma-Tadema and George Clausen. He also served on the advisory council of the Saint John's Wood Art School.

George Frederic Watts

1817–1904

Portraitist, painter of myth and allegory, and foremost representative of the idealist (or symbolist) tendency within the aesthetic movement. Watts, son of an impecunious London piano-maker, attended the Royal Academy schools from 1835, and made his debut at the RA exhibition in 1837. In 1843 he won a premium in the first of the competitions held to select artists to paint frescoes in the New Palace of Westminster (Houses of Parliament), which enabled him to travel to Florence. He stayed there for almost four years as guest of the British minister to the court of Tuscany, Lord Holland, and painted frescoes at Holland's villa at Careggi, outside the city.

In 1847 Watts returned to London. Though successful in another of the Westminster competitions, he entered a period of despondency, painting gloomy scenes of poverty and oppression. From 1851 or 1852 until 1875 he lived as the house guest of Mr. and Mrs. Thoby Prinsep at Little Holland House, Kensington. Known affectionately as "Signor," he became the resident genius to

Mrs. Prinsep's artistic salon, which was frequented by many of the leading painters and writers of the day. In the 1850s he painted several frescoes, notably in the Great Hall of Lincoln's Inn (1853–1859). Watts formed close friendships with the poet Alfred Tennyson and the photographer Julia Margaret Cameron, Mrs. Prinsep's sister. His marriage in 1864 to the sixteen-year-old Ellen Terry ended in separation within a year. In 1867 he was elected royal academician. In 1875 he built a new house on Melbury Road, his principal home until his death; he became close friends with his neighbor Frederic Leighton. He helped the Prinseps build their new home at Freshwater on the Isle of Wight, where he spent a number of winters. Watts' reputation as a mythic and allegorical painter was firmly established by exhibitions of his work in 1880 at the Royal Institution, Manchester (the collection of his most devoted patron, Charles Rickards); in 1881–1882 at the Grosvenor Gallery; and in 1884–1885 at the Metropolitan Museum of Art, New York. About 1883 he began work on his most important venture into sculpture, the monumental

Physical Energy. In 1885 he declined Gladstone's offer of a baronetcy. He remarried in 1886, to the much younger Mary Fraser Tytler. From 1891 he spent winters at a country retreat, Limnerslease in Compton, near Guildford. Just before his death he built a gallery in Compton for the display of his own works (the Watts Gallery).

James McNeill Whistler

1834–1903

Key figure in British aestheticism and international modernism. Whistler was born in Lowell, Massachusetts. His father was a civil engineer who accepted a position on the Russian railroad in 1842, and Whistler began his art training in Saint Petersburg. In 1851 he entered the U.S. Military Academy at West Point, from which he was expelled in 1854 for deficiency in chemistry. Later that year he accepted a position in the drawing division of the U.S. Coast and Geodetic Survey, Washington, D.C., staying only a few months. He moved to Paris for further art training, including a period in the studio of the neoclassical painter Charles Gleyre. In September of 1857, he visited the Art Treasures Exhibition in Manchester, where he saw works by Velázquez, as well as contemporary British painters. In 1858 he became friends with Henri Fantin-Latour and the two artists, along with Alphonse Legros, formed the Société des Trois. Whistler settled in London in 1859 and began work on his "Thames Set" of etchings.

During the winter of 1861–1862, Whistler returned to Paris, where he painted *Symphony in White, No. 1: The White Girl* (cat. 28). This painting was rejected for the Royal Academy exhibition of 1862, but *The Coast of Brittany* (1861; Wadsworth Atheneum, Hartford), *The Thames in Ice* (1860; Freer Gallery of Art), and the etching *Rotherhithe* were accepted. That summer he met Dante Gabriel Rossetti and the critic Algernon Swinburne, and in late December he moved to Chelsea. In 1863 *The White Girl* was rejected by the Paris Salon and exhibited at the Salon des Refusés, where it drew much attention. In 1864 Whistler began his *Japonisme*-inspired works, including *Symphony in White, No. 2: The Little White Girl* (Tate Gallery), which was exhibited at the Royal Academy the following year. In late 1865 he went to the seaside town of Trouville, where the French painter Gustave Courbet was also working. He continued painting seascapes at Valparaiso, Chile, in March 1866, returning to England later that year. In the spring of 1867 *Symphony in White, No. 3* (The Barber Institute of Fine Arts, The University of Birmingham), the first of his works to be exhibited with a musical title, was shown at the Royal Academy. Over the next three decades he produced a number of portraits, including *Arrangement in Grey and Black: Portrait of the Painter's Mother* (1871; Musée d'Orsay, Paris).

In the early 1870s he began his series of ethereal landscapes entitled Nocturnes. *Nocturne in Black and Gold: The Falling Rocket* (Detroit Institute of Arts) caused a controversy when exhibited at the Grosvenor Gallery in 1877: the critic John Ruskin accused Whistler of insolence for charging "two hundred guineas for flinging a pot of paint in the public's face." Whistler responded by charging Ruskin with libel. The ensuing trial of November 1878 involved many of the major figures of the Victorian art world: William Powell Frith and Edward Burne-Jones testified on Ruskin's behalf, while Albert Moore and William Michael Rossetti supported Whistler. Whistler won the trial and was awarded one farthing in damages.

In September 1879, Whistler traveled to Venice, commissioned by the Fine Art Society to produce a set of etchings. He returned to London in November 1880, where he exhibited his Venetian prints and pastels in a series of exhibitions at the Fine Art Society. He met his pupil and assistant Walter Sickert in 1882. In 1884 he was made a member of the Society of British Artists, elected president in June 1886, and resigned in June 1888. In the mid-1880s, he held a series of one-man exhibitions at London art galleries in which he created interiors befitting his work. In the 1880s and 1890s, he exhibited widely in Europe, including the Société des XX, Brussels, and the International Kunst-Ausstellung, Munich. He married Beatrice Godwin in August 1888, abandoning his mistress Maude Franklin, with whom he had a child in 1879. He was awarded the Chevalier of the Légion d'Honneur in September 1889 after receiving a gold medal for *The Balcony*

at the Paris Exposition Univer-
selle of 1889. In 1890, he met
Charles Freer, who formed an
important collection of Whis-
tler's work. In 1891, the Cor-
poration of Glasgow acquired
the portrait of Carlyle, which
became the first of Whistler's
paintings to be purchased by a
public collection. In 1898 he
was elected president of the
International Society of Sculp-
tors, Painters and Gravers.
Whistler received numerous
awards at international exhi-
bitions in the last decade of
his life.

Franz Xaver Winterhalter

1805–1873

German painter, the most suc-
cessful court portraitist of his
time, much favored by Queen
Victoria. Winterhalter studied
at the Munich Academy from
1823. After periods of work at
the court of the grand duke of
Baden in Karlsruhe, and travels
in Italy, he moved in 1834 to
Paris, which remained his base
for the rest of his career. He
painted official portraits of
King Louis-Philippe and his
family during the July Monar-
chy, Napoleon III and his fam-
ily during the Second Empire,
and sitters from royal, princely,
and aristocratic houses all over
Europe. He was first brought
to Queen Victoria's attention
by her aunt Louise, queen of
the Belgians, in 1838, and he
spent periods working for her
and Prince Albert in England
almost every year between
1842 and 1861. He painted
more than a hundred portraits
of members of the queen's
family and court, many replicas
and copies of which were in-
stalled in embassies and other
official buildings, or used as
diplomatic gifts.

Winterhalter's British out-
put is generally polished,
highly respectful toward tradi-
tions of royal portraiture, un-
adventurous, yet with the occa-
sional touch of freshness and
charm, especially in his por-
traits of the royal children. In
1851–1852 he gave the queen
lessons in oil painting. As a for-
eigner who enjoyed the queen's
high opinion and lavish royal
patronage, he was the object
of resentment among native
painters. Following the defeat
of France and the collapse of
the Second Empire in the
Franco-Prussian War of 1870,
he retreated from Paris to
Karlsruhe. He died in 1873,
leaving a large fortune.

references cited

Allderidge 1974
Allderidge, Patricia. *The Late Richard Dadd, 1817–1886* [exh. cat., Tate Gallery] (London, 1974).

Allingham 1907
William Allingham: A Diary. Edited by Helen Allingham and D. Radford. London, 1907.

Armstrong 1990
Armstrong, W.A. "The Countryside." In *The Cambridge Social History of Britain, 1750–1950.* Edited by F.M.L. Thompson. Vol. 1. Cambridge, 1990.

Arnold 1932
Arnold, Matthew. *Culture and Anarchy.* Edited by John Dover Wilson. Cambridge, 1932.

Arnold 1993
Arnold, Matthew. *Selected Poems and Prose.* Edited by Miriam Allott. London and Vermont, 1993.

Baldry 1894
Baldry, A.L. *Albert Moore, His Life and Work.* London, 1894.

Baron 1973
Baron, Wendy. *Sickert.* London and New York, 1973.

Baron and Shone 1992
Baron, Wendy, and Richard Shone. *Sickert: Paintings* [exh. cat., Royal Academy of Arts; Van Gogh Museum, Amsterdam] (London and New York, 1992).

Barringer 1994
Barringer, T.J. "Representations of Labour in British Visual Culture, 1850–1875," Ph.D. dissertation, University of Sussex, 1994.

Barrington 1906
Barrington, Emilie. *Life, Letters and Work of Frederic Leighton.* 2 vols. London, 1906.

Bell 1927
Bell, Clive. *Landmarks in Nineteenth-Century Painting.* London, 1927.

Bendiner 1985
Bendiner, Kenneth P. *An Introduction to Victorian Painting.* New Haven and London, 1985.

Bennett 1967
Bennett, Mary. *PRB Millais PRA* [exh. cat., Walker Art Gallery; Royal Academy of Arts] (London, 1967).

Bennett 1969
Bennett, Mary. *William Holman Hunt* [exh. cat., Walker Art Gallery; Victoria and Albert Museum] (Liverpool, 1969).

Bennett 1984
Bennett, Mary. "The Price of 'Work': The Background to its First Exhibition, 1865," 143–152. In Parris, *Papers,* 1984.

Bennett 1988
Bennett, Mary. *Artists of the Pre-Raphaelite Circle: The First Generation.* London, 1988.

Blashfield 1925
Blashfield, Edwin. "John Singer Sargent—Recollections." *North American Review* 220 (June–July 1925), 643–644.

Boime 1981
Boime, Albert. "Ford Madox Brown, Thomas Carlyle, and Karl Marx: Meaning and Mystification of Work in the Nineteenth Century." *Arts Magazine* 56 (September 1981), 116–125.

Bronkhurst 1984
Bronkhurst, Judith. "'An interesting series of adventures to look back upon': William Holman Hunt's Visit to the Dead Sea in November 1854," 111–125. In Parris, *Papers,* 1984.

Burne-Jones 1904
Burne-Jones, Georgiana. *Memorials of Edward Burne-Jones.* 2 vols. New York and London, 1904.

Burne-Jones 1981
Burne-Jones, Edward Coley. *Burne-Jones Talking: His Conversations 1895–1898 preserved by his studio assistant Thomas Rooke.* Edited by Mary Lago. London, 1981.

Bury 1976
Bury, Shirley. "Rossetti and His Jewellery." *Burlington Magazine* 118 (February 1976), 94–102.

Butlin and Joll 1984
Butlin, Martin, and Evelyn Joll. *The Paintings of J.M.W. Turner.* 2 vols. Revised ed. New Haven and London, 1984.

Carlyle 1901
Complete Works of Thomas Carlyle. 24 vols. New York, 1901.

Carr 1908
Carr, Joseph Comyns. *Some Eminent Victorians.* London, 1908.

Castagnary 1892
Castagnary, Jules. *Salons 1857–1870.* Paris, 1892.

Casteras 1985
Casteras, Susan P. "John Everett Millais' 'Secret-Looking Garden Wall' and the Courtship Barrier in Victorian Art." *Browning Institute Studies* 13 (1985), 71–98.

Casteras and Denny 1996
Casteras, Susan P., and Colleen Denny, ed. *The Grosvenor Gallery: A Palace of Art in Victorian England* [exh. cat., Yale Center for British Art; Denver Museum of Art; Laing Art Gallery] (New Haven, 1996).

Chapel 1982
Chapel, Jeannie. *Victorian Taste: The Complete Catalogue of Paintings at the Royal Holloway College.* London, 1982.

Chesterton 1904
Chesterton, G.K. *G.F. Watts.* London, 1904.

Christian 1975
Christian, John. *Burne-Jones: The Paintings, Graphic and Decorative Work of Sir Edward Burne-Jones 1833–98* [exh. cat., Hayward Art Gallery; Southampton Art Gallery; City Museum and Art Gallery, Birmingham] (London, 1975).

Cowling 1989
Cowling, Mary. *The Artist as Anthropologist: The Representation of Type and Character in Victorian Art.* Cambridge, 1989.

Crowther 1981
Crowther, M.A. *The Workhouse System, 1834–1929.* London, 1981.

Cunningham 1843
Cunningham, Allan. *The Life of Sir David Wilkie.* 3 vols. London, 1843.

Curtis 1992
Curtis, Gerard. "Ford Madox Brown's *Work*: An Iconographic Analysis." *Art Bulletin* 74 (December 1992), 623–636.

Dean 1991
Dean, Deborah. *Benjamin Williams Leader: A Rural Vision* [exh. cat., Worcester City Museum and Art Gallery] (Worcester, 1991).

Dorment and MacDonald 1994
Dorment, Richard, and Margaret F. MacDonald. *James McNeill Whistler* [exh. cat., Tate Gallery; Musée d'Orsay; National Gallery of Art, Washington] (London, 1994).

Doughty and Wahl 1965–1967
Doughty, Oswald, and John Robert Wahl, eds. *Letters of Dante Gabriel Rossetti.* 4 vols. Oxford, 1965–1967.

Du Maurier 1951
The Young George Du Maurier: A Selection of His Letters, 1860–67. Edited by Daphne Du Maurier. London, 1951.

Eastlake 1870
Lady Eastlake (Elizabeth Rigby). "Memoir of Sir Charles Eastlake." In *Contributions to the Literature of the Fine Arts.* 2d series. London, 1870.

Edelstein 1983
Edelstein, Teri J. "Augustus Egg's Triptych: A Narrative of Victorian Adultery." *Burlington Magazine* 125 (April 1983), 202–210.

Edwards 1984
Edwards, Lee. "Hubert von Herkomer and the Modern Life Subject," Ph.D. dissertation, Columbia University, 1984.

Egley Catalogue
Egley, William Maw. "Catalogue of Pictures, Drawings, and Designs." 2 vols. National Art Library, Victoria and Albert Museum, London.

Emerson 1856
Emerson, Ralph Waldo. *English Traits.* Boston, 1856.

Errington 1984
Errington, Lindsay. *Social and Religious Themes in English Art 1840–1860.* New York and London, 1984.

Exh. cat. Manchester 1978
Victorian High Renaissance [exh. cat., Manchester City Art Galleries; Minneapolis Institute of Arts; Brooklyn Museum] (Minneapolis, 1978).

Exh. cat. Munich 1993
Viktorianische Malerei, von Turner bis Whistler [exh. cat., Neue Pinakothek; Prado] (Munich, 1993).

Exh. cat. Providence 1985
Ladies of Shalott: A Victorian Masterpiece and Its Contexts [exh. cat., Bell Gallery, List Art Center, Brown University] (Providence, 1985).

Faberman 1983
Faberman, Hilarie. "Augustus Leopold Egg, R.A.," Ph.D. dissertation, Yale University, 1983.

Fennell 1978
Fennell, Jr., Francis L., ed. *The Rossetti–Leyland Letters: The Correspondence of an Artist and His Patron.* Athens, Ohio, 1978.

Fildes 1968
Fildes, Luke V. *Luke Fildes, R.A.: A Victorian Painter.* London, 1968.

Fox and Greenacre 1985
Fox, Caroline, and Francis Greenacre. *Painting in Newlyn, 1880–1930* [exh. cat., Barbican Art Gallery] (London, 1985).

Fredeman 1975
Fredeman, William E., ed. *The P.R.B. Journal: William Michael Rossetti's Diary of the Pre-Raphaelite Brotherhood 1849–1853.* Oxford, 1975.

Fredeman 1991
Fredeman, William E., ed. "A Rossetti Cabinet." *Journal of Pre-Raphaelite and Aesthetic Studies* 2 (1991), ix–17.

Frith 1887–1888
Frith, William Powell. *My Autobiography and Reminiscences.* 3 vols. London, 1887–1888.

Gibbs-Smith 1950
Gibbs-Smith, C.H. *The Great Exhibition of 1851.* London, 1950.

Girouard 1981
Girouard, Mark. *The Return to Camelot: Chivalry and the English Gentleman.* New Haven and London, 1981.

Gosse 1883
Gosse, Edmund. *Cecil Lawson: A Memoir*. London, 1883.

Green 1971
Green, Richard. *John Frederick Lewis, R.A.: 1805–1876* [exh. cat., Laing Art Gallery] (Newcastle upon Tyne, 1971).

Green 1972
Green, Richard. *Albert Moore and His Contemporaries* [exh. cat., Laing Art Gallery] (Newcastle upon Tyne, 1972).

Grieve 1969
Grieve, Alastair. "The Pre-Raphaelite Brotherhood and the Anglican High Church." *Burlington Magazine* 111 (May 1969), 294–295.

Grieve 1973
Grieve, Alastair. "The Applied Art of D.G. Rossetti—I. His Picture-Frames." *Burlington Magazine* 115 (January 1973), 16–24.

Hamerton 1887
Hamerton, Philip Gilbert. *Imagination in Landscape Painting*. London, 1887.

Hardie 1972
Hardie, William Robertson. *Sir William Quiller Orchardson* [exh. cat., Scottish Arts Council] (Edinburgh, 1972).

Hawthorne 1941
Hawthorne, Nathaniel. *English Notebooks*. Edited by Randall Stewart. New York, 1941.

Hayes 1992
Hayes, John. *British Paintings*. Washington, D.C., 1992.

Held 1965
Held, Julius S. *Museo de Arte de Ponce. Fundación Luis A. Ferré. Catalogue I. Paintings of the European and American Schools*. Ponce, 1965.

Herkomer 1910
Herkomer, Hubert von. *The Herkomers*. 2 vols. London, 1910.

Hobson 1980
Hobson, Anthony. *The Art and Life of J.W. Waterhouse 1849–1917*. London and New York, 1980.

Hoge 1981
Lady Tennyson's Journal. Edited by James O. Hoge. Charlottesville, Va., 1981.

Horn 1984
Horn, Pamela. *The Changing Countryside in Victorian and Edwardian England and Wales*. London and Rutherford, N.J., 1984.

Horner 1933
Horner, Frances. *Time Remembered*. London, 1933.

Houghton 1957
Houghton, Walter. *The Victorian Frame of Mind*. New Haven and London, 1957.

Hunt 1905
Hunt, William Holman. *Pre-Raphaelitism and the Pre-Raphaelite Brotherhood*. 2 vols. New York and London, 1905.

James 1920
The Letters of Henry James. Edited by Percy Lubbock. 2 vols. London, 1920.

James 1974
Henry James Letters. Edited by Leon Edel. Cambridge, 1974.

Jones et al. 1996
Jones, Stephen, et al. *Frederic Leighton 1830–1896* [exh. cat., Royal Academy of Arts] (London, 1996).

Johnson 1980
Johnson, E.D.H. "The Making of Ford Madox Brown's Work," 142–151. In *Victorian Artists and the City*. Edited by Ira Bruce Nadel and F.S. Schwarzbach. New York, 1980.

Landow 1979
Landow, George. *William Holman Hunt and Typological Symbolism*. New Haven, 1979.

Lavery 1940
Lavery, John. *The Life of a Painter*. Boston, 1940.

Löcher 1973
Löcher, Kurt. *Der Perseus-Zyklus von Edward Burne-Jones*. Stuttgart, 1973.

Lomax 1979
Lomax, James. *John Singer Sargent and the Edwardian Age* [exh. cat. Leeds Art Galleries; Detroit Institute of Arts] (Leeds, 1979).

Longley 1874
Longley, Henry. *Report to the Local Government Board on Poor Law Administration in London*. London, 1874.

Loshak 1963
Loshak, David. "G.F. Watts and Ellen Terry." *Burlington Magazine* 105 (November 1963), 476–485.

Lovett and Johnston 1991
Lovett, Jennifer Gordon, and William R. Johnston. *Empires Restored, Elysium Revisited: The Art of Sir Lawrence Alma-Tadema* [exh. cat., Sterling and Francine Clark Art Institute] (Williamstown, Mass., 1991).

Lucas 1921
Lucas, Edward Verall. *Edwin Austin Abbey, Royal Academician*. London, 1921.

Macleod 1981
Macleod, Dianne Sachko. "Dante Gabriel Rossetti, a Critical Analysis of the Late Works, 1859–1882," Ph.D. dissertation, University of California at Berkeley, 1981.

Mahey 1967
John A. Mahey, ed. "The Letters of James McNeill Whistler to George Lucas." *Art Bulletin* 49 (September 1967).

Mancoff 1985
Mancoff, Debra. "A Vision of Beatrice: Dante Gabriel Rossetti and the *Beata Beatrix*." *Journal of Pre-Raphaelite Studies* 6 (November 1985), 76–84.

Martineau 1877
Martineau, Harriet. *Autobiography, with Memorials by Maria Weston Chapman*. 3 vols. London, 1877.

Matyjaszkiewicz 1984
Matyjaszkiewicz, Krystyna, ed. *James Tissot* [exh. cat., Barbican Art Gallery; Whitworth Art Gallery, Manchester; Petit Palais, Paris] (London, 1984).

McConkey 1980
McConkey, Kenneth. *Sir George Clausen R.A., 1852–1944* [exh. cat., Bradford Museums and Art Galleries; Tyne and Wear County Council Museums] (Bradford, 1980).

McConkey 1984
McConkey, Kenneth. *Sir John Lavery R.A. 1856–1941* [exh. cat., Fine Art Society, Edinburgh; Fine Art Society, London; Ulster Museum; National Gallery of Ireland] (Belfast and London, 1984).

McConkey 1993
McConkey, Kenneth. *Sir John Lavery, RA*. Edinburgh, 1993.

Merrill 1992
Merrill, Linda. *A Pot of Paint: Aesthetics on Trial in Whistler v. Ruskin*. Washington, D.C., 1992.

Millais 1899
Millais, John Guille. *The Life and Letters of Sir John Everett Millais, P.R.A.* 2 vols. London and New York, 1899.

Millar 1992
Millar, Oliver. *The Victorian Pictures in the Collection of Her Majesty the Queen*. 2 vols. Cambridge, 1992.

Morris 1910–1915
The Collected Works of William Morris. With introductions by his daughter May Morris. 24 vols. London, 1910–1915.

Morris 1970
Morris, Edward. "The Subject of Millais' *Christ in the House of His Parents*." *Journal of the Warburg and Courtauld Institutes* 33 (1970), 343–345.

Morris 1996
Morris, Edward. *Victorian and Edwardian Paintings in the Walker Art Gallery and at Sudley House*. London, 1996.

Myers 1885
Myers, Frederic William Henry. "Rossetti and the Religion of Beauty." In *Essays — Modern*. London, 1885.

Noakes 1985
Noakes, Vivien. *Edward Lear* [exh. cat., Royal Academy of Arts] (New York, 1985).

Noakes 1991
Noakes, Vivien. *The Painter, Edward Lear*. Newton Abbot, 1991.

Olson 1986
Olson, Stanley. *John Singer Sargent: His Portrait*. New York, 1986.

Ormond 1970
Ormond, Richard. *John Singer Sargent: Paintings, Drawings, Watercolors*. London, 1970.

Ormond 1981
Ormond, Richard, with contributions by Joseph Rishel and Robin Hamlyn. *Sir Edwin Landseer* [exh. cat., Philadelphia Museum of Art; Tate Gallery] (New York, 1981).

Ormond and Ormond 1975
Ormond, Leonée, and Richard Ormond. *Lord Leighton*. New Haven and London, 1975.

Parris 1984
Parris, Leslie, ed. *The Pre-Raphaelites* [exh. cat., Tate Gallery] (London, 1984).

Parris, *Papers*, 1984
Parris, Leslie, ed. *Pre-Raphaelite Papers*. London, 1984.

Pater 1910
Pater, Walter. *The Renaissance. Studies in Art and Poetry*. London, 1910.

Pennell and Pennell 1908
Pennell, Elizabeth Robins, and Joseph Pennell. *The Life of James McNeill Whistler*. 2 vols. London and Philadelphia, 1908.

Pennell and Pennell 1921
Pennell, Elizabeth Robins, and Joseph Pennell. *The Whistler Journal*. Philadelphia, 1921.

Pointon 1978
Pointon, Marcia. "The Representation of Time in Painting: A Study of William Dyce's *Pegwell Bay: A Recollection of October 5th, 1858*." *Art History* 1 (March 1978), 99–103.

Pointon 1979
Pointon, Marcia. *William Dyce 1806–1864. A Critical Biography*. Oxford, 1979.

Pointon 1981
Pointon, Marcia. "Romanticism in English Art," 77–14. In *Romantics*. Edited by Stephen Prickett. London and New York, 1981.

Pollen 1912
Pollen, Anne. *John Hungerford Pollen*. London, 1912.

Postle 1996
Postle, Martin. "Leighton's Lost Model: The Rediscovery of Mary Lloyd." *Apollo* 143 (February 1996), 27–29.

Ratcliff 1982
Ratcliff, Carter. *John Singer Sargent*. New York, 1982.

Reynolds 1959
Reynolds, Sir Joshua. *Discourses on Art*. Edited by Robert R. Wark. San Marino, 1959.

Richmond 1896
Richmond, William Blake. "Lord Leighton and His Art." *Nineteenth Century* 39 (March 1896).

Robertson 1945
Robertson, W. Graham. *Time Was*. London, 1945.

Robertson 1978
Robertson, David. *Sir Charles Eastlake and the Victorian Art World*. Princeton, 1978.

Rossetti 1910
The Poems of Dante Gabriel Rossetti. Edited by William Michael Rossetti. Revised ed. London, 1910.

Rossetti and Swinburne 1976
Notes on the Royal Academy Exhibition, 1868. Part I by William Michael Rossetti, Part II by Algernon C. Swinburne. London, 1868. Repr. New York, 1976.

Royal Academy 1874
The Exhibition at the Royal Academy of Arts. London, 1874.

Ruskin 1903–1912
The Works of John Ruskin. Edited by E. T. Cook and Alexander Wedderburn. 39 vols. London, 1903–1912.

Spencer 1989
Whistler: A Retrospective. Edited by Robin Spencer. New York, 1989.

Spielmann 1898
Spielmann, Marion H. *Millais and His Works, With Special Reference to the Exhibition at the Royal Academy, 1898*. Edinburgh and London, 1898.

Staley 1906
Staley, Edgcumbe. *Lord Leighton of Stretton, P.R.A.* London, 1906.

Stephens 1850
Stephens, Frederic George. "The Purpose and Tendency of Early Italian Art." *The Germ* (February 1850).

Stewart 1993
Stewart, David. "Theosophy and Abstraction in the Victorian Era: The Paintings of G. F. Watts." *Apollo* 139 (November 1993), 298–302.

Strachey 1907
Letters of Edward Lear to Chicester Fortescue. Edited by Lady Strachey. London, 1907.

Surtees 1971
Surtees, Virginia. *The Paintings and Drawings of Dante Gabriel Rossetti (1828–1882): A Catalogue Raisonné*. 2 vols. Oxford, 1971.

Surtees 1979
Surtees, Virginia, ed. *Reflections on a Friendship. John Ruskin's Letters to Pauline Trevelyan, 1848–1866*. London, 1979.

Swanson 1990
Swanson, Vern. *The Biography and Catalogue Raisonné of the Paintings of Sir Lawrence Alma-Tadema*. London, 1990.

Swinburne 1925–1927
The Complete Works of Algernon Charles Swinburne. Edited by Sir Edmund Gosse and Thomas James Wise. 20 vols. London, 1925–1927.

Symons 1906
Symons, Arthur. *Studies in Seven Arts*. London, 1906.

Tennyson 1897
Hallam, Lord Tennyson. *Alfred Lord Tennyson. A Memoir By His Son*. 2 vols. London, 1897.

Tennyson 1953
The Complete Poetical Works of Tennyson. Edited by T. Herbert Warren. Revised and enlarged by Frederick Page. Oxford, 1953.

Thackeray 1991
Thackeray, William Makepeace. *Notes of a Journey from Cornhill to Grand Cairo*. Heathfield, East Sussex, 1991.

Thornton 1983
Thornton, Lynne. *The Orientalists, Painter-Travellers, 1828–1908*. Paris, 1983.

Thorp 1937
Thorp, Margaret Farrand. *Charles Kingsley, 1819–1875*. Princeton, 1937.

Thorp 1994
Whistler on Art: Selected Letters and Writings, 1849–1903 of James McNeill Whistler. Edited by Nigel Thorp. Manchester, 1994.

Treble 1978
Treble, Rosemary. *Great Victorian Pictures: Their Paths to Fame* [exh. cat., Leeds City Art Gallery; Leicestershire Museum and Art Gallery; Bristol City Art Gallery; Royal Academy of Arts] (London, 1978).

Treuherz 1987
Treuherz, Julian. *Hard Times: Social Realism in Victorian Art* [exh. cat., Manchester City Art Galleries; Rijksmuseum Vincent Van Gogh; Yale Center for British Art] (London, 1987).

Treuherz 1993
Treuherz, Julian. *Pre-Raphaelite Paintings from Manchester City Art Galleries* [exh. cat., Manchester City Art Galleries] (Manchester, 1993).

Usherwood and Spencer-Smith 1987
Usherwood, Paul, and Jenny Spencer-Smith. *Lady Butler: Battle Artist, 1846–1933* [exh. cat., National Army Museum, London; Durham Light Infantry Museum; Leeds City Art Gallery] (London, 1987).

Warner 1984
Warner, Malcolm. "John Everett Millais's *Autumn Leaves*: 'a picture full of beauty and without subject,'" 126–142. In Parris, *Papers*, 1984.

Watts 1912
Watts, M.S. *George Frederic Watts: The Annals of an Artist's Life.* 3 vols. London, 1912.

Wentworth 1978
Wentworth, Michael. *James Tissot: Catalogue Raisonné of His Prints* [exh. cat., Minneapolis Institute of Arts; Sterling and Francine Clark Art Institute] (Minneapolis, 1978).

Wentworth 1984
Wentworth, Michael. *James Tissot.* Oxford, 1984.

Whistler 1890
Whistler, J.M. *The Gentle Art of Making Enemies.* London and New York, 1890.

Wilde 1908–1922
Collected Works. Edited by Robert Ross. 15 vols. London, 1908–1922.

Yeats 1989
The Collected Works of William Butler Yeats. Volume 1: The Poems. Edited by Richard J. Finneran. Revised ed. New York, 1989.

Young et al. 1980
Young, Andrew McLaren, Margaret MacDonald, Robin Spencer, and Hamish Miles. *The Paintings of James McNeill Whistler.* 2 vols. New Haven and London, 1980.

Zola 1886
Zola, Emile. *Oeuvres Complètes.* Paris, 1967.

additional sources

Agnew, Geoffrey. *Agnew's 1817–1967*. London, 1967.

Allderidge, Patricia. *Richard Dadd*. London and New York, 1974.

Amer, Anne Clark. *William Holman Hunt: The True Pre-Raphaelite*. London, 1989.

The Art of Seeing: John Ruskin and the Victorian Eye [exh. cat., Phoenix Art Museum; Indianapolis Museum of Art] (New York, 1993).

Asleson, Robyn. "Classic into Modern: The Inspiration of Antiquity in English Painting, 1864–1918," Ph.D. dissertation, Yale University, 1993.

Bell, Quentin. *A New and Noble School: The Pre-Raphaelites*. London, 1982.

Bell, Quentin. *Victorian Artists*. London, 1967.

Bendiner, Kenneth P. "The Portrayal of the Middle East in British Painting, 1835–1860," Ph.D. dissertation, Columbia University, 1979.

Bennett, Mary. *Ford Madox Brown 1821–1893* [exh. cat., Walker Art Gallery] (Liverpool, 1964).

Blunt, Wilfrid. "*England's Michelangelo*": *A Biography of George Frederic Watts, O.M., R.A.* London, 1975.

Boase, T.S.R. *English Art, 1800–1870*. Oxford, 1959.

Bowness, Alan. "The Victorians," 249–290. In *The Genius of British Painting*. Edited by David Piper. London, 1975.

Bradley, Laurel. "Evocations of the Eighteenth Century in Victorian Painting," Ph.D. dissertation, New York University, 1986.

Bronkhurst, Judith Elaine. "William Holman Hunt: A Catalogue Raisonné of Paintings and Drawings Executed up to His Departure for the Near East on 13 January 1854," Ph.D. thesis, Courtauld Institute of Art, University of London, 1987.

Casteras, Susan. *Images of Victorian Womanhood in English Art*. Rutherford, N.J., 1987.

Casteras, Susan. "'Seeing the Unseen': Pictorial Problematics and Victorian Images of Class, Poverty, and Urban Life." In *Victorian Life in the Victorian Visual Image*. Edited by Carol T. Christ and John O. Jordan. Berkeley, 1995.

Casteras, Susan. *The Substance or the Shadow: Images of Victorian Womanhood* [exh. cat., Yale Center for British Art] (New Haven, 1982).

Cecil, David. *Visionary and Dreamer. Two Poetic Painters: Samuel Palmer and Edward Burne-Jones*. Princeton, 1969.

Cherry, Deborah. *Painting Women: Victorian Women Artists*. London and New York, 1993.

Christian, John. *The Last Romantics: The Romantic Tradition in British Art* [exh. cat., Barbican Art Gallery] (London, 1989).

Cowan, Leslie. *Arthur Hughes, 1832–1915: Pre-Raphaelite Painter* [exh. cat., National Museum of Wales] (Cardiff, 1971).

Cowling, Mary. "The Artist as Anthropologist in Mid-Victorian England: Frith's *Derby Day*, the *Railway Station*, and the New Science of Mankind." *Art History* 6 (December 1983), 461–477.

Cummings, Frederick, and Allen Staley. *Romantic Art in Britain: Paintings and Drawings, 1760–1860* [exh. cat., Detroit Institute of Arts; Philadelphia Museum of Art] (Philadelphia, 1968).

Curry, David Park. *James McNeill Whistler at the Freer Gallery of Art*. Washington, D.C., and New York, 1984.

Edelstein, Teri J. "'But Who Shall Paint the Griefs of Those Oppress'd': The Social Theme in Victorian Painting." Ph.D. dissertation, University of Pennsylvania, 1979.

Elzea, Rowland. *The Samuel and Mary R. Bancroft, Jr. and Related Pre-Raphaelite Collections*. Revised ed. Wilmington, 1984.

Errington, Lindsay. *Sir William Quiller Orchardson, 1832–1910* [exh. cat., National Gallery of Scotland] (Edinburgh, 1980).

Faberman, Hilarie. "William Holman Hunt's Notes of the Life of Augustus Egg." *Burlington Magazine* 127 (Feb. 1985), 86, 91.

Fairbrother, Trevor. *John Singer Sargent*. New York, 1994.

Farr, Dennis. *English Art 1870–1940*. Oxford and New York, 1984.

Faxon, Alicia. *Dante Gabriel Rossetti*. New York, 1989.

Fitzgerald, Penelope. *Edward Burne-Jones: A Biography*. London, 1975.

Fleming, Gordon H. *That Ne'er Shall Meet Again: Rossetti, Millais, Hunt*. London, 1971.

Forbes, Christopher. *The Royal Academy (1837–1901) Revisited: Victorian Paintings from the Forbes Magazine Collection* [exh. cat., Metropolitan Museum of Art; Princeton University Art Museum; and other venues] (New York, 1975).

Fox, Caroline. *Stanhope Forbes and the Newlyn School*. Newton Abbot, 1993.

Fox, Caroline, and Francis Green-acre. *Artists of the Newlyn School 1880–1900* [exh. cat., Newlyn Art Gallery] (Newlyn, 1979).

Fredeman, William. *Pre-Raphaelitism: A Bibliocritical Study.* Cambridge, 1965.

Gage, John. *J. M. W. Turner: "A Wonderful Range of Mind."* New Haven, 1987.

Gage, John. *Turner: Rain, Steam and Speed.* London, 1972.

Gage, John, and Chris Mullen. *G. F. Watts: A Nineteenth-Century Phenomenon* [exh. cat., Whitechapel Art Gallery] (London, 1974).

Gaunt, William. *The Aesthetic Adventure.* London, 1975.

Gaunt, William. *The Pre-Raphaelite Tragedy.* London and New York, 1942.

Gaunt, William. *The Restless Century.* London, 1972.

Gaunt, William. *Victorian Olympus.* London, 1952.

Gillett, Paula. *Worlds of Art: Painters in Victorian Society.* New Brunswick, N.J., 1990.

Goodchild, Anne. *J. W. Waterhouse, R.A., 1849–1917* [exh. cat., Mappin Art Gallery] (Sheffield, 1978).

Gordon, Catherine M. *British Paintings of Subjects from the English Novel, 1740–1870.* New York, 1988.

Greysmith, David. *Richard Dadd: The Rock and the Castle of Seclusion.* New York, 1973.

Grieve, Alastair. *The Art of Dante Gabriel Rossetti: The Pre-Raphaelite Period 1848–50.* Hingham, 1973.

Grieve, Alastair. *The Art of Dante Gabriel Rossetti: 1. "Found," 2: The Pre-Raphaelite Modern-Life Subject.* Norwich, 1976.

Grieve, Alastair. "Whistler and the Pre-Raphaelites." *Art Quarterly* 34 (Summer 1971), 219–228.

Hamilton, Walter. *The Aesthetic Movement in England.* London, 1882.

Harrison, Martin, and Bill Waters. *Burne-Jones.* London, 1973.

Herkomer, Hubert von. *Autobiography of Hubert Herkomer.* Printed for private circulation, 1890.

Hichberger, Joan W.M. *Images of the Army: The Military in British Art, 1815–1914.* Manchester, 1988.

Hills, Patricia. *John Singer Sargent.* New York, 1986.

Hilton, Tim. *John Ruskin: The Early Years 1819–1859.* New Haven and London, 1985.

Hilton, Timothy. *The Pre-Raphaelites.* London and New York, 1971.

Hobsbawm, E.J. *Industry and Empire.* Vol. 3. Harmondsworth, 1969.

Holman-Hunt, Diana. *My Grand-father, His Wives and Loves.* London, 1969.

Hueffer, Ford M. *Ford Madox Brown: A Record of His Life and Work.* London and New York, 1896.

Ironside, Robin, and John Gere. *Pre-Raphaelite Painters.* London, 1948.

Jenkyns, Richard. *Dignity and Decadence.* London, 1991.

Jenkyns, Richard. *The Victorians and Ancient Greece.* Cambridge, 1980.

Johnson, E.D.H. *Paintings of the British Social Scene: From Hogarth to Sickert.* London, 1986.

Johnson, Ronald W. "Dante Rossetti's *Beata Beatrix* and the *New Life*." *Art Bulletin* 57 (December 1975), 548–558.

Kestner, Joseph. *Masculinities in Victorian Painting.* Aldershot and Brookfield, Vt., 1995.

Kestner, Joseph. *Mythology and Misogyny: The Social Discourse of Nineteenth-Century British Classical-Subject Painting.* Madison, Wis., 1989.

Klingender, Francis D. *Art and the Industrial Revolution.* London, 1968.

Kriz, Kay Dian. "An English Arcadia Revisited and Reassessed: Holman Hunt's *The Hireling Shepherd* and the Rural Tradition." *Art History* 10 (December 1987), 475–491.

Lamb, Jody. "Lions in Their Dens: Lord Leighton and Late Victorian Studio Life," Ph.D. dissertation, University of California, Santa Barbara, 1987.

Lennie, Campbell. *Landseer, the Victorian Paragon.* London, 1976.

Levi, Peter. *Edward Lear, a Biography.* New York, 1995.

Lewis, Frank. *Benjamin Williams Leader, R.A., 1831–1923.* Leigh-on-Sea, 1971.

Lewis, Michael. *John Frederick Lewis, R.A. 1805–1876.* Leigh-on-Sea, 1978.

Lewis, Michael. *The Lewis Family, Art and Travel.* Old Woking, 1992.

Lister, Raymond. *Victorian Narrative Paintings.* London, 1966.

Llewllyn, Briony. "The Islamic Inspiration: J.F. Lewis, Painter of Islamic Egypt." In *Influences in Victorian Art and Architecture.* Edited by Sarah Macready. London, 1985.

Lusk, Lewis. *The Life and Work of B.W. Leader.* London, 1901.

Maas, Jeremy. *Gambart, Prince of the Victorian Art World*. London, 1975.

Maas, Jeremy. *The Victorian Art World in Photographs*. New York, 1984.

Maas, Jeremy. *Victorian Painters*. London, 1969.

Macleod, Dianne Sachko. *Art and the Victorian Middle Class: Money and the Making of Cultural Identity*. Cambridge and New York, 1996.

Mancoff, Debra. *The Return of King Arthur: The Legend through Victorian Eyes*. New York, 1995.

Marillier, H.C. *Dante Gabriel Rossetti: An Illustrated Memorial of His Art and Life*. London, 1899.

Marsh, Jan. *Pre-Raphaelite Women: Images of Femininity*. New York, 1987.

McConkey, Kenneth. *British Impressionism*. New York, 1989.

McConkey, Kenneth. *Impressionism in Britain* [exh. cat., Barbican Art Gallery; Hugh Lane Municipal Gallery of Modern Art] (New Haven, 1995).

McConkey, Kenneth. "'Well-Bred Contortions' 1880–1918," 352–386. In *The British Portrait 1660–1960*. Woodbridge, 1991.

Meisel, Martin. *Realizations: Narrative, Pictorial, and Theatrical Arts in Nineteenth-Century England*. Princeton, 1983.

Meyers, Bernard. "Studies for *Houseless and Hungry* and the *Casual Ward* by Luke Fildes, R.A." *Apollo* 117 (July 1982), 36–43.

Millais, Geoffroy. *Sir John Everett Millais*. London, 1979.

Mills, J. Saxon. *Life and Letters of Sir Hubert Herkomer*. London, 1923.

Morris, Edward. *Victorian and Edwardian Paintings in the Lady Lever Art Gallery*. London, 1994.

Nature and the Victorian Imagination. Edited by U.C. Knoepflmacher and G.B. Tennyson. Berkeley, 1977.

Nead, Lynda. *Myths of Sexuality: Representations of Women in Victorian Britain*. Oxford and New York, 1988.

Newall, Christopher. *The Art of Lord Leighton*. Oxford, 1990.

Newall, Christopher. *The Grosvenor Gallery Exhibitions: Change and Continuity in the Victorian Art World*. Cambridge, 1995.

Newall, Christopher. "The Victorians 1830–1880," 298–351. In *The British Portrait 1660–1960*. Woodbridge, 1991.

Newman, Teresa, and Ray Watkinson. *Ford Madox Brown and the Pre-Raphaelite Circle*. London, 1991.

Nicoll, John. *The Pre-Raphaelites*. London, 1970.

Noakes, Aubrey. *William Frith, Extraordinary Victorian Painter: A Biographical and Critical Essay*. London, 1978.

Nunn, Pamela Gerrish. *Problem Pictures: Women and Men in Victorian Painting*. Brookfield, Vt., 1996.

Nunn, Pamela. *Victorian Women Artists*. London, 1987.

Olson, Stanley, Warren Adelson, and Richard Ormond. *Sargent at Broadway: The Impressionist Years*. New York and London, 1986.

Ormond, Richard. *National Portrait Gallery: Early Victorian Portraits*. 2 vols. London, 1973.

Ormond, Richard, and Carol Blackett-Ord. *Franz Xaver Winterhalter and the Courts of Europe, 1830–1870* [exh. cat., National Portrait Gallery] (London, 1988).

Parkinson, Ronald. *Victoria and Albert Museum. Catalogue of British Oil Paintings 1820–1860*. London, 1990.

Poole, Stephen, ed. *A Passion for Work: Sir Hubert von Herkomer, 1849–1914* [exh. cat., Watford Museum] (Watford, 1982).

Pre-Raphaelite Art in its European Context. Edited by Susan P. Casteras and Alicia Craig Faxon. Madison, N.J., and London, 1995.

Pre-Raphaelites. Painters and Patrons in the North East [exh. cat., Laing Art Gallery] (Newcastle upon Tyne, 1990).

Pre-Raphaelites Reviewed. Edited by Marcia Pointon. Manchester and New York, 1989.

Rabin, Lucy. *Ford Madox Brown and the Pre-Raphaelite History-Picture*. New York, 1978.

Reynolds, Graham. *Painters of the Victorian Scene*. London, 1953.

Reynolds, Graham. *Victorian Painting*. London, 1966.

Roberts, Lynn. "Nineteenth Century English Picture Frames, I: The Pre-Raphaelites." *International Journal of Museum Management and Curatorship* 4 (June 1985), 155–172.

Roberts, Lynn. "Nineteenth Century English Picture Frames, II: The Victorian High Renaissance." *International Journal of Museum Management and Curatorship* 5 (September 1986), 273–293.

Rodee, Howard. "The 'Dreary Landscape' as a Background for Scenes of Rural Poverty in Victorian Paintings." *Art Journal* 36 (Summer 1977), 307–313.

Rose, Andrea. *The Pre-Raphaelites*. Oxford, 1981.

Sato, Tomoko, and Toshio Watanabe. *Japan and Britain: An Aesthetic Dialogue 1850–1930* [exh. cat., Barbican Art Gallery; Setagaya Art Museum] (London, 1991).

Schindler, Richard Allen. "Art to Enchant: A Critical Study of Early Victorian Fairy Painting," Ph.D. dissertation, Brown University, 1988.

Shone, Richard. *Walter Sickert.* Oxford, 1988.

Smith, Sarah Phelps. "Dante Gabriel Rossetti's Flower Imagery and the Meaning of His Painting," Ph.D. dissertation, University of Pittsburgh, 1978.

Spalding, Frances. *Magnificent Dreams: Burne-Jones and the Late Victorians.* New York, 1978.

Sparrow, Walter Shaw. *John Lavery and His Work.* London, 1911.

Spencer, Robin. *The Aesthetic Movement: Theory and Practice.* London, 1972.

Staley, Allen. *The Pre-Raphaelite Landscape.* Oxford, 1973.

Standing, Percy Cross. *Sir Lawrence Alma Tadema.* London and New York, 1905.

Stevens, Mary Anne, ed. *The Orientalists, Delacroix to Matisse: The Allure of North Africa and the Near East* [exh. cat., Royal Academy of Arts; National Gallery of Art, Washington] (London, 1984).

Stewart, David Alan. "G.F. Watts: The Social and Religious Themes," Ph.D. dissertation, Boston University, 1988.

Strong, Roy. *And When Did You Last See Your Father? The Victorian Painter and British History.* London, 1978.

Surtees, Virginia. *Dante Gabriel Rossetti: Painter and Poet* [exh. cat., Royal Academy of Arts; City Museum and Art Gallery, Birmingham] (London, 1973).

Surtees, Virginia, ed. *The Diary of Ford Madox Brown.* New Haven and London, 1981.

Sutton, Denys. *Walter Sickert: A Biography.* London, 1976.

Swanson, Vern. *Sir Lawrence Alma-Tadema, The Painter of the Victorian Vision of the Ancient World.* London, 1977.

Thomson, David. *England in the Nineteenth Century 1815–1914.* Revised ed. Harmondsworth, 1978.

Thomson, David Croal. *The Life and Work of Luke Fildes, R.A.* London, 1895.

Tomlinson, R. *The Athens of Alma Tadema.* Stroud, Gloucestershire, and Wolfeboro Falls, N.H., 1991.

Treuherz, Julian. *Victorian Painting.* London and New York, 1993.

Turner, Frank. *The Greek Heritage in Victorian Britain.* New Haven, 1981.

Usherwood, Paul. "Elizabeth Thompson Butler, A Case of Tokenism." *Women's Art Journal* 11 (1990–1991): 14–18.

Vaughan, William. *German Romanticism and English Art.* New Haven and London, 1979.

Victorian Artists and the City. Edited by Ira Bruce Nadel and F.S. Schwarzbach. New York, 1980.

Victorian Painting: Essays and Reviews. Compiled by John Charles Olmsted. 3 vols. New York and London, 1980.

Warner, Malcolm. "The Professional Career of John Everett Millais to 1863, with a Catalogue of Works to the Same Date," Ph.D. dissertation, University of London, Courtauld Institute of Art, 1985.

Warner, Malcolm, et al. *The Pre-Raphaelites in Context.* San Marino, Calif., 1992.

Watkinson, Raymond. *Pre-Raphaelite Art and Design.* London, 1970.

Weisberg, Gabriel. *Beyond Impressionism: The Naturalist Impulse.* New York, 1992.

Wildman, Stephen. *Visions of Love and Life: Pre-Raphaelite Art from Birmingham Museums and Art Gallery* [exh. cat., Seattle Art Museum; Cleveland Museum of Art; Delaware Art Museum; Museum of Fine Arts, Houston; High Museum of Art; Birmingham Museums and Art Gallery] (Alexandria, Va., 1995).

Wilton, Andrew. *The Life and Work of J.M.W. Turner.* London, 1979.

Wilton, Andrew. *Turner in His Time.* London, 1987.

Wood, Christopher. *Olympian Dreamers: Victorian Classical Painters, 1860–1914.* London, 1983.

Wood, Christopher. *Paradise Lost: Paintings of English Country Life and Landscape, 1850–1914.* London, 1988.

Wood, Christopher. *The Pre-Raphaelites.* London, 1981.

Wood, Christopher. *Tissot: The Life and Work of James Jacques Tissot.* London, 1986.

Wood, Christopher. *Victorian Painters.* Woodbridge, 1995.

Wood, Christopher. *Victorian Panorama: Paintings of Victorian Life.* London, 1976.

index of paintings

photo credits

Lawrence Alma-Tadema: Photo by London Stereoscopic Co. Courtesy of the National Portrait Gallery, London

Ford Madox Brown: Photo by W & D Downey. Courtesy of the National Portrait Gallery, London

Edward Burne-Jones: Photo by Rodney Todd-White & Son, London

George Clausen: Courtesy of the National Portrait Gallery, London

Richard Dadd: Photo by Rodney Todd-White & Son, London

William Dyce: Photo by John Watkins. Courtesy of the National Portrait Gallery, London

Augustus Leopold Egg: Photo by Rodney Todd-White & Son, London

William Maw Egley: Victoria and Albert Museum, London

Samuel Luke Fildes: Photo by Ralph W. Robinson. Courtesy of the National Portrait Gallery, London

Stanhope Forbes: Courtesy of the National Portrait Gallery, London

William Powell Frith: Photo by F. Joubert. Courtesy of the National Portrait Gallery, London

Hubert von Herkomer: Courtesy of the National Portrait Gallery, London

Arthur Hughes: Photo by W & D Downey. Courtesy of the National Portrait Gallery, London

William Holman Hunt: Photo by Elliott & Fry. Courtesy of the National Portrait Gallery, London

Edwin Landseer: Photo by John and Charles Watkins. Courtesy of the National Portrait Gallery, London

John Lavery: Photo by Rodney Todd-White & Son, London

Cecil Gordon Lawson: Frontispiece to Edmund Gosse, *Cecil Lawson, A Memoir,* 1883. Library of Congress, Washington, D.C.

Benjamin Williams Leader: Photo by Rodney Todd-White & Son, London

Edward Lear: Photo by McLean, Melhuish and Haes. Courtesy of the National Portrait Gallery, London

Frederic Leighton: Photo by Ralph Winwood Robinson. Courtesy of the National Portrait Gallery, London

John Frederick Lewis: Photo by Elliott & Fry. Courtesy of the National Portrait Gallery, London

John Everett Millais: Photo by Herbert Watkins. Courtesy of the National Portrait Gallery, London

Albert Moore: Photo by Frederick Hollyer. The Royal Photographic Society, Bath

William Quiller Orchardson: Photo by Ralph W. Robinson. Courtesy of the National Portrait Gallery, London

Dante Gabriel Rossetti: Photo by Charles Lutwidge Dodgson. Courtesy of the National Portrait Gallery, London

John Singer Sargent: Photo of Sargent at Broadway, painting "Carnation, Lily, Lily, Rose." Gift of Mrs. Francis Ormond, Fogg Art Museum, Harvard University Art Museums

Walter Sickert: Photo by George Charles Beresford. Courtesy of the National Portrait Gallery, London

Elizabeth Thompson (Lady Butler): Photo by Rodney Todd-White & Son, London

James Tissot: Private collection

Joseph Mallord William Turner: Drawing by Cornelius Varley. Sheffield Arts and Museums

Henry Wallis: Library of Congress, Washington, D.C.

John William Waterhouse: Photo by Ralph W. Robinson. Courtesy of the National Portrait Gallery, London

George Frederic Watts: Photo by Lock and Whitfield. Courtesy of the National Portrait Gallery, London

James McNeill Whistler: Glasgow University Library, Department of Special Collections

Franz Xaver Winterhalter: Photo by L. Caldesi. Courtesy of the National Portrait Gallery, London

Page 149: Amsterdam, Van Gogh Museum (Vincent van Gogh Foundation)

Page 154: Library of Congress, Washington, D.C.